The Life and Photography of Doris Ulmann

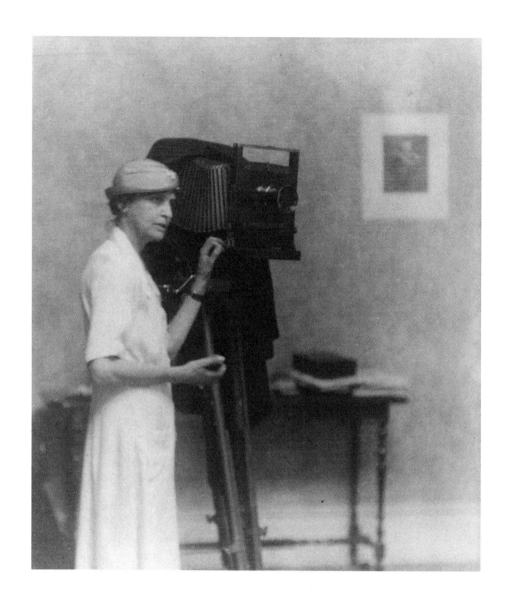

The Life and Photography of Doris Ulmann

Philip Walker Jacobs

THE UNIVERSITY PRESS OF KENTUCKY

Publication of this volume was made possible in part by grants from the E.O. Robinson Mountain Fund and the National Endowment for the Humanities.

Scholarly publisher for the Commonwealth,
serving Bellarmine College, Berea College, Centre
College of Kentucky, Eastern Kentucky University,
The Filson Club Historical Society, Georgetown College,
Kentucky Historical Society, Kentucky State University,
Morehead State University, Transylvania University,
University of Kentucky, University of Louisville,
and Western Kentucky University.

Editorial and Sales Offices: The University Press of Kentucky
663 South Limestone Street, Lexington, Kentucky 40508-4008

05 04 03 02 01 5 4 3 2 1

Frontispiece: Doris Ulmann Taking Photograph with View Format Camera, ca.1933–1934. Gelatin silver print. John Jacob Niles. John Jacob Niles Collection, Special Collections and Archives, University of Kentucky Libraries.

Library of Congress Cataloging-in-Publication Data
Jacobs, Philip Walker.
 The life and photography of Doris Ulmann / Philip Walker Jacobs.
 p. cm.
 Includes bibliographical references and index.
 ISBN 0-8131-2175-2 (cloth : alk. paper)
 1. Ulmann, Doris, d. 1934. 2. Women photographers—United States—Biography. 3. Portrait photography—United States. I. Title.
TR140.U426 J33 2001
770'.92—dc21
[B] 00-036337

Manufactured in the United States of America.

To Thomas, and Anna, and Jane, as always

Just as painters get the likenesses in their portraits from the face and the expression of the eyes, wherein the character shows itself, but make little account of the other parts of the body, so must I be permitted to devote myself rather to the signs of the soul in men, and by means of these to portray the life of each, leaving to others the description of their great conceits.

Plutarch

Sometimes give me thought,—when you wake during the night, you can think of me working with my plates in my dark room.

Doris Ulmann, in a letter to Cammie Henry

Contents

Figures and Plates

Figures

Plates

Preface

If you had come upon Doris Ulmann talking with an African American man or an Appalachian woman in the 1920s or early 1930s, you would not have imagined that the person before you was the creator of the ethereal and evocative photographs of Appalachians and African Americans that you might have recently seen in one of the prominent periodicals of the day. You would not have imagined she was the composer of the beautiful photographs recently exhibited at the Arts Center or the Delphic Studios in New York City or at Harvard University. And you would not have imagined she was the author of exquisite books of portrait photography designed and produced in the manner of William Morris and his followers in the Arts and Crafts movement. A short, dark-haired, dark-complexioned woman, her frail physical appearance, refined manners, elegant dress, and New York accent would not have given her away. Nor would these distinctive features have suggested she was on a mission to portray and document the character and work of southern African Americans and Appalachians, engaged in what one of her African American sitters called: "God's work."[1]

Instead, everything about Doris Ulmann would have suggested she was completely lost—far from the road her chauffeur or friend had meant to take—or worse, that she was a wealthy, mean-spirited spectator who had come to patronize and denigrate, only to get together later with her equally arrogant big-city friends to gossip and laugh about the language, demeanor, and dress of those she had seen. Everything about Doris Ulmann would have suggested these things, unless you had seen her at work, engaged in her art, physically and psychologically struggling to place into each image "temperament, soul, and humanity," working to make portraits "that are biographies."[2]

I first saw photographs by Doris Ulmann in the spring of 1993 in the archives of the Special Collections Department of the University of Kentucky. Though I had never seen her work before, I immediately recognized the importance of her photographs: first, as southern and American social documents and records; and second, as significant aesthetic works that merited a place within

the canon of photography. I also recognized that her work had a quality about it that is rare in modern portraiture and photography. Photographer William Clift noted this about Doris Ulmann's photography some years ago when he wrote: "When so many photographers these days are delving into the emptiness, sordidness and apparent hopelessness of man, it is refreshing to see pictures which offer us a quiet but deeply felt human experience."[3]

But something else struck me about these images, too—something more personal. As I studied them, I began to realize they reminded me of people I had known growing up in the South, of people like my Grandpa Jacobs, and my Granddaddy and Grandmother Saturday, and scores of other southerners who had touched my life.

Taken as I was by these photographs, I sought more information about their creator. This led me to examine the present literature on Ulmann, including *Doris Ulmann, American Portraits* by David Featherstone; *The Appalachian Photographs of Doris Ulmann,* edited by John Jacob Niles; *The Darkness and the Light* by William Clift and Robert Coles; and several articles about the photographer. Although I found these contributions attractive and insightful, I was left with the impression that their authors had uncovered only part of the story of Ulmann's life and work. Intrigued and moved as I was by the fascinating and beautiful images she left behind, I set about to see if I could find additional details about this distinguished photographer.

Certain things made this effort challenging, not the least of which was the fact that most of Ulmann's personal papers and correspondence, like that of so many other women photographers and artists, had been destroyed or lost with the passing years. This fact has made it impossible to provide a strict chronological record and to answer certain questions about Ulmann's life and work. Retrieval and examination of the personal papers and other documents that *do* remain was made difficult by the fact that these items are scattered among many public institutions and private collections throughout the country. Matters were further complicated by the fact that much previous scholarship and publication has been based on the later published accounts of her one-time assistant and paramour, John Jacob Niles. These accounts raised as many questions as they answered. Though they contain some accurate information about Doris Ulmann's work and health in the last two and a half years of her life, the questions these recollections raised required thorough study of Niles's personal papers at the University of Kentucky. They also required extended discussions with Niles biographer Dr. Ronald Pen, who has been extremely helpful at every turn. Evaluating Niles's notes, correspondence, autobiographical drafts, and published accounts required extensive investigation and continual checking and rechecking. This process helped me ascertain the degree of authenticity and accuracy in Niles's papers and helped me recognize that his later published accounts were peppered with inaccuracy and exaggeration.

One inaccuracy from these later accounts stands out: Niles's claim that Ulmann seldom wrote letters and that the ones she did compose were only "brief, cryptic letters, 'the kind you read and destroyed.'" It was this claim and Niles's portrayal of himself as the authority on Ulmann's life that led researchers to rely too heavily on his representation of Ulmann and to doubt the existence of significant correspondence by the photographer. These factors also dissuaded scholars from searching for additional materials and thus prevented them from discovering the important caches of letters and documents that are, in fact, spread across the United States. I have included notable portions of these letters and documents in this text because they provide valuable, indeed crucial, information about the personality, character, and work of Doris Ulmann and allow her to tell her own story.[4]

Among other things, these letters and documents offer insight into Ulmann's family history and background. They also help us to understand how these factors shaped her life and art and fashioned a person who was at one and the same time shy and bold, reluctant to be on public display but unafraid to step into the male-dominated worlds of medicine and literature or the cultures of Appalachians and African Americans. These records also enable us to appreciate the fact that this student of education and teaching remained, in her own way, a teacher throughout her life—one of those photographers who, as Martha Sandweiss wrote, "thought of themselves as historians," who understood "that their craft could not only preserve the past by recording the appearance of vanishing things, but could also function as an aid to memory and thus contribute to the increase of knowledge."[5]

In addition, these documents provide information about Doris Ulmann's health and the way it affected her work and life. Ulmann often wrote of her health problems, and her letters reveal that her own suffering and sense of mortality made her sensitive to the frailty and suffering of others, and evoked much of her passion for the elderly, particularly elderly Appalachian, African, and Native Americans. They also enable us to achieve a better understanding of her physical illnesses: her early history of stomach ailments, her confrontation with death in the early 1920s, her continual orthopedic problems, her later struggles with a variety of respiratory infections (exacerbated by her poor diet, chain-smoking, and constant work with photographic chemicals), and finally her struggles with kidney problems and septicemia, or blood poisoning. They further give us a picture of her lifestyle and her work habits that evokes sympathy when we realize how much she drove and pushed herself to create photography that both pleased and challenged others. At the same time, these documents elicit admiration when we grasp how determined she was to carry on in the face of so many obstacles and do the work she felt led to do.

In a similar way, these documents and extant family and census records disclose Ulmann's social class and indicate that she did not have to face many of the problems other women artists and photographers faced. Independently wealthy, she did not have to maintain a commercial portrait studio, solicit busi-

ness, or work for someone else, as did other women photographers, in order to pay bills and make ends meet. Nor did she have to worry about responsibilities that preoccupied many women of her day such as house cleaning, cooking, and raising children. Surrounded by servants, she enjoyed a freedom few could afford. And it was this freedom and her wealth that enabled her to pursue her photographic vocation at her own pace and in her own way.

Ulmann's photographs, letters, and books further reveal her philosophy of portraiture and her approach to her sitters and help explain how someone like herself was able to photograph a very diverse group of sitters. Among other things, they reveal that Ulman believed, as Alan Trachtenberg states, that "photographs do in fact 'mean,'" that they "insinuate ideas" and disclose a photographer's understanding of her sitters and her society. Shaped by the liberal and tolerant spirit of her parents and Felix Adler, the founder of the Ethical Culture Society, Ulmann viewed her sitters in an egalitarian way, believing, as Adler taught, "that differences in type contribute importantly to a democratic society." This belief about her subjects and her vision of America as a society of promise, tolerance, freedom, and opportunity permitted her to approach people very different from herself, both "different" and "vanishing" types.[6]

Ulmann's personality also enabled her to approach and photograph individuals from all walks of life. A friendly, congenial person and adept conversationalist, Ulmann always began her work by engaging her sitters in conversation that permitted the photographer to comfort and reassure her subjects and allowed her to get to know something of their interests and concerns. A preface to the actual work of photography, Ulmann understood that she could only create the kind of images she sought if she had good rapport with her subjects.

Another factor, profound and compelling, also helped her work, particularly in the last five years of her life: her sense of her own fragility and impending death. And most of those she photographed in this period, especially those who knew what it meant to suffer, must have seen this—not only in her physical appearance, but also in her eyes. All the trappings about her, her Lincoln, her elegant clothes, her photographic equipment, her chauffeur—none of these things could hide what they could see in her eyes. So they talked to the wealthy lady with the unusual accent and the disarming smile and let her take pictures of them.

The artist's photographs, letters, and books also demonstrate that while she was not, as John Szarkowski called Frances Benjamin Johnston, a "drill sergeant among photographers" who "ordered life to assume a pose," she did work with certain artistic presuppositions that attest to her general debt to the photo-secession and pictorialist movements and her specific debt to Clarence White.[7] They also suggest that she perceived herself—as most photo-secessionists and pictorialists did—as, first and foremost, working like a painter and artist. So it is that even when she worked in a manner similar to photographic documentarians and recorded an elderly Appalachian man playing a fiddle or a young African American

woman packing asparagus, she still approached her subject from the perspective of a painter; she saw a person worthy of thoughtful study and artistic portrayal.

Ulmann probably would have eschewed attempts to compare her work to later documentary photographers who, following in the traditions of Jacob Riis, Frances Benjamin Johnston, and Lewis Hine, reshaped photography in the middle 1930s and early 1940s. Ulmann had her own agenda—to create dignified and respectful photographic paintings of individuals who would probably never have the opportunity to sit for a good painter or portraitist or photographer—and, in many respects, she fulfilled this agenda by creating images that honor those who were often dishonored and "function to dispel negative stereotypes. . . ."[8] And yet, one cannot help but set her photographs next to those of Riis and Johnston and Hine and the photographers of the Resettlement Administration and the Farm Security Administration and see the similarities that do exist and concur with one scholar that Ulmann "combined pictorial and documentary techniques, creating a vehicle for preserving a pastoral, pre-industrial vision of the South (as well as other parts of rural America)." It is this fact that permits us to classify Ulmann as a pictorial documentarian.[9]

Still, her photographs leave little question that her work shares more similarities with the work of the great portrait photographers and artists who sought to reveal "the signs of the soul" and "tell stories" than with the photography and art of the strict documentarian.[10] Unlike two female contemporaries, Margaret Bourke-White and Dorothea Lange, who created a largely positive vision of American industrialism in the 1920s and 1930s, Ulmann never did bow before the powerful messiah of machinery and endorse the technological ideology of her day. Though this undoubtedly restricted her appeal in popular circles and diminished her opportunities for commercial publication, she chose to stay the course and keep to her focus on those personal subjects that meant the most to her. In this respect she stood over and against many of her colleagues and adhered to the aesthetic standard of the female novelist George Eliot, who wrote: "Do not impose on us any esthetic rules which shall banish from the reign of art those old women with work-worn hands . . . those rounded backs and weather-beaten faces that have bent over the spade and done the rough work of the world." For these reasons, her compositions enable us, as James Guimond said of Arthur Rothstein's picture of Artelia Bendolph, to see and understand "that ordinary people are worth seeing as much as the idealized or extraordinary people whom we see in the media." Ulmann's photographs permit us to understand that her portrayal of African American farmer Martha Sander is as worthy of our attention as Man Ray's composition of writer Gertrude Stein; and her photograph of Appalachian musician Jethro Amburgey is as deserving of our time as Eduard Steichen's portrait of George Cohan.[11]

In his book of essays, *Whistling in the Dark,* Frederick Buechner says that it is the artist's gift to put a frame around a fragment of time and life. He writes:

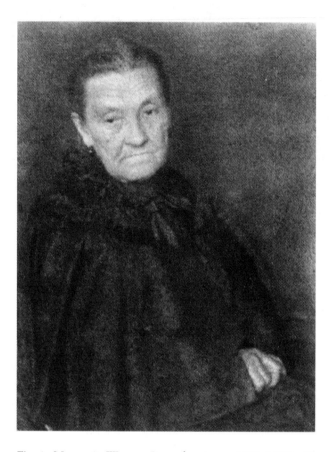

Fig. 1. *Mennonite Woman, Pennsylvania*, ca. 1925–1926. Oil pigment print. Private collection.

"Rembrandt puts a frame around an old woman's face. It is seamed with wrinkles. The upper lip is sunken in; the skin is waxy and pale. . . . It is not a remarkable face. You would not look twice at the old woman if you found her sitting across the aisle from you on a bus. . . . But it is a face so remarkably seen . . . that it forces you to see it remarkably."[12] The same may be said of the faces Doris Ulmann saw and photographed (fig. 1), of her remarkable portraits of southern Appalachians and African Americans, as well as her distinguished portraits of urban intellectuals. In putting "a frame" around the lives of these individuals, Ulmann challenged and challenges still the human inclination to not see those who are before us, whether across the aisle on the bus or subway, or across other spaces and lines and walls in the greater theater of human life. In doing so, she invites us to see our fellow human beings and ourselves more fully and completely.

No one comes to the vocation of historical research and writing without the instruction, insight, and guidance of others. Over the years, I have been enlight-

ened and shaped by the instruction of several individuals, including my father, Paul H. Jacobs, late of the University of Illinois; D. Elton Trueblood, late of Earlham College; Paul Achtemeier, James Mays, James Smylie, and Ken Goodpasture of Union Theological Seminary in Virginia; and Harry Gamble, Paul Barolsky, and Judy Kovacs of the University of Virginia. I have also been influenced by several other scholars, including Bruce Metzger, Martin Hengel, Ernst Kasemann, Hasia Diner, William Leuchtenberg, Andre Malraux, Martha Sandweiss, Richard Brilliant, Ronald Paulson, Helmut and Alison Gerasheim, Peter Palmquist, Naomi Rosenblum, William Innes Homer, Mike Weaver, A.D. Coleman, John Szarkowski, and Peter Bunnell. It is my hope that this work is indicative of their guidance and influence and will open the eyes of many to the beauty and grace of the photography of Doris Ulmann.

Many different individuals have provided assistance and guidance to me during my research and work: Kathy Erwin, Curator of the Warren and Margot Coville Photographic Collection; Dr. Jan Davidson, Executive Director of the John Campbell Folk School; Dr. James Birchfield, Curator of Books, Special Collections, University of Kentucky; Judith Keller, Department of Photography, J. Paul Getty Museum; William Marshall, Director, Special Collections, University of Kentucky; Barbara Lovejoy, Registrar, and Dr. Harriet Fowler, Director, University of Kentucky Art Museum; Claire McCann, Gordon Hogg, and Lisa Carter, Special Collections, University of Kentucky; Christian Peterson, Assistant Curator of Photography, Minneapolis Institute of Art; Mr. William Clift, Santa Fe, New Mexico; Susan Osborn, Assistant Director, Art Library, University of Kentucky; Marion Hunter, Conservator of Photography, Charleston, South Carolina; Libba Taylor, Assistant Director of the South Carolina Room, Charleston County Library, Charleston, South Carolina; Rabbi William Rosenthall, Charleston, South Carolina; Dr. Paul Barolsky, Professor of Art, University of Virginia; Dr. Ron Pen, Professor of Music, University of Kentucky; Monika Half, Photographic Consultant, Bronxville, New York; Dr. Melissa McEuen, Professor of History, Transylvania University, Lexington, Kentucky; Dale Neighbors, North Carolina; Peggy Vollmer, Research Assistant, New York Public Library; May Stone, Librarian, New-York Historical Society; Dr. Diane R. Spielmann, Public Services and Development Coordinator, Leo Baeck Institute, New York City; Dr. Toby Himmel and Natalie Koretz, the Ethical Culture Society, New York City; Paula Stewart, Amon Carter Museum; Ruth Summers and Laurie Fay Long, Southern Highland Handicraft Guild, Asheville, North Carolina; Julia Doyle, the Presbyterian Historical Society, Montreat, North Carolina; Dr. Loyal Jones, Berea College, Berea, Kentucky; Alton Cook and Kerry Beckham, Beckham's Bookstore, New Orleans; Amy Harvey, County Clerk, Washoe County, Nevada; Daile Kaplan, New York; Dr. Eric Moody, Curator of Manuscripts, Nevada Historical Society; the late Mrs. John Jacob Niles and Hannah Shephard, Lexington, Kentucky; Mary Yearwood, Schomburg Center

for Research in Black Culture; Martin Collins, Archivist, Columbia Medical Center; Mary Linn Wernet, University Archivist, Northwestern State University of Louisiana; Jerry Cotton, University of North Carolina; Gerald Roberts, Shannon Wilson, and Donna Lakes, Special Collections, Berea College; Evelyn Stiefel, niece of Doris Ulmann; Mary Wolfskill, Manuscripts Division, Library of Congress; Nancy Shawcross, Special Collections, University of Pennsylvania; June Peters, Univeristy of Kentucky; and the staff of The University Press of Kentucky.

The following individuals provided information about the photographic holdings of their respective collections and institutions: Marcia Tiede, Center for Creative Photography; Eve Schillo, Los Angeles County Museum of Art; Michael Hargraves, J. Paul Getty Museum; Samuel Daniel, The Library of Congress; Kristin Bauersfeld, National Portrait Gallery; Laurie Hicks, High Museum of Art; Lisa D'Acquisto, Art Institute of Chicago; Lisa Carter and Barbara Lovejoy, University of Kentucky; Sally Stassi; Historic New Orleans Collection; Mary Linn Wernet, Northwestern State University of Louisiana; Nancy McCall, Johns Hopkins University; Anne Haringa, Museum of Fine Arts, Boston; Kathy Erwin, Colville Collection; Olivia Gonzales, Saint Louis Art Museum; Dr. Jan Davidson and David Brose, John C. Campbell Folk School; Lisse Oland, Brasstown, North Carolina; Clementine Gregory, Asheville, North Carolina; Janie C. Morris, Duke University; Toby Jurvoics, Princeton University; William Clift, Santa Fe, New Mexico; Nancy Green, Cornell University; John McIntyre, International Center of Photography; Laura Muir, Metropolitan Museum of Art; Nell Farrell, Museum of Modern Art; Mary Yearwood, Schomburg Center for Research in Black Culture; Joe Struble, George Eastman House; Kristin Spainenberg, Cincinnati Art Museum; Gail Kana Anderson, University of Oklahoma; Will Harmon, University of Oregon; Joan Bewley, John F. Kennedy University; Elizabeth Brown and Diana Peterson, Haverford College; Rhonda Davis, Philadelphia Museum of Art; Elizabeth Fuller, Rosenbach Museum and Library, Philadelphia; Angela Mack, Gibbes Museum of Art; Dr. David Percy, South Carolina Historical Society; Courtney De Angelis, Amon Carter Museum; Phil Keagy, Menil Foundation; Linda Cagney, Chrysler Museum; Sue Bartlett, Seattle Museum of Art; Dr. Robert Boyce, Berea College; Dr. and Mrs. Gordon Layton, Paris, Kentucky; Holly Hinman, New-York Historical Society; Melanie Ventilla, San Francisco Museum of Modern Art; and Steven Maklanski, New Orleans Museum of Art.

I am also thankful to Louise Polan, Curator of Art, Huntington Museum of Art in West Virginia, who invited me to lecture on Doris Ulmann and curate my first exhibit of her photographs, and to Dr. Alexander Moore, Dr. David Percy, Stephen Hoffius, and Peter Varrick of the South Carolina Historical Society, and Paul Figueroa and Angela Mack of the Gibbes Museum, who invited me to organize a symposium on Ulmann at the Gibbes and curate a traveling exhibition of her South and North Carolina photographs. I am also grateful for

the financial assistance and contributions of the West Virginia Commission on the Arts, the Huntington Museum of Art, the University of Kentucky Art Museum, the National Endowment for the Humanities, the Institute of Museum Services, the South Carolina Humanities Council, the South Carolina Historical Society, the Gibbes Museum of Art, the John C. Campbell Folk School, the South Carolina State Museum, the Southern Highland Handicraft Guild, and Erskine College, which enabled these exhibitions to be held.

I wish to extend further thanks to Dr. Susan Williams, biographer of Julia Peterkin, who shared her extensive research on Peterkin and provided significant insight into the character and work of Peterkin.

This book would never have come to fruition without the loving and patient support of my wife, Jane, and our children, Thomas and Anna, the great loves of my life, who have each blessed me in their own special ways. Jane has been a constant source of inspiration and encouragement, and often served as my best critic. She and Thomas and Anna have also been willing to permit "Dad" to do the work he needed to do, though this sometimes meant that I missed certain activities and excursions. I cherish their love and care.

I have also been blessed by the moral support and encouragement provided by my oldest friends Rev. Dwain DePew and Rev. David Bower; other good and helpful friends and colleagues Lyn Layton, Josiah Ashurst Jones, James Bloomfield, William Stephens, Elizabeth Witt, Frank and Elizabeth Scott, Stuart Mackintosh, William Baldwin, Judy Powers, Judy Fortner, Sam Savage and Nora Manheim, Ila Mae Cumbee, Rev. Michael Schumpert, Sara Reeves, Genevieve Peterkin, Roy and Shirley Hutto, Charles De Antonio, Josephine Humphreys, Dr. Dwight Williams, Rev. George Coleman, Dr. Timothy Lyons, Dr. Alicia Jenkins, Ernest and Mary Barry, William Marshall, Dr. James Birchfield, Kathy Erwin, Christian Peterson, Barbara Lovejoy, William Clift, Judy Keller, Allison Webster, Rabbi William Rosenthall, Irene Rosenthall, Katherine Fleming, Dr. Jan Davidson, Dr. Alexander Moore, Rev. Owen Tucker, Dr. William Finley, Rev. Alexander Tartaglia, Rev. Richard Cushman, Rev. George Fletcher, Rev. Terry Sutherland, Rev. Robert M. Knight, Marion Hunter, Catherine Rodgers, Monika Half, Nancy Higgins, Eleanor Cutadean, Hank Kenny, S.J., Dr. Robert Ross, Dr. Dale Rosengarten, and Dr. Ron Pen, Norma Thomsen, Elizabeth Wallace, Ann Hockaday, Doug Cherrington; my mother, Helen Stark; my stepfather, George Stark; and the elders and members of the congregations of First Presbyterian Church, Paris, Kentucky; New Wappetaw Presbyterian Church, McClellanville, South Carolina; and my present parish, Providence Forge Presbyterian Church, Providence Forge, Virginia.

Chapter One
Beginnings

D oris May Ulmann was born on May 29, 1882, in New York City—the second child and second daughter of Bernhard and Gertrude Maas Ulmann.[1] Her father, a descendant of a distinguished line of European Jews, was a textile merchant. As a twenty-five-year-old resident of Fuerth, Germany, Bernhard Ulmann had immigrated to America in 1867, arriving in New York City on the ship *America* that August. A month later, his younger brother, Ludwig, joined him.[2]

Both brothers adjusted quickly to the new opportunities and freedom America provided, but they never lost sight of the fact that Christian Americans often responded to them, as author Hasia Diner recounts, in contradictory ways:

> On the one hand, Christian Americans welcomed them [Jewish immigrants]; in word and deed, America truly differed from any other Diaspora home. On this side of the Atlantic, no legacy of state-supported exclusion and violence, encrusted aristocracy, no embittered peasantry, or legally established church hierarchy manipulated centuries-old Judeophobia.
>
> On the other hand, despite tolerance and pluralism, Christians still articulated negative stereotypes about Jews. They wrote and spoke about the Jews' treachery and dishonesty in business at the expense of honest, hardworking Christians, about the Jews' eternal curse for the killing of Jesus . . . and their retrograde religion.[3]

Nonetheless, post–Civil War America and New York City afforded Bernhard Ulmann and other German Jews opportunities for economic and business development seldom experienced in their European homeland—opportunities available in part because of the economic boom that was taking place in New York City and across the United States.[4] *Trow's New York City Directory* provides infor-

mation about the movement and growth of Bernhard Ulmann's business in the second half of the nineteenth century. It shows that by 1869 Ulmann had formed his own company, *Bernhard Ulmann,* located at 54 Leonard Street. In the entry for this year, he is listed as an "importer of worsted, embroideries, etc." This record also documents that his brother Ludwig was a "clerk" in the business.[5]

An intelligent and hard-working businessman, within one year Bernhard Ulmann had moved into a residence with his uncle, Adolph Ulmann, at 118 East Fifty-eighth Street and had moved his business to 69 Leonard Street.[6] By the following year, 1871, the young importer had relocated the business to 374 Broadway.[7] Here it remained until 1880, when he moved it to 96 and 98 Grand Street.[8] Between 1875 and 1878, Ulmann expanded his business to include the manufacture of "Germantown wool," and he moved his residence from 31 East Twentieth Street to 47 East Fifty-ninth Street.[9]

Either just before this period or in 1875, Bernhard Ulmann married Gertrude Maas. Born in New York City on June 26, 1857, Gertrude Maas was the daughter of Martin Maas and Regina Ochs, prominent and affluent Reform German Jews.[10] After Ulmann's marriage to Maas, she gave birth to their first child, Edna, on November 16, 1876.[11] Five years later, they gave birth to their second and last child, Doris, at their home at 47 East Fifty-ninth Street.[12]

Bernhard Ulmann's business continued to expand in the remaining decades of the nineteenth century and into the next century. Sometime in the mid to late 1880s, Ulmann moved his family from their East Side Manhattan home into a new home at 129 West Eighty-sixth Street in the prestigious Upper West Side, an area which was home to many affluent German Jews. According to the 1890 New York City Police Census, Ulmann resided at this address with his wife "Gertie"; his two daughters, Edna and Doris; his mother-in-law, Regina Maas; and three servants—Kathaken Schunk, Annie Hurley, and Anna Schulz.[13] The expansion of Ulmann's business and the increase of his family's wealth brought recognition to the entrepreneur and his family, beginning in the early 1890s: the family was selected for inclusion in *Phillips' Elite Directory,* one of the foremost social registries in New York City, which contained a "list of selected names of distinguished families in New York."[14] By 1906, the four immediate family members had also been selected for listing in *Dau's New York Blue Book,* another prestigious social registry, which subsumed *Phillips' Elite Directory* in 1910.[15]

While many of the personal and family records of Doris Ulmann's early life have disappeared or been destroyed, these New York records and others confirm that she was raised in a highly affluent and sophisticated home. In this environment, she was waited on by servants and instructed in the proper manners, etiquette, and dress expected of a young woman in her position. She also was taught respect for her family (including an extended family of uncles, aunts, cousins, and other relatives with whom she always lived in close proximity in Manhattan), as well as respect for the elderly. Moreover, she was provided op-

portunities to travel abroad in Europe, particularly in Germany, where four of her father's siblings and many other relatives lived.[16]

Under the influence of her parents and her uncle Carl Ulmann, she was schooled in the value of education, literature, the arts, and fine books and handicrafts. She also was encouraged to treasure both her German Jewish heritage and the heritage and traditions of her ancestral home. A trusted associate of her father, her uncle Carl had been her father's business partner since the earliest days of *Bernhard Ulmann and Company.* He had also fulfilled the roles of family historian and bibliophile. It was this last role that had a particular influence on Ulmann's interest in literature. Over the years, Carl Ulmann built a substantial antiquarian book collection. Doris Ulmann would follow suit, in her own way, by collecting the autographs and signed works of contemporary authors, many of whom she photographed. Her uncle Carl's appreciation and knowledge of books undoubtedly shaped Ulmann and influenced the design and composition of her own books.[17]

The affluence of Ulmann's family continued to grow in her late adolescence. The record of the *Census Index* compiled by the Bureau of Census in 1900 shows that by this time Bernhard Ulmann had hired an additional household servant and had moved his business to a new and expanded location at 109-113 Grand Street.[18] Doris was eighteen at that time, and her parents gave her the opportunity to study in the Ethical Culture School, one of the major missions of the Ethical Culture Society of Manhattan.[19]

The Ethical Culture Society was founded in 1876 by Dr. Felix Adler, son of Dr. Samuel Adler, the German rabbi of New York City's Temple Emanu-El, the leading Reform synagogue in America.[20] A charismatic and intellectual activist, Adler rebelled against the ritual and theology of his father and the Reform Jewish heritage. He articulated instead "a religion such as Judaism ever claimed to be—not of the creed but of the deed."[21] His was a religious philosophy of good works and "benevolent action," based on the writings of Kant and Emerson and on the writings and traditions of Judaism and Christianity.[22] Such a religious philosophy proved attractive to many. Within a short period of time, Adler enlisted several prominent members of the liberal German Jewish community in Manhattan, including Joseph Seligman and Henry Morgenthau Sr.—two of the wealthiest men in America—and Samuel Gompers, founder of the American Federation of Labor.[23]

The Ethical Culture Society served as a vehicle for Adler's "faith in the worth of every human being, his belief that differences in type contribute importantly to a democratic society."[24] A man of his convictions, Adler established many benevolent organizations and helped implement many programs in New York City that provided assistance to its poor, sick, and uneducated citizenry.[25] One of the most important organizations he founded was the Ethical Culture

School, which he established in 1878.[26] As Mabel Goodlander, noted teacher and principal in Manhattan's Ethical Culture Schools recounted, the first Ethical Culture School began "in humble fashion as a free kindergarten for the very poor—the first of its kind in New York City. Its first home was in the old Wendel Dance Hall on West Sixty-fourth Street."[27]

Along with other liberal philosophers and educators of his age, Adler believed education, not religion, to be the "means to salvation." He went so far as to state that the primary purpose of education was to "train reformers." "By reformers are meant persons who believe that their salvation consists in reacting beneficently upon their environment. This ideal of beneficent transformation of faulty environment is the ideal of the Society and the School."[28]

Adler's ideas and his "ideal of beneficent transformation" attracted Bernhard and Gertrude Ulmann. Adler's influence led them to support, both morally and financially, their daughter Doris's desire to enroll in the two-year training course in kindergarten education of the Normal Department of the Ethical Culture School in 1900, following Doris' own elementary and high school education in Manhattan schools.[29] Located in a rented space in a building on West Fifty-fourth Street, the Normal Department offered an opportunity for young adult women to prepare for the "priestly" vocation of teaching children to learn how to act, as Adler had said, "beneficently upon their environment."[30] In an interview in 1964, noted educator Sidonie Gruenberg, a graduate of the Normal Department program, recalled the quality of the training prospective teachers received. She found the Normal Department to be "a place that was seething with ideas and very thorough training. When I finished at the Normal School and went to Teacher's College [Columbia] it seemed an anti-climax after the work I had gotten in education and psychology. They [the Normal Department] were so far ahead of anything that was being done at Columbia that it seemed as if I wasn't taking a graduate course."[31] Doris Ulmann's interest in this program reflected, among other things, her philosophical agreement with Adler, her love of children (later documented in her numerous photographs of children), and her commitment to join with people of like mind to help educate and protect those unfortunate innocents who were often disregarded and mistreated in a swiftly changing American society.

The ideas and ideals of Felix Adler and the Ethical Culture Society influenced Ulmann throughout her life.[32] One of her first and most cherished professional photographic portraits was her portrait of Adler in his mid-sixties, which she selected for repeated exhibition (fig. 2).[33] This influence can also be seen in the focus of her work. The fact that a substantial portion of her professional life was dedicated to uplifting and documenting the lives of people outside the mainstream of a rapidly developing American industrial culture indicates her acceptance of Adler's repeated criticism of this culture and his belief that it needed "reconstruction." According to Howard Radest, Adler thought

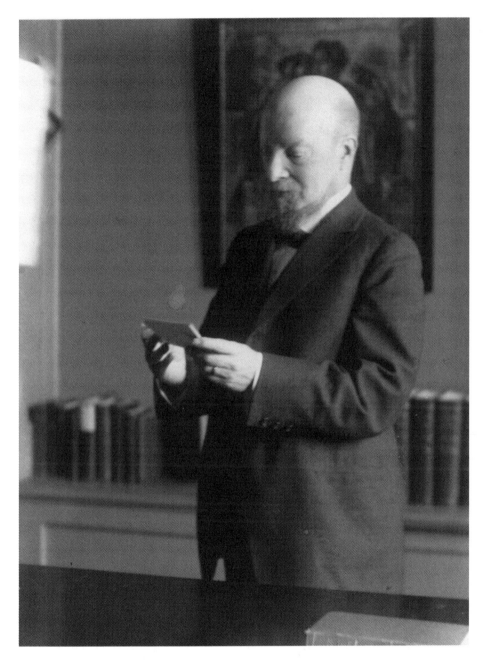

Fig. 2. *Felix Adler, Philosopher and Founder of the Ethical Culture Society*, ca. 1915–1916. Posthumous gelatin silver print. Printed by Samuel Lifshey ca. 1934–1937. Doris Ulmann Collection, Special Collections and University Archives, University of Oregon, U2302.

the reconstruction of industrial society was both possible and neces-
sary. The clue to reconstruction was the development of vocational
opportunity for every member of society based upon the "talents" that
were attributed to each person. Vocation, the commitment of the per-
son to meaningful work, was the core. . . . Adler saw in his concept of
vocationalism the possibility of a reconstruction of the democratic
ideal as well. . . . Each person, through the development of his talents
and through interaction with others, would find a place, a meaning-
ful place, in society. Thus, the pressures of alienation would be met
and the deadly superficiality of the commercial spirit could be suc-
cessfully challenged.[34]

In her later photographic work with Appalachian, African, and Native
Americans, and in her later bequests to two Appalachian schools, Ulmann would
affirm Felix Adler's "faith in the worth of every human being" as well as "his
belief that differences in type contribute importantly to a democratic society."[35]
In both her art and her life, she would seek, as Adler had suggested, to change
American society "by active intervention" and thus to "reconstruct" it.[36]

It would have been very difficult if not impossible for Ulmann to study
"various American types" in depth and make these large bequests without the
monies she received from her father's estate. The success of his business in the
first two decades of the century provided her with the financial means and the
freedom to respond to Felix Adler's invitation to "reconstruct" her culture. Records
of the period indicate that her father's business, *Bernhard Ulmann and Company,*
had assets of over $1 million.[37] They also indicate that the company's line of
products had grown during this time to include cotton and wool crocheting and
knitting materials and designs; photographically illustrated manuals of "handi-
craft" and "yarn-kraft," and "bucilla wool," with "original and popular designs
with full working instructions"; and household products, such as "silk draper-
ies."[38] The continual success of his company brought additional benefits to
Bernhard Ulmann's family. Records from *Dau's Blue Book* indicate that by 1906,
Mr. and Mrs. Bernhard Ulmann had acquired a summer residence at Fleischmann,
New York. A short time later Ulmann's sister Edna left their parents' home and
married Manhattan attorney Henry Necarsulmer.[39]

On May 6, 1908, Doris Ulmann's first and only niece, Evelyn, was born to
her thirty-two-year-old sister Edna and brother-in-law Henry (fig. 3).[40] Evelyn's
birth evoked much joy, not only for the baby's parents, but also for her grand-
parents, Bernhard and Gertrude Ulmann, and for Ulmann, too. This joy led to
the photographic documentation of this new family member, selections of which
were placed in a small, fifty-page contemporary photographic album.[41]

It is uncertain who took all of the photographs in the album, which records
the first several years of the life of Ulmann's niece. But it is possible that this

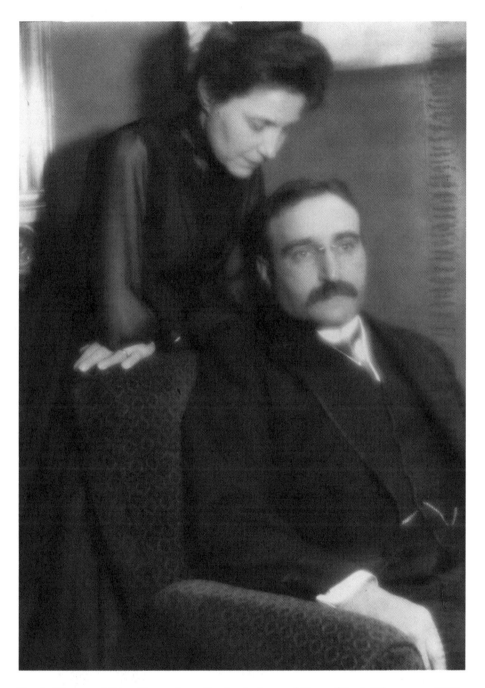

Fig. 3. *Henry and Edna Necarsulmer, Brother-in-law and Sister of Doris Ulmann,* ca. 1920s. Posthumous gelatin silver print. Printed by Samuel Lifshey, ca. 1934–1937. Special Collections and University Archives, University of Oregon, U 8036.

album contains the earliest known photographic works of Doris Ulmann. Ulmann treasured her niece. According to Evelyn Necarsulmer's testimony, her aunt Doris often dressed her up (especially with bows in her hair) in her early years and took photographs of her.[42] Several portraits of Evelyn, dressed up and posing with a bow in her hair, can be found in this early album.[43] Later evidence of similar compositions can be found in a particularly beautiful photograph Ulmann took of her niece in the 1910s (fig. 4).[44] The subtlety and beauty of this photograph (it is one of only a few existing Ulmann platinum photographs on rice paper) indicates the affection Ulmann held for her niece. Two other vintage compositions of her niece are known (see plate 1).[45]

Ulmann may also have taken a photograph of Bernhard Ulmann holding his only granddaughter and a picture of two-year-old Evelyn standing alone on the sidewalk in the same dress, both of which were taken in 1910 and included in this album (fig. 5). It is also feasible that Ulmann was the creator of six other photographs found in the photo album. Four of these photographs are of Evelyn; two are of Evelyn and another woman, possibly Ulmann's mother. Three of these six photographs are annotated "Fleischmann 1911."[46]

It is also likely that Ulmann was the author of most of the photographs on pages 26-31 in the photo album. Apparently taken on the same day, several of these photos feature Evelyn, neatly dressed and adorned with a large bow in her hair. Two of these are annotated "Scarsdale 1914," as are two other photographs (page 29) that feature Evelyn with her grandfather, Bernhard Ulmann, and another older person and a child. The Ulmanns had a residence in Scarsdale. The remaining two pages of this section of the album (pages 30-31) contain two additional photographs of Evelyn with Bernhard Ulmann, which were possibly taken by Doris Ulmann, and another of Evelyn with her grandfather, her aunt Doris, her uncle, Doris's new husband, Charles Jaeger, and two unidentified individuals. This last photograph is annotated "Glenhead 1915." The family is dressed in sweaters and coats. This photograph may have been taken a short time before Bernhard Ulmann's death at Glen Head, on Long Island, on November 29, 1915 (fig. 6). Taken by an unknown individual when the photographer was thirty-three years of age, and had only been married for a short time, it reveals Ulmann's fragility and her continual dependence upon her father, whom she both holds onto and leans upon.[47]

The photographs in this album reinforce the evidence of scores of other materials that document the degree of the Ulmann family's assimilation into urban American culture (this Jewish family celebrated "X-mas" with a large ornamented tree and presents) and the degree of their affluence (they owned more than one large residence, had servants, and wore the finest contemporary clothes).[48]

While it does not appear that Bernhard Ulmann and his family attended synagogue, it is clear that his Jewish heritage continued to inform his life. Though he did not subscribe to traditional Jewish ideas about God, the Torah, the syna-

Fig. 4. *Evelyn Necarsulmer, Dressed Up, Seated in Chair*, ca. 1915–1917. Platinum print on rice paper. Private collection, Paris, Kentucky.

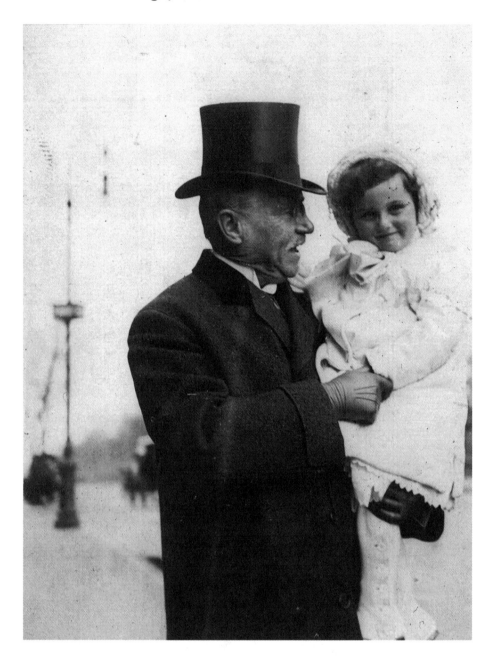

Fig. 5. *Bernhard Ulmann in Top Hat, Holding His Granddaughter, Evelyn Necarsulmer*, 1910. Printing-out paper. Unsigned. Private collection.

Fig. 6. *Bernhard Ulmann, Doris Ulmann, and Her Husband, Dr. Charles Jaeger, Her Niece, Evelyn Necarsulmer, and Two Other Individuals,* 1915. Printing-out paper. Unsigned. Private collection.

gogue, high holy days, human nature, sin, repentance, and messianic redemption, he still felt himself to be a Jew.[49] The remarks of his younger brother, Carl Joseph Ulmann, confirm this.[50] Writing in the introduction to his English translation of *Chronicle of Ber Bernhard Ulmann,* the 1803 Deutsche Yiddish text compiled by their Orthodox Jewish grandfather, Carl Ulmann noted the contrast between this grandfather and his grandchildren.[51] He wrote: "This ancient and venerable faith I cannot share . . . And yet—having confessed my system of non-belief or of agnosticism . . . I am bound to confess myself in feeling and in allegiance strongly a Jew. . . . Belonging to the Jewish people has never ceased to be disadvantageous and inconvenient. We live in a Ghetto still, no longer of inclusion, but yet one of exclusion. While such conditions exist, I shall ever remain true to the Star of David."[52]

Regardless of his differences with his Orthodox and Reform Jewish ancestors, Bernhard Ulmann did not neglect his responsibility to others. Upon his retirement in 1914, he joined with others to organize a new company, "Bernhard Ulmann Co., Inc. for the benefit of his former employees."[53]

Shortly after Bernhard Ulmann's death in late 1915, the Board of Directors of the newly organized company composed and adopted the following "Minute" in tribute to Doris Ulmann's father:

> Mr. Bernhard Ulmann's personal character added a peculiar value to his devotion to the Company's interests. His high sense of honor and integrity, his lofty standards of business ethics, his convictions of justice and fairness not only won for him the respect and esteem of all privileged to know him intimately, but rendered his influence in the councils of the Company, an active and potent force for good.
>
> His unfailing courtesy, his uniform gentleness and charm of manner are qualities which greatly endeared him to his associates, who will ever hold him in affectionate remembrance.[54]

Bernard Ulmann's "convictions of justice and fairness" not only led him to be a good business owner and manager but also influenced his gifts to many charities in New York City during his life as well as his bequests to several Jewish charitable organizations, the Ethical Culture Society, and the German Hospital Dispensary.[55] These convictions, and his personal characteristics of "unfailing courtesy," "uniform gentleness," and "charm of manner," helped to shape Doris Ulmann's own character. Not surprisingly, this litany of characteristics ascribed to Bernhard Ulmann could also be used to describe his daughter Doris.

~~~

Not much is known about Doris Ulmann's life and activities during the time following her graduation from the Normal Department of the Ethical Culture

School. Aside from the few facts she shared in a 1930 interview for *The Bookman* and provided for Marquis's *Who's Who in America,* Ulmann provided no direct information about this period of her life.[56] However, these facts and other information provide the basis for a construction of an outline of Ulmann's life and activities during this time.

Under no pressure to complete an additional educational degree, choose a career, establish her own financial security, or leave home, Ulmann continued to live with her family and their servants at her parent's residence at 129 West Eighty-sixth Street.[57] Situated as she was, she assumed additional responsibility for her aging parents in this period. She also continued to expand her aesthetic and intellectual interests and most likely took additional courses as a matriculated and nonmatriculated student at nearby Columbia University and other institutions in Manhattan. By her own account, Ulmann "studied psychology" and "went to law school," but her study of law was brief. In a 1930 interview with Dale Warren, she recounted that she gave up her study of law "because she felt that the human element was obscured beneath a welter of legal technicalities."[58]

The residential record of the United States Census of 1910 indicates that at age 27 Ulmann still resided with her parents, along with their four new German servants—Clara Hechtle, Julia Schmidt, Katie Bierman, and Frieda Hoeffler.[59] It also reveals that Ulmann was "unemployed."[60] She was probably preoccupied with the care of her mother, who became seriously ill around this time. Less than three years later, in February 1913, her fifty-six-year-old mother passed away of chronic nephritis.[61] (Chronic nephritis was an extremely common condition for women of the period, and was usually the result of years of kidney problems.)[62]

---

Several months after her mother's death, Ulmann met and married Dr. Charles H. Jaeger. Although there is no definitive record of the date of the marriage in Manhattan, *New York Telephone Directory* records suggest the marriage between Ulmann and Jaeger took place between May and October of 1914.[63] It is hard to determine where the couple first met, but it is possible that she met Jaeger as a patient at the Vanderbilt Clinic, where he served as Chief of Orthopedic Surgery at the time. Ulmann had serious orthopedic problems in later years, and it is likely these were the result of an earlier orthopedic injury.[64] It is also conceivable that Ulmann initially met Jaeger through her uncle Ludwig Ulmann, who, like Jaeger, was a member of the National Arts Club.[65] Since both Ulmann and Jaeger also shared a keen interest in the arts, they might have first become acquainted at an exhibition opening, fund-raising event, or club meeting. Certainly this shared interest, their common German-Jewish heritage, their passion for creative intellectual endeavors, and their mutual desire to help the less fortunate moved them to develop their relationship and eventually marry.

Fig. 7. *Dr. Charles H. Jaeger, Husband of Doris Ulmann, Physician, and Assistant Professor of Orthopaedics, The College of Physicians and Surgeons, Columbia University in the City of New York, Examining the Leg of a Young Girl,* ca. 1914–1918. Posthumous gelatin silver print. Printed by Samuel Lifshey, ca. 1934–1937. Doris Ulmann Collection, Special Collections and University Archives, University of Oregon, U 7491.

Jaeger was born in New York City in 1875 and graduated from the College of Physicians and Surgeons at Columbia University in 1896.[66] Following his graduation, he interned at Lenox Hill Hospital.[67] In 1899, he was licensed as a physician in the State of New York.[68] Shortly after this, Jaeger did post-graduate study in orthopedics with Dr. Albert Hoffa in Berlin and Dr. Adolf Lorenz in Vienna (fig. 7).[69]

Upon his return to America, Jaeger established himself as a specialist in orthopedics in the Manhattan medical community, becoming Clinical Assistant in Orthopedics at the prestigious Vanderbilt Clinic in 1901.[70] Between 1903 and 1909, he maintained private offices at 24 Central Park South and 24 West Fifty-ninth Street.[71]

In 1905, Jaeger was selected to be Chief of Orthopedic Surgery at the Vanderbilt Clinic, a position he would hold for thirteen years.[72] It was during his tenure in this capacity (he was also serving as Assistant Visiting Orthopedic Surgeon at the German Hospital) that Jaeger "realized that many of the cripples who came under his notice could be made self-supporting if they could be taught trades."[73] With a desire to help the maimed become "independent and useful," Jaeger found a financial patron, Mr. Artemus Ward, to help begin and sustain a "trade school for cripples" along the lines of similar schools in Germany.[74] The Trade School of the Hospital of Hope for Crippled and Injured Men, as it was called, was formally opened in 1912 at 159th Street and Mott Avenue in the Bronx.[75] Jaeger was appointed its director that year.[76] The trades taught at the hospital's six-month program were "art glass work . . . , reed furniture and wickerwork, cabinetmaking, silversmithing, monogram and wood engraving, die work, showcard writing and mechanical drawing."[77] The first institution of its kind in Manhattan, the hospital-trade school provided its pupils with free instruction and the opportunity to become "self-supporting and self-respecting."[78] Writing about "Trade Training For Adult Cripples" in the first volume of the *American Journal of Care for Cripples* in 1914, Jaeger revealed his sympathy for the problems crippled men faced when they sought employment:

> Many manufacturers will not employ badly crippled workers. They not only object to their appearance but they are afraid that they are not able to do a full day's work, and they do not wish to mix sentiment with business. . . .
>
> To make future employment reasonably certain it is therefore absolutely necessary to train the men so well that they become highly skilled. Their service will then be sought after, in spite of their affliction. . . .
>
> Considering how wretched and hopeless the life of a cripple needs must be, it should be our earnest aim to extend to them opportunities for becoming independent and self-respecting.
>
> The Trade School of the Hospital of Hope has been active during a period of business and financial depression recognized as the hard-

est known in twenty years. It has reacted upon the school in efforts to secure positions for our men. It can readily be seen when 300,000 or more men are out of work an employer will not take recourse to a cripple when numberless able-bodied operatives are available.

In spite of this handicap, the school has shown encouraging results and has proven that with a more general appreciation of the needs the problems of the cripple will be solved.[79]

It is interesting that this article authored by Charles Jaeger also contains two photographs—one of a class of crippled men making rattan furniture, and another, a still life of arts-and-crafts-styled articles (lamps, cooking pots, bookends, and other items), all made by crippled adults at the trade school.[80] Though the photographs are unattributed, they could well have been taken by either Jaeger or Doris Ulmann. This first volume of the *American Journal of Care for Cripples* also provides additional information about Jaeger and the trade school. Among other things, it lists Jaeger as a member of the editorial board of the journal and as a member of the Executive Committee, the Shop Committee, and the Legislation Committee of the Federation of Associations for Cripples.[81]

Following his marriage to Ulmann, Jaeger's medical reputation continued to grow. By January 1916, he had been appointed Instructor in Orthopedic Surgery at the College of Physicians and Surgeons at Columbia University.[82] In the same month that the Association of the Pictorial Photographers of America was organized, in his medical office at 471 Park Avenue, the *American Journal of Surgery* published an article by Jaeger.[83] Two years later, in July of 1918, Jaeger was appointed Assistant Professor in Orthopedic Surgery at the College. He remained in this position until 1930.[84]

After their wedding, Ulmann and Jaeger resided at the large Ulmann family residence at 129 West Eighty-sixth Street with Ulmann's father and the family's four servants.[85] The newlyweds regularly traveled together in the United States and Europe and shared their interests in the arts and photography.[86] There is every reason to believe Ulmann was quite pleased with her new role as the wife of a prominent Manhattan physician and Columbia University academician. There is also every reason to believe that the thirty-three-year-old Ulmann was pleased to finally be married and using the surname of a husband. While the couple's living arrangements with Ulmann's father may not have been completely comfortable, they did not have to live under these circumstances for long. On November 29, the *New York Times* recorded that Bernhard Ulmann "died suddenly of a cerebral hemorrhage . . . while playing golf at Glenhead, Long Island."[87]

Ulmann had been very close to her father, and his death hit her hard, especially with it coming so soon after that of her mother. But it also made her think about the future. Her father's long-standing interest in the design and

creation of artistic and functional handicrafts, and his understanding of the power of photography to present ideas as well as products, had not been lost on his daughter. They left her with deep respect for those who worked with their hands and for the objects they created, and pointed her in a new direction.

By the time of Doris Ulmann's birth in 1882, photography had become a recognized art form and was perceived as a vocation particularly suited to the "intuitive" female spirit, a profession in which women could excel, as they had in painting, printmaking, pottery, and woodcarving.[88] Such views were promoted not only by female practitioners but also by their male counterparts. Noted photographic portraitist Napoleon Sarony felt that "if women 'only once start out and become photographers, there is no doubt they will succeed,' because 'the medium by its very nature' seemed to invite them in."[89] Of course, the most significant proponents for photography as a profession for women were contemporary professional female photographers such as Rose Clark, Frances Benjamin Johnston, Gertrude Käsebier, Adelaide Skeel, Octave Thanet (Alice French), Elizabeth Flint Wade, and Catherine Weed Barnes.[90]

While Barnes was perhaps the greatest advocate for photography as a profession, Johnston and Käsebier probably exercised the greatest influence upon Doris Ulmann's generation.[91] Writing in such popular periodicals as *The Ladies Home Journal,* Johnston encouraged women to pursue the profession, noting it "should appeal particularly to women, and in it there are great opportunities for a good-paying business. . . ."[92] She also described the "training necessary for good work," the "necessary apparatus for photographic work," the study necessary in order to create portrait photographs of "distinction" and "originality," work in the darkroom, "the business side of photography," and many other pertinent matters.[93] Käsebier, in turn, inspired women by inviting them to join with her in an artistic journey to "make likenesses that are biographies" and "to put into each photograph . . . temperament, soul, humanity."[94] Such essays encouraged women, such as Ulmann, who were seeking a purpose and direction for their lives, and invited them to consider a vocation in photography. The efforts of Johnston, Käsebier, and others, and the possibility of significant success in the field, helped to dramatically increase the number of female photographers in the years between 1910 and 1920, the period in which Ulmann herself joined the profession.[95]

Ulmann first took up photography as a hobby, as did so many other Americans, and used a camera to document her family and their activities. But her own extant photographic record and the records of the Clarence H. White School and the Teacher's College (where White also taught) indicate that she only began serious study of photography after she married Dr. Charles H. Jaeger in 1914.[96] Once she decided to commit herself to the study of photography, she

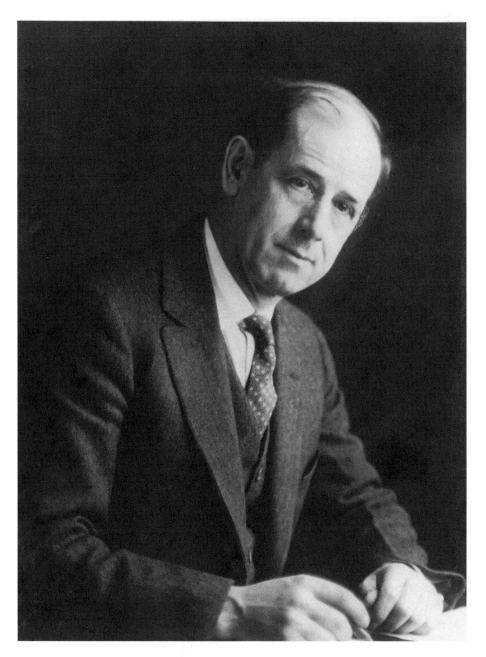

Fig. 8. *Clarence H. White, Ulmann's Photography Teacher and Founder of the Clarence H. White School of Photography in New York City*, ca. 1920–1925. Posthumous gelatin silver print. Printed by Samuel Lifshey, ca. 1934–1937. Doris Ulmann Collection, Special Collections and University Archives, University of Oregon, U 1113.

sought instruction from the most prominent teacher of photography in New York City, Clarence H. White (fig. 8).

A gifted photographer and teacher, Clarence White had moved in 1906 from his home in Newark, Ohio, to New York City at the encouragement of his fellow pictorialist photographer Alfred Stieglitz. Stieglitz encouraged White to play a more active role in the American Photo-Secession movement, which Stieglitz directed from its base in New York City. As the counterpart of The Linked Ring in Great Britain, the Photo-Club de Paris in France, and the Kamera Klub in Vienna, American Photo-Secessionism sought, in the words of Stieglitz, to secede "from the accepted idea of what constitutes a photograph." Like their European colleagues, American Secessionists were shaped by the aesthetic ideals of Impressionism and Symbolism. As such, they let these ideals inform their photography and help them place photographic images on an equal artistic plane with fine prints and paintings.[97]

In 1907, shortly after moving to New York, White was appointed the nation's first lecturer in photography by Arthur Wesley Dow, chairman of the art department at Teacher's College at Columbia and an artist and photographer in his own right. However, unlike many other Photo-Secession photographers who had fallen under the spell of Stieglitz and become disciples rather than artistic partners of the photographer, Clarence White seems to have maintained a sense of his own autonomy and artistic vision. This was partly because White had already established himself as an independent leader and artist in American photography through his organization of the first national exhibition of pictorialist photographers in November of 1899, under the auspices of his hometown (Newark, Ohio) camera club, his involvement in numerous photographic exhibitions, and through his participation in supporting Stieglitz's establishment of the Photo-Secession movement in 1902.[98] White cooperated and collaborated with Stieglitz in many ways, as is evident from White's work with the Photo-Secessionists in the first years of their history and in the two photographers' collaboration on a series of photographs in 1907. Nevertheless White, Käsebier, and other pictorialist photographers resisted Stieglitz's attempts to dominate the Photo-Secession movement. Stieglitz's relationship with Käsebier was especially bad, which led her to sever her ties with him in 1910. Stieglitz had a long history of trouble with his peers, and particularly with female colleagues. Others broke with Stieglitz following the Photo-Secession's International Exhibition of Pictorial Photography at the Albright Art Gallery in Buffalo in November of that same year. Within a year and a half, White followed suit. On May 15, 1912, in a letter to Stieglitz, White ended his relationship with the photographer and relinquished his membership in the Photo-Secession.[99]

Completely independent of Stieglitz, White called on Käsebier, Edward Dickson, and several others who had also broken with Stieglitz, and began to organize a photographic exhibit for the fall of that year. Many of White's friends offered to help.

Frederic and Bertha Goudy, the celebrated typographers of The Village Press, designed, lettered, and printed a poster for the event. The poster included a drawing by the artist Max Weber, who also agreed to install the exhibit.[100] On October 10, 1912,"An Exhibition Illustrating the Progress of the Art of Photography in America" opened at the Montross Art Galleries on Fifth Avenue in New York City. The first of many exhibits of the nascent confederation, the show ran until October 31 and marked just the beginning of many other activities.[101]

Shortly after this exhibit, White and his associates created a new journal of photography, *Platinum Print: A Journal of Personal Expression,* in order to perpetuate the philosophy of their burgeoning pictorialist confederation and provide an alternative to *Camera Work* and those photographic journals designed for the less advanced photographer. Highlighted with high-quality halftone photographic reproductions, the journal was designed and printed by Frederic Goudy and edited and published by White's student, photographer Edward Dickson. In addition to the beautiful reproductions, most issues included the work of contemporary poets; essays on style, composition, aesthetics, photography, and the history of lettering; a column on photographic events; and a review of current photographic exhibitions. The first issue of *Platinum Print* was distributed in 1913, and publication of the journal continued until the fall of 1917. The last two issues were published as *Photo=Graphic Art.*[102]

In January 1914, White organized a second pictorialist photographic exhibition, "The International Exhibition of Pictorial Photography," once again gathering Stieglitz dissidents for a show. This time the exhibition was held at the Ehrich Galleries at 707 Fifth Avenue in New York City.[103] Adelaide Ehrich, the wife of owner Walter L. Ehrich, was a student of White's.

This event was followed by an even more important one later in the year: the opening of the White School of Photography in October 1914.[104] In collaboration with the artist Max Weber, White established the Clarence H. White School of Photography at his rented residence at 230 East Eleventh Street, next to St. Mark's-in-the-Bouwerie, the oldest Episcopal Church in Manhattan.[105]

Under the leadership of White, Weber, Paul L. Anderson, and the many other outstanding teachers who would teach there at different times, this school would exercise more influence in the field of photography than any other photographic school in pre–World War II America. Clarence White's list of pupils would constitute a virtual "who's who" of prominent art, documentary, design, advertising, and fashion photographers, as well as filmmakers, and included Margaret Bourke-White, Anton and Martin Bruehl, Laura Gilpin, Dorothea Lange, Paul Outerbridge, Ralph Steiner, Karl Struss—and Doris Ulmann. With the founding of his own school, White had finally realized his dream. He was still committed to teaching at the Brooklyn Institute of Arts and Sciences and at Columbia University. But the creation of his own school offered White more instructional freedom and financial opportunities.[106]

White taught the school's courses on "The Art of Photography," which included such topics as "the discovery and development of photography," and the "selection of point of view in photography."[107] Anderson complemented White's instruction by teaching courses on the "Technique of Photography." In these courses, Anderson instructed Ulmann and other students in the different photographic printing processes, including commercial and hand-coated platinum, silver, single and multiple gum, oil, bromide, and photogravure.[108] Weber's lectures further complemented White's instruction. From 1914 to 1918, the avant-garde painter and printmaker taught "Art Appreciation and Design." In his courses, Weber lectured Ulmann and other students on the history of artistic design and composition and had them create their own photographic compositions. He did so in order to introduce his students to the variety of designs within their own world and to help them create beautiful photographic compositions.[109]

In her early photographic compositions of Weber and later compositions of other subjects, Doris Ulmann revealed her appreciation of his instruction, her own emphasis on design and composition, and her commitment to Weber's and White's philosophy of design (fig. 9). She also indicated her agreement with Weber's belief that "the photographer's art lies supremely in his choice or disposition of visible objects, as prompted and guided by his intellect and his taste. . . . He may shift objects, he may choose his position, he may vary the spaces between movable objects. . . . After this, he may display rare quality and great skill in the particular art of printing and developing, emphasizing or subduing tones and contours."[110]

While her husband's and uncle Carl's interest in photography, her attraction to the work of the pictorialists, and her facility with a camera undoubtedly motivated Ulmann to become a photographer, two key factors provided significant incentive for her: the desire for fellowship with other artists and photographers, and the desire to establish the meaning and definition of her own personality.[111] The camaraderie of other photographic enthusiasts and students at Columbia University, in the White School, and later in the Pictorial Photographers of America and other venues, provided Ulmann with a sense of community and the inspiration she sought to find her own distinctive voice and vision. In turn, Ulmann's desire to "make her own mark" and to develop her own spirit led her to seek to possess, through her study with White, that same material world of the photographic image she believed he possessed—to create photographs similar to his.[112]

At Teacher's College and at his own school, White used John Dewey's "project method" as a means for instructing Ulmann and her classmates. As such, "White used his students' immediate environment and emphasized problem-solving experiments rather than content."[113] Photographer and White student Dorothea Lange, who took courses with White in the Extension Division at Columbia University in 1917 and 1918, later recounted: "The assignment

Fig. 9. *Max Weber, Ulmann's Art and Design Teacher at the Clarence H. White School of Photography, New York City*, 1917. Platinum print. Audio-Visual Archives, Special Collections and Archives, University of Kentucky Libraries, 96 PA 104, Box 1, No. 100.

was generally to go out to a certain place . . . something like . . . a wrought iron gate, nothing better than that, something that you'd never really look at, . . . an undistinguished thing—and photograph that thing! . . . It was close by, and it was handy, so he sent these students there."[114] Some of these completed assignments and "problem-solving experiments" were later published in newspapers, calendars, and school brochures. One of these, a 1920 pamphlet entitled *Columbia University Photographic Studies,* included two reproductions of photographs by Ulmann published under her married name.[115]

It is not difficult to understand what led Ulmann to become a pupil of Clarence White. Certainly the beauty of his work, his majestic and yet subtle and lyrical compositions of women, as well as his capacity to make the ordinary appear extraordinary, enthralled and inspired Ulmann and left her with the desire to learn how to do what White did. As André Malraux has stated, an artist's sense of vocation does not come as much from "a sudden vision or uprush of emotion" as from "the vision, the passionate emotion or the serenity, of another artist."[116] White's photographic work evoked an "irresistible fascination" in Ulmann and other pictorialist students and inspired them to create their own pastiches.[117]

Dorothea Lange also spoke of other factors that drew students to White. She recounted that he was a humble and "gentle" man, "of very great tenderness." According to Lange, White had "an uncanny gift of touching people's lives, and they didn't forget it."[118] "He always saw the print [produced by the student] in relation to the person, and then he would start to stammer and writhe. He was most uncritical. But the point is he gave everyone a feeling of encouragement in some peculiar way—a nudge here, a nudge there. You walked into that room knowing that something was going to happen."[119] In a similar spirit, the photographer Laura Gilpin, who attended the Clarence White School from 1916 to 1917, described White as "an extraordinary person, an extraordinary teacher."[120] Undoubtedly, White's approach to photography and to his photographs served as a bridge between himself and Ulmann and his other female students, because they conveyed as well as any text or lecture White's respect for women and their femininity. White's obvious openness to women, his gentle demeanor, and his genuine respect for them drew female students to the photographer.

---

At Columbia University and the Clarence H. White School of Photography, Ulmann came to appreciate the value of the view camera for portrait photography. Following the example of White, Frances Benjamin Johnston, Gertrude Käsebier, and others, Ulmann normally used a large 6½" x 8½" glass-plate tripod-mounted folding view camera to make both studio and field portraits (fig. 10).[121]

There were two major disadvantages to this camera. First, unlike the Graflex

Fig. 10. *Doris Ulmann Taking Photograph with View Format Camera*, ca. 1933–1934. Gelatin silver print. John Jacob Niles. John Jacob Niles Collection, Special Collections and Archives, University of Kentucky Libraries.

camera and many others that were popular with her contemporaries, the large-format view camera Ulmann used was bulky and difficult to carry and use, particularly outside the studio. Second, the image the photographer saw on the viewing screen was reversed and upside down, which made composition difficult. It was much easier for a photographer to compose an image with a Graflex camera. In contrast to the view camera, the Graflex enabled photographers to photograph images as they saw them. Nonetheless, the view camera was recognized by many nineteenth-century and early twentieth-century photographers to be the best camera for studio portrait photography, and it fit Ulmann's personality and her desire to interact and relate with her sitters because its size and design "compelled" Ulmann to rely on the cooperation of her subjects.[122]

Further, like many older pictorialists, Ulmann used a soft-focus lens, which enabled her to bring an impressionistic quality to her photographic portraits. Her use of this lens and "her delicate use of natural light" reflected, as William Clift noted, "her attitude toward people," both the gentleness with which she wanted to approach them and the gentleness with which she hoped to be received. Also, like many of her predecessors, Ulmann did not use a shutter. Rather, she used her lens cap as a shutter. Once she had settled on a composition, she removed the lens cap for a few seconds. This provided proper exposure to the orthochromatic glass-plates that she used for her portraits.[123]

Similarly, Ulmann primarily used expensive commercial platinum papers in her printing. These required direct contact printing from the 6½" x 8½" dry glass-plate negative rather than enlargement.[124] Ulmann and other photographers used platinum paper, as W.I. Homer has noted, because platinum "offered a wide range of grays in the middle values, delicacy of tonal gradation, and a velvety surface unmatched by any process."[125] However, the gray platinum surface sometimes required "brightening."[126] This was particularly true of Ulmann's platinum images. Thus, she often used a wax (similar to a floor wax) on her images in order to brighten them and "obtain a gloss which gave better detail to the shadows" in the platinum image.[127]

White's influence upon Ulmann is most evident in her compositional and aesthetic design, in the different ways in which she positioned her sitters' faces, hands, upper torso, or whole body in natural light, against a background of the darkness of a room or window or door so that their personality and character might become the primary concern of the viewer.

There is little doubt that White also influenced Ulmann and Jaeger's decision to associate with the informal group of artists and photographers who had gathered around the influential teacher. The group included Max Weber, Edward Dickson, Gertrude Käsebier, F. Holland Day, Paul Anderson, Karl Struss, and Arnold Genthe. Since their first exhibit, in 1912, they had loosely organized themselves in order to facilitate communication and smooth the organization of their exhibits.[128] In December 1915, they held their final event as an

informal assembly. Organized by White as his third major installation, "An Exhibition of Pictorial Photography" was held at the Print Gallery (a part of the Ehrich Galleries) in New York City.[129] But this was not to be the end of the group; indeed, a more formal organization awaited birth.

This new organization was created January 15, 1916, when the "Pictorial Photographers of America" gathered to form an "association" at a formal meeting "held at the offices of Dr. Charles H. Jaeger."[130] Influenced by the ideas and ideals of the earlier Photo-Secession movement, the Pictorial Photographers of America believed pictorial, or art photography, to be a fine art similar to printmaking, drawing, and painting. The Pictorialists sought to demonstrate, through instruction and exhibitions, the scientific and aesthetic principles that could enable a photographer to create art in the photography.[131] As such, the organization provided its members, including Ulmann and Jaeger, with opportunities to become familiar with a variety of photographers and their work, to engage in further study of the technical aspects of photography, and to exhibit their own photography in New York and other cities throughout the United States and Europe.

At this first formal meeting, Walter Ehrich, whose gallery the group had used in the last two exhibits, was "appointed temporary chairman, and a committee, consisting of Edward R. Dickson, Dr. Charles H. Jaeger, Karl Struss, Clarence H. White, and Mary B. White" was "empowered to draw up a constitution through which the association might be enabled to carry on its work."[132] At the next meeting, several individuals were elected to serve as officers and members of the executive committee of the association, including, among others, Clarence H. White, President; Dr. A.D. Chaffee, Vice-President; Gertrude Käsebier, Honorary Vice-President; Dr. Charles H. Jaeger, Treasurer; Edward R. Dickson, Secretary; and Adele Shreve, Dr. D.J. Ruzicka, and Karl Struss.[133] It is an imposing list and was comprised of many of the finest pictorial photographers of the day, including Ulmann's husband. The appearance of his name among that of six others on a committee assigned to draft the association's constitution, the appearance of his name as treasurer among the list of the association's elected officers and executive members, and the fact that the first formal meeting was held in his office indicate that Jaeger and Ulmann had been involved with this group for some time. The fact that their photography was selected for exhibit in the first group exhibition of the Pictorial Photographers of America also suggests that they were already recognized as competent pictorialist photographers and printmakers. The show, "An Exhibition of Photography," was held under the auspices of the American Institute of Graphic Arts at the National Arts Club in New York in October of that year. Ulmann's photograph was entitled *The Blacksmith*.[134]

The first regular meeting of the Association of the Pictorial Photographers of America was held in February of 1917 at the National Arts Club at 119 East

Nineteenth Street and included addresses by Dr. Walter Hervey, Chairman of the Board of Examiners of the Board of Education; Walter Ehrich of the Ehrich Galleries; and Henry Hoyt Moore, of *Outlook* magazine on "the value of association in work."[135] An "Exhibition of Photographs by the Alumni Association of the Clarence H. White School of Photography" was held in the same month at Walter Ehrich's print gallery at 707 Fifth Avenue. Two prints by Ulmann were selected for this exhibit: *Substance and Shadow* and *The Coal Worker.*[136] Following the two-week show at the Print Gallery, the exhibition traveled to The Neighborhood Playhouse in New York; Princeton University; Vassar College; and Normal College at Oneonta, New York.[137] Other monthly meetings for the year included addresses on "photography in fiction," "photography in advertising," "photography and humanity," "overproduction in photography," "maturing the picture," "the evolution of the soft-focus lens," "opinions regarding the various printing processes and the use of the ray filter in pictorial photography." Also a part of these meetings were tours of art and photographic exhibits and viewings of stereopticon exhibitions of photographs by David Octavius Hill and Robert Adamson, Julia Margaret Cameron, J. Craig Annan, Gertrude Käsebier, George H. Seeley, Alvin Langdon Coburn, Clarence H. White, and other contemporary pictorialists.[138]

Three of these photographers seemed to have had the greatest effect on Ulmann: the nineteenth-century Scottish portrait team of David Octavius Hill and Robert Adamson, and Ulmann's teacher, Clarence H. White. Among the earliest pictorial documentarians, Hill and Adamson photographed both intellectuals and workers in 1840s Scottish society in a painterly fashion. In their body of soft reddish-brown and sepia calotype photography are many compositions of wistful and contemplative-looking men and women, posed at different angles (away from the photographer and observer), with books and other objects that reflect their respective vocations. Looking at these images, which are similar in size to those of Ulmann, it is easy to see the influence Hill and Adamson had on the twentieth-century photographer's understanding of design and composition and the inspiration they offered for the far-away and contemplative look for which she is known (figs. 11 and 12).[139]

It is possible Ulmann first encountered the work of Hill and Adamson, as did many other photographic enthusiasts, in Stieglitz's quarterly magazine, *Camera Work.* Stieglitz had first seen the work of these Scottish masters in the Dresden photographic show. In a display of obvious enthusiasm for their work, Stieglitz had written: "In the British exhibit but two deserve mention—Hill, the painter-photographer of fifty years ago, [to whom the photographs were solely attributed at the time] and J. Craig Annan. Their pictures will always hold their own in the very best of company—sane, honest, temperamental."[140] Impressed by Hill's photography, Stieglitz decided to share it with other photographic students and practitioners. In his April 1905 issue of *Camera Work,* Stieglitz pub-

Fig. 11. *Miss Grizzel Baillie, Scotland*, ca. 1843–1847. Calotype print. Robert Adamson and David Octavius Hill. National Portrait Gallery, London, England.

Fig. 12. *The Rev. Dr. Jabez Bunting, Scotland*, ca. 1843–1847. Calotype print. Robert Adamson and David Octavius Hill. National Portrait Gallery, London, England.

lished six photogravure reproductions of Hill's and Adamson's work and an article on Hill by the Scottish photographer J. Craig Annan.[141] Stieglitz's publication of these photographs led to a resurrection of interest in Hill's and Adamson's prints among photo-secessionists and pictorialists and the inclusion of their photography in several exhibits at 291 Fifth Avenue, Stieglitz's Little Galleries, and the National Arts Club in Manhattan.[142] These exhibits were followed by an important photographic exhibition at the Albright Art Gallery in Buffalo, where forty images by Hill and Adamson dominated the show.[143] The further publication by Stieglitz of several more photogravure reproductions of their work in issues of *Camera Work* in 1912 and 1914 and the inclusion of their work in two more pivotal New York photography exhibits provided Ulmann with ample opportunity to study the work of these "old masters" of photography and to develop an appreciation for their historic contributions to pictorial photography.[144]

An examination of Ulmann's portrait photographs as well as those of other pictorialists also reveals the influence of the early Dutch and Flemish portrait painters, such as Rembrandt, Hals, and Rubens; the British portraitists Raeburn, Romney, and Reynolds; the Pre-Raphaelite portraitists, such as Rosetti; and many American portraitists, including James McNeil Whistler, John George Brown and Thomas Eakins, Cecila Beaux, and William Merrit Chase (see plates 1, 16, and 34).[145] The influence of British portrait photographer Julia Margaret Cameron and the American portrait photographers Gertrude Käsebier, Frances Benjamin Johnston, and Alvin Langdon Coburn, whose work Ulmann viewed and studied with Clarence H. White and the Pictorial Photographers, can also be noted (see fig. 34 and plate 27).[146]

Other topics at these early meetings of the Pictorial Photographers reflected new developments at home and overseas. On February 3, 1917, the United States cut diplomatic ties with Germany. Two months later, on April 6, America declared war on the Axis powers. In the fifth regular meeting of the Association, in June, photographer Bernhard Horne spoke about the value of Pictorialist photographers providing "the soldier with photographs of his family or friends at home." In addition, Joseph Ashmore spoke about "Photography in the Army" and Dr. Charles Jaeger, Ulmann's husband, spoke about "X-Ray Photography."[147] Jaeger's talk was summarized in the *Pictorial Photographers of America Yearbook*:

> Dr. Charles H. Jaeger, who has had considerable practice in the work of X-ray photography, explained minutely the making of an X-ray negative and told the members how science had progressed in making these plates quickly and with less danger to the operator and patient, by the inter-position of the protective leaden wall. He recounted how X-ray photography had come to the relief of mankind; how inestimable is its value in locating bullets or fragments of shells which

are embedded in the soft tissues. Had it not been for X-ray photography many lives would be lost through inability to locate readily these embedded shells. He wanted the members to realize that the work of X-ray photography did not stop there in its relief to pain and regain of health; but is also used to determine the condition and position of the bone fragments in fractures, as well as being useful in detecting deceit where disability of bones or joints is feigned.[148]

Though America's engagement in the war preoccupied its collective mind in the spring and summer of 1917, the Association nonetheless completed "successful negotiations with sixteen of the leading Art Museums throughout the country" for two separate exhibitions of photographs by its members to travel to these different museums between September 1917 and May 1918. Five of Ulmann's prints (exhibited under her married name, Doris U. Jaeger) were selected. Three of them—*Substance and Shadow, Dr. Jacobi,* and *Dr. F. Adler*—were chosen for the "Western Group" traveling exhibition of the Pictorial Photographers of America (fig. 13). Through the use of a soft-focus lens Ulmann portrays Dr. Abraham Jacobi as a person of gentleness and understanding. One senses that the photographer reveres her subject. Renowned as he was in the field of children's diseases, it is possible the distinguished doctor may have seen Ulmann as a patient in her youth. A total of 104 prints were presented in this exhibition.[149] In the second initiative, two works by Ulmann—*The Gangway* and *Professor F. Adler*—were chosen for the "Eastern Group." One hundred and eight prints were sent in this exhibition (see fig. 2, *Felix Adler*).[150]

In the fall of 1917, Ulmann was further honored, both by Clarence White and by the Pictorial Photographers of America, when she was invited to give photographic presentations and lectures at the White School.[151] Another distinction quickly followed these. In December, five of Ulmann's photographs were selected for a group exhibition of alumni of the Clarence H. White School of Photography. The chosen works were *Peace and Sunshine, Design, The Old Wharf, Eventide,* and *Portrait.* With the exception of *Peace and Sunshine,* which was an oil print, the rest of these images were platinum prints. Entitled "An Exhibition of Pictorial Photography," the show ran from December 18, 1917, to January 12, 1918.[152]

The year 1917 proved a watershed year both for Jaeger and for Ulmann. Jaeger's professional achievement continued in 1917 with the renewal of his appointment as Instructor in Orthopedic Surgery at the College of Physicians and Surgeons at Columbia University, and with his reelection to the post of Treasurer in the Association of Pictorial Photographers of America. Ulmann enjoyed similar professional success through the increased visibility of her work and the growth of her reputation among her colleagues. She also reached a new level of independence and security as a result of the settlement of her father's

Fig. 13. *Dr. Abraham Jacobi, Professor of Children's Diseases, The College of Physicians and Surgeons, Columbia University in the City of New York*,1916. Platinum print. 6¾"x 4¾". Private collection, Paris, Kentucky.

estate. This inheritance, as well as a later inheritance from her uncle, Ludwig Ulmann, provided her with the means to develop her aesthetic gifts and to focus her primary attention on her photographic work.[153]

—◄◄◄—

The next three years (1918-1920) were very full years for Jaeger and Ulmann. In March 1918, four of Ulmann's prints (exhibited under her married name, Doris U. Jaeger) were selected for exhibition at the Fifth Annual Pittsburgh Salon of Photography at the Carnegie Institute of Fine Arts, along with the work of Jane Reece and Edward Weston. The installation ran from March 4 to March 31. *The Orphan, The New Boat, The Beachcomber,* and *Wilfred, the Lute-Player,* were just the first of many contributions Ulmann would make to this prestigious photographic salon over the next decade.[154]

During this period, Ulmann began to concentrate her energies on a special

project—her first book, a photographic record of her husband's new academic associates at Columbia. A bibliophile in her own right, as well as a gifted photographer, she enlisted Frederic and Bertha Goudy of The Village Press to help her produce her first photographically illustrated text, *The Faculty of the College of Physicians and Surgeons, Columbia University in the City of New York: Twenty-Four Portraits.*[155]

Master designers and typesetters of the period, the Goudys, along with Will Ransom, had established The Village Press in the summer of 1903. Their first publication revealed their philosophical and professional commitment to the principles of William Morris and the Arts and Crafts movement, a commitment shared by many pictorial photographers. The premiere book, *An Essay by William Morris and Emery Walker,* was designed and printed in Goudy's own Village type and was bound by Frederic Goudy and Will Ransom in August 1903.[156]

After relocating The Village Press to New York, the Goudys began collaborating with different pictorial photographers. Their first alliance was in the publication of H.G. Wells's *The Door in the Wall.* Frederic and Bertha Goudy set the type and designed the decorations for this text, which was illustrated with ten photogravures from images by the famous British pictorialist Alvin Langdon Coburn.[157] The Goudys' next collaboration was with Clarence White and Max Weber in the fall of 1912. This time they designed, lettered, and printed an exhibition poster (which included a drawing by Weber) for a Pictorialist photographic exhibition organized by White and installed by Weber at New York's Montross Art Galleries. "An Exhibition Illustrating the Progress of the Art of Photography in America" ran from October 10 to October 31. In *A Bibliography of the Village Press,* this show is described as "the first annual exhibition of the Pictorial Photographers of America."[158]

It is very possible that further inspiration for Ulmann came from Alvin Langdon Coburn's early association with the Goudys and from his text, *Men of Mark.*[159] She had likely seen several examples of Coburn's photographs and photogravures and had had an opportunity to study hand-printed and handcrafted books.[160] Coburn was a close associate of Clarence White and a highly respected pictorialist, whose work had long been the subject of serious study by White's photographic students and also by members of the Pictorial Photographers of America.

Respecting Ulmann's wishes for the development of her book on the Columbia medical faculty, Frederic Goudy created the designs for the layout of the text, and his wife Bertha set the type. The book was printed in New York City, and P.B. Hoeber saw the work to completion at the Marchbanks Press. The 14"x 10¼" folio was limited to 375 copies and printed on Hammer and Anvil paper. In gratitude to her mentor, Ulmann dedicated the book to Clarence White. Her efforts resulted in the creation of a beautifully designed and hand-printed vol-

ume featuring twenty-five of her works in photogravure. It is obvious that this first collaborative effort between Ulmann and the Goudys was fruitful.

*The Faculty of the College of Physicians and Surgeons* is a magnificent aesthetic achievement that reveals a sensitivity and maturity in Ulmann's work also found in that of her senior pictorialist colleague, Gertrude Käsebier (fig. 14). Even at this early stage in her photographic career, it was true, as Arthur W. Dow wrote of Käsebier, that Ulmann looked "for some special evidence of personality in her sitter, some line, some silhouette, some expression or movement; she searches for character and for beauty in the sitter. Then she endeavors to give the best presentation by the pose, the lighting, the focusing, the developing, the printing—all the processes and manipulations of her art which she knows so well. She is not dependent upon an elaborate outfit, but gets her effects with a common tripod camera, in a plain room with ordinary light and quiet furnishings. Art always shows itself in doing much with few and simple things."[161] *The Faculty of the College of Physicians and Surgeons* demonstrates Ulmann's appreciation for the work of William Morris and his intellectual disciples in the Arts and Crafts movement as well as for the work of photographers before her who had sought to produce similar books (fig. 15).

Though the book contains the date 1918 on the copyright page and the date 1919 on the title page, it was not actually published until the spring of 1920. As with the photographs she exhibited in this period, Ulmann authored the book under her married name, Doris U. Jaeger.[162]

While it is impossible to prove a direct relationship between the two events or to suggest that one led to another, it is curious that Jaeger was promoted to Assistant Professor in Orthopedic Surgery at the College of Physicians and Surgeons within the same year, 1918, that Ulmann was finishing her work with the medical faculty. It is hard to imagine that Ulmann's painstaking efforts to photograph the medical faculty and the effort resulting in this beautiful work made anything but a positive impression on Jaeger's colleagues. By completing this project, Ulmann not only assisted her husband in his professional progress but also furthered her own career.

Unlike some female artists before her, Ulmann did not let herself be either intimidated or eclipsed by the art of her husband. She had an independent personality, and did not imitate the work of her spouse (who largely concentrated on architectural photography). Instead, she concentrated her efforts on what interested her the most: the character and personality of individual human beings. In so doing, she held her own with Jaeger and eventually overshadowed him. It can be argued that this was inevitable, since most of Jaeger's energies had to be spent in his primary vocation of medicine, thus preventing him from attaining Doris Ulmann's level of achievement. But to make such an argument is to misunderstand and ignore Jaeger's deep personal commitment to his photographic work and to the Pictorial Photographers of America. The design and

Fig. 14. *Dr. Adrian Van Sindern Lambert, Associate Professor of Surgery, The College of Physicians and Surgeons, Columbia University in the City of New York,* ca. 1916–1917. Platinum print. 8"x 6½". Private collection, Paris, Kentucky.

# FOREWORD

PUBLICATION of the portraits of the faculty of the College of Physicians and Surgeons has occurred on at least two occasions. In 1846 while the College was still in Crosby Street a Broadside was published in lithograph which presented the seven chiefs of the existing faculty. Willard Parker, John B. Beck, Alexander Stevens, Jos. M. Smith, John Torrey, Robert Watts and Chandler R. Gilman appeared on that sheet. A similar group dated about 1875 hangs on the wall of the Faculty room. Among the notable men who appear there are T. Gaillard Thomas, Thomas M. Markoe, Alonzo Clark and John C. Dalton.

The faculty of 1850 shown in this earlier group, introduced into Medical Education in New York the methods of clinical lectures and of ward walks at the bedside of the patients, which have made the French school famous and Paris the Mecca of the young medical generation seeking for the highest development of medical truth.

The faculty of 1880 added to medical education in this city, the enormous advantages of laboratory instruction in the medical sciences and also

Fig. 15. Page from *The Faculty of the College of Physicians and Surgeons*, 1919. Private Collection.

quality of his work, his participation in regular photographic exhibitions, and his long involvement with the Pictorial Photographers of America testify to his enthusiastic identification with the photographic enterprise.[163]

The end of World War I opened the door to many changes, including publication of the first advertisements showing women holding cigarettes, the short-lived Eighteenth Amendment, which prohibited the sale and distribution of alcoholic beverages, and the Nineteenth Amendment, which gave women the right to vote. The war's end also opened the door to a new era of literary and artistic creativity in America that brought the likes of playwright Eugene O'Neill, writers Sinclair Lewis and F. Scott Fitzgerald, artists Edward Hopper and Georgia O'Keefe, and musician George Gershwin to the forefront of American cultural life.

The blossoming creativity of the time further inspired and encouraged the middle-aged Ulmann to continue her own work. In March 1919, Ulmann responded readily to another opportunity to exhibit her work at the annual Pittsburgh Salon of Photography. Five of her prints (still being exhibited under her married name) were selected for the show: *The Smith, Reverie, Long, Long Ago, At Work,* and *High Noon.*[164] The following month, several oil and bromoil prints by Jaeger and Ulmann and five other Pictorialists were exhibited in the galleries of the Clarence White School of Photography in New York at Seventeenth Street and Irving Place (see plates 7 and 10).[165]

In May, portrait photographs by Ulmann and architectural photographs by Jaeger were exhibited in a large group showing—"Second Annual Exhibition by Art Alliance of America and the American Institute of Graphic Arts"—at 10 East Forty-seventh Street in New York City. Along with numerous prints, the exhibition included a large display of photographic printing processes and different types of photographic methods.[166]

In the late winter months of 1919 and early 1920, Ulmann's interest in photography was enriched by an important conference. The Association of the Pictorial Photographers of America sponsored lectures by several prominent individuals, including H.J. Potter of the Eastman Kodak Company; artist Albert Sterner; photographers Pirie MacDonald and Walter Wolfe; Allen Eaton, Field Secretary of the American Federation of the Arts; William Ivins, Curator of Prints at the Metropolitan Museum of Art; and Frank Weitenkampf of the New York Public Library.[167]

The beginning of 1920 brought other opportunities for Ulmann to reveal her artistic gifts. From January 3 through January 31, her work was presented in a group exhibition at the Third International Photographic Salon in Los Angeles. The show, organized under the auspices of the Camera Pictorialists of Los Angeles, was held at the Gallery of Fine and Applied Arts in the Museum of History, Science, and Art. Six of her photographs were included: *Masts, Poplars,*

*Gloucester, Frederick Villiers, At the Water Front,* and *Sunlight and Shadow.*[168] Seven days later, another group installation containing her photographs opened on the west coast at The Art Museum in Portland, Oregon. "An Exhibition of Pictorial Photography" was organized under the auspices of The Pictorial Photographers of America and included two images by Ulmann—one entitled *Fish Handler* and the other, *Reflections.* This group exhibit lasted until February 1 and later traveled to the Dubuque Art Association (April 1920), Colorado Springs (June 1920), and Denver (July 1920).[169]

Within this same period, the first volume of *Pictorial Photographers in America,* the journal of the Pictorial Photographers of America, was published. It included a large number of reproductions of photographs by members, including Ulmann's *Portrait of a Child* and Jaeger's *Portico, Columbia University,* which were also reproduced in the journal *Photo-Era.*[170] This volume also includes an essay on the "work and aim" of the Association by photographer and recording secretary Edward R. Dickson, in which he wrote: "The Pictorial Photographers of America is an association having in mind solely the development of the art of photography from a standpoint of educational value. The Association holds monthly meetings at the National Arts Club, 119 East 19th Street, New York, where exhibitions and lectures are given. Admission is free. . . . Membership in the Association is open to men and women of good character and ambitious intentions, including those who, though not photographers, are interested in the development of art."[171]

During the first few months of the year, Ulmann traveled back and forth between New York and Baltimore in order to do photographic studies of thirty-six members of the faculty of the Medical Department of Johns Hopkins University. The project was similar in scope and character to the work she had done with the faculty of the College of Physicians and Surgeons of Columbia University. Though the photographer hoped her work at Hopkins would go as well as it had at Columbia, she was unable to get the same level of cooperation from the Hopkins faculty. While the extant correspondence between Ulmann and three Hopkins's faculty members, Drs. William H. Welch, William S. Halsted, and William G. Mac Callum, reveals the disappointment and frustration she felt over the resistance she encountered in preparing her book, the letters also show Ulmann to be a determined and assertive individual who could hold her own in a man's world.[172] Troubled as she was that Dr. Welch, a leading figure at the Medical Department, would not write a foreword for her text, Ulmann was very direct with one member of the faculty, Dr. Mac Callum (fig. 16), about her intentions to move ahead with the publication of her book: "I regret exceedingly that I am obliged to publish the book without Dr. Welch's message, but I really cannot afford to wait any longer as it is now two years since I have finished my work for this book. It seems especially unfortunate as the announcements giving the promise of Dr. Welch's foreword have been distributed a long time ago. In a

Fig. 16. *Dr. William George Mac Callum, Baxley Professor of Pathology, The Faculty of the Medical Department, Johns Hopkins University, Baltimore, Maryland,* 1920. Photogravure after a platinum print. Published in *A Book of Portraits of the Medical Department of the Johns Hopkins University.* Private collection.

week I hope to be in a position to plan for a definite date for the appearance of the book."[173] The letters also disclose Ulmann's passion for photography and the way it had already shaped her life. In a letter to Dr. Halsted, she wrote: "I must tell you how I feel about my work. It has always been a pleasure, more in the nature of a hobby, for me, and my love for my work has given me the enthusiasm to go ahead with it . . . the greatest appreciation you can show me is to understand what photography has meant to me."[174]

As Ulmann was finishing her photographic studies of the medical faculty at Hopkins, she and Jaeger had another opportunity to show their photography at the annual Pittsburgh Salon of Photography. Only one of Ulmann's prints was selected for this March exhibit: *An Illustration.* Two of Jaeger's prints were selected: *Boats* and *Guinea Wharf, Gloucester.* But the catalog of the salon reported an important honor: for the first time, "Dr. Charles H. Jaeger, New York" and "Mrs. Doris U. Jaeger, New York," were listed as "contributing members," "who, by their consistent work and contributions to our salons, have won a place on our rolls."[175]

Later in 1920 Clarence White moved his school from 122 East Seventeenth Street to 460 West 144th Street, the address of the school until 1940.[176] At the celebration of the opening of the school's new offices at the Autumn Meeting of the Alumni, many of Ulmann's photographs and images were displayed in a solo exhibit. The photographer's work could be seen on the walls of the new exhibition room, in portfolios, and in her book *The Faculty of the College of Physicians and Surgeons.* In *The Bulletin of the Alumni of the Clarence H. White School* (House Warming Number), which recounted Ulmann's "remarkable" exhibit, it was noted that Ulmann's "variety of subject, excellent quality of the photography, and the extraordinarily fine composition gave us ideals rarely found in any exhibit." It was a tremendous honor to have her work chosen for such an event, and this honor and the opportunity to lecture on her photographic studies of the medical faculty at Columbia once again indicated the high regard Clarence White had for her work.[177]

— — —

The 1920 Census Index records Charles H. and Doris U. Jaeger as the residents at 129 West Eighty-sixth Street in New York City and also lists the names of four residential servants.[178] This information suggests that along with their many professional accomplishments of the period, Ulmann and Jaeger had assumed a position of prestige within affluent New York City society. A few months after the census was taken, three portrait photographs by Ulmann (still exhibiting under the name Jaeger) were selected for an exhibition by alumni at the Clarence H. White School of Photography.[179] Around the same period of time, the second volume of *Pictorial Photography in America* was published. It included a reproduction of a photograph by Ulmann of an elderly man holding a hat and cane, simply titled *Portrait.*[180]

Some months later, Ulmann and Jaeger again displayed their work together in a group show, "The International Exhibition of the London Salon of Photography." It was held at the Galleries of the Royal Society of Painters in Water Colours and included two photographs by Ulmann and three photographs by Jaeger.[181]

However, it appears Ulmann and Jaeger had separated by November 1920. Late that month, still using her married name, she wrote one of the faculty members at Hopkins of her impending departure, noting: "I am leaving New York for an absence of a number of months—and it is now impossible for me to change my plans to go West." It is not clear where she initially went. A letter written in February contains a post office box address in Reno, Nevada, which was a secluded and fashionable "divorce colony" at the time. A recognized retreat for artists and photographers, as well as for the wealthy, the small community of Reno was known as a hideaway, where one could obtain a "quiet divorce" after a six-month residency. But there is no evidence that Ulmann secured a divorce in Reno or any of the other major communities in Nevada. It is possible she obtained her divorce in one of the smaller communities in the state or perhaps obtained it in California, where she also visited during this time. But residency requirements in California would have necessitated that she remain there for a much longer period of time than in Nevada. Certainly either of these locations would have provided a peace and respite from her troubles that she could not have found in Manhattan. What is clear is that her marriage was over by November 1921.[182]

In the November 1921 *Bulletin of the Alumni,* it was reported that an alumni exhibition had been held (since the last *Bulletin,* which had been published in June), "including prints of superior quality, by Misses Boyd, Gilpin, Erving, Spencer, Wallace, Watkins, Weston, Wilson, White (Cornelia F.) and by Mistresses Hervey, Hoops, Richards, Shreve, and Ulmann." The name shift used here to identify the photographer is pivotal. For the first time in an exhibit, she was listed by her maiden name, and from this time forward, Ulmann exclusively used her maiden name in association with her works.[183]

Additional confirmation of this change had come on the evening of October 31. That evening marked the opening of the Art Center at 65-67 East Fifty-sixth Street, an occasion on which Dr. Charles Jaeger posed for a photograph (standing in the front row), along with such New York City social and artistic leaders as Charles Lamb, Mrs. Ripley Hitchcock, Charles Dana Gibson, Edward Penfield, Mrs. Elihu Root, Frank Weitenkampf, Joseph Pennell, Louis Comfort Tiffany, and F.W. Goudy. The "Catalogue of Exhibition by Pictorial Photographers of America" printed for this opening listed three prints by Ulmann under her maiden name, two of which she had previously exhibited and signed under her married name. They were: *High Noon* and *The War Correspondent.*[184] Antoinette Hervey, an associate of Ulmann's as well as a White School graduate, acknowledged this change in her late November correspondence to Laura Gilpin,

another White School graduate, noting Ulmann had stopped using the name Jaeger and begun to use her maiden name.

More importantly, Hervey revealed that the thirty-nine-year-old Ulmann was extremely ill at the time. "Do you know that she [Ulmann] is very, very ill? She has had a very severe operation performed after she had had two blood transfusions and is very low. We are very sad over it."[185]

This near encounter with death, along with other physical and emotional suffering the photographer had confronted up to this point in her life, left her with a deep sense of her own fragility and vulnerability, and logically drew her to people who had also had to face their own fragility and vulnerability and enabled her to establish a relationship with them. It permitted this wealthy and sophisticated urbanite to walk into the homes and lives of those "for whom life had not been a dance."[186]

Once Ulmann had procured her divorce, the photographer returned to New York, where she began to reestablish her identity as a single woman. Among other things, she erased her married name on most of her photographs and signed them again, in pencil, with her maiden name (fig. 17). Some of her earliest images still retain her married name. A few even retain her married name and a red monogram of her married name, which she usually placed in the lower right or left corner of the image. But most of her signed images are in pencil and are in her maiden name. Though her prints reveal that the erasure was often done hurriedly, in a way which left the earlier signature partially visible, they nonetheless reveal Ulmann's desire to completely end her connection and association with Jaeger.[187] The fact that she refused to acknowledge her association with Jaeger or refer to their marriage in later interviews, correspondence, and texts attests to the depth of her pain over the loss of this relationship.[188]

--- --- ---

Despite the sorrow of marital separation, Ulmann's photographic career moved "full speed ahead" in 1922. The American Federation of the Arts provided her with her first opportunity for exhibition for the year. They arranged for photographs selected for the October-November 1921 Pictorial Photographers of America group show at the Art Center to travel to such distant sites as Corvallis, Oregon; Birmingham, Alabama; Muncie, Indiana; and Washington, D.C., over a five-month period (January to May). This meant thousands of people outside of New York City would be able to see her *High Noon, Columbia at Night,* and *The War Correspondent.*[189]

In March of 1922 another opportunity arose with the selection of two of her photographs for exhibition in the Ninth Annual Pittsburgh Salon of Photography: *Gossip* and *Portrait—Mr. Warner.*[190] This was followed by the selection of an oil print called *Long, Long Ago* (which had been previously exhibited in the Sixth Annual Pittsburgh Salon) by The Pictorial Photographic Society of San

Fig. 17. Magnified views of Doris Ulmann's pencil signatures ("Doris U. Jaeger" and "Doris Ulmann"), a grayish-black raised inked stamp of the name "Doris Ulmann" created by the Doris Ulmann Foundation, and her red-colored monogram. Collection of the University of Kentucky Art Museum.

Francisco for a group showing entitled "First Annual International Exhibition of Pictorial Photography." The exhibition ran from May 20 to June 18 and was held at the Palace of Fine Arts in San Francisco.[191]

Around this same time, the third volume of *Pictorial Photography in America* was published. While Ulmann is not represented in this volume, as she had been in the first two, Jaeger's *Gateway, Dinan: A Portrait of a Street Scene,* is reproduced.[192] Ulmann had been largely preoccupied with her second book during this time, *A Book of Portraits of the Medical Department of the Johns Hopkins University,* another limited edition portfolio of photogravures. Based on photographs Ulmann had taken in the spring of 1920, it was another artistic masterpiece. Published by Johns Hopkins University Press, the 15¾"x 10¾" work featured thirty-seven beautiful photogravure reproductions of Ulmann's photographs, executed by Harry Phillips, the exquisite designs and typesetting of Frederic and Bertha Goudy, and the fine printing of William Edwin Rudge. *A Book of Portraits* also gave insight into Ulmann's philosophy and view of portraiture. In the introduction to the text, she wrote:

> The author's conception of a book of portraits is a volume in which the portraits grasp enough of the dominant character and outstanding personality of the individual to make verbal delineation superfluous. . . .

In these portraits the aim has been to express as much as possible of the individuality and character of each member of the faculty, though this has not always been an easy task, nor perhaps has it always been attained. In trying to achieve this purpose the portraits have been made in the more intimate surroundings of office, laboratory or study, thus avoiding the conventional trappings and posing of the professional studio.

In their own environment natural attitudes are more readily taken with less tendency to assume an unconscious photographic expression, and it is in their more familiar haunts that their students and associates have come to picture them.

With these words the photographer disclosed her deep concern to properly portray the individuality and character of her sitters, a goal she felt could only be achieved when portraiture was created in an environment that was familiar and comfortable to the subject. She also revealed her humility about her own work in her capacity to be critical and objective about her own efforts.[193]

The publication of *A Book of Portraits* in June generated as much publicity for Ulmann as her previous book and made her the star of the Pictorial Photographers of America's group exhibition at the Art Center in October. Recounting the event, in which exhibitors such as Ralph Steiner, Laura Gilpin, and Paul Outerbridge participated, the associate editor of the *Bulletin of the Art Center* wrote in its November issue: "The gem of the exhibition, as even most of the exhibitors would admit, was Doris Ulmann's sumptuous book of photogravure portraits of Johns Hopkins medical men."[194]

# Chapter Two
# Moving On

By the beginning of 1923, Doris Ulmann had moved out of her family home on West Eighty-sixth Street and moved into apartment 9-C at 1000 Park Avenue.[1] The move from her home of forty years was a dramatic change for the photographer, but it gave her an opportunity for a new beginning—a real chance to start over and step away from the past. From her new home, Ulmann continued to explore the difficult oil pigment photographic process and created several photographs in this medium, including a portrait of a woman outside a tenement house (fig. 18). Seeking to imitate the work of American and European Impressionist painters, early pictorial photographers, including Robert Demachy, Eduard Steichen, Gertrude Käsebier, and Alvin Langdon Coburn, created numerous oil pigment photographic prints in the 1890s and 1900s. Charcoal-like and "grainy" in appearance as they are, these monotype images helped legitimize the claim of pictorialists that they were also creators of fine art. It was difficult and time-consuming to produce an oil pigment print from a glass plate negative. By the time Ulmann became active in her vocation oil pigment work had fallen into disfavor. Nonetheless, she created over 150 beautiful oil prints, including this striking image, between 1917 and 1925. In March, four of Ulmann's oil pigment photographs were selected for exhibit in the Tenth Annual Pittsburgh Salon of Photography at the Carnegie Institute. Of the 129 exhibitors in the show, only one other photographer, Miss Delight Weston, exhibited an oil pigment print. Ulmann's four prints were entitled, *Portrait—Mr. Hoag, Curls, The Shadow on the Wall,* and *The Old Door.*[2]

Another exhibit, "The International Salon of the Pictorial Photographers of America," followed in May and gave Ulmann another occasion to show examples of her oil pigment work. Three previously exhibited photographs were selected for this show: *Mrs. G.* (platinum), *The Shadow on the Wall* (oil), and *The Old Door* (oil).[3]

In August of 1923, the forty-one-year-old photographer began to work on

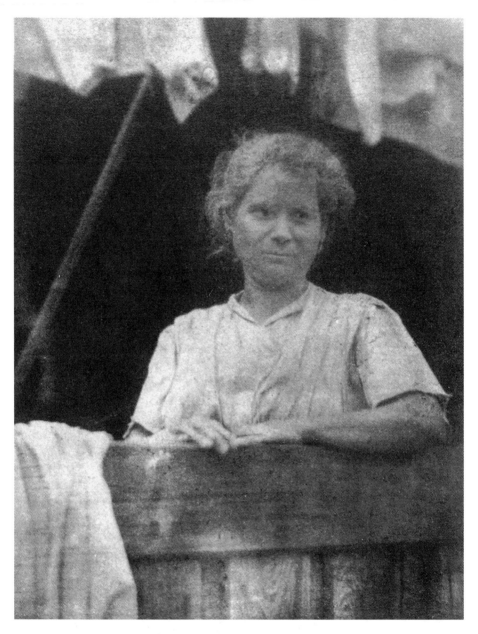

Fig. 18. *City Woman*, ca. early 1920s. Oil pigment print. Collection of the University of Kentucky Art Museum, No. 87.39.5.

a new book idea—a collection of photographs of American editors, her most ambitious and largest project to date. It would take her several months to photograph the forty-three editors she chose to include. Her first subject for study was Louis Evans Shipman, editor of *Life,* who originally suggested the project and eventually provided an introductory essay for the new text.[4] A later subject, John Farrar, provided suggestions about the project and procured accompanying essays from the editors.[5] Once again, Frederic Goudy was enlisted to design the book and select the types, and Bertha Goudy was asked to compose the text at their Village Press at Marlborough-on-Hudson.[6] William Edwin Rudge of Mt. Vernon, New York, and Charles Furth were also persuaded to work on the project. As he had before, Rudge did the presswork, and Furth, according to Ulmann, "faithfully copied the portraits" for photogravure printing.[7] In typical fashion, Ulmann worked methodically and deliberately during the fall of 1923 and the spring of 1924 and photographed, among others, Robert Bridges, editor of *Scribner's Magazine;* Frank Crowninshield, editor of *Vanity Fair;* Elizabeth Cutting, editor of *North American Review;* Henry Sherman Adams, editor of *The Spur;* Herbert Croly, editor of *The New Republic;* Thomas Wells, editor of *Harper's Magazine;* Samuel Strauss, founder of *The Villager;* John Farrar, editor of *The Bookman;* Carl Van Doren, literary editor of *The Nation;* Briton Hadden, editor of *Time;* George Jean Nathan, editor of *Smart Set Magazine;* Karl Edwin Harriman, editor of *The Red Book;* and Edna Woolman Chase, editor of *Vogue* (fig. 19).[8] In an era of male dominance in business, Edna Woolman Chase, pictured here, and Elizabeth Cutting, the only other woman in Ulmann's collection of American editors, represented a new and important group of individuals who, like Ulmann herself, believed women had essential gifts to contribute to American culture. Ulmann indicated her reason for her extensive effort on her third book in the brief essay she authored for the text:

> Magazines are so great a part of our daily life that almost unbeknown to us they mold our opinions and colour our views on most of the great problems of the day. Insidiously they have become a part of us and often times the views we hold as our own have in truth been formed by the editors of our favourite magazines. It is but natural that we should care to know what manner of men are these, who have thus formulated our ideas, coloured our thoughts and directed our perception of humour. We have generally thought of an editor as one closed off behind innumerable doors, an enigma, inaccessible. In this volume an attempt has been made to bring the editors to book, to portray their personality and something of their character by means of photographic portraits.[9]

Ulmann also requested that the editors themselves write a short essay about their vocation and their responsibilities for the book. Louis Evans Shipman,

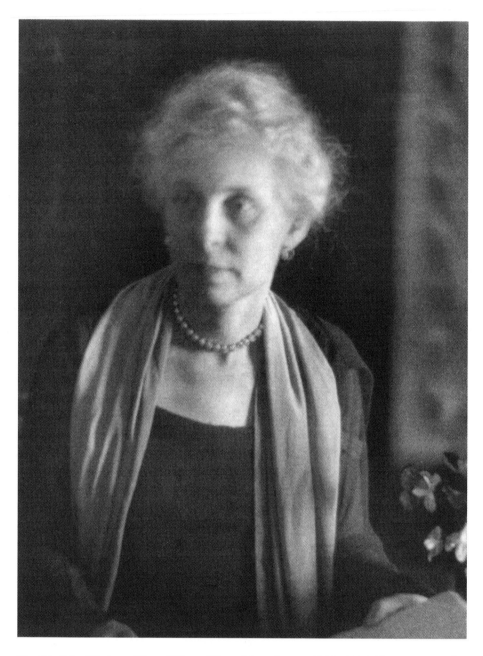

Fig. 19. *Edna Woolman Chase, Editor of Vogue Magazine*, ca. 1923–1924. Photogravure after a platinum print. Published in *A Portrait Gallery of American Editors, Being a Group of XLIII Likenesses by Doris Ulmann*. John Jacob Niles Collection, Special Collections and Archives, University of Kentucky Libraries.

editor of *Life,* reflected on the quality and importance of Ulmann's work in his preface for the volume.

> To bring together the portraits of a group of American editors required so much more than the expert and peculiar knowledge of photography which Doris Ulmann possesses, that it deserves some comment by way of introduction. The adventure, for it was undeniably adventure, has an unusual analogy, it seems to me, to those extraordinary expeditions one hears of as departing, at frequent intervals, for the far ends of the earth, there to rescue from oblivion the last specimens of almost extinct species.
> Doris Ulmann, with rare skill, persistence, enthusiasm, and, I dare say, courage has collected a group—a distinguished and tragic group—of a fast-disappearing species. Tragic, because they are the last of a line of notable progenitors, who vitalized and adorned a notable profession.[10]

In his words, Shipman highlighted the "rare skill, persistence, enthusiasm," and "courage" Ulmann brought to her work, as well as her passion for "a fast-disappearing species." Interested as Ulmann was in these prominent American editors, she had an even greater passion for writers—a passion that is manifest in her hundreds of photographic portraits of contemporary American novelists, essayists, poets, and playwrights. She skillfully produced portraits of such figures as Robert Frost, Sherwood Anderson, H.L. Mencken, Julia Peterkin, Thornton Wilder, James Weldon Johnson, Fannie Hurst, and Edna St. Vincent Millay (see figures 23 and 33). Her zeal for writers is also evident in her correspondence and association with noted authors and in her collection of autographed copies of literary works written by her sitters. Its depth is unabashedly revealed in a letter to the novelist Theodore Dreiser.

> My dear Mr. Dreiser,
> At a tea given by Longmans Green on Wednesday, October the Eighth at the Savoy-Plaza Hotel, I had the pleasure of seeing the most interesting man join the assembled guests. He was so interesting to me as a subject for a portrait that I inquired, "Who is that man?" "But don't you know?" was the response. And then my replay was "And to think that I have been so anxious to have the opportunity to make a portrait of Theodore Dreiser!"
> Will Theodore Dreiser be good enough to sit for me? I have his permission to remind him of this request and I should appreciate extremely if he were to designate a time that will be convenient to him. It is possible and perhaps preferable to do the portrait in his

own home and there is just one request, — that he will be kind enough to give sufficient time to make a real portrait study.

My telephone number is Butterfield 3279 and may I hope for good news?

<div align="right">

Very sincerely yours,
Doris Ulmann[11]

</div>

Because she was such an avid bibliophile, it is not surprising that her personal interests and passions eventually led her to direct her mind and camera toward the writers of her day.[12] Her sensitive photographic portraits of the literary faces and personalities of her age substantiate her deep respect for these individuals and her sense of camaraderie and collegiality with them. As she stated in her 1930 interview with Dale Warren, "my particular human angle leads me to the men and women who write."[13]

Ulmann loved to bathe in the creative spirit of others and did so repeatedly, feeling that the creativity of her female and male contemporaries enhanced and enlivened her own work. And yet, for all the camaraderie and collegiality she shared with many of these contemporaries, much separated them. She would never have stated, "The greatest problems of the world—social, political, economic, and theological—do not concern me in the slightest," as her one-time sitter drama critic George Jean Nathan stated. She would never have concurred with the famous contemporary poet Carl Sandburg that the past was "a bucket of ashes." Nor would Ulmann have felt comfortable with the kind of narcissism her friend and sitter Joseph Hergesheimer expressed when he said, "If all the Armenians were to be killed tomorrow and if half of Russia were to starve to death the day after, it would not matter to me in the least. What concerns me alone is myself, and the interests of a few close friends. For all I care the rest of the world may go to hell at today's sunset."[14] Self-absorbed as some of her letters reveal Ulmann could be, her interest in different and vanishing "types" and her desire to create artistic portrayals of Appalachian, African, and Native American adults and children placed her in conflict with many of her contemporary intellectual friends and peers.

Ulmann was undoubtedly still preoccupied with her project on American editors when her photograph "Village Smith" was selected by the Alumni Association of the Clarence White School of Photography for publication in *Camera Pictures,* a compilation of student work. The book was published in New York by the L.F. White Company, the publishing company directed by Clarence White's oldest son, Lewis.[15] This recognition was followed by two more opportunities: the selection of a photograph for exhibition at the Kodak Park Camera Club's Fourth Annual Exhibition and the selection of her photograph *The Mill* (platinum) by the Camera Pictorialists of Los Angeles for exhibition at the "Eighth International Salon of Photography" at the Los Angeles Museum.[16]

These honors were followed by the publication of Ulmann's A *Portrait Gallery of American Editors* in early January 1925. As with the issuing of her two previous books, the publication of *A Portrait Gallery of American Editors* brought an invitation from her colleagues at the White School to lecture on the production of this volume. Ulmann accepted the invitation and lectured at the school on January 30.[17]

In March, Ulmann's work was shown in two different exhibits. The first exhibit, the Twelfth Annual Pittsburgh Salon of Photography, ran from March 3 until March 31 and featured two of her prints, *Young Girl* (oil pigment) and *The Selectman* (platinum). The second show, "Exhibition of Photographs by the Students and Alumni of the Clarence H. White School of Photography," opened on March 16 and lasted only a week. It included five of Ulmann's platinum photographs and for the first time in her career offered three photographic studies of the same sitter. The five featured prints were entitled, *New England Type 1, New England Type 2, New England Type 3, Hands,* and *South Canaan.*[18]

Like Charles Shank, Alfred Cheney Johnston, Alfred Stieglitz, Imogene Cunningham, and Lotte Jacobi, Ulmann was fascinated with the significance of the human hand and the ways human beings used their hands to accomplish routine tasks, express their emotions, and create beautiful artistic objects. In the photograph of the hands of her paramour, John Jacob Niles (fig.20), taken in the last year of the photographer's life, Ulman has captured the movement of the musician's hands to complete a simple task—very common to the photographer herself, who was a chain-smoker—to knock off ashes from the cigarette he has been smoking.

Ulmann's exhibits in Pittsburgh and New York were followed by the "Second International Salon of Pictorial Photography," a group presentation by the Pictorial Photographers of America. It opened at the Art Center in New York on May 19 and ran until June 15, featuring three platinum photographs by Ulmann: *Still Life-Autumn, Laborer's Hands,* and *The Black Laborer.*[19]

Ulmann had always had an interest in different types of workers and peoples. This can be seen in several of her studies, beginning with the print she entered in the first group exhibit of the Pictorial Photographers in 1916, *The Blacksmith.* Further examples are *The Coal Worker,* exhibited in 1917; *At Work* (plate 7), exhibited in 1919; *Portrait—Mr. Hoag,* exhibited in 1923; and *The Selectman,* exhibited in 1925. Ulmann's interest in different types of people beyond the bounds of her race, culture, and class, and her desire to photograph these subjects in a positive and artistic way, are evident in her dignified portrayal of this young African American worker (fig. 21), who was probably a middle Atlantic oysterman. Against the social and political context and backdrop of the period in which African Americans faced murder, lynching, legal exclusion, and overt racism, Ulmann created a painterly portrait of this hardworking individual that

Fig. 20. *Hands, John Jacob Niles,* ca. 1933–1934. Posthumous gelatin silver print. Stamped signature of Doris Ulmann. Berea College and the Doris Ulmann Foundation, No. 1594.

challenged the contemporary social and political norms. Ulmann became much more interested in a wider variety of "types" during this period, perhaps because of the death of Clarence White in July, perhaps because she had grown tired of photographing the "beautiful people" of New York's intelligentsia and social elite, or perhaps because the city and its arts and her circle of friends had ceased to move her as they once had. It is likely that all of these factors played a role in changing the direction and emphasis of her photography.[20]

Though Ulmann still felt closely aligned to the work of Clarence White and the Pictorial Photographers of America, she decided to shift her focus by concentrating on subjects uncommon to most pictorialists. She began to move beyond what she, White, Stieglitz, Steichen, and most other pictorialists had always appeared to concentrate upon—the very introspective boundaries of family and the circles of the rich and famous and powerful.

Although Ulmann certainly permitted Clarence White's work and vision to continue to instruct and nurture her own artistic sensibilities, she was unwilling to limit her work in the ways in which he limited his own. White focused his work on sentimental and romantic personages and domains and on what was inside his limited personal environment. In contrast, Ulmann felt impelled to

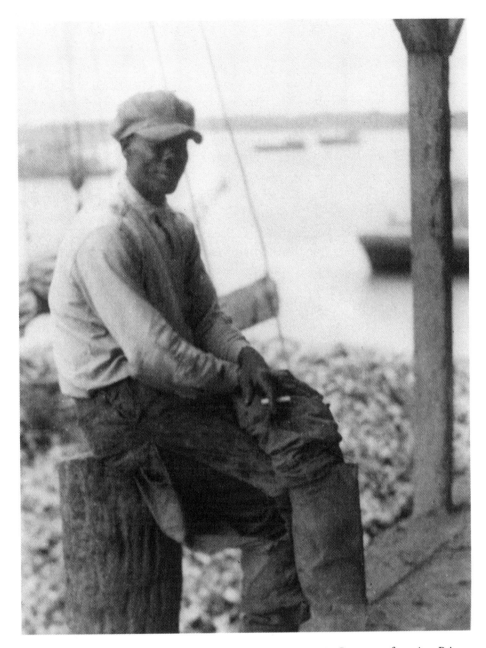

Fig. 21. *Young African American Dock Worker,* ca. 1918–1920. Gum transfer print. Private collection, Paris, Kentucky.

direct her attention outside the parochial bounds of her familial and social spheres, because she believed there was more to see than White had seen and, thus, more on which to focus her camera.[21]

Affluent, sophisticated, and well-connected as she was, Ulmann could have easily concentrated on people like herself and spent the rest of her career producing fine photographs of these personalities, much as she had in her work on the faculties of the College of Physicians and Surgeons at Columbia University and the Medical School of Johns Hopkins University and in her work on American editors. It would certainly have been easier for her to work with such subjects. She could easily have followed in Steichen's footsteps and those of similar peers. She might have turned her camera toward the glamorous world of society. Or she might have followed in the direction of her fellow White School graduates—Ralph Steiner, Anton Bruehl, and Paul Outerbridge—and focused her energies on advertising photography. Alternatively, she could have concentrated her camera on industrial photography, as Lewis Hine and Margaret Bourke-White did. In so many ways, it would have made much more sense for her to move in one or more of these directions. But Ulmann chose instead to move in a different direction and to focus her attention on "pre-industrial" and folk cultures. In making this decision, Ulmann joined other White School graduates—notably Laura Gilpin, who focused on Native Americans, and Clara Sipprell, who focused on Mexican and Yugoslavian peasants.[22]

It is important to remember that when Doris Ulmann was born in 1882, much of America still resembled the idyllic agrarian republic that Thomas Jefferson had envisioned. Most of America was still shaped by Puritan and Anglo-Saxon values, housed in small villages and towns, carried and transported by the horse, and moved and run by the individual worker—by the farmer, the craftsworker, the artisan, and the storekeeper. But the country was undergoing tremendous transformation due to the increasing migration of rural Americans to larger towns and cities, the increasing immigration of Europeans, the redevelopment of old industries and the unfolding of new ones, the spread of electricity and the telephone, and the inevitable reconstruction and expansion of America's cities. And it is these changes which helped determine the direction and focus of Doris Ulmann's life and work.[23]

Ulmann chose not to focus her camera and attention on what was coming into being in the form of new machines, products, and designs created by industrialized America. Instead, she focused on what was and had been—on the people she believed had made America what it was, on their traditions and skills. She was not interested in what America was generating through the means of its technical genius and its sophisticated machinery. Her fascination was with what America had created and what it continued to create with its imagination, soul, and hand. Though she was herself a person of means, she had little interest in the modern aesthetics of the wealthy, the popular, and the glamorous seen in the

photographic advertising for machines, mechanical conveniences, and fashion. Instead, her interest lay in the traditional aesthetics of the craftspeople, farmers, common laborers, writers, dramatists, and poets, for whom vision, spirit, and heart ruled.

This fascination is revealed both in the studio portraits and in the field portraits she created after 1925. These photographs reveal Ulmann's unique focus and her desire to frame the faces of the soul and spirit of an America she believed was rapidly disappearing. They also reveal her concern about the effects of the rapid industrialization of America and her fear that this industrialization would extinguish many of the special traditions, skills, and even peoples that had made America what it was. The social historian William Leuchtenberg reminds us that the frequent changes taking place in our nation in the teens, twenties, and thirties gave reason for this concern and evoked anxiety among many. Writing about the rapid industrialization that took place in America during the period of Ulmann's work, he notes:

> In 1914, the United States was not so far from the early years of the republic. . . . There were thousands of men still alive who had fought under Stonewall Jackson at Chancellorsville or had marched with Winfield Scott on the Halls of Montezuma. . . . Blacks walked the streets of Savannah and Charleston, who had been born in slavery. . . . Only eighteen years later, when 1932 rolled around, it seemed an eon since the days of the nineteenth century. The task of industrialization had been essentially completed. Machines had replaced the old artisans; there were few coopers, blacksmiths, or cobblers. The livery stable had been torn down to make way for the filling station. Technology had revolutionized the farm. In 1918, there were 80,000 tractors, in 1929, 850,000.[24]

There is no question that Ulmann's concern that the industrialization of America would essentially extinguish certain American peoples, their traditions and skills, led her to take a different path from many other photographers.

Certainly Ulmann's understanding of the vast changes taking place in America, of the rapidly increasing immigrant population, and of the growing dominance of a new America—an urban and industrial and irreligious America—also elicited her interest and the interests of other intellectuals and artists in the more "primitive" and "pre-industrial" communities within American society.[25] This drew her toward such diverse "pre-industrial" communities as the fishermen of New England; the Shakers of New York; the Quakers, Mennonites, and Dunkards of Pennsylvania and the Shenandoah Valley of Virginia; the Primitive Baptists and Pentecostals of the mountains of Kentucky, Tennessee, and North Carolina; the Cherokee and Lumbee Indians of North Carolina; and the African American Baptists and Methodists in South Carolina.

It was with good reason that she assumed that many of the faces and "types" of these pre-industrial communities, particularly their elderly members, represented the last generation of a special group of Americans who carried within them—in their oral traditions, religious and social practices, and handicraft skills—memories of a much different America and certain characteristics and gifts that were rapidly disappearing. Thus, Ulmann felt challenged to do all she could to photograph and record this vanishing generation with as much respect and dignity as she had previously documented many intellectuals and professionals in urban and industrial America.

She had always been attracted to older people, especially older men, as can be seen in some of her earlier photographs from the teens and early 1920s of Gloucester fishermen and workers, of Manhattan gentlemen, and of military officers. Perhaps this attraction derived from her experience of having lived with a much older father, who was twelve years older than her mother. Ulmann herself said that the "face of an older person" was "more appealing than the face of a younger person who has scarcely been touched by life."[26]

Her interest in these types became even more evident and pronounced in 1925. A child and beneficiary of the city, she treasured the cultural and intellectual opportunities her native New York City offered, and she often took advantage of these opportunities through her association with different artists and intellectuals. Other avenues were through involvement with such groups as the American Women's Association, the Town Hall Club, the Clarence White School of Photography, and the Pictorial Photographers of America.[27] However, Ulmann's life in the city and her close familiarity with its culture and industry had made her aware of its limitations and saved her from the romanticism of some of her intellectual contemporaries, who frequently described the urban centers of the day as "bright metropolises shiny with promise," offering salvation from the parochialism and social practices and traditions of rural America.[28]

Children of this vision of America—writers such as Sherwood Anderson, Sinclair Lewis, and Thomas Wolfe—established their literary reputations in their novelistic exposés of the fear and prejudice of small-town America, exposés that had a ring of truth to the many rural intellectual and artistic exiles who fled to the "bright metropolises" in the teens and twenties.[29]

Although Ulmann was quite respectful of the gifts of Anderson, Lewis, and Wolfe, all of whom she photographed, she sought to record things she felt they and other contemporary writers had not seen in rural America—the unrelenting pride of the southern African American man, the gentlemanly dignity of the southern Appalachian craftsman, the unabating beauty of the elderly Pennsylvania Dutch woman, the remarkable love and serenity of the Appalachian couple—things all too many of her bright and articulate contemporaries in New York and Chicago and Hollywood never seemed to see.

By the fall of 1925, Ulmann had begun to focus her camera and attention

on different "vanishing types" in American culture. Interestingly, some of her early subjects in this period were religious vanishing types—members of relatively small Christian sects who resided in New York, Pennsylvania, and Virginia. Between this time and the fall of 1926, Ulmann traveled to these locations to study and photograph the leaders and members of the Shaker community in New York; the Mennonite communities in southeastern Pennsylvania and the Shenandoah Valley of Virginia; and the Dunkard (German Baptist) communities, also in the Shenandoah Valley. Though her own religious sensibilities elude classification, her work in this period and in her later studies of African American and Appalachian Christian communities reveal her fascination and absorption with religious subjects. That she was "moved" by her study and photography of the "religious types" she documented in 1925 and 1926 is obvious, evident in her masterful portrayals of these people (fig. 22).[30]

Ulmann's new passion became very clear in two early shows in 1926: the February group exhibit of the Pictorial Photographers of America at the Art Center in New York and the March group exhibit at the Thirteenth Annual Pittsburgh Salon of Photography. The Pittsburgh event revealed something of both her new direction and her new travels. Two platinum photographs were featured, *Virginia Landscape* and *Old Virginia Type—1.*[31]

Around the same time, the fourth volume of *Pictorial Photography in America* was published, with a reproduction of Ulmann's study of an "Old Virginia Type." In the back of the text, a commentator observed that "Doris Ulmann collects quaint and unspoiled types in remote places, before they are jazzed out of existence."[32] Clearly, others had also noticed her new direction. By November, Ulmann's new focus on "quaint and unspoiled" and "vanishing types" would be obvious.

Although taking this new direction made Ulmann vulnerable to criticism, none was forthcoming. Instead, her new focus and work appear to have been welcomed. Sometime in the late summer or early fall of 1926, she was invited by the Pictorial Photographers of America to have a solo exhibit, "largely comprising the types for which she is noted." Not only was the invitation a very special honor, but it was also a testimony to her colleagues' regard for her new direction and work. The show opened at the Art Center in New York City in November and featured, among other prints of "vanishing types," a print of Sister Sarah Collins and Sister Adelaide of the Shaker community of Mount Lebanon, New York. This print was reproduced in the December 1926 issue of the *Bulletin of the Art Center.*[33] The photographs she displayed at the Center brought even more attention and acclaim to Ulmann and led to the publication of a feature article on the photographer and her work in a widely distributed periodical some months later.

In July 1927, *The Mentor* published an article by novelist Hamlin Garland entitled "Character Portraits by Doris Ulmann." It highlighted eight reproductions of photographs Ulmann had taken in her visits to Dunkard, Mennonite,

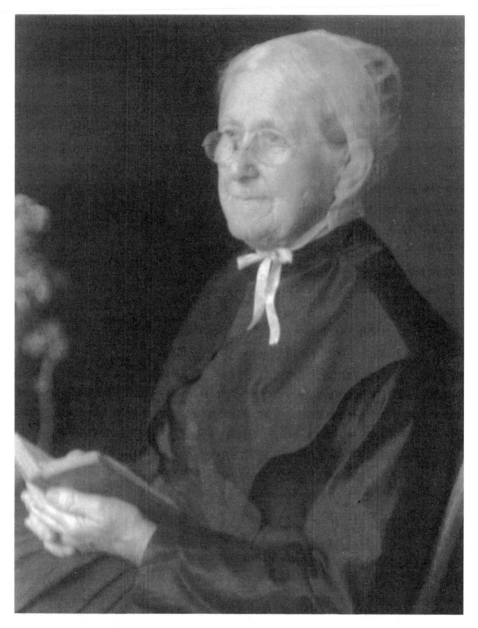

Fig. 22. *Dunkard Woman, Shenandoah Valley, Virginia*, ca. 1925–1926. Platinum print. Private collection.

and Shaker communities in 1925 and 1926 (see plates 23, 24, and 25). The article also provided insight into Ulmann's work as an artist of "American types." Garland was struck by the way Ulmann won "the cooperation of her subjects" and how she was able "to induce in her subjects the mood which is subtly characteristic of them." He noted that she strived to catch them in "natural moments of action or repose," in their "workday clothing." But doing so was difficult. As Ulmann testified, "They all want to go and dress up. . . . The men give less trouble than the women, but even the men, old and young, are insistent on having their pictures taken in their very best clothes, with their hair carefully combed." Nonetheless, Garland reported that she sought to patiently photograph them as they really were—with "gnarly hands," "wrinkled brows and bowed shoulders," and with that "wistful sadness" which seemed to characterize them. In this manner, he felt she invested her subjects "with dignity and self-respect." Garland was also amazed by the way Ulmann went about her vocation. "Doris Ulmann not only pursues her way without commercial intent but also . . . with aesthetic devotion. In her spacious motor car, fitted with all the necessary materials for her work, she travels leisurely from point to point gathering together her negatives, which she develops and prints herself." He concluded: "I know of no one who has surpassed Doris Ulmann in securing and presenting such sympathetic records of American types."[34]

Ulmann was not the first photographer to document pre-industrial American cultures. By the time she began to concentrate a large portion of her time and energy on various American types, the pictorialist Edward Curtis had nearly completed his monumental work documenting members of Native American tribes of the West.[35] Others, particularly Karl Moon, Adam Clark Vroman, and F.A. Rhinehart, had also carried out extensive work on Native Americans in the West.[36] In a more journalistic spirit, Frances Benjamin Johnston had photographed Native Americans in a very different setting—the Carlisle Indian Industrial School in Carlisle, Pennsylvania—in the summer of 1901. Earlier, in December 1899, she had photographed African Americans and Native Americans at Hampton Institute in Hampton, Virginia. And in the winter of 1902, Johnston photographed African Americans in Alabama at the Tuskegee Institute, the Snow Hill Institute, and the Mt. Meigs Institute.[37] Johnston's interest in African American subjects was shared by Leigh Richmond Miner, who produced significant records of similar subjects in documenting African Americans at the Hampton Institute, on St. Helena Island, and on the South Carolina coast in the first and second decades.[38]

Still other photographers had concentrated their attention on Appalachians some years before Ulmann.[39] But only two, Curtis and Miner, had approached any of these groups from a similar pictorialist standpoint. And none had sought

to portray their subjects as Ulmann, in the manner of David Octavius Hill and Robert Adamson. By following traditional pictorialist principles of portraiture passed from Hill and Adamson to White and Käsebier, Ulmann was able to bring a new perspective to the study and documentation of African, Appalachian, Native, and other American types, thus encouraging the re-evaluation of their place and importance in the American story. This perspective is present in her earlier portrayals of Appalachians, Shakers, Mennonites, and Dunkards and is also evident in her photographs of Appalachians featured in two articles that were published in the summer of 1928—one in *Scribner's Magazine* and one in *The Mentor*.

In the spring of that year, Robert Bridges, editor of *Scribner's,* whom Ulmann had photographed in 1923, had invited Ulmann to submit several photographs for an article. The photographs she offered accompanied an article entitled, "The Mountaineers of Kentucky: A Series of Portrait Studies," in the June 1928 issue of the magazine. A few months later, more of Ulmann's photography appeared in the August issue of *The Mentor* with an article entitled "Among the Southern Mountaineers." Gracious, sensitive, and successful portrait studies of people who had often been belittled and disparaged by urban sophisticates and intellectuals such as H.L. Mencken, the images in these two articles reestablished the dignity and importance of these particular Americans and constructed a permanent bond between the photographer and the people of Appalachia.[40]

—◆◆◆—

In her contact and development of a friendship with South Carolina novelist Julia Peterkin in the spring of 1929, Ulmann found someone who could help her expand and further her interest in rural American types. The forty-seven-year-old photographer had felt a predictable attraction to the tall and statuesque forty-nine-year-old Peterkin, whom she had first met in New York. Not only was Peterkin a writer, a member of that guild of persons Ulmann held in high esteem, but she was specifically and unquestionably a female southern writer who was, as H.L. Mencken described her, both "distinguished" and "exotic."[46] A person of undeniable charm and wit, as well as seriousness, Peterkin was the very kind of female friend Ulmann had long sought—the kind of friend with whom the photographer could be herself, who would understand both her artistic impulse and her deep need for love. This led Ulmann to do something with Peterkin that she would not do with anyone else: pose with her for a series of photographs (fig. 23).[41]

Ulmann's portraits of herself and Julia Peterkin are unique in the oeuvre of the photographer. There are no other extant self-portraits and no other similar compositions of Ulmann with another person. The absence of other self-portraits and images of the photographer is quite telling—it reveals not only Ulmann's shyness and unease at having others photograph her but also her reluctance to pose with other people. Peterkin's presence and physical proximity in these unique compositions indicates Ulmann's respect for the novelist as well as her comfort

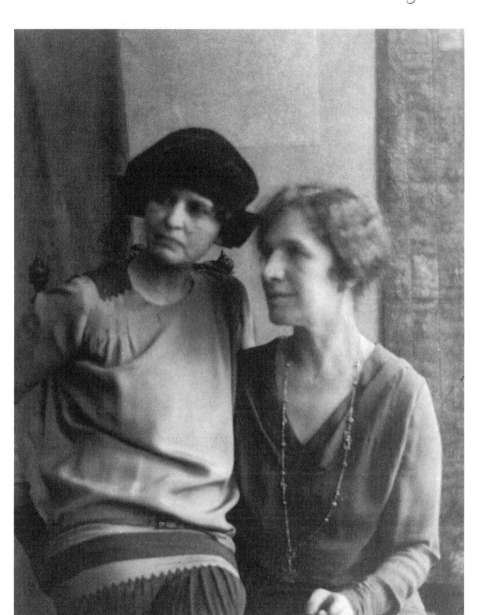

Fig. 23. *Doris Ulmann and Julia Peterkin*, ca. 1929–1931. Platinum print. South Carolina Historical Society, No. 33–110–10.

with her. Ulmann's desire to be perceived as a sophisticated and cosmopolitan individual is also evident. In these remarkable portraits of herself and Peterkin, Ulmann used the presence of Peterkin, the Pulitzer Prizewinner and celebrity, as well as her own furniture, dress, posture, and demeanor to portray herself as a distinguished, sophisticated, and modern woman of means.[42]

Part of Ulmann's delight in her relationship with Peterkin undoubtedly stemmed from the realization that the author was someone who could help her further document various American types (see plates 36 and 37). It was Peterkin who had invited Ulmann to come south with a promise to introduce the photographer to African Americans at different sites within South Carolina, including her and her husband's plantation at Fort Motte and their coastal retreat at Murrells Inlet.

By early May, several days before her friend Julia Peterkin would be officially awarded the Pulitzer Prize for her 1928 novel, *Scarlet Sister Mary,* Ulmann was in South Carolina. Here she photographed African Americans in and around the coastal village of Beaufort and at the plantation home of the Peterkins, thirty miles from the state capital, Columbia. The fifteen hundred–acre farm, Lang Syne, was also home to some three hundred African American workers. Purchased in 1877 by James Peterkin, the father of William Peterkin, the farm had been the home of Julia Peterkin since her marriage in 1903 and, like so many large estates, had been sustained by monies from the production of cotton. It had also been the inspiration for Peterkin's two earthy and moving novels of southern African American life, *Black April* and *Scarlet Sister Mary.* Picturesque and inspiring as it was, Ulmann found it a natural setting for her work, for her desire to create "drama from the ordinary."[43]

At the same time that Ulmann was furthering her contacts and work in the Southeast, she was also continuing the kind of work for which she was best known in the Northeast. This can be seen in three photographs she submitted to illustrate two articles in the June 1929 issue of *The American Magazine.* The first reproduction was of Dr. Harry Allen Overstreet, head of the Department of Philosophy of the College of the City of New York, which accompanied the article "The Kind of Poise that Gives You Power," written by M.K. Wisehart.[44] The second portrait was of Helen Keller and her teacher, Miss Annie Sullivan (later known as Mrs. John A. Macy). The third image was of Helen Keller. These two photographs appeared in the article "I Am Blind—Yet I See, I Am Deaf— Yet I Hear" written by Helen Keller.[45]

Despite these successes, a certain sadness seemed to dominate the photographer's life. After having tea with Ulmann in her Park Avenue apartment, the young novelist Irving Fineman had written to Peterkin: "she is attractive and intelligent, and can be amusing . . . yet as you say is 'so sad.'"[46] An engineer turned novelist, Fineman had first met Peterkin on an ocean liner in the summer of 1925 when he was still an instructor at the University of Illinois. Feeling spurned by her husband because of his affair with a younger woman,

Peterkin took an interest in the younger Fineman, who was dissatisfied with his current profession, and encouraged him to develop his interest in writing. Realizing that the older novelist could give him much needed assistance, Fineman eventually welcomed both Peterkin's affection and her help in contacting prominent New York publishers and personalities, including Ulmann. There can be little doubt that Fineman appreciated Peterkin's introduction and found the wealthy and well-connected photographer, a fellow Jew and artist, "attractive and intelligent." Ulmann had many friends in the literary world that might be useful in his career, so it behooved him to pose for her, befriend her, and even court her for a while. And yet, he did tire of her sadness, that sadness that even he seemed unable to abate, that only seemed to ease when she left the streets and the people of the city for places and people far beyond.[47]

By the fall of 1929, Ulmann was back on the road photographing other "vanishing types" in North Carolina, concentrating her attention on Native Americans. According to an article in the September 30, 1929, issue of the Lumberton *Robesonian,* Ulmann spent two days photographing Lumbee Indians in Robeson County, North Carolina. The writer of the article provides interesting insight into Ulmann's photographic philosophy and mission:

> Miss Doris Ulmann, a photographer of national reputation, spent Thursday and Friday in Robeson County working among the Indians in the Pembroke and Elrod sections, seeking out and getting pictures of Indians representative of the race. Miss Ulmann came to Lumberton with a letter of introduction to former Governor A. W. McLean from Governor Richards of South Carolina. Governor McLean happened to be away at the time, and Mr. Dickson McLean sent her out into an Indian settlement. On one of these trips, that of Thursday afternoon, she was accompanied in her car by Malinda Locklear, well-known Indian woman, who piloted her into Indian communities near Pembroke. Pictures were made of Malinda, Rhoda Locklear, Gertrude Blue and others. Friday Miss Ulmann went out to Pembroke and Elrod. Miss Ulmann, who is chiefly interested in her art photography, but also writes some, came here from Bryson City, where she had made a study of the Cherokee Indians.[48]

Later, the reporter continued:

> Miss Ulmann in her work seeks out types. She was therefore very much interested in finding old members of the Indian race in this county and also representative young people. Some difficulty was experienced she stated, in finding old Indian men on her first day here. She was most favorably impressed with the beauty of one In-

dian girl whom she photographed. She also had pictures of some of the oldest Indian women of the county, who appeared to be good representatives of the race. Miss Ulmann talked interestingly of the similarity of names among the Indians she has made a study of. She also discussed their language and customs.[49]

After her study in North Carolina, Ulmann headed to Charleston. Here, she photographed more low-country African Americans and a few prominent South Carolina literary figures, including John Bennett and Laura Bragg, but she encountered a lot of resistance from some African Americans she sought to photograph. In a letter to a Manhattan friend, Averell Broughton, on October 4, 1929, Ulmann wrote:

> It seems to be exceedingly difficult to get the studies in which I am interested here. The place is rich in material, but these negroes are so strange that it is almost impossible to photograph them. So this is rather a strenuous affair and then I do not feel satisfied! . . .
>
> I think the people in Charleston are rather difficult because they are so very self-conscious. . . . There are a number of authors here, John Bennett is one and I shall probably do his portrait today. It will be a rather pleasant diversion after my hunt for Negro types.[50]

Following her stay in Charleston and photography along the coast, Ulmann once again headed to the middle of the state to William and Julia Peterkin's plantation. Here, she continued her study of the African Americans who resided and worked on the plantation.

Though Ulmann did express concern about her ability to establish a cooperative relationship with some of her African American sitters in South Carolina, some of her finest images are of her southern African American subjects (figs. 24, 25, and 26). In the final analysis, her portraits of these individuals seem to have been as successful as her Appalachian portraits. Reluctant as many of Ulmann's African American subjects must have been to let her take pictures of them, the success of many of the extant images suggests that they, nonetheless, cooperated with what Ulmann sought to do. It also indicates that many of Ulmann's subjects trusted her, took pride in their participation in her portraiture, and perceived themselves, as portrait subjects of the past, as co-creators with the photographer. One of her African American subjects, described only as "Nancy," acknowledged this in a dramatic way at one point in Ulmann's work in South Carolina. When the photographer told her it would be acceptable "for her to talk and move her head slightly," this sitter replied, "'No. I will not talk and I will not move. Something tells me to be quiet. This is God's work.'"[51]

Fig. 24. *Footwashing, South Carolina,* ca.1929–1931. Platinum print. South Carolina His-
torical Society, No. 33–110–1.

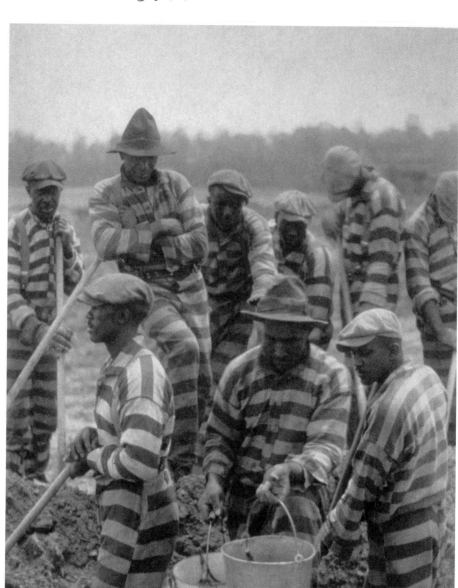

Fig. 25. *The Chain Gang, South Carolina*, ca. 1929–1931. Platinum print. South Carolina Historical Society, No. 33–110–4.

Moving though dissimilar images, Ulmann used both *Footwashing* (fig. 24) and *The Chain Gang* (fig. 25) in the trade and deluxe editions of *Roll, Jordan, Roll. Footwashing* is one of a series of ten photographs in this text that Ulmann used to depict southern African American Christian rituals. In her portrayal of this ancient sacrament Ulmann captured the sacredness and simplicity of this act. Substantively, ritually, and aesthetically linked to the record of Jesus' washing of his disciples' feet in the Gospel of John, the image evokes feelings of awe, humility, peace, and freedom, emotions Ulmann both sought and cherished. In contrast *The Chain Gang,* one of a series of three images of southern African American prisoners published in *Roll, Jordan, Roll,* illustrates a very different phenomenon—the racial penal system of the South—that an inordinate number of southern African American men experienced firsthand in the period Ulmann worked. And though the photographer attempted to create a certain symmetry and balance in this image, as in her other two published images of the chain gang, the different positions of the heads and bodies of the members of this group convey their independence, defiance, and longing for freedom.

In the same month, reproductions of Ulmann's work were published in two journals. A literary magazine, *The Bookman,* published Ulmann's photographs of writers Hamlin Garland and Robert Nathan.[52] Six reproductions of photographs by Ulmann also illustrated two articles in the October issue of *The American Magazine.* The first reproduction was of Mrs. Calvin Coolidge, wife of the former president of the United States. It appeared in the article "How I Spent My Days at the White House," written by Mrs. Coolidge. The other five reproductions were photographs of the American sculptor George Grey Barnard. They appeared in an article about the famous artist entitled "You May Be Young in Years—But Old in Hours, If You Do Not Waste Your Time," written by M.K. Wisehart.[53]

Ulmann's professional success, however, was quickly overshadowed by an unfolding national tragedy. Most of the country came to a standstill on Thursday, October 24—"the first of the days which history . . . identifies with the panic of 1929"—the day known as "Black Thursday," according to economic historian John Kenneth Galbraith.[54] Five days later, the situation got worse. "Tuesday, October 29," Galbraith noted, "was the most devastating day in the history of the New York stock market."[55] After years of fast-paced change and growth, the "roaring" twenties had ended in a great crash. Even though Ulmann was quite affluent, these events shook her deeply and increased her sense of urgency about her work. They also heightened her awareness of the additional burdens the economic crisis would bring to both those she had photographed and those she hoped to portray in the future.

Even though America's economic matters were tragic, the month of November 1929 brought Ulmann her greatest opportunity to exhibit her photographs. During this month, 119 of her prints were showcased in a solo exhibit at Alma Reed's Delphic Studios. A devotee of the Delphic Movement—which

sought to revive the Hellenistic spirit in the arts—Mrs. Reed lived with Madame Eva Sikelianos, the widow of Ionian hero–poet Anghelos Sikelianos, in a large house on lower Fifth Avenue known as the Ashram. Here they spoke Greek, celebrated Greek festivals and rituals with members of the Greek American community and other Delphic followers, and hosted numerous intellectual guests, including the émigré Dutch poet Van Noppen; the exiled Lebanese poet and artist Kahil Gibran; and the Indian activist Sarojini Naidu. A passionate and persuasive patron of the arts, Reed opened her gallery in September 1929 and represented, among others, Thomas Hart Benton, Boardman Robinson, and José Clemente Orozco. Located at 9 East Fifty-seventh Street, across from the new Museum of Modern Art, the Delphic Studios offered significant exposure for Ulmann's portraits of different American types.[56]

A review of Ulmann's exhibit at the Studios was published in the December issue of *Light and Shade,* the bulletin of the Pictorial Photographers of America. The writer of the review pointed out the significance and value of Ulmann's body of work:

> One of the most interesting exhibitions of photography held in New York for some time was that of Doris Ulmann at the Delphic Studios last month. For a number of years Mrs. Ulmann has been motoring through different parts of the country recording the character, types, and mode of living of our people who inhabit some of the remote rural districts. Thirteen of the prints shown were of "Negro Baptizings and Spirituals," fifty-four "In South Carolina," thirty-six "Kentucky Mountains," and twenty-six portraits of interesting and prominent people; a hundred and nineteen in all, 6½ x 8½ in size and printed on platinum.
>
> There is no doubt that the work being done by Mrs. Ulmann will become very valuable as time and customs change the character of these "Folks." Her photography presents these people with all their sincere simplicity and charm without affectation or stage-craft and preserves for all time their character which, from the earliest pioneer, has been the foundation of America.[57]

Another of Ulmann's depictions of southern African American Christian ritual, *Baptism* (fig.26), was also featured in the trade and deluxe editions of *Roll, Jordan, Roll.* In her portrayal of the baptism of a female disciple into the Christian community Ulmann created both a document and a work of art, both a record of the contemporary practice of this ancient Christian ritual in one southern African American community and a gentle and dignified tableau. With the aid of a soft-focused lens and the subtleties of the natural light and shadow of the moment, Ulmann captured the mystery and holiness of this event.

On November 11, Ulmann received news that her uncle Ludwig Ulmann, a banker, had passed away. Ulmann quickly discovered that she and her sister

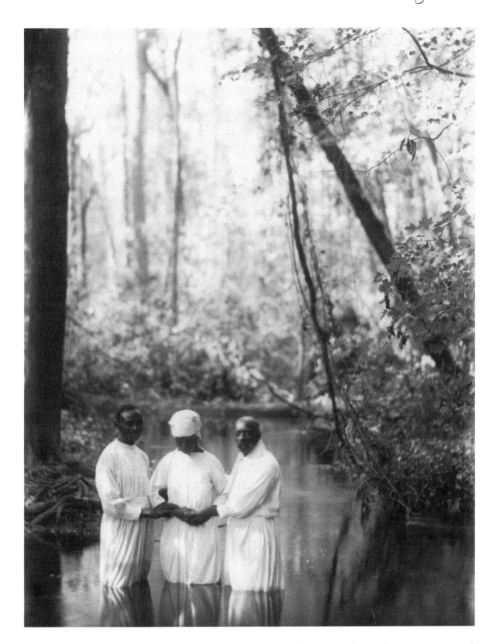

Fig. 26. *Baptism, South Carolina,* ca. 1929–1931. Posthumous gelatin silver print. Printed by Samuel Lifshey, ca. 1934–1937. Doris Ulmann Collection, Special Collections and University Archives, University of Oregon, U 3423.

Edna were his primary beneficiaries. In the context of the social and economic crises taking place in the nation, it must have been a strange discovery for her to realize that her own personal wealth would now substantially increase.[58]

It may have been this fact that permitted her to keep her commitment to host an afternoon cocktail party for José Clemente Orozco's birthday on November 23, less than a month after "Black Thursday." The Mexican artist and the photographer had met sometime before, probably at the occasion of the opening of her exhibit at the Delphic Studios, where Orozco's work was on permanent display. Ulmann had been deeply moved by Orozco's powerful fresco portrayals of the suffering of the Mexican people. In turn, Orozco had been touched by Ulmann's pastoral studies of poor southern African Americans and Appalachians and had been honored when the photographer asked him to pose for her. At the party, Ulmann presented the artist with the results of his sitting. Pleased with the special birthday gift, Orozco described Ulmann's portraits as "the most truthful and most penetrating photographs" ever taken of him. Thoughtful and generous, Orozco's remarks proved a gift of their own.[59]

Shortly afterward, the photographer found even more to celebrate in the publication of the December issue of *The Bookman*. The issue contained a pictorial article composed exclusively of Ulmann's photography. "Portrait Photographs of Fifteen American Authors" featured her images of some of America's greatest poets, playwrights, and novelists and confirmed Ulmann's position as the leading photographer of American literati. It included portraits of Robert Frost, Sinclair Lewis, Glenway Westcott, Lizette Woodworth Reese, Zona Gale, Struthers Burt, Dubose Heyward, James Weldon Johnson, Thorton Wilder, Edwin Arlington Robinson, Anne Parrish, Sherwood Anderson, Julia Peterkin, Wilbur Daniel Steele, and Thomas Wolfe.[60]

Still, this professional success could not erase Ulmann's deep longing for regular male companionship and her desire to be loved. Julia Peterkin mentioned this in a letter to Irving Fineman, whom Peterkin had herself pursued. But interestingly, in correspondence with him on December 18, 1929, Peterkin lambasted him for his insensitivity to Ulmann's feelings for him: "Irving, you are so dense. When Doris took me to the train she asked, 'Who'd you marry, Julia, if you were in my place?' 'Irving Fineman,' I said promptly. 'Yes, I believe you are right,' she came back and sighed."[61] Still, Ulmann did not respond to the marital possibilities of Fineman or of other men in her life. As much as she wanted to be loved, as much as she welcomed and desired the attention of the men she dated, she was unable to resolve her ambivalence about marriage. In her mind, friendship was a much easier thing. And it was what she needed most. Several days later, exhausted from her work and travel, Ulmann returned to see Peterkin in South Carolina. Soon afterward, she and Peterkin headed to New Orleans for the Christmas holidays.[62]

Despite the economic and social disasters of the fall of 1929, Ulmann's reputation continued to grow. In February 1930, *Theatre Arts Monthly* published "The Stuff of American Drama in Photographs by Doris Ulmann," illustrated by eight reproductions of photographs that had been part of the large solo exhibit Ulmann had held at the Delphic Studio gallery the previous November. The photographs were *Country Store, Catawba Indian, South Carolina "Turk," Kentucky Mountain Girl, Mammy, The Printer, South Carolina "Cracker,"* and *Convict Gang*. Being an avid follower of the theater, Ulmann must have felt particularly honored by the words of the writer of this article:

> The littleness and insignificance of Broadway in the great field of American life is sometimes made startlingly apparent for those who look for drama that shall be nationally interpretative. . . . These photographs by Doris Ulmann . . . are . . . highly significant in that they are strong reminders of the richness and depth and variety of dramatic treasure to be found in the mountains and valleys of country districts. . . . It is out of characters and life such as Miss Ulmann has depicted that such impressive plays as Paul Green's *In Abraham's Bosom*, and Lulu Vollmer's *Sun-Up*, Loretto Carroll Bailey's *Job's Kinfolks* and the other plays of the Carolina Playmakers have come. These should be but the beginning of a great group of plays that shall use the dramatic material provided by the American country. . . . This is the stuff of American Folk drama, a drama that shall present the nation in a true perspective before the theatre of the world.[63]

In early March, Ulmann sent several photographs for inclusion in the first exhibit of the Southern Mountain Handicraft Guild.[64] Organized by Allen Eaton, of the Department of Surveys of the Russell Sage Foundation, and Olive Dame Campbell, director of the John C. Campbell Folk School, the Guild exhibit was held at the Second Presbyterian Church in Knoxville at the "spring meeting of the Conference of Southern Mountain Workers." A New York acquaintance of Ulmann and a native Oregonian, Eaton had had a strong interest in the production, exhibition, and sale of handicrafts, dating back to the 1910s. In this period, he and his family had created miniature toy handicrafts, and he had organized exhibitions of Oregon artists and handicraft artisans in the Oregon pavilion at the Panama-Pacific International Exposition in San Francisco. Later, in his capacity as Field Secretary for the American Federation of Arts, the position he held when he first met Ulmann in 1920, Eaton had organized a series of exhibitions of "Arts and Crafts of the Homelands" for the University of the State of New York and an exhibition of "Prints in Color and Photographs for American Homes" for the Federation of Arts. In the 1920s, Eaton had become interested and passionate about publicizing and dramatizing the peoples and handicrafts

Fig. 27. *Allen Eaton, Field Worker, Russell Sage Foundation,* 1933. Posthumous gelatin silver print. Printed by Samuel Lifshey, ca. 1934–1937. Collection of the University of Kentucky Art Museum, No. 98.6.114.

of the southern highlands, so it is likely that he was the person who initiated contact with Ulmann and solicited a group of her Appalachian portrait studies for exhibition in the first Guild show. An old hand at exhibition organization, he understood how Ulmann's photographs of highlanders could enhance the display of handicrafts in Knoxville and help the handicraft artisans sell their products (fig. 27).[65]

Olive Dame Campbell also understood the value and significance of Ulmann's photographs. The daughter of wealthy parents from Medford, Massachusetts, Campbell had been introduced to the mountain people of the southern highlands by her husband, John C. Campbell, who had served as Secretary of the Southern Highland Division of the Russell Sage Foundation from 1912-1919.[66] Moved by the needs of southern Appalachians, Campbell had worked side by side with her husband until his sudden death in 1919. She eventually committed herself to work with mountain people in the area of Brasstown, North Carolina, located in the southwestern corner of the state (fig. 28).

Fig. 28. *Olive Dame Campbell, Director, John C. Campbell Folk School, Brasstown, North Carolina,* ca. 1933–1934. Platinum print. John C. Campbell Folk School.

Campbell and Eaton had first met in 1926, when she had invited him, in his capacity as a member of the Russell Sage Foundation's Department of Surveys and Exhibits, to speak about the economic and personal value of handicraft work at the spring meeting of the Conference of Southern Mountain Workers in Knoxville, Tennessee. Established in memory of financier Russell Sage, the Russell Sage Foundation had been created by his widow, Margaret Olivia Sage, for "the improvement of social and living conditions in the United States of America."[67] Eaton's remarks met with a positive response from many mountain workers and leaders, and sparked further discussions among the membership of the Conference. Two and a half years later, the Southern Mountain Handicraft Guild (later named the Southern Highland Handicraft Guild) was given birth as an "informal association" in its first organizational meeting, held at the headquarters of the Penland Weavers and Potters in Penland, North Carolina, in December of 1928. Not surprisingly, both Olive Campbell and Allen Eaton were present at this meeting, as well as Helen Dingman and Dr. William J. Hutchins of Berea College in Berea, Kentucky; Clementine Douglas of The Spinning Wheel in Asheville, North Carolina; Miss Fuller (on behalf of Frances Goodrich) of Allanstand Cottage Industries of Asheville, North Carolina; Lucy Morgan, the host of the event, of the Penland Weavers and Potters; Dr. Mary Sloop of Crossnore School of Crossnore, North Carolina; and Miss Williams of Cedar Creek Community Center of Greenville, Tennessee.[68]

At this meeting, these leaders unanimously approved a formal motion that strengthened the connection between this association and the Russell Sage Foundation (and, thereby, Allen Eaton) and, among other things, requested "the Foundation conduct an early survey of the handicrafts in the schools and homes of the Southern Mountains."[69] This laid the groundwork for Eaton and Campbell to organize "the first comprehensive exhibit of the handicrafts of the region" at the April 1930 meeting of the Conference of Southern Mountain Workers—the first "co-operative exhibition" sponsored by the Guild. It also led Eaton and Campbell to request handicrafts from thirty-two different mountain centers, including "a large collection of baskets, brooms, elaborate and beautiful examples of hand weaving, hooked rugs, and modern adaptations of mountain handicrafts," and led Eaton to solicit a large group of photographs of southern highlanders from Ulmann.[70]

Ulmann's photographs drew substantial attention at the exhibit and meeting. Dr. William J. Hutchins (fig. 29), president of Berea College in Berea, Kentucky, Olive Dame Campbell, and Allen Eaton were particularly impressed with Ulmann's work. In correspondence with Ulmann on March 28, Dr. Hutchins expressed their enthusiasm for her work. "As one of the scores of people who saw your exquisite photographs at the Mountain Workers Conference in Knoxville, I wish to express my own thanks and the thanks of all who saw them. You have made an extraordinary contribution to our appreciation of the mountain

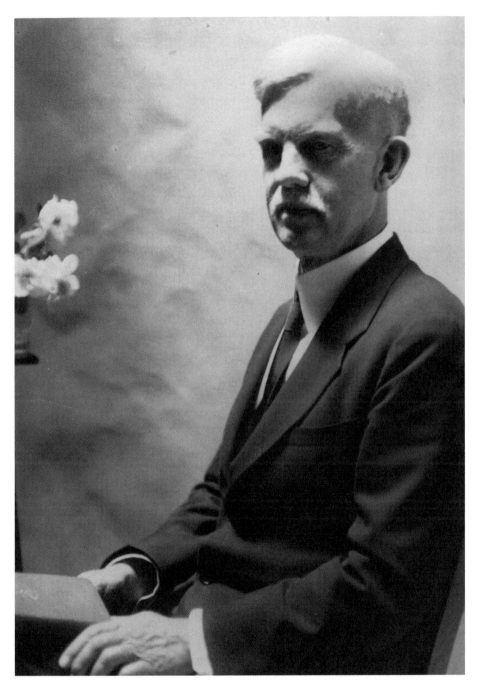

Fig. 29. *Dr. William J. Hutchins, President, Berea College, Berea, Kentucky*, ca. 1933–1934. Platinum print. Collection of the University of Kentucky Art Museum, No. 98.6.13.

people."[71] The effect of her work grew on Hutchins. Two months later, he queried Ulmann about the possibility of receiving copies of the images he had seen in Knoxville: "Are there any circumstances under which it might be possible for Berea College to receive copies of the photographs which you had on exhibit at the Mountain Worker's Conference in Knoxville? If you would be willing to have copies of these photographs made for me, I should be glad to learn what would be the cost to the College. I should be interested also to know whether you would be willing for us to duplicate such photographs, and under what conditions."[72] Interestingly, it was finally Allen Eaton (who had shown a similar enthusiasm for Ulmann's photographs at the spring exhibit) who answered Hutchins' query. On July 21, Eaton wrote: "In a visit with Mrs. Doris Ulmann the other day she spoke of your inquiry about photographs with the result that we are going to try to get together this fall and arrange a much better exhibition than the one you saw in Knoxville and send it to Berea (to the autumn meeting of the Southern Mountain Handicraft Guild at Boone Tavern on the Berea College Campus). Mrs. Ulmann will take up later with you the matter of the prints to which you referred. She was just leaving for a photographic trip (to Boston) and asked me if I would send this word to you."[73] Hutchins quickly responded to Eaton: "You and Mrs. Ulmann are generous. It will be a perfect delight to us to have her photographs displayed in Berea. . . . I think she has done a masterly piece of work."[74]

Despite her professional success in the early months of 1930, Ulmann still yearned for serious male companionship, for someone to help end the loneliness she had long felt. She became hopeful that she had found such a companion that spring, when she and Dr. Arnold Koffler, a specialist in internal medicine, began to date. Born in 1894, Koffler was, unlike her former husband, considerably younger than Ulmann.[75] He had graduated from University and Bellevue Hospital in New York in 1917 and had been licensed the same year.[76] By 1925, he had become a Fellow in the American Medical Association and had established an office at 175 W. Eighty-eighth Street, a relatively short distance from Ulmann's Park Avenue apartment.[77] In late March, Ulmann shared her enthusiasm and hope about Koffler with Peterkin. But Peterkin was only interested in using this news for her own ends—to better secure her romantic position with Irving Fineman, who, as she knew, had also had a personal interest in Ulmann. She made this unabashedly clear in the words she wrote to Fineman on April 2: "A letter from her [Ulmann] tells much of Dr. Koffler who takes her to dinner, dines with her now. I suspect this. Doris is undoubtedly looking for a mate. You were a potential one but she suspects you may not be forth coming. Dr. Koffler is now being looked over instead. . . . Doris seems so bitterly lonely. I did for her what would stir my gratitude if it were done for me. . . . I sent you to see her."[78]

In a letter to Peterkin on April 23, Ulmann verified the novelist's remarks

and indicated how much the writer meant to her. "I know that when I am working, all other things seem less important and probably, my premise always is that no one cares a great deal whether he sees me or not . . . It means so much to me that I can speak to you about anything that is in my mind or in my heart. I am not used to such understanding."[79] So Ulmann felt. She was not "used to such understanding." It is one of the reasons she maintained her relationship with the novelist, despite their differences. At this point in their relationship, Peterkin was much more of a sister to Ulmann than her own sister; the girlfriend the photographer seems to have never before had; someone with whom she could be foolish and laugh and cry; someone with whom she could talk about the real problems of her life and the struggles of her art.

In the first part of May, Ulmann and Peterkin joined forces once again for another journey into the heart of the South. Meeting in Greenville, South Carolina, and driven by Ulmann's chauffeur, George Uebler, they followed novelist Joseph Hergesheimer, who was gathering data for a novel in Alabama.[80] On the evening of May 9, Ulmann wrote Fineman from Hotel Eutaw in Eutaw, Alabama:

> While Julia is smoking and drinking coffee after having walked since dawn until now, 8 p.m., I am writing these lines to preserve her strength to meet two old Negro women who have been to Rome to visit the Pope. . . . Julia is a grand chauffeur. The roads do not suit my car so Julia and I proudly travel in a Ford which refuses to start, and we must push it down hill . . . and before we are half down the hill Julia's red hair starts the sparks firing and my blasphemy helps and we are off. . . . We wonder just what each day will bring us![81]

A few days later, in correspondence with Fineman, Peterkin bragged of her and Ulmann's foolishness and attempted to dismiss the idea that she would be jealous of him pursuing a relationship with the photographer:

> Six days have I ridden over the land, today, the seventh, I rest and read and write while Doris and George gallivant. It has been interesting, amusing. . . . The nice husbands call on us but wives are uncertain about us. No other woman here smokes. . . . We are having pleasure. Doris says she's never been foolish before. Poor child. Being foolish is my chief joy in living. Why take anything except pain, physical pain, seriously. God forbid. Doris wanted you to come with her. She wants you still. Come on. I'll never for a second interfere. I'll sit with George and learn some words of my forgotten Deutsche. I'm really never jealous. I was spiffing when I said I was. Come test it. Doris does so need a beau. . . .[82]

Once they reached Mobile, Peterkin wrote Fineman again. It is hard to believe this letter was only written a few days after the last. For in this letter, written from the Battle House Hotel in Mobile, Peterkin again revealed her jealousy of Ulmann and showed herself capable of doing whatever was necessary in order to draw Fineman's attention to herself.

> Your letter cheers me. I've been a bit weary. No privacy. Heat, dust, irregular food, annoy me in spite of much that's interesting. "Theatre Arts" wants an article illustrated with Doris's pictures, but she and I differ in ideas of dramatic values. Dynamic characters intrigue me. I think they repel her. I loathe social affairs, and slick, sweet-talking southern males. Know their insincerity so well. She does not yet. She likes them. . . . Of course I know you'd never come here. I'd have stopped you if you'd considered it. Doris longed for you. I did not blame her. She asks so many questions about you, what you think, what you do etc. etc. I never know anything at all. I send you messages when she writes you, which seems to reassure her. What else is there to do. Poor little undeveloped child. Kind little Doris. Consumed with ambition. Devouring her very soul with it. Never living, never experiencing. Lonely, unhappy. Wearing Rambora gowns and hats at her work here in the heat and dust, blistering her heels with beautiful shoes. I all but weep over the pathos of it all. She's afraid of George, her chauffeur, of his displeasure. Poor Doris. . . .[83]

The next day Ulmann and Peterkin headed to New Orleans.[84]

In June, essayist Dale Warren, whom Ulmann had photographed, met with her on several occasions at her Park Avenue apartment. These visits enabled Ulmann to once again play a role she loved, that of the generous and gracious host, and permitted Warren to gather information for his article on Ulmann for the October issue of *The Bookman*.[85] Ulmann also photographed Irving Fineman at her apartment during this time.

On July 8, Ulmann and George Shivey (director of advertising for the Bobbs-Merrill Publishing Company in New York City) came to visit Peterkin at Lang Syne for just the day. But on this visit, Ulmann's remarks about her photography of Fineman evoked further jealousy in Peterkin. In a letter to Fineman on July 9, Peterkin commented on Ulmann's contact with Dale Warren and criticized Ulmann in a very condescending manner:

> Doris, who has just gone, is typical of all people with her birth-date. She is all excited about Dale and is going to Boston the end of the month for a stay. She insisted on my going too. She still needs another woman along. She picks me as a safe one who will chaperon

her, yet not overshadow her. How little she knows me. She says your [Fineman's] portraits are good and that you said I might have one. She and Henry Bellamann had one in the Columbia State on Sunday, which is good of you. . . . I noticed however, that Doris hesitated when I asked her to send me your pictures. I know she will not. I do not blame her.[86]

Toward the end of July, Ulmann headed to Boston, where she spent more time with Dale Warren. She also worked, continuing her efforts to document American literary types. In Boston and its surrounding area, she photographed authors Margaret Ayer Barnes, Hamilton and Jeannette Gibbs, Mary Lee, Sophis Cleugh, Gamaliel Bradford, John Livingston Lowes, and Esther Forbes in their own studies and homes. Some of the photographs she took were later reproduced in *the Bookman* in the fall.[87]

In September, Ulmann headed to the South Carolina coast with Dr. Arnold Koffler. Once the pair reached the coast, they found lodging at the Seaside Inn in Myrtle Beach, where Peterkin joined them. In a letter to Fineman on September 20, Peterkin was once again very critical of Ulmann.

> Yesterday I came here to be with Doris and Dr. Koffler for a few days. I think she prizes me because I make a good chaperon. I make her feel comfortable with her gentlemen friends, and she can experiment with various techniques. But I'm like a lost soul. Neither of them fish, swim, play golf, ride a horse, shoot, enjoy lying on the sand. I sit primly, or maybe rock in my chair for variety. My God, how can people become adults and remain inanimate? Tomorrow, I shall take them to Heaven's Gate Church to hear my black friend Andrew Keith preach to his flock. Maybe the black people will wake them up a little. Maybe. Still, Doris will wake only enough to take a picture, I fear, and feel no response to prayers to God or to warnings of hell's dangers. Koffler may. He's tired, though. I'm so glad you are alive, sensitive to things, curious about them, eager to experience them. I think it's better to suffer than to be numb, unmoved by beauty. You see, I'm a bit cross. Wanted to go on a fox hunt, fish for trout, have them play in the waves with me. They're afraid . . . Doris has come in with her hat on. We shall go ride in a car and view the landscape.[88]

While it is uncertain if Ulmann photographed some or all of her series on African American worship during this visit to Heaven's Gate Church, there is no question Ulmann was moved by what she experienced. The depth of her response is evident in her artistic portrayals of African American worship previ-

ously noted in the images *Footwashing* and *Baptism* (see figs. 24 and 26), and in the image *African Americans Worshipping in South Carolina Church* (fig. 30).

A few days after the visit to Heaven's Gate Church, Peterkin expressed further dissatisfaction to Fineman about her visit with Ulmann and the doctor: "I left Doris and Koffler in Charleston. I could not stay another minute with them. Unhappiness does not agree with me. I become irritable. They come here [Lang Syne] Friday for a short stay."[89]

October brought more good news for Ulmann. *The Bookman* published Dale Warren's article, "Doris Ulmann: Photographer in Waiting." It was illustrated by reproductions of portraits Ulmann had made of nine contemporary American writers: Margaret Ayer Barnes, Gamaliel Bradford, Esther Forbes, Waldo Frank, Joseph Hergesheimer, Oliver La Farge, S.S. Van Dine, and Carl Van Vechten. Based on his personal interviews with the photographer, Warren's article offers significant insight into Ulmann's photographic method and philosophy.[90]

Warren noted that her photographic studio was her own luxurious Park Avenue apartment, where her "sitters" could find "all the amenities one expected in the apartment of a woman of Ulmann's station." In Ulmann's opulent home, each subject was indulged and served by Ulmann and her servants in a casual yet thoughtful way.

> Here the "sitter" wanders leisurely about among an army of chairs and couches upholstered in claret red, gazes longingly at Oriental bronzes and wistful madonnas, and drops at length onto some inviting cushion to open an autographed Robert Frost or Edna Millay. The well-trained Clara emerges at length with a tray of sandwiches, tea or cocktails, according to the hour and season, and the work begins in earnest. There is an old pewter bowl filled with Benson and Hedges, Pall Malls, English Ovals, Luckies and Chesterfields, for no visitor . . . is forced to bring, smoke, or roll his own. Four large windows, admitting all the light that is necessary, open above the Church of St. Ignatius.[91]

The same thoughtfulness and casualness also shaped Ulmann's photographic work: "One who sits for Mrs. Ulmann does not 'sit' in the usual sense of the word. There is no mechanical apparatus behind your neck." While Ulmann attempted to provide a certain atmosphere for her sitters and sought to draw them out, she permitted them to "dress" and "position" themselves as they wished. Describing her photographic method, Warren stated:

> You select your own chair, move it up to the window, and then assume the position that you enjoy above all others, with or without

Fig. 30. *African Americans Worshipping in South Carolina Church*, ca. 1929–1932. Platinum print. South Carolina Historical Society, No. 33–110–14.

pipe, cigarette, ukulele, or volume of the Encyclopaedia Britannica, according to the state of your desire. . . . You continue to smoke, play, read, or ponder silently on your sins and with never so much as a click of a shutter the likeness of all that is mortal of you is for all time preserved. If you should be led to think that the tea and the cocktails and the cigarettes and the conversation are merely dispensed for your enjoyment you will be all wrong. Mrs. Ulmann would say that these things are offered to "draw you out." She studies your hands as you pass her a plate of cakes, observes which leg you cross over the other, notices the expression of your eyes, tells you a funny story to make you laugh, and another not so funny to see if you are easily reduced to tears.[92]

Following the practices of nineteenth-century artistic and photographic portraitists, Ulmann used external objects to identify the vocation as well as the social position and identity of her rural and urban sitters. Through the means of books, tools, handicrafts, medical and writing instruments, clothes, furniture and other objects, she provided a more complete picture of the identity of her subjects (figs. 31 and 32). Though taken in very different settings, the rural mountains of eastern Kentucky and the urban Johns Hopkins University, both *Christopher Lewis* and *Max Broedel* substantiate the photographer's desire to use external objects to disclose her sitter's identity, vocation, and social position.

While the subjects she photographed in her Park Avenue apartment and their places of work were permitted to choose certain external objects in order to clarify their own self-understanding and their particular vocation and interests and tastes, it is clear that Ulmann helped to shape their choices. This is most evident in the use of her own antique chair and a book in many of the portraits. The same chair can be found in many of the images made in her apartment.

Not suprisingly, some of the external objects Ulmann used to identify her subjects also identified the photographer. As the fine clothes Sherwood Anderson chose to wear for his portrait provided particular information about this author's social position and vocation and self-understanding, fine clothes also identified Ulmann, herself. As the antique chair that many of her subjects sat in said something about them, it also said something about Ulmann. The same can be said of the book that is often present in her photographs of urban and intellectual sitters and of the Bible or religious book in many of her photographs of rural subjects, which serve as common links between her urban and rural sitters. By placing a book in the hands (or near the body) of some of her rural and urban sitters, Ulmann discloses the deep meaning the printed word has for each of them (be they rural believer or urban intellectual). Believing as some of her rural subjects did, it was only logical to the photographer that she pose certain African American and Appalachian Christian subjects with a Bible in their hands (see

Fig. 31. *Christopher Lewis, Appalachian Minister,* Wooten, Kentucky, ca. 1933–1934. Posthumous gelatin silver print. Printed by Samuel Lifshey, ca. 1934–1937. Audio-Visual Archives, Special Collections and Archives, University of Kentucky Libraries, 78 PA 101, No. 20.

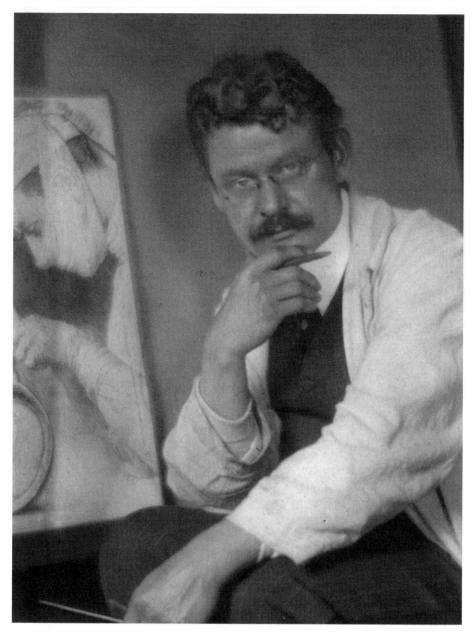

Fig. 32. *Max Broedel, Associate Professor of Art as Applied to Medicine, The Faculty of the Medical Department, Johns Hopkins University, Baltimore, Maryland,* 1920. Photogravure after platinum print. Published in *A Book of Portraits of the Medical Department of the Johns Hopkins University,* 1922. Private collection.

figs. 22 and 31 and plates 27, 38, and 58). Likewise, feeling as passionate as some of her urban sitters did about other books, it was only appropriate for Ulmann to pose certain teachers, writers, and professors with books they had created or books that were essential to their vocation (see figs. 2, 14, and 16 and plate 20). Because books were very much a part of her own identity, the presence of a book, whether a novel or a religious scripture, in Ulmann's photographs also reveals critical information about the portraitist. Ulmann was not only a photographer but also an editor and author in her own right. Whether consciously or unconsciously, she reminds us of this and other aspects of her self-understanding when she permits different external objects to have a part in her artistic compositions.

Ulmann did not just seek to simply "document" the person she photographed. Nor did she merely seek to create a photographic portrait like the common picture created by so many studio and field photographers of her day. Instead, she sought to compose and create, and did so—slowly and methodically—instructing her subject to do certain things for one photograph and then other things for others. Again and again she composed and recomposed the individual before her until she felt she had captured the essence of their character and personality.

In describing her method and philosophy to Warren, Ulmann noted: "Whenever I am working on a portrait, I try to know the individuality or real character of my sitter and, by understanding him, succeed in making him think of the things that are of vital interest to him. My best pictures are always taken when I succeed in establishing a bond of sympathy with my sitter. When there is the slightest suggestion of antagonism, then my best efforts are of no avail."[93] It was this method and philosophy that informed Ulmann's work with literary sitters as well as her work with rural sitters, including Kentucky mountaineers, South Carolina African Americans, and North Carolina Native Americans.

Warren's mention of Ulmann's prestigious sitters further illustrated the esteem with which she was held in the literary community. Aside from those seen in the reproductions of the article, she had photographed Robert Frost, Thornton Wilder, H.L. Mencken, Edna St. Vincent Millay, John Galsworthy, Edward Arlington Robinson, Ellen Glasgow, Paul Green, Carl Van Doren, and Henry Van Dyke (fig. 33).[94]

There is no question that Ulmann was very proud of the fact that these individuals had sat for her; she was delighted with both the opportunity and the recognition this provided her. Nonetheless, she admitted that she sometimes reached the point "when literary faces all begin to look alike and invitations to literary teas tread upon one another's heels." At such a point, Warren noted: "Mrs. Ulmann decides it is time to get away. She gets into her car, gives George (her chauffeur) a road map and sets out—always at midnight—for South Carolina, Kentucky or New England, but never without her photographic parapher-

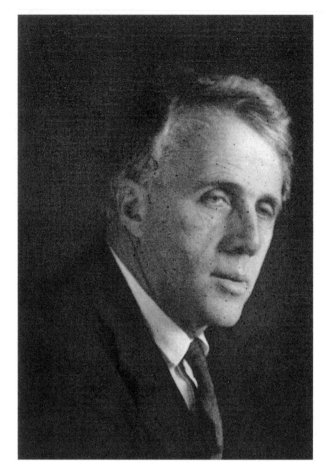

Fig. 33. *Robert Frost, Poet,* ca. 1928–1929. Photogravure after platinum print. Published in Sidney Cox's, *Robert Frost: Original "Ordinary Man,"* Henry Holt, 1929. Private collection.

nalia in the tonneau and a set of well-defined plans in her head."[95] But more than the similarity of literary faces motivated these departures. As she grew older and her health diminished, and the economic depression revealed the vulnerability of the messiah of the machine, Ulmann felt less attracted to the city and the character of the urban personality and more attracted to those who had had to struggle and suffer on their journey through life. Their faces moved the photographer more than those of literary types. As Ulmann described it: "I am not interested exclusively in literary faces, because I have been more deeply moved by some of my mountaineers than by any literary person, distinguished as he may be. A face that has the marks of having lived intensely, that expresses some phase of life, some dominant quality or intellectual power, constitutes for me an interesting face."[96] And so it remained for Ulmann for the rest of her life.

In the middle of October Ulmann left New York to join Peterkin in Washington, D.C., for the opening of the play based on Peterkin's *Scarlet Sister Mary* at the Belasco Theater. In a letter to Irving Fineman from the Mayflower Hotel, written a short time before Ulmann arrived, Peterkin expressed her concerns about the condition of the play, the state of the nation, and Ulmann's matrimonial interests:

> I'm here, hoping to be of use mending the play's broken spots, and wondering if I can. Wish you were here too. Washington's untidiness amazes me, papers littering the parks, fallen leaves everywhere, broken fences, dilapidation. Perhaps all this is evidence of business depression in the whole nation. Doris wrote she'd join me here and invite you to come along. I must form a matrimonial bureau, and try Doris for my first client. Will you give me a commission if I make you this successful marriage? Or a better commission if I keep you free?[97]

Once again Peterkin brought to light her jealousy of her good friend. Her letters to Fineman reveal she often felt jealous of Ulmann, particularly when she sensed she was competing with Ulmann for the attention of Fineman or some other man. But, ironically, they also show Peterkin's affection and respect for Ulmann, as can be seen in her correspondence with Fineman on October 24, 1930: "Doris has sent me a regular Christmas box, delicious coffee, a whole big Roquefort cheese, and English crackers. I feast. She is so kind. She keeps me under obligation to her constantly, yet I've no way to pay my debt to her. She gave me an account of her tea. . . . Patterson with bibs only, Mr. Gautier as bar tender, her own Turkish trousers, etc. She is a little little girl. . . ."[98]

"Little girl"–like and humorous as the forty-eight-year-old photographer could be, there was no question she was also continuing to make a mark for herself in the American art scene and attracting the kind of attention and respect she desired. In the early fall of 1930, Lincoln Kirstein, a Harvard undergraduate, solicited Ulmann's work for an exhibition at the Harvard Society for Contemporary Art.[99] A future patron and promoter of contemporary American artists, Kirstein had founded the Harvard Society along with fellow Harvard students Edward Warburg and John Walker, future director of the National Gallery of Art. Its 1929 inaugural exhibition had included American paintings, watercolors, drawings, prints, and photographs, as well as decorative arts. However, in the 1930 exhibition Kirstein focused on photography. As he stated in the exhibition catalogue, he desired "to prove that the mechanism of the photograph is worthy and capable of producing creative work entirely outside the limits of reproduction or imitation, equal in importance to original effort in painting or sculpture," a point that has only recently been recognized by art critics and

historians.[100] In order to do so, Kirstein sought work from Ulmann and a variety of other photographic artists whom he thought represented the best of photography and could substantiate his conviction. Kirstein chose photographs by Berenice Abbott, Eduard Atget, Cecil Beaton, Margaret Bourke-White, Anton Bruehl, Walker Evans, Arthur Gerlach, George Hoyningen-Huene, Tina Modotti, Moholy-Nagy, Man Ray, William Rittasse, Sherrill Schell, Charles Sheeler, Eduard Steichen, Ralph Steiner, Alfred Stieglitz, Paul Strand, and Edward Weston, placing Ulmann in distinguished company.[101] Kirstein displayed several photographs of each artist. He also included "five astronomical and eight aerial views, nine press photographs of accidents and parades, and ten medical X-rays."[102] The exhibit opened at 1400 Massachusetts Avenue in Cambridge on November 7 and continued there until November 29. The show then traveled to the Wadsworth Athenaeum in Hartford, Connecticut, for a December exhibition, the Albright-Knox Art Gallery in Buffalo for a February exhibition, and the College of Architecture gallery in Ann Arbor for a March exhibition.[103]

Flattering as it was to have her work exhibited with that of Stieglitz, Steichen, Strand, Modotti, and Weston; significant as it remained to have her work shown and appreciated, as time went on and her health continued to deteriorate, Ulmann found herself less drawn to people and things that had once captivated her. Though she still felt a strong kinship with her many friends and acquaintances in the northeastern photographic and arts communities, she knew a distance had grown between them and she felt less in common with them and more in common with her Appalachian and African American sitters, whose vulnerabilities were often evident and who were less able and less inclined to hide the real struggles of their lives.

# Chapter Three
# Photographing the South

*I*n 1931, Lewis Hine did a photographic study of the construction of the Empire State Building. His work documented not only the rise of the largest building in the largest city in America but also, symbolically, the depth and breadth of the power of American industry. Many other American photographers of the period also focused their cameras on this building and photographed contemporary American architecture, technology, machines, and designs that revealed the profundity of this power. In contrast, Ulmann continued to aim her camera in other directions.[1]

In the latter part of May 1931, she returned to New Orleans. She was joined there by Louisiana writer Lyle Saxon, in whose New Orleans home she and Peterkin had visited during the Christmas of 1929.[2] A well-known New Orleanian, who resided in the Vieux Carré, Saxon provided entrée for Ulmann to people she sought to photograph in the city.[3] In New Orleans, she photographed members of the Catholic Ursuline Convent of the Sacred Heart for a day. Ulmann then spent two days photographing members of the Sisters of the Holy Family, an African American order.[4]

After she finished her work in New Orleans, Ulmann's chauffeur, George Uebler, drove her and Saxon to Melrose Plantation, a place where Saxon had often retreated to write. Located outside the northwest Louisiana community of Nachitoches, this early nineteenth-century plantation was the home of a vivacious and enthusiastic fifty-year-old woman named Carmelite "Cammie" Garrett Henry. A patron of the arts, "Miss Cammie," as Henry was called, had provided residence and support to many struggling southern writers and artists over the years, including Saxon, Roark Bradford, Gwen Bristow, Rachel Field, Rose Franken, Clementine Hunter, Harnett Kane, Alberta Kinsey, and

Francois Mignon.[5] So it was natural for Henry to welcome Ulmann and encourage the photographer's study of many of her African American servants and workers.

Intrigued by the intensity and artistry of his friend's photographic efforts during their visit to Melrose, Saxon provided information about Ulmann's photographic techniques in a letter to Carrie Dormon. "Doris is taking pictures like mad. Or rather with a methodical saneness and intense activity, an average of four dozen a day. She doesn't photograph places, ever, but takes only portraits of Sammie Peace with a cross-cut saw, etc. . . . She doesn't even glance toward acer rubrum or salix babylonica, except with a thought as to a suitable background (out of focus) so I suppose that she wouldn't interest you much; but her figure studies are really superbly good."[6] And so they were. Driving away from Cammie Henry's plantation, Ulmann felt positive about what she had accomplished there. But there was something more, something else that had been uplifting about her visit to Melrose: brief as it had been, it had given her the opportunity to meet Henry and begin a lasting relationship with this wonderful woman.[7]

Three letters penned by Ulmann shortly after her departure from Melrose indicate the effect Henry had on her. In the first letter, written on May 31 from the Hotel Monteleone in New Orleans, Ulmann expressed her thankfulness to Henry:

> Dear Aunt Cammie,
>
> The few days that I have been fortunate enough to spend with you at Melrose seem like a beautiful dream that took place in a delightful country. However, I hope that I will be able to prove to you that the days were real when I start work on my plates. It is one of the precious events of my life that I have had the privilege to know you and I am deeply grateful to Lyle for having brought me to you. I have not known you very long but you must believe me when I tell you that I have been missing you intensely. You cannot know how deeply I appreciate all your trouble and your interest.[8]

In another letter to Henry, written on June 12 from her New York apartment, Ulmann again disclosed her deep affection for her new friend. She also revealed the way she prepared her photographs for display:

> You cannot know what a joy it was to find your dear letter when I reached home after a long and rather fatiguing trip. . . . And today your second welcome letter came,—I was so happy to hear from you and bless you for your lovely thoughts and words. . . . Of course I am so eager to develop my plates because I must know whether I have succeeded in doing that which I was keen to express. I have started

this job,—and I am hoping that my pictures will be interesting. Certainly you must have the pictures that I do in Louisiana,—but let us decide just how the group should be after I have finished them. And now I will tell you just the way I feel about the pictures,—I always prefer to mount them because they never seem complete to me when they are not properly finished. Mounted the pictures can be put in a portfolio,—or in one of those paper portfolios in which I carry my pictures. There is another advantage in having them mounted,—they are always ready to exhibit and one can always select certain ones for different purposes. . . . I do miss you and please always know that I am thinking of you. Sometimes give me thought,—when you wake during the night, you can think of me working with my plates in my dark room.[9]

On June 3, Ulmann and George Uebler left New Orleans for Columbia, South Carolina, to rest and spend a couple of days with Peterkin. Ulmann's contact with Peterkin elicited a letter to Fineman. With her tongue buried deep into her cheek, Peterkin encouraged Fineman to reconsider the rewards of marriage to Ulmann. "I keep thinking what a fine wife she'd make you. How well you'd sleep on that liberty-bond stuffed mattress of hers. You're perverse, Irving. With all the good advice I give you, you take so little. You'd better change and listen to me and live happily ever afterward."[10]

Following her visit with Peterkin in Columbia, Ulmann returned to New York. She had thought of returning to Melrose Plantation in Louisiana later in the summer and planned other work. However, on her way to see her doctor in the middle of August, the forty-nine-year-old Ulmann "fell on the street and knocked [her] knee against the curbstone and fractured it badly." In a letter to Cammie Henry on August 23 from Lenox Hill Hospital in Manhattan, where she was a patient, Ulmann expressed her frustration over her misfortune. "They have not been able to do much because the surgeon must wait—until it is in condition to operate,—he will operate on Tuesday and then I hope that it will be less painful. . . . I had planned so much work for August and September and now I am here not able to move, not able to do anything. The worst of all this is that it will take so very long before I can be active again. . . . It will be five or six weeks before I can move about on crutches—and much longer before I can walk without a cane."[11]

This fall was not Ulmann's first, and it would not be her last. She seemed to have a propensity for accidents. Peterkin noted this in her August 31 letter to Fineman. She wrote: "Except for the serious illness of my sister-in-law I'd go see Doris. Poor little soul, she seems to live under some unlucky star. George and Thekla, her maid, write me the most delicious letters urging me to come stay in Doris' apartment, promising to care for me, etc. If I could leave here now, I'd do

it."[12] It took a long time for Ulmann to get on her feet after her accident. However, she continued to gain professional recognition.

In the fall, the Pictorial Photographers of America invited Ulmann, Imogene Cunningham, and Laura Gilpin to each submit several photographs for a fifty-print traveling show that would be available in 1932 for exhibit in galleries, museums, libraries, and clubs throughout the country. In the December issue of their monthly *Light and Shade,* the Pictorial Photographers announced this show in an article on their travel salons:

> In order to fill a demand for more individual exhibitions we have made up the fifty-print show from the works of three of our leading women: Imogene Cunningham, Laura Gilpin, and Doris Ulmann. Here we have the works of three women in extreme locations: the eastern metropolis, the plains and mountain country, and the Pacific Coast. The geographical locality does not seem to have much influence on the work, however. . . . Doris Ulmann lives in New York City but is interested in the American types of people who inhabit the remote parts of the eastern half of our broad country.[13]

Peterkin finally visited Ulmann in New York City in the middle of November. Following this visit, George Uebler drove the two of them back to Columbia, South Carolina. With a keen sense of the dramatic, Peterkin pulled out all the stops to recreate their rush to Columbia for Fineman: "We slid over the miles of road like bats out of hell, fleeing Satan. Twas a mad journey, no time for any enjoyment but a swift leaping around cars, dodging, lurching, holding tense to our souls for fear they'd be left naked in the road whenever we sped around a curve."[14]

Her rhetoric aside, however, Peterkin remained concerned about Ulmann's mental and physical condition. It was this concern that led Peterkin to arrange for Ulmann to stay at Miss Eastway's Sanatorium once they reached Columbia. Ulmann had not recovered from her fall as quickly as Peterkin believed she should and even displayed a reluctance to do what was necessary to ensure her own recovery. Peterkin expressed this in another part of her November 24 letter to Fineman. She wrote: "Doris is in good hands. If she will only be reasonable and eat, sleep, rest, she will grow strong. Her own New York doctor says so. For some reason she clings to frailty. Maybe her longing for sympathy, love is the hidden reason. Poor little woman. She is very pathetic."[15]

Ulmann stayed at the sanatorium for a few weeks, and by the middle of December she felt recuperated and ready to travel.[16] The months of recuperation and rest after her fall in May had been very difficult for her and made her anxious about her work. In correspondence with Cammie Henry on December 19 from Hotel Columbia, Ulmann wrote of this difficulty and of her anxiety: "These

months have been strange ones for me and my hope is that I shall be able to do better work when once I am able to start and to do all that I want to do. . . ."[17] On December 20, Ulmann and Peterkin and Ulmann's driver left Columbia for New Orleans.[18] Here, Ulmann and Peterkin celebrated the holidays with Saxon.[19] The next day, the New Orleans *Times-Picayune* ran an article on Ulmann and Peterkin's visit to the city. The newspaper columnist noted that the photographer and writer were residing at the Hotel Monteleone and had visited Lyle Saxon at his Vieux Carré residence. The columnist went on to state: "Mrs. Ulmann, whose home is in New York City, began her photographic art work in 1918, and has become famous for her portraits of noted persons. Her work appears in periodicals of this country. She has also had photographs published as illustrations of books."[20]

After several days of rest and celebration, Ulmann returned to work. Once again she focused her camera on a group of people who had had a profound effect on her earlier that spring—the Sisters of the Holy Family, the African American Catholic order she had visited in New Orleans (fig. 34). Founded by Harriet Delisle and Josephine Charles of New Orleans, Louisiana, in 1842, the Sisters of the Holy Family is a contemplative congregation of African American Catholic nuns, located in New Orleans, who adhere to the rule of St. Augustine. One of their primary missions in the first century of their existence, as Ulmann documented in this photograph that recalls the earlier photography of Frances Benjamin Johnston, was to provide spiritual and academic instruction to African American youth. Saxon had earlier commented on Ulmann's fascination with them, and Peterkin had seen it as well. In correspondence with Fineman, she wrote, "Doris is obsessed with adoration for these Negro nuns. Queer."[21] And so it must have appeared to some people. But Ulmann knew there was something important here, that same kind of uniqueness and dignity she had seen in the eyes of the Mennonites, Dunkards, Appalachians, Native Americans, and African Americans she had already photographed—that individuality, character, and dignity which she hoped to document once again, through her artistry. So she turned to them, in adoration.

<p style="text-align:center">- - -</p>

Peterkin described the return of Ulmann and herself to South Carolina at the beginning of 1932 in the same way she had described their previous holiday journey to New Orleans—as "a wild journey." Once again she took the opportunity to criticize Ulmann to Fineman. In a letter to him on January 6, Peterkin wrote:

> Doris is afraid of George, obeys whatever he says, and he, German that he is, scorns women and their orders. I wanted to kill him, but was too weak. He nodded once at high speed, ran off the pavement

Fig. 34. *Member of the Sisters of the Holy Family with School Children, New Orleans, Louisiana*, ca. 1929–1931. Platinum print. Collection of the University of Kentucky Art Museum, No. 88.10.67.

almost into a car. The lights were bad and I made him stop, helped him adjust them, then . . . he ran out of gas and poor Doris sat for an hour in darkness while he walked miles to a filling station. Poor little helpless Doris. She stops at terrible places for food, spends nights in hellish holes. In Tallahassee, God knows where we were, but stealthy knocks on my door made me suspect twas not a reputable joint.[22]

And yet, Peterkin's affection for Ulmann remained strong as she revealed in a note to a contact at Bobbs-Merrill about her forthcoming novel, *Bright Skin*—"tell Mr. Chambers," she wrote, "the dedication is 'for Doris.'"[23]

Following their trip Ulmann returned to New York City. At the beginning of February 1932, Ulmann returned to South Carolina, where she joined Peterkin to prepare for their parts in an upcoming presentation of Henrik Ibsen's play *Hedda Gabler* at Columbia's Town Theater. Writing to Fineman on February 4, from her residence at the Columbia Hotel, Peterkin said: "Doris and I have had two rehearsals. She suits her part amazingly (Aunt Julia Tesman). She seems well, happy . . . Doris and I each have two beds in our rooms. When you come you might use whichever you choose. Doris suggests—now really I am shocked. This air has gone to her head, surely."[24]

In another letter to Fineman on February 22, Peterkin added: "We've begun the last lap of rehearsals. The play opens Thursday night, goes on through Saturday matinee and night. It's been fun. We've a pleasant group, all of us doing our damnedest best, however poor that may be. . . . Yes, my book's out March 31st. . . . I've dedicated mine to Doris. She seems pleased. She's been so kind to me. I'm glad to have a chance to show her this courtesy. And yet I think, how will she feel if critics pounce on it, tear it to pieces."[25] *Hedda Gabler* ran for three days in Columbia.

Once the Columbia performance was over, Ulmann returned to New Orleans to care for Saxon, who had fallen ill. In correspondence with Fineman on March 7, Peterkin questioned the purpose of Ulmann's journey. She wrote: "Doris writes somewhat sadly from New Orleans. I keep wondering why she went. Lyle is ill. She can do nothing for him. She should establish a home for the ailing. Never does she prize me so much as when I'm utterly down. Perhaps it gives her a sense of strength, superiority to see her friends feeble."[26]

After spending several days in New Orleans caring for Saxon, Ulmann returned to Columbia, South Carolina, and spent more time with Peterkin. Her time away from New York had given her needed rest, time to spend with Peterkin, and the opportunity to act in a performance of Ibsen's great drama. Yet she still remained unable to move well and work as she wished.[27] In correspondence with Cammie Henry on March 30, Ulmann wrote:

Ever since the last days of January I have been away from home and have spent most of the time right here in Columbia. . . . the reason

for my being here now, is that we are to give a performance of *Hedda Gabler* in Charleston on Saturday, April the second. . . . I am hoping it will be possible for me to work as much as I plan when I return to my home. My knee is better but not well—I cannot bend it very well and the doctors tell me that a fracture of this kind always takes at least a year before it is entirely cured. Of course, I have done a little work, but not as much as I should like. . . .[28]

Much as Ulmann wanted to do more work, she had another setback just before her fiftieth birthday in May of 1932, when she fell again. The writer Francis Frost noted this in her correspondence with Irving Fineman on May 13. She wrote, "Doris Ulmann . . . had another bad fall the other day and about ruined her shoulder so that she's all black and blue and can't lift her arm. . . ."[29] This accident further frustrated the photographer and made her realize she would not be able to continue her work as she had planned without additional assistance. Unable to deny her present physical limitations, Ulmann sought an assistant to help her in her work. Some time before, she had been introduced to the forty-year-old folk musician John Jacob Niles, a native Kentuckian and World War I veteran, who lived in New York City. An accomplished musician and musical compiler, Niles had studied music at the Cincinnati Conservatory and the Schola Cantorum and the Université Lyon in France. He had co-edited two books, *Singing Soldiers,* a collection of African American songs (1927), and *Songs My Mother Never Taught Me,* a collection of doughboy songs (1929) before he associated with the photographer. Their first introduction may have come when they were both publishing work in *Scribner's Magazine* in the middle 1920s. But both had been preoccupied with many different professional and personal interests in the ensuing years. Now, since Ulmann's physical limitations required she have an assistant, she contacted Niles, who agreed to help her on a project she had accepted for the summer.[30] As it turned out, Niles also needed Ulmann's help. It was a critical time for the musician. He had reached a point where he found less and less satisfaction in his professional partnership with contralto Marion Kerby. Further, Niles's marriage to the actress Helene Niles, his second wife, was up in the air. Certainly a summer break from his concerns about his marriage and career would be good for him. Of additional benefit was the fact that Ulmann had agreed to compensate him well for his assistance and to provide him with the material items and contacts he needed in order to continue his own work and develop his career. Surely in 1932, the midst of the Depression, Niles understood that a person of Ulmann's wealth and connections could provide him with the very means he needed to further his musical career. So, unsettled as he was, Niles was undoubtedly delighted to have the opportunity to assist Ulmann for the summer. She in turn was certainly happy to have the company of an energetic and handsome young man.[31]

It was predictable, of course, that Ulmann's German chauffeur, George Uebler, would have difficulty with Niles. It was inevitable that he would look upon Niles as a usurper—not only because he and Niles had been on opposite sides in World War I, but particularly because Uebler had been with Ulmann for many years and had always fulfilled his responsibilities in a dutiful and respectful manner. Within the confines of his role, he had done many things for her that a husband would have done and had done these things out of consideration for her position as a single woman—as "my Miss," as Uebler identified her. In the time he had served her, he had come to take pride in the things he had done to assist the photographer in her photographic journeys as well as in his regular responsibilites. He had enjoyed these different roles. The fact that Ulmann was willing to permit Niles to take responsibility for matters that had long been under Uebler's charge troubled her employee greatly.

But Uebler had never evoked Ulmann's passion. Niles did, however, kindle deep affection and intensity in the lonely fifty-one-year-old photographer and fostered and encouraged Ulmann's love with his own passion for a brief period of time. And this is candidly exhibited in Ulmann's photographs of the musician. In her numerous photographs of John Jacob Niles, Ulmann unveils her feelings and reveals herself to be a woman in love. The photographs—substantially documented in scores of images of Niles in albums in the Special Collections Department of the University of Oregon—leave no question that she loved and admired Niles and sought to construct a large body of pictures of the musician. Her feelings are evident in both the impassioned compositions of the properly dressed and groomed Niles, photographed in her apartment (fig. 35), and in the tableau of the music collector Niles (still properly dressed and groomed), photographed in the field, standing or sitting next to an elderly Appalachian man or woman (fig. 36). Ulmann's affection and esteem are also found in her portrayals of Niles's hands, her photographs of Niles playing the piano, and in her curiously playful compositions of a hatted and cloaked Niles peeking beyond the lines of his cloak. Ulmann's feelings for the musician are also demonstrated by the fact that she bequeathed all of her "pictures, photographs, plates, negatives, developed and undeveloped, and prints" to him. Her photographs of the musician leave little question that Niles, likewise, valued the admiration and affection of the photographer and was a very cooperative subject.[32]

In the spring of 1932, Ulmann was contacted by Dr. Orie Latham Hatcher, president of the Southern Woman's Educational Alliance, and asked to accept a commission to do a photographic study of mountain people in the Appalachians. While Hatcher knew that the photographer would want to photograph mountain people of all ages, she asked Ulmann to do several studies of mountain youth that the Alliance might use in their literature and fundraising efforts. In

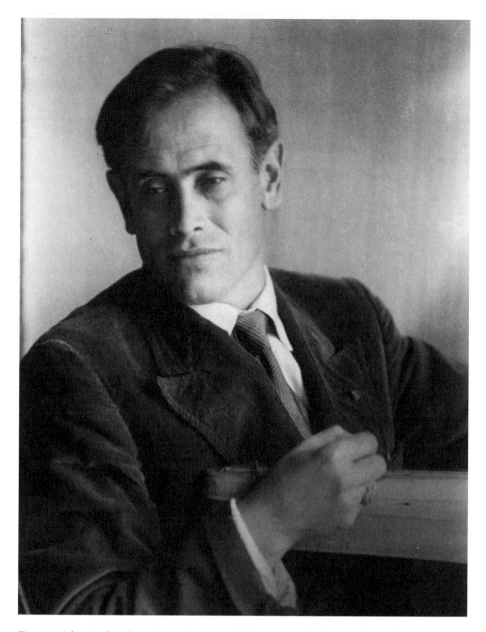

Fig. 35. *John Jacob Niles with Dulcimer*, ca. 1932–1934. Platinum print. Collection of the University of Kentucky Art Museum, No. 87.39.47.

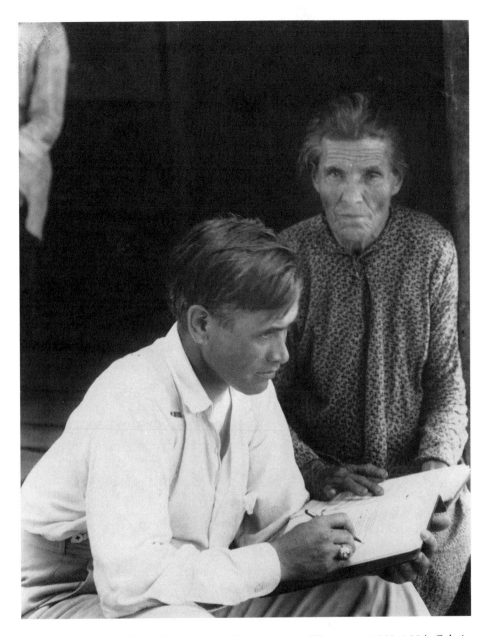

Fig. 36. *John Jacob Niles Collecting Music from Mountain Woman*, ca. 1932–1934. Gelatin silver print. Collection of the University of Kentucky Art Museum, No. 87.39.43.

her striking study, *Group of Four Kentucky Musicians* (fig. 37), Ulmann documented an anomaly and rarity in early 1930s Appalachia and America, a racially mixed musical group. Though she had often been surprised by the character and personality of individuals and groups she photographed, the photographer must have been astonished to find this integrated quartet in the hills of eastern Kentucky and made every effort to adequately record their existence.[33] A former professor of English literature, Hatcher had grown up in Petersburg, Virginia, and had been educated at Vassar and the University of Chicago. Always a champion for southern women, Hatcher had become president of the Virginia Bureau of Vocations for Women in 1915, which became known as the Southern Woman's Educational Alliance in 1921.[34] A persuasive advocate for her organization, Hatcher induced Ulmann to accept the commission. Hatcher had initially suggested Ulmann photograph the mountain people around Alpine and Baxter, Tennessee. But, by the middle of June, Dr. Arthur Estabrook, a retired eugenist with the Carnegie Institution in Washington, with experience in eastern Kentucky, and a position on the Alliance's national board, had persuaded the photographer to concentrate on the highland people in eastern Kentucky. Ulmann spoke of this in a letter to Dr. Hatcher, dated June 12, 1932. The letter provides significant insight into both the extent and intensity of her schedule on this photographic expedition into Appalachia. It also offers further information about the photographer's strong desire to please others, her affection for older women, and the role that Niles played on this trip. Writing to Hatcher from her Manhattan home, Ulmann wrote:

> My plans have been changed as Dr. Estabrook asked me to see him and he has been urging me to go to Kentucky, as he thinks the material there would be more interesting and more valuable than in Alpine, Tenn. He suggested my attempting to work at Line Fork Settlement as he believes that I can reach it with a Ford car. This would mean that I make Whitesburg, Kentucky, my headquarters. Then he suggests my going to Hazard where I will find a hotel,—and from Hazard also go to Hyden to work. Then he also mentioned the Experiment Station at Quicksand,—and after I have covered this ground he planned for me to go to Alpine and Baxter. Of course, if this were really possible, I should like to try for the work in this way. My plan is now to leave New York on July first,—to motor to Ashland by way of West Virginia. At Ashland I want to do some work with the Old Kentucky Singers and musical people. Mr. Niles wants to meet me at Ashland because he wants to work with these same people. I would go from Ashland to Whitesburg and try to do the work which Dr. Estabrook has suggested. Then end my work at Alpine and Baxter. Will you be good enough to send me a few notes about the pictures which you want me to do? . . .

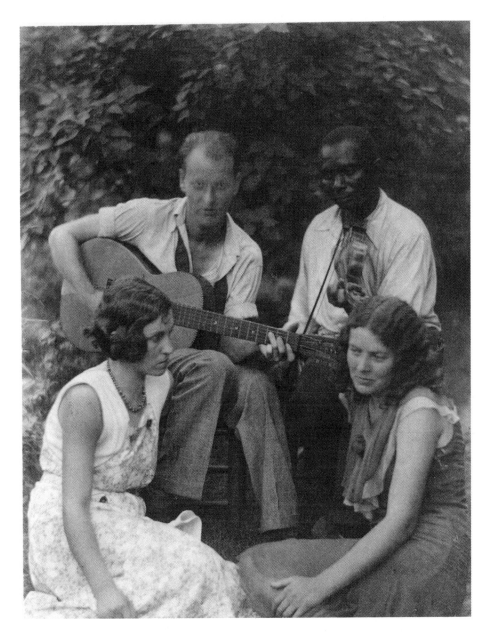

Fig. 37. *Group of Four Kentucky Mountain Musicians, Including African American Fiddler,* 1932. Platinum print. Alliance for the Guidance of Youth Collection, Special Collections, Duke University.

Do tell me what you think of Dr. Estabrook's suggestions,—whether you think it is wise for me to travel according to his plan. As things look now, I probably should be passing through Richmond around the fifteenth of July. Knowing you has meant a great deal to me and I look forward with real pleasure to seeing you again.[35]

On July 1, Ulmann left New York City and headed south for Kentucky. She reached the river town of Ashland the next day, catching up with Niles at the Henry Clay Hotel. From there, the photographer and the musician spent the next few days exploring and taking photographs in the Ashland area.[36] On the second day of their stay, Ulmann penned another letter to Hatcher. "Thank you for your letter giving me suggestions for my work,—they certainly are helpful and I hope that I may be able to make the pictures which you wish to have. Dr. Estabrook said that he would write to Whitesburg, Hazard and Alpine and Baxter so that the people will be good enough to assist me in getting the material for me."[37]

Confident she would receive the assistance she needed, Ulmann headed south on July 5 for the town of Whitesburg, in Letcher County. In Whitesburg, she and Niles met with one of Dr. Estabrook's contacts and established headquarters at the Daniel Boone Hotel. Ulmann quickly surmised that she had come to the right place. In a letter to Hatcher, written the night of their arrival, Ulmann expressed her excitement about the opportunities that lay before her: "I find that there is so much valuable material in this part of the country, that it would be foolish to travel to Cookeville. I am quite sure that the types in Tennessee cannot be more interesting if as interesting."[38]

From Whitesburg, she and Niles traveled into the countryside and photographed scores of individuals and families. John Jacob Niles kept a record of some of the people Ulmann photographed. On July 6, he wrote:

> Whitesburg Ky July the 6th 1932 . . . rain . . . Took about 15 shots of Adams family . . . Mrs. Ben Adams work[s] in the local jail . . . that is she cleans the jail. Her house burned down about 6 months ago and she lost everything . . . Her man Ben Adams has not worked a lick in 18 months . . . He was a fairly nice looking fellow who seemed to be younger than Mrs Adams . . . The oldest daughter "bertha" was a very sad example of mountain girl . . . she has no friends . . . the only form of fun she has is going to church, which she does nearly every night . . . She has managed the household for her mother now for a long while . . . She is now 20. Miss Ulmann bought her several pairs of very nice silk stocking[s].[39]

On the same day, Niles also wrote about a second family that Ulmann photographed—the family of "Postman William Williams," whom Niles identi-

fied as "lyin' Bill." According to Niles, William Williams was a thirty-eight-year-old Republican, who believed Hoover was going to win the presidential election. The musician also mentioned that Ulmann photographed Williams's son Claud, who "was photographed looking out the window," and Williams's wife, who had a "goitre." Following her work with the Williams family, Ulmann photographed two other families—the Hughes family and the Holcomb family. Niles found Mrs. Holcomb a particularly compelling character. In writing about meeting her, Niles revealed how he and Ulmann could work together with various members of a family to achieve their different artistic goals. Recounting his encounter with Aunt Beth Holcomb, Niles wrote:

> Aunt Beth is a famous singer of old songs and ballads . . . While Miss Ulmann was photographing Solomon (Holcomb) I wrote off the music Aunt Beth sang . . . Her memory is still quite good . . . now and then she misses a verse or two, but in all the 14 songs she sang she gave me enough of the verses to get a very clear picture of the entire ditty . . . in her youth she was known all over the country side as a singer . . . Of late she has been very ill, and . . . is unwilling to sing the dance songs and the love songs, except on rare occasions. . . . Our visit was one of the occasions (happily). A full list of her songs is recorded elsewhere. . . . She will not possibly survive the coming winter, and for that reason it was most fortunate that Miss Ulmann was able to photograph her. . . . She has lived in Letcher Co. all her life.[40]

By the middle of July, Ulmann left Kentucky and headed to Richmond. She felt she had taken enough photographs to fulfill the needs of the Southern Woman's Educational Alliance. Although Ulmann did not have children, she had a tremendous interest in children that she revealed throughout her adult life: from her early studies in kindergarten education at the Normal Department of the Ethical Culture School to her early photography of her niece, Evelyn Stiefel (see figs. 4 and 5 and plate 1) to her very last photographs of the Higgs child (see front cover) outside Asheville, North Carolina. Her affection for children and youth is evident in *Kentucky Mountain Youth* (fig. 38). It is also manifest in the hundreds of photographs of children and youth Ulmann created between 1915 and 1934 (see fig. 34 and plates 6, 8, 10, 11, 12, 33, 34, 41, 42, 54, 57, and 60). These images constitute one of the largest archives of children (particularly Appalachian and African American children) and document Ulmann's belief that portraits of children and youth (as those of adults) can tell stories about the human experience. *Kentucky Mountain Youth* was one of several of Ulmann's images Dr. Hatcher felt represented those the Southern Woman's Educational Alliance sought to serve in the 1930s. A dramatic and painterly rendering, it was used in two annual fund-raising publications of the organization.

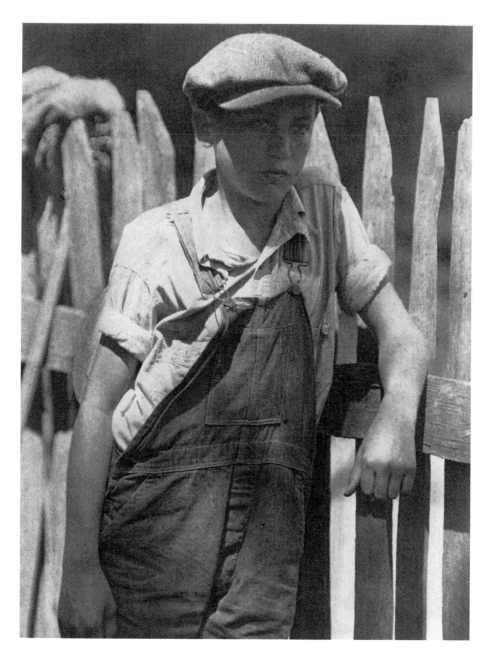

Fig. 38. *Kentucky Mountain Youth Leaning against Picket Fence*, 1932. Platinum print. Alliance for the Guidance of Youth Collection, Special Collections, Duke University.

Though she was quite fatigued from the intensity of her work in Kentucky, Ulmann wanted to keep her commitment to meet with Dr. Hatcher and discuss the work she had done for the Alliance. Exhausted as she was, Ulmann enjoyed her meeting with the indomitable and enthusiastic Hatcher, who had deep respect for the photographer. Following her brief stay in Richmond, Ulmann headed back to New York.[41] Here, she settled down to the business of developing and printing the Kentucky plates she had just made. Two weeks after her return, she wrote Hatcher:

> I appreciate so much that you have a warm feeling for me. After all, this is the thing that events for most in life. It was a pleasure to see you in Richmond and I enjoyed so much being with you. I hope that I was not too fatigued to be myself,—forgive me if I seemed a bit queer. . . . I have been developing my Kentucky plates and still have a great many to develop,—and I think that I have some interesting things. Of course it will take some time for me to get them printed. Any way, when I see you again I hope that I will have something to show you. I am sending you Mr. Niles' address and I have asked him to send you some of his publicity material.[42]

A few days later, a member of the national board of the Southern Woman's Educational Alliance thanked Ulmann for the effort she had made in Kentucky to document mountain youth and adults on behalf of the Alliance. The writer also discussed the significance of the photographer's work:

> May I . . . express our deep appreciation of the service which you are rendering the Alliance in providing us with illustrative material of the sort, which I know from others, to be invaluable. Our president has doubtless told you that the difficulties attendant upon securing such material from rural areas, and in having the artist eye and hand at work in the effort have, for one reason or another, thus far seemed insuperable. What you are so graciously doing for us now is therefore peculiarly gratifying to us, both from the aesthetic standpoint and from the financial. . . . We are much gratified too, to learn that, at the board meeting in New York this fall, we are to have the pleasure of meeting you, and also of seeing such of the pictures as are ready then, and of hearing directly from you something about the human and other environments in which the pictures were taken.[43]

As reticent as the shy photographer must have felt about her upcoming appearance before the board of the Alliance, this letter encouraged Ulmann to continue to portray and document many of the different types of Americans in the

southeast region of the nation. The words of this writer must have also reminded the photographer that she was doing something special, something that so few of her colleagues would ever do. Like Laura Gilpin and Clara Sipprell, Ulmann was giving an often ridiculed and caricatured people a voice. Perhaps she thought her finished images—the portraits of her mind and hand, portraits which revealed the dignity and character of the people of the mountains—would finally permit these people to be heard.

<div align="center">———</div>

In September, Niles rejoined Marion Kerby for their fall concert tour across the country. Between September and December, the two musicians performed fifteen concerts together.[44]

Shortly after Niles went on tour, Ulmann again became ill. Even though she did not feel as well as she would like, she did join Niles, some weeks later, for their presentations at the annual meeting of the board of the Southern Woman's Educational Alliance at the St. Regis Hotel in Manhattan on October 31. The clerk of the Alliance recorded the details of their presentations:

> Following the morning session, there was an informal reception and a showing of the large and very beautiful collection of photographic studies of mountain people which Doris Ulmann, well known artist photographer, had made last summer in the Kentucky mountains, as a gift to the Alliance for interpretative purposes. The collection has much value both sociologically and artistically. Mrs. Ulmann was the special guest of honor at the luncheon and her companion on the mountain journey, Mr. John Jacob Niles, told entertainly there of the young people and others pictured in the exhibit.[45]

In correspondence with Cammie Henry on the same day, an exhausted Ulmann reflected on the year and the state of the country:

> I have been quite ill. I was obliged to be in bed about four weeks,—and I have not been completely well since, although I am much better now. Fortunately, I have been able to do some work. . . . I have been obliged to work at the pictures which I made in Kentucky in July because I promised to have them finished for the Woman's Southern Educational Alliance. . . . There is so much that I would like to do and I have had such a bad year for my work. . . . the whole country is so sad and troubled! I hope that you are not having more than you can carry.[46]

Nineteen-thirty-two had been a difficult but rewarding year for Ulmann. She had been unable to do many of the things she had wished. And yet at the

same time she had made new strides in her work, furthered her association with Niles, and received more recognition for her professional achievements. Additional acknowledgment of her artistry came in December. The publication of a reproduction of her photograph of Nobel Prizewinner John Galsworthy in *The Bookman's* "Christmas Portfolio of Literary Portraits" reminded her of the respect others had for her.[47] The year had been quite challenging, but it had also brought Ulmann a sense of accomplishment and a sense of hope about her future. This seems to be reflected in the greeting card she prepared for the season. It was an unusual card for a person who had stated that she did not like the holidays, who found the holidays a difficult and sad time to endure. The card features a hand-carved and hand-colored woodblock print of the three wise men mentioned in the Matthean narrative of the birth of the Christ child. The typed inscription inside the card reads: "Christmas greetings and best wishes for the New Year from Doris Ulmann."[48]

But the New Year started rather unpleasantly for Ulmann. Signs of the photographer's deteriorating health became more evident as, nearing the age of fifty-one, she contracted one illness after another. In correspondence with Saxon and with Henry (during the winter of 1932 and spring months of 1933), Ulmann reported having "the grippe" and "bronchitis," and being "quite ill" and often "fatigued."[49] Julia Peterkin did visit Ulmann in the winter and stayed with Ulmann in her apartment, but not even Peterkin's "delightful self" could lessen Ulmann's steady decline. Comparing Carl Van Vechten's portrait of the photographer (fig. 39), shot in 1933, with her 1929 self-portrait, taken with novelist Julia Peterkin (see fig. 23), it is hard to believe that this gaunt, aged woman is the same person. The time between 1929 and 1933 had been very difficult for the artist, and not even her letters divulged the full extent of the struggles she had faced.

These illnesses and Ulmann's constant sense of being "fatigued" substantially affected her ability to work in the first part of 1933. Her poor health kept her in New York and deterred her from completing the printing of her Louisiana photography for Henry and Saxon as well as other photography she needed to print. These ongoing health problems further prevented her from continuing her search for "various American types."[50]

Meanwhile, John Jacob Niles was preoccupied with his own work and career. In January, he rejoined his musical partner, Kerby, for another tour. They performed several concerts in different American cities in January and February.[51] Nonetheless, Niles continued to associate with Ulmann when he was able to do so. As the months passed, their relationship deepened. When they met Julia Peterkin in late February, Peterkin acknowledged her awareness of Ulmann and Niles's relationship and spoke of them as a couple. She also admitted she disliked Niles, who went by the familiar nickname "Jack." Peterkin wrote to Fineman: "Doris and Jack met me. Jack's small upturned nose gives the lie to his paternal manner with me. His good-bye invariably ends with 'Julia, never forget

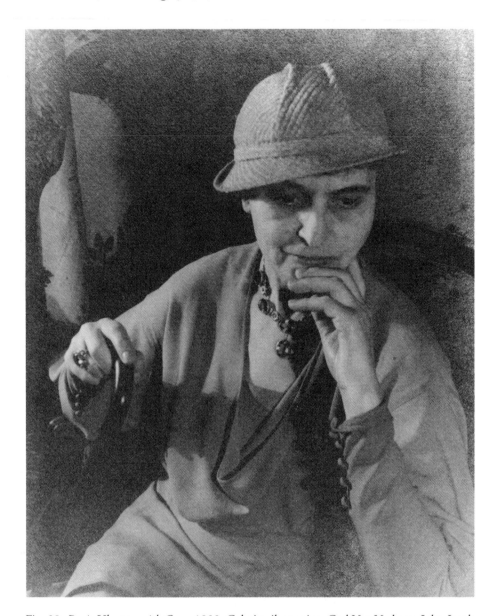

Fig. 39. *Doris Ulmann with Cane*, 1933. Gelatin silver print. Carl Van Vechten. John Jacob Niles Collection, Special Collections and Archives, University of Kentucky Libraries.

you are a great lady,' and his unctuous tones sound like a Bishop administering the body and blood of Christ to newly confirmed communicants. I always want to respond, 'Lord have mercy upon us and write all these thy laws in our hearts we beseech thee.'"[52]

While it is clear that Ulmann felt quite close to Peterkin in the first few years of their relationship, this feeling seems to have diminished once she became involved with Niles in the late spring of 1932. Ulmann and Peterkin had enjoyed the time they spent in the early spring of 1932 preparing for the performance of the play *Hedda Gabler* in Columbia and Charleston, South Carolina, and wandering about the countryside, but it was to be the last time they spent an extensive period of time with each other.[53]

Unfortunately, it appears Peterkin felt abandoned by her friend once Ulmann's relationship with Niles got underway. She also felt jealous about Ulmann's new relationship. By this time, Peterkin's relationship with Fineman had virtually evaporated, as Ulmann's relationship with another young man was coming to bloom. Peterkin was not only jealous of Ulmann's new companion, but she was also hurt by the fact that this new relationship substantially changed her own relationship with the photographer. Though this disappointment was often expressed by Peterkin in very sarcastic ways, which must have upset Ulmann, Peterkin's sense of loss over this significant alteration in their relationship and then the eventual death of her friend is particularly evident in letters composed after Ulmann's death, in which Peterkin attempted to establish herself as Ulmann's most sympathetic friend.[54]

Shortly after meeting Peterkin with Ulmann, Niles sailed for Antwerp, Belgium. Here, he played the harpsichord for Frederick's Circus and Wild Animal Show from March 3 through April 9. On April 13, Niles joined Kerby at the Delegencia in Den Haag, Holland, for their first concert on their European tour.[55]

Meanwhile, in New York Ulmann continued to fight illness. In correspondence with Saxon on March 26 she wrote: "Since Thursday I have been in bed (for a change!)—enjoying an attack of bronchitis. However, I am better today and hope that the doctor will allow me to be up in a few days. How I hate wasting my time with illness!"[56]

A few weeks later she wrote Saxon again. This time she admitted more about the toll her repeated illnesses were taking on her. "I felt so worn, fatigued, and down that I did not want to talk and make you think that I am queer or something,—I am much better again—but really have been quite ill and it is taking me a little while to recuperate."[57] Sick as she had been, Ulmann was beginning to recuperate.

Around the same time, Ulmann also received a very encouraging letter from Dr. William J. Hutchins, president of Berea College, in which he spoke of the meaning and significance of her portrayals of the Appalachian peoples. His

words touched her deeply, and in her response she revealed both her humility and her uncertainty about the value of her work. She wrote: "I am very grateful to you for your letter because your words have made me feel that I have perhaps succeeded in expressing a little of the great and deep humanity of these fine and sturdy mountain people. It helps to know that one's work has been of some value."[58]

In the early part of June Ulmann took on another project—photographing New York City dancers and actors (fig. 40). In correspondence with Lyle Saxon on June 5, Ulmann wrote about her work with these dancers and actors:

> Recently I have been working with a number of dancers—this is interesting and particularly so because it is difficult. I have worked with Martha Graham—Doris Humphrey and her group of dancers. I did some work at the Neighborhood Playhouse, which is now on Madison Avenue—and of course my work with Angna Enters goes on all the time because we want to do all her dance compositions. Martha Graham is a charming person—but of all these people Angna Enters seems to me to be the most interesting, the most original, and the most gifted. Then I have been doing some portraits,—did picture of "Run Little Chillun"—which is bad as a play but has some interesting parts. It is an entire negro cast.[59]

In the same letter, Ulmann spoke of her plans to return to the southern mountain region and continue her search for "American types." "I am planning to go to North Carolina and Kentucky in July because there [is] work that I must do. Allen Eaton of the Russell Sage Foundation is making connections for me so that my trip will be as easy as possible in this respect—probably he will use some of my pictures for a book which he is planning."[60] Ulmann's reflection was correct. Allen Eaton had long recognized the significance of Ulmann's work and been moved by her portrayal of Appalachian peoples. The cooperative relationship between Ulmann and Allen Eaton on Eaton's book would prove to be one of Ulmann's most important collaborations.

As Ulmann was beginning her formal collaboration with Allen Eaton, John Jacob Niles was contemplating the end of his musical partnership with contralto Marion Kerby. The five-year professional relationship between Niles and Kerby had never been completely satisfactory to Niles. For him the relationship had always been a professional "marriage of convenience." Pressed to keep his musical career alive and food on the table and a roof over his head, he had tolerated Kerby, but his ability to put up with her had dissipated over the last year.

Ulmann had initially encouraged Niles to stay in the relationship with

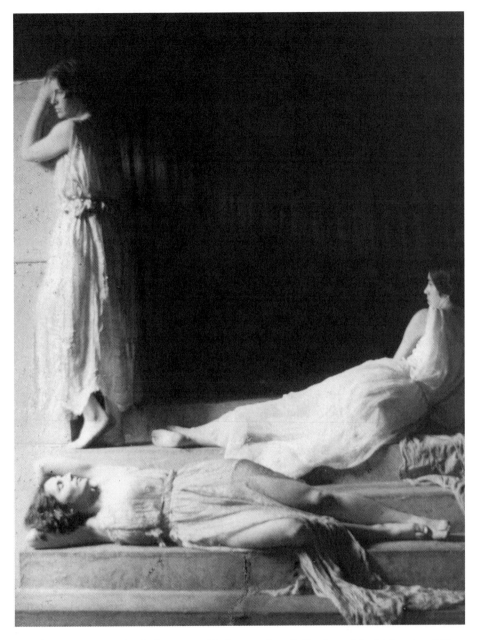

Fig. 40. *Dancers, New York City*, 1933. Platinum print. Collection of the University of Kentucky Art Museum, No. 88.10.15.

Kerby. But the photographer's financial generosity and social connections had diminished the value of his professional relationship with the contralto, permitting him to contemplate its dissolution. Following the final concert of their second European tour, on June 29 at Montrose House in London, Niles resolved to end his partnership with Kerby and focus his attention on developing his personal musical career, collecting American folk songs, and assisting Ulmann.[61]

Shortly after Niles returned from Europe, Ulmann began preparations for a new photographic tour of the South. This time she would concentrate her attention on southwestern North Carolina, particularly on the area around the town of Murphy. Allen Eaton had previously spoken with her about the Campbell Folk School outside Murphy in Brasstown, North Carolina, and the work Olive Campbell and Marguerite Butler were doing among the mountain people there. An associate and supporter of Olive Campbell and the Folk School, Eaton had planned to provide information and photographs about the school in his forthcoming book on the handicrafts of the southern highlands. Eaton believed Ulmann could bring Mrs. Campbell and the school the recognition they deserved. He had also told the artist that her visit and photography of the people and handicrafts at and around the school would provide her with more opportunities to photograph vanishing American types.

Ulmann needed little prodding. She had long hoped to visit Brasstown and the Campbell School. Having been in the area before, when she photographed Cherokee Indians in the summer of 1929, she had heard of the John C. Campbell Folk School and was familiar with Olive Dame Campbell from her previous contact with Campbell and Allen Eaton in the spring 1930 Highland Handicraft Guild exhibition.

The product of a wealthy New England home, Campbell had first come to Appalachia with her husband, who had served as Secretary of the Southern Highland Division of the Russell Sage Foundation. Following her husband's death in 1919, she made a commitment to continue the work he had begun. She resolved, among other things, to finish his book on the southern highlands and to work for the establishment of "Folkehoiskoler," or folk schools in Appalachia, "based upon the experiences of Grundtvig and Kild in Denmark and Sir Horace Plunkett in Ireland."[62]

Within two years, Campbell completed her husband's book. Pleased with the result of her efforts, the Russell Sage Foundation published *The Southern Highlander and His Homeland* in 1921.[63] Once she had finished this work, she turned her attention to the study of Scandinavian Folk Schools. Supported by a fellowship from the American Scandinavian Foundation and accompanied by Marguerite Butler, a mountain worker from the Pine Mountain Settlement School in Kentucky, Campbell set sail for Scandinavia in 1922. During their time in Scandinavia, Campbell and Butler "visited seventeen folk schools in Denmark,

three in Norway, seven in Sweden, and eight in Finland" and became convinced that the "folk school" concept was, as John Campbell had thought, ideally suited to the southern highlands.[64]

Following their return to America, Campbell and Butler shared their experience and their enthusiasm with others at the April 1924 meeting of the Conference of Southern Mountain Workers and resolved to see the development of a community and site for such a folk school.[65] Subsequently, with the assistance of a grant from the Russell Sage Foundation, they spent several months traveling in Appalachia looking for a suitable site.[66] Finally, according to Robert Stanley Russell, author of "The Southern Highland Handicraft Guild":

> When Marguerite Butler was staying in Murphy, North Carolina, Fred O. Scroggs and his father came over from Brasstown to invite her to visit their community and tell the mountain folk of that community about the school that she and Mrs. Campbell were going to start. All the people of the area turned out for that Sunday morning meeting. They did not go home until it was time to feed the chickens and milk the cows and before they left they planned a second meeting for the following Wednesday.
>
> Mrs. Campbell and Marguerite Butler continued to look at sites in West Virginia; at the end of two months the women returned to North Carolina. During this time a committee had been appointed, a pledge card had been distributed, and 116 people in the Brasstown area had made pledges of land, labor, logs, stone, firewood, and cash. The largest single pledge of land—thirty acres—was made by the Scroggs family [fig. 41]. An additional sixty acres of abutting farmland was purchased, and in December 1925, the Folk School (named the John C. Campbell Folk School) was incorporated under the laws of North Carolina.[67]

Campbell and Butler immediately moved into an old farmhouse located on the Folk School's property and set to work to establish the kind of school John C. Campbell had always hoped to build.

In the ensuing years between the Folk School's beginnings and Ulmann's arrival in July of 1933, Campbell and Butler's dream of a mountain folk school came to fruition. By the time Ulmann contemplated a visit to the Folk School, it provided an extensive program of adult education for mountain peoples in the area around Brasstown and Murphy, North Carolina, and was a center for handicraft production in the Appalachian region.[68]

In correspondence with Lyle Saxon on July 9, Ulmann mentioned her preparation for her upcoming visit to the Campbell Folk School. "I must now prepare for my trip to North Carolina. . . . Probably I shall go to Brasstown, N.C. first

Fig. 41. *Mrs. Lucius Scroggs, Brasstown, North Carolina,* ca. 1933–1934. Posthumous gelatin silver print. Printed by Samuel Lifshey, ca. 1934–1937. John C. Campbell Folk School.

because there is quite a lot of work for me at the Campbell Folk School. I stay at Murphy, N.C. which is the nearest place where one can live in a civilized way."[69]

Ulmann and Niles left for North Carolina in the very early morning hours of July 13. In a letter written the same day, Allen Eaton notified Olive Campbell of Ulmann and Niles's forthcoming arrival. Among other things, Eaton provided information about the photographer and her assistant and discussed the people and subjects he hoped Ulmann would photograph. He also revealed his own objectives:

> John Jacob Niles is a nice fellow at times, is particularly interested in mountain music, and is a little more aggressive on some matters than I am—all this you will find out. He is a professional musician, has just been in Holland, I think specializes in mountain music, and is interested in mountain folks generally . . . Mrs. Ulmann does not seem to me any too strong and I am glad she has such a husky young man to help her in the work. You can help a lot by suggesting the way to approach a few of the folks . . . I have told Mrs. Ulmann to feel free to include or exclude any of the subjects which either I or you folks suggest. I know, however, that she will want to include all of the subjects which you think worth while and please add to her list as they come to you . . . I am asking others besides you folks to do this. . . . Finally, I will check the lists over against each other and will undoubtedly have some good subjects for Mrs. Ulmann to take which otherwise would be missed. I enclose herewith a list of the subjects which Louise sent me, plus a few of my own suggestions as a basis for Mrs. Ulmann's work in your section. You will all be adding to this I know and I have also given Mrs. Ulmann a part of this list, so when you get together you might check it over with her. As I have told you, I want her to get this time subjects which not only interest her and me, but those in which you are especially interested. So please feel free to make any suggestions.[70]

A couple of days later, Ulmann and Niles checked into the Hotel Regal in Murphy. The following day she began her work. In a letter to Eaton dated July 16, Ulmann informed him of her first subjects. She also assured him of her desire to focus her attention on the Folk School and the nearby area. "Today was our first day at Mrs. Campbell's school. . . . I made a portrait of Mrs. Campbell and Miss Butler—and I also worked with Mrs. Donaldson [Granny Donaldson, a local blanket maker] and her husband. I am sure that we will be busy here for at least two weeks and we have not made any plans for working elsewhere. I think it is best to do all that is possible here."[71]

The Folk School proved a balm for the exhausted photographer. In corre-

spondence with Lyle Saxon dated July 20, she described the peace and joy she had found in her work at the school:

> It is a blessing to be away from the noise of New York and to breathe pure air. I have been working ever since I have arrived and the work is most interesting. Allen Eaton of the Russell Sage Foundation had paved the way for me at the Campbell Folk School, so I could begin work immediately. The Campbell Folk School is a remarkable place and the group of people guiding this venture is a delightful group of real individuals. It is impossible to write all there is to tell about this place because this letter would not ever finish. Mrs. Campbell is bringing something of true value to the people of the community—and she is planting the seed in fine young people who will go out and carry on. There is so much work for me here.[72]

Ulmann reiterated her enthusiasm for the Folk School and for her work with them in a letter to Allen Eaton a few days later. She also spoke of her admiration and respect for Mrs. Campbell. Writing from the Hotel Regal in Murphy on July 24, Ulmann noted: "The work at Brasstown has progressed well, and the more I see of Mrs. Campbell and her work, the more interested I become, and I admire her and her achievements tremendously. They have all been wonderfully thoughtful and helpful and, of course, understand exactly what I want. What an interesting country it is, there is so much fine material that it seems quite impossible to do all that I think and plan."[73]

Mrs. Campbell also admired Ulmann and her work. In correspondence with a member of the faculty at Berea College, Campbell voiced her respect for Ulmann and Niles and the work they were attempting to do. On July 25, she wrote:

> We are having a very interesting visit from Mrs. Doris Ulmann who takes the marvelous mountain pictures of which you have doubtless heard. We had an exhibit of some of them at Knoxville two or three years ago. With her is a professional musician by the name of John Jacob Niles. He is from Kentucky originally, brought up on the edge of the mountains, or at all events in close touch with mountain people. He learned folk songs from his own father and mother. During the years he has gone on collecting and harmonizing not only mountain songs but Negro and others wherever he comes upon them. He sings abroad every year. We have been enchanted with his singing and playing, with which he is most generous.[74]

Several days later, Campbell reiterated her enthusiasm for Ulmann and Niles to a friend: "We have had a beautiful time with them. . . . I have also had

to explain a good many times that she [Ulmann] wants people as they live and work, not dressed up for the photographer's studio. That is sometimes hard for people to understand. They are always crazy about Mr. Niles and his singing of old songs. Get him to the piano and you will have a good time too."[75]

In their time together, Ulmann and Campbell forged a friendship not unlike the friendship Ulmann had established with Cammie Henry of Louisiana. Always in search of affection and guidance, Ulmann had found Campbell to be a person of kindness and wisdom and quickly came to depend on her.

When it came time for Ulmann to leave several days later, she revealed the depth of her attachment to Campbell. Writing the evening of her departure, August 7, Ulmann told Campbell:

> You cannot know how strange it seemed, not to see you today and not to be able to have some of the lovely talks with you—not to mention the fact of missing your guidance and your advice . . . These interesting busy weeks will always remain a landmark in my life and it is such a precious possession to know you. We spoke of you and all the dear people at the school constantly, because you have become part of our lives. Jack has been upset as I have been. We left Murphy at seven this morning . . . Please give my fondest greetings to everybody,—and tell them that my thoughts are still with you at Brasstown. My love to you, my dear Mrs. Campbell, and my genuine appreciation of all your loving kindness and attention.[76]

The day of their departure, Ulmann and Niles stopped at the home of Zilla Wilson and her family and spent the afternoon with them. Ulmann photographed Mrs. Wilson and her family for two hours. Afterward, they traveled to the town of Highlands, and stayed at the Highlands Country Club. The next day was spent in Asheville at The Spinning Wheel, a handicraft center where Ulmann tried her hand at carding and spinning, and they talked at length with the director, Miss Clementine Douglas, who would later guide and assist Ulmann in the area. The following day, August 9, they traveled to Hickory, North Carolina, where Ulmann photographed the potter Mr. Hilton and his family and some pieces of his pottery.[77]

Marion, Virginia, was the next day's destination. Miss Douglas had told the couple that musician John Powell was scheduled to give a concert that evening at the Third Interstate Music Festival. Interested in seeing Powell and the many folk musicians they knew would be present, Ulmann and Niles traveled to Marion and spent a few days in the area. Ulmann found the Festival at White Top Mountain to be "a mess." Complaining to Olive Campbell in correspondence on August 19, she wrote: "Those mountain people are at their best when you find them in their homes, speak to them quietly, and give them the opportunity to be

themselves with you."[78] Ulmann was also annoyed by the arrival of an army of newspaper reporters who showed up to cover the arrival of Eleanor Roosevelt at the Festival. "It was crowded particularly on Saturday on account of the presence of Mrs. Roosevelt. While the simple mountain singing and playing was going on—the buzz of the reporters' typewriters was heard. And what a dissonance! I wished I were at Brasstown with you and your people—you have the reality and you do not even disturb it with anything that you do."[79] While at the festival, Ulmann and Niles also saw the famous Charleston writer Dubose Heyward, whom Ulmann had photographed in an earlier visit to Charleston, as well as Heyward's wife and Clementine Douglas.

After the Interstate Music Festival, Ulmann and Niles headed back to New York to regroup and order new supplies. The photographer also worked to develop some plates she had exposed so that Allen Eaton might examine some proofs of her work in North Carolina.[80]

At her apartment, she found a letter from Dr. William J. Hutchins of Berea College inviting her and Niles to visit the college. Hutchins had addressed the letter to Niles. In it he wrote: "Several years ago I had the privilege of seeing the beautiful and significant photographs of Mrs. Ulmann. Our mutual friend, Mrs. J. C. Campbell, tells me that you and Mrs. Ulmann have been 'talking about going to Berea in the fall.' It would be a happiness to us in Berea if you might visit us. You would be our guests at our excellent hotel, Boone Tavern. . . . My thought would be that you might address all our student body at eleven o'clock on any one of these dates. My hope would be that Mrs. Ulmann would be glad to exhibit her photographs."[81]

Niles responded by letter the next day, penning the kind of dramatic and presumptuous epistle that was sometimes characteristic of the flamboyant musician. The tone, style, vocabulary, and content of this letter reveal much about his personality:

> Miss Ulmann is all for this thing of visiting you and so am I. We have talked it over many times . . . in fact we went into what we call a "calm studyment" about it. The Southern Womens' Ed Alliance, for whom Miss Ulmann did a lot of pictures last summer want us to come to Richmond, Virginia on October the 24th. . . . They will hang a show of pictures and I will explain them and do music. . . . Miss Ulmann will send you enough pictures to cover the Mountain subject, say a week before our arrival and then you can hang them at your convenience . . . I believe you will want us to make an effort in the direction of the Youth . . . that is rather than the old folk of the hills . . . we will send weavers, spinners, chair makers, workmen, children, etc. . . . It's too bad you can't sell this show out and make yourself some money, because I hear tell that all schools do need money. . . .

Perhaps you can do this later at some other city where the rich could be caught and impressed with your needs. . . . Don't mind about paying me, or Miss Ulmann, we carry on some how. . . . My motto is "O T H E R S" . . . You see I'm a backwoods-man who seldom saw the outside world until he was 20 and then out side of the state until I went to War . . . So I have the Berea movement in my heart . . . I have all such constructive education in my heart . . . All education is not constructive however . . . Some is such hopeless La-Dee-Da. . . . If you would help me with my Dictionary of Southern Mountain English I would be ever so thankful. . . . I spent most of 3 months this spring in England, at the British Museum and at Oxford in the Bodleian, working on the Glossaries of the middle ages, to track down the origins of our strange words. It's a thrilling job, and almost as interesting as my music collection. . . Per chance I could get your English department to help me too . . . Mrs. Campbell and her staff are doing it . . . They just write down any out of the way word and ask its meaning . . . then I take it to the Glossary on the 8th, 9th, 10th, 11th, 12th, 13th, or 14th century and try to connect it with the Saxon Original . . . The work will be finished in about two or three years at the present rate. . . . However, don't let this bother you . . . Miss Ulmann and I will arrive about the 26th and we will be at your disposal.[82]

At 4 A.M. on August 21, Ulmann and Niles departed for Kentucky. She hoped to visit a number of places in several days to continue her photographic documentation of mountain people and their crafts for Allen Eaton. Writing to Olive Campbell the day before, Ulmann noted, "Mr. Eaton has been kind enough to write to people in Hazard and near Hazard, so I hope that it will be possible to find good material."[83]

Ulmann and Niles arrived in Hazard on August 22, checking into the Hotel Grand. Shortly after their arrival at the hotel, they hung a group of her photographs in the lobby. Following Allen Eaton's suggestions, Ulmann first concentrated her attention on the nearby Homeplace Craft School in Ary, Perry County, Kentucky, where she photographed its founders, Miss Lula Hale and Miss Allen and some of their students and handicrafts. After her work at the school, Miss Hale took them to the village of Quicksand. There, Ulmann met and photographed the fine chairmaker Enos Hardin and his son, who was a knifemaker. Under the direction of Miss Hale, Ulmann spent the next two days photographing people in several nearby mountain communities. After working in the area around Hazard, Ulmann and Niles made their way through the villages of Wayco, Cody, Isom, and Happy and the town of Whitesburg on their way to what is known as "Kingdom Come" country. They established their headquarters in the town of Cumberland, taking day trips from there into the sur-

rounding area, photographing residents of nearby hamlets and collecting folksong words and tunes.[84]

By the first part of September, Ulmann and Niles were back in New York City. Ulmann spent much of the fall developing and printing the plates she had exposed on her trips to North Carolina and Kentucky. Niles, in turn, spent this time preparing and practicing new material for his fall musical concerts. He also continued to nurture his and Ulmann's relationship with Dr. William J. Hutchins in preparation for their trip to Berea College in October. In late September, Niles wrote Hutchins:

> Miss Ulmann and I are home again after many months of wandering up and down creek bottoms and mountain roads. . . . She has about 1100 plates and I have three note books full of various sentimentalia. . . . I have suggested a permanent exhibition of her folk studies for your library or some other place in your college, and she seems to be favorable to the idea. . . . Have you a place where some pictures could be hung? If so, how many, and what kind exactly . . . old men, or young ones . . . children . . . ancient females . . . musicians . . . workmen . . . etc., etc., etc. . . . Mr. Allen Eaton of the Russell Sage Foundation was with us Sunday night and he said he is about to write you about our trip, as he usually plans what pictures we are to take . . . Miss Ulmann will bring her equipment with her and will plan to photograph some of you all. . . . We will no doubt arrive rather weary from the trip from Richmond, Virginia, on the night of the 26th. After the Friday morning performance Miss Ulmann and I will hang the pictures, as it is too much of a job to do the night before singing. . . . If you have any suggestions let me have them please. . . . I mean about what I am to say or sing, and act and wear, etc., etc., etc. . . . because I do not want to make a bad impression on your folk by breaking the rules. . . . I understand you folk do not smoke. . . . That will not bother me, but Miss Ulmann will have to lay off until she is alone in her hotel room. . . . However, she can do that very well. . . . She sends you her best wishes and so do I.[85]

This letter reveals some very important things: first, Niles acknowledges the significant role Allen Eaton played in selecting the subjects for Ulmann's photography during this period. He also reveals Ulmann's desire (at Niles's suggestion) to establish a "permanent exhibition of her Folk studies" at Berea College. Finally, he discloses his and Ulmann's wish to adjust their lives and behavior in order to make a good impression on the staff and students at the college.

Hutchins was delighted to hear of Ulmann's desire to establish a permanent exhibition of her folk studies and was particularly pleased that she and Niles considered Berea College a suitable site for a permanent exhibition of her

photography. Writing on September 30, Dr. Hutchins said: "In response to your recent generous letter, I would say that we have already enough money to build the first unit of an art building. . . . The only thing now lacking is plans and specifications upon which we can all agree. Just as soon as this building is complete we should almost infallibly love to have a permanent exhibition of Mrs. Ulmann's Folk Studies. I should much rather wait until your visit before saying anything more about this wonderful suggestion of yours."[86]

With these plans underway, Niles was ready to direct his efforts toward his musical career. On October 20, he performed his first solo concert in New York City at the Greenwich House Musical School. It was a turning point for Niles, an opportunity he had longed for for some time. It may also have marked the first time a young Russian Jewish woman named Rena Lipetz (who would later become Niles's third wife) heard the musician perform. Lipetz, the daughter of renowned psychiatrist Basile Lipetz, had been educated at the Sorbonne and Wellesley and was employed as a translator at *Living Age,* a journal of foreign affairs, when she and Niles began their relationship. The forty-one-year-old musician immediately recognized Lipetz, an attractive, vivacious, and refined twenty-year-old woman, as someone who could bring him a level of sophistication, much like the frail and aged Ulmann had. Over the years, both John Jacob and Rena Niles permitted, and perhaps even encouraged, the development of the idea that they met only shortly before Ulmann's death. One account stated that Rena Niles did not meet the musician until she "attempted to interview him about Ulmann shortly after the photographer's death."[87] But Rena Niles recalled that their first meeting took place on December 31, 1932, on Eleventh Street in Greenwich Village—more than a year and a half before Ulmann's death.[88] Their letters also substantiate that Niles and Lipetz formed a romantic attachment shortly after their initial meeting. It is hard to determine how deep the attachment was in the first few months of the relationship. In a letter postmarked October 23, 1933, written from the Jefferson Hotel in Richmond, Virginia, Niles addressed Lipetz as "Rena sweetest" and concluded the letter with the words: "I send you kissings, and all such strange things. . . . More later Johnnie. . . . Love. . . ."[89] In another letter, postmarked October 31, 1933, written from the Lincoln Hotel in Marion, Virginia, Niles addressed Lipetz as "Rena dearest" and wrote, among other things, "I'll see you Monday I suppose when you come back from Albany," and added, "I kiss you as you know I can."[90] The other extant letters from Niles to Lipetz in 1933 are of a similar nature.

By the spring of 1934, Niles and Lipetz's relationship had become very intimate. Writing to Lipetz from the Raleigh Hotel in Washington on the evening of April 16, the musician wrote: "Sweet blue-eyes[?]: Never again will I go into fiddle de dee before departure . . . not that I love you and fiddle de dee less but that I love efficiency more. . . . Never was I so dog weary as that morning."[91] A week later, in a letter postmarked from Murphy, North Carolina, on April 23, 1934, Niles wrote

Lipetz: "I'll bet you were 'weary' all day Friday . . . as I was slightly 'weary' but what the hell . . . its worth something to be properly 'bestial' . . . that's what they call it in books about what every young woman should know . . . I kiss you my sweet little thing and leave my best wishes with you and fold you up in my arms and hold you tight."[92] Further evidence of the depth of Niles and Lipetz's attachment can be found in several other letters dated in the spring and summer of 1934.[93]

Letters written by Niles to Lipetz in 1933 and 1934 also reveal Niles's duplicity with Lipetz about his relationship with Ulmann. At no point in his correspondence does Niles reveal he has had and continues to have an intimate romantic relationship with Ulmann. In fact, Niles only refers to Ulmann on seven occasions, and on these occasions he portrays her in a very objective fashion, as an employer, and refers to her as "Frau Ulmann," and "Ulmann," "Miss Ulmann," "Doris Ulmann" or "she."[94]

~~~

Shortly after his first solo concert at the Greenwich House Musical School, Ulmann and Niles departed New York for Richmond, Virginia, in order to attend and address a forum of the Southern Woman's Education Alliance at the A.A. Anderson Art Gallery, where several of Ulmann's Appalachian photographs were on exhibition. Ulmann and Niles spoke about the individuals she photographed. Niles complemented the exhibit by performing several pieces of folk music on the dulcimer for members of the Alliance. While in Richmond, they were also entertained by the Richmond Academy of the Arts.[95] On October 24, 1933, the photographer and the musician left Richmond for a brief return visit to Hazard, Kentucky. Two days later they arrived in Berea for their first visit to the college.[96]

The October trip to Berea provided Ulmann with the opportunity to closely examine the culture of the mountain community and its historic college. In the several days she was there, Ulmann photographed Dr. Hutchins and several other faculty and staff members. The visit also gave John Jacob Niles an opportunity to perform. During their stay, he gave a private concert for Dr. and Mrs. Hutchins as well as a public concert before the faculty and the student body.[97]

Ulmann's visit to Berea also gave her an opportunity to spend time with Dr. Hutchins and his staff and to get a sense of the personality and philosophy of those with whom she was planning to entrust a substantial portion of her photographic work. Hutchins and his staff and the student body made a very positive impression on Ulmann. She left the Kentucky community feeling certain the college would provide a proper home for her work. Writing from Washington, D.C., a few days after her departure, Ulmann told President and Mrs. Hutchins:

> My visit at Berea has made a deep and delightful impression and ever
> since we bade you farewell, my thoughts have been busy with your

remarkable and effective institution. It is a blessing to know of a place in the world where everybody is giving out of the fullness of his heart without ever thinking of a spiritual or material return. I am extremely grateful to you for your great kindness and consideration which have made our visit at Berea a very beautiful experience. It is with impatience that I am looking forward to the time in the spring when I hope to make pictures of the activity and interesting people at your college. There are so many things which I saw which ought to be recorded in the best possible way and I know that there will be many more which you will suggest.[98]

A month later the first two photographic volumes of the German photographer August Sander's textual series *Deutsche Lande, Deutsche Menschen (German Land, German People)* were published in Germany. Six years Ulmann's senior, Sander spent the first twenty years of his life in the small farming and mining town of Herdorf in the mountainous region of Siegerland near Cologne farming with his father and working in the area mines. Following two years of military service, he began his photographic career in the city of Linz. Shortly after this he acquired his own commercial studio, which he ran for several years. Despite his success in Linz, Sander moved his studio to Cologne-Lindenthal in 1909. Though he continued his adherence to the aesthetic principles of pictorialism for some time, his contact with artists in the Rhineland Progressive group led him to abandon it in 1922 for "clear, sharp portrait photography that could be readily identified as a technical product."[99]

Nonetheless, similarities exist between Ulmann and Sander. Like their pictorialist predecessors, both used older photographic equipment and materials, including a view camera and orthochromatic plates. Both preferred natural light.[100] They also held a similar philosophy toward their sitters that included a desire to "pay homage" as well as a desire to "analyze," evident in the formal and dignified way they portrayed them and in the manner in which both photographers used tools and objects to identify their subjects. Ulmann and Sander can be further connected by the fact that they abhorred snapshot photography and believed homage and analysis could only be achieved slowly, through extensive and thoughtful communication between the sitter and the photographer.[101]

Most critically, Ulmann and Sander can be linked by their mutual interest in different "types" within their respective societies, ranging from authors to workers, and particularly by their common focus on rural and intellectual types. Both types attracted Ulmann and Sander and were documented by them, albeit in different ways: Ulmann approaching them, particularly after 1925, following her specific studies of professors of medicine and American editors, in a more general and artistic way; and Sander approaching them, particularly after 1924, as he began to contemplate the production of large photo texts, in a more ana-

lytical and scientific fashion. Ulmann and Sander had great respect for writers and artists, perceiving themselves as members of these groups, and created hundreds of portraits of these types. But they held rural peoples in greatest esteem.[102]

Similar as Ulmann and Sander appear, it must be recognized that their differences are significant. Part of this can be attributed to their divergent artistic and socio-economic backgrounds, which led Sander to approach his subjects in a more analytical way and required he limit his repertoire of motifs to "a few compositional formulas routinely used by commercial portrait photographers."[103] While Sander valued the individual and the aesthetic character of the individual portrait, his primary goals were commercial and sociological. On the one hand, he produced photographs that could be reproduced for his customers' personal interests and needs. On the other hand, he organized his images into distinct portfolios, according to professional organization and guild, in order that Germans could better understand the "social conditions and relationships" in Weimar Germany.[104]

Ulmann, in contrast, was most interested in creating individual artistic portraits that celebrated the uniqueness of her subjects. Though her later work was used to illustrate texts about African American culture and religion and Appalachian culture and religion and handicrafts, her images functioned, primarily, as art objects and illustrations rather than sociological tools for analyzing different socio-economic groups, professions, and guilds within American society.

This can be seen when Ulmann's and Sander's work is compared. It is most evident when Sander's images in his later portfolios are set side by side with Ulmann's in *Roll, Jordan, Roll* and *Handicrafts of the Southern Highlands*. Sander's work has a starkness, rigidity, and objectivity that disclose that his primary purpose was to "analyze and specify." By contrast, though of similar Germanic heritage, Ulmann's photography, born of pictorialism, has a softness, painterliness, and subjectivity that is seldom seen in Sander's Weimar portraits. But the most substantial and evident difference is in their subject matter: rich and fascinating and informative as Sander's work is, it is limited to a relatively small group of subjects (largely, the German people from the Cologne area), that is largely homogenous, whereas Ulmann's work, though not as analytical, is concerned with a much more diverse and heterogeneous group, including Appalachian American, Native American, African American, and German American peoples.[105]

By the end of April 1933, Ulmann had agreed to let Robert Ballou publish a book of her photographs of southern African Americans. A highly admired book designer with a strong background in printing and editing, Ballou had the necessary knowledge, skills, and refinement to bring Ulmann's literary dream of a union of her photographs and Peterkin's writing into reality. While she welcomed the opportunity to have another book of her photography published, it was Ulmann's desire that this book be a collaborative effort between herself and Julia Peterkin and that Peterkin provide the text for the book. Since many of the photographs she hoped to publish had been taken of African Americans at

Peterkin's Lang Syne Plantation, it was only logical that her dear friend work with Ulmann on this project, a prospect that initially excited the novelist. In a letter to D. Laurance Chambers, her editor at Bobbs-Merrill, Peterkin expressed her enthusiasm for the project. She wrote, "Doris Ulmann has agreed to let Ballou publish a book of her photographs and has asked me to write a sketch about each one since I know the people. It will give me pleasure to do this and I hope you too will be glad."[106]

Chambers reluctantly acquiesced to Peterkin's collaboration with Ulmann. On May 1, he wrote, "This here Ballou book is another blow. It will be a beauty, I know, and you know we love both you and Doris, but I hate like sin to see anything steal your time for the big novel which should be, after all, the main chance."[107]

As far as Peterkin was concerned, Chambers had no legitimate reason to complain about her collaboration with Ulmann. In correspondence with Irving Fineman on May 19, Peterkin wrote: "Poor Mr. Chambers needs a tonic. He has case after case of jitters. . . . Now he is all up in the air because I want to do the text for a book of Doris' photographs. He does not want to publish the book but he doesn't want any other publisher to do it either."[108] Peterkin began work on the book in May.[109] But her enthusiasm quickly waned. In correspondence with Irving Fineman, Peterkin wrote: "I sometimes wish I might be arrested and put in jail for six months so I could finish Doris's book."[110]

Her feeling that Ulmann was avoiding her further diminished Peterkin's interest in the book. The two had not actually seen each other for some time. When Peterkin heard that Ulmann had come south but had not made an effort to contact her, she felt slighted. In correspondence with Irving Fineman on July 24, the novelist wrote: "People constantly puzzle me. I hear that Doris has been in North Carolina for some time and I naturally wonder why she did not tell me she'd be there. Who said 'To know all is to forgive all?' George Eliot, I think. She's probably right and I might go, still further and say, 'To hold to friends, forgive what you cannot understand.'"[111]

Peterkin felt hurt and slighted but sensed there must be something else behind Ulmann's recent "silence." She got confirmation of this in a letter from the publisher, Robert Ballou. In an August 5th letter to Irving Fineman, she reiterated her frustration and hurt about the matter, while at the same time rationalizing Ulmann's behavior: "Ballou wrote me today in connection with this book she and I are doing, that she and Jack Niles are taking a holiday together. I did not need to hear this from Ballou however, for I knew it as soon as I heard where Doris was and for how long. Poor thing, she knows I loathe Jack, and wants to spare me a spell of cursing him, I guess. Women in love are such utter idiots. I often wonder why the Creator made them so they cannot tell gentlemen from other men. None of us can where our emotions are involved. It's pathetic."[112]

Peterkin had also felt frustrated about her own efforts to write acceptable essays for the text. In further correspondence with Fineman on August 15, she

had written: "When I look over what I've done, a light sense of nausea seizes me. The title, "This Side of Jordan" is the one thing I'm sure I like, and since I cannot locate Doris, I'm not sure she will. Do you? I think it's appropriate for the book is much concerned with the religious life and beliefs of the Negroes. My chief worry is its lack of form with sketches mixed together in dangerous confusion."[113]

Annoyed and angry as she was, Peterkin finished the essays for the book in early September. She must have been quite surprised and elated when the early reviews indicated a positive response to the book that, by this time, had been entitled *Roll, Jordan, Roll.* One of the earliest reviews came from Walter White, Secretary of the National Association for the Advancement of Colored People. He had been asked by Harry Sherman of the Book-of-the-Month Club to review the "advance sheets" of the texts. In correspondence with Sherman on November 13, White wrote: "Thank you for permitting me to read the advance sheets of *Roll, Jordan, Roll.* It is a beautifully written and veritable picture of plantation life. It, of course, represents but one type of Negro, but in picturing the one type it is, in my opinion, a magnificent accomplishment. Of equal importance are the superb photographs by Doris Ulmann. I very much hope that the Book-of-the-Month Club will select *Roll, Jordan, Roll.*"[114]

On December 15, Robert Ballou issued the trade edition of *Roll, Jordan, Roll.* It contained twenty-one essays by Peterkin on the life of the southern African American. Peterkin had published several of these essays at an earlier date. Seventy-one halftone reproductions of Ulmann's photographs of South Carolina and Louisiana African Americans illustrated the text.[115]

Praise was immediately forthcoming. Poet and writer James Weldon Johnson, an influential voice in the African American and arts communities who had been previously photographed by Ulmann, was effusive in his remarks. "*Roll, Jordan, Roll* is the most beautiful and most charming book about the plantation Negroes of the deep South that I know of. Doris Ulmann's photographs alone will work a great change in the general ideas about the Southern rural Negro." Harry Hansen, critic of the *New York World-Telegram,* followed suit, describing Ulmann's photographs as "so real and affecting that the book stands at once in a class by itself." Reporting for the *New York Sun,* Herschell Brickell echoed these thoughts, writing, "*Roll, Jordan, Roll* is a complete record of the Gullahs. The volume, with its seventy illustrations from Doris Ulmann's magnificent photographs, stands as a priceless piece of work . . . a real contribution to the study of the Negro."[116]

Though this initial publication of the text received much praise, opinions of the reproductions of Ulmann's photographs in this edition were mixed. Many of her African American photographs were quite dark, and the printers had had problems reproducing them. Financial constraints also placed additional limitations on the printers of the trade edition. In correspondence with Irving Fineman on December 16, Julia Peterkin noted the limitations of this edition. She wrote:

"I thought t'would never get into print because of difficulties in reproducing Doris' wooly pictures."[117] Some of the pictures were, in fact, "wooly" and blurred, and this dissipated the power the publication should have had. Others also noted the limitations of the trade edition. Reviewing *Roll, Jordan, Roll* for the *New York Times,* John Chamberlin wrote: "Mrs. Peterkin has put into prose sketches the various figures which Miss Ulmann has posed so revealingly before her camera. . . . [The photographs] tell stories in their own right and it is a pity they don't come out more in the reproductions."[118] Dorothy Van Doren concurred in her review in *The Nation.* She wrote: "A look at the faces in Mrs. Ulmann's photographs shows it clearly—when the face can be seen at all. For many of the pictures are so soft and vague as to be mere black blobs."[119]

Nonetheless, *Roll, Jordan, Roll* made a significant impact on those who took the time to peruse the volume and marked, as Peterkin scholar Susan Williams has noted, "one of the first of many photo-documentaries that have shaped our collective memory of the Great Depression."[120]

Although Ulmann was disappointed with the trade edition of *Roll, Jordan, Roll,* she knew her real masterpiece, the limited edition photogravure folio, would be published soon. Probably financed in its entirety by Ulmann, as her previous photogravure folios on the medical faculties of Columbia and Johns Hopkins and her folio on American editors had been, this forthcoming volume would reveal the full beauty of her photography and her high aesthetic standards. For a short time, she would have to live with the limitations of the trade edition and the criticism of reviewers about the reproductions of her photographs.[121]

~ ~ ~

While Ulmann had spent much of December preoccupied with the publication of the trade edition of *Roll, Jordan, Roll,* making corrections on the limited edition, and preparing for her and Niles's trip to North Carolina, Niles had been preoccupied with practices and performances. On December 8, he had another opportunity for a solo concert, this time at the American Dalcroze School in Manhattan. This performance was followed by a concert with Dr. Augustus Zanzig at the New School for Social Research and two more solo concerts in the city at the Cosmopolitan Club and the McDowell Club.[122]

Ulmann and Niles also collaborated on a holiday card, along with one of Ulmann's servants. Ulmann had produced a hand-colored woodcut of the wise men to mail to her friends for the last holiday season. Once again she focused on the nativity of Jesus. However, this time she stuck to the medium with which she was most familiar. She posed Niles and her servant (probably Thekla) on their knees, before an oriental statue of the Virgin Mary and the child. Once she was satisfied with the picture's composition, she photographed it. Ulmann had the photograph made into a photogravure and had an unknown quantity printed on handmade paper (fig. 42). Inside the folded cards, she had the following

Fig. 42. *Christmas Card*, 1933. Photogravure after a platinum print. Audio-Visual Archives, Special Collections and Archives, University of Kentucky Libraries.

words printed: "May I send you my best wishes for the holiday season? Doris Ulmann."[123] It was, as was her card for the previous year, an unusual card for a person who "did not like the holidays."

Ulmann had also packed and made plans for her and Niles's upcoming journey to the Campbell Folk School. Sometime earlier, Olive Campbell had invited them to celebrate the Christmas season with her and the staff and students of the school. Campbell had been quite clear about the extent of the festivities and the different ways they celebrated the holiday at the school. There was no question that this would be unlike anything Ulmann had ever experienced before. However, she wanted to be with Olive Campbell and the rest of the staff and students of the school and all those in the Brasstown area with whom she had become acquainted. They had about them a reality and truth that she desperately needed. Ulmann also wanted to document more of the people and activities at the school and knew the holiday festivities would provide ample opportunities for photography.[124]

Ulmann and Niles arrived in Murphy late on the night of December 22. The next day, she and Niles went to the Folk School. Even Niles was surprised by the reception they received. Informing Rena Lipetz of the details of their visit, Niles wrote: "I arrived in Murphy on time . . . Thursday night and slept until noon Friday. Then Frau Ulmann and I went to the school and did we have a reception . . . it was swell. . . . I sang for them at the party that followed . . . 33 at the table and then I sang later in the big hall before a gigantic wood fire. . . . Today they sing for me . . . my carols . . . oh what a thing it will be."[125]

On Christmas Eve, Mrs. Campbell and the students presented a nativity play, which Ulmann documented with her small camera she had brought along.[126] Ulmann was deeply affected by the play and the festivities at the Folk School. Writing to Lyle Saxon on December 31, she expressed awe over her experiences:

> You surely were surprised to hear that I did not stay in New York for the holidays,—you know that I have never liked the holiday season. . . . Mrs. Campbell of the Campbell Folk School asked me to come for their Christmas celebration—I did not believe that I really could arrange to go until I actually was on my way. I have never experienced a true Christmas spirit as I did at Brasstown,—they do everything in so beautiful and unique a way that it moves you deeply. They had a nativity play acted by the students,—Mrs. Campbell with her group and a few of the students sang carols through the whole play and those who acted also sang. The play was a beautiful performance—it reminded you of Oberammergau, but I thought it more vital and moving because it had a strange naive and primitive quality. Everything connected with the play has been made at the school,—stage properties, costumes, etc. The costumes were lovely, having the exact colors of the old mas-

ters,—and the costumes were made of anything which they happened to have,—naturally they dyed their colors. Then they had Christmas for the students,—Christmas Eve was beautifully celebrated. Lyle dear, this Folk School has a wonderful spirit and the influence which it has upon the mountain people in that section of the country is almost unbelievable. The days spent at Brasstown were well worth the trip.[127]

Ulmann could not have written a more effusive letter. It left no question that Olive Dame Campbell and the staff and students of the Folk School had made their mark on the heart of the photographer.

After taking time to celebrate in the Christmas festivities at the Folk School and to welcome the New Year, Ulmann and Niles departed Brasstown. Making their way to Richmond, Virginia, they stopped in Winston-Salem, North Carolina, and in Roanoke and Charlottesville, Virginia. At Charlottesville, Ulmann and Niles took time to visit Monticello—Thomas Jefferson's home—and the University of Virginia, two places Ulmann had always wanted to see.[128]

The next day, on January 2, they drove to Richmond, where they joined Washington drama critics and members of the Southern Woman's Educational Alliance for supper and a dress rehearsal of *Heaven Bound,* a "Negro play" about the trials and temptations of spiritual pilgrims on their way to heaven. Written and directed by the African American playwright Nellie L. Davis, this folk drama was sponsored by the Educational Alliance during its Virginia and Washington tour. Writing to Olive Campbell, Ulmann described the play in much the same way as she had described the Campbell Folk School play to Lyle Saxon. She wrote that it was "really very beautiful—and naïve. . . . The singing and acting in some instances was superb."[129]

From Richmond, Ulmann and Niles went to Washington, D.C., where Niles was scheduled to give a concert and meet with music publisher Carl Engel. While there, Ulmann also met with a curator of the Library of Congress and discussed arrangements for her upcoming February exhibition at the institution.

Once they returned to New York from Washington, Ulmann and Niles got back to business. Ulmann concentrated on developing prints she had recently taken in North Carolina and Kentucky for the February opening of her forthcoming exhibition at the Library of Congress and for Olive Dame Campbell.[130]

As excited as Ulmann was about her forthcoming exhibit in Washington, she was particularly delighted that Robert Ballou finally published the limited edition of *Roll, Jordan, Roll* the first month of the new year. Having endured a barrage of criticism about the poor quality of the reproductions of her photographs in the trade edition, Ulmann had anxiously awaited the publication of this beautifully crafted edition.

The deluxe edition of *Roll, Jordan, Roll* was very different from the trade edition. Though the text was the same, the deluxe edition was limited to 350 numbered copies, signed by both Ulmann and Peterkin. Fine designed type, hand-made wove paper and binding materials, and photogravure prints, similar in quality to those used in Ulmann's earlier books, enhanced this edition. A significantly larger book than the first (measuring 11⅝" x 8½"), the deluxe edition contained ninety images within the narrative and one loose image that the photographer had signed in pencil—twenty more than the trade publication. These images were made more attractive and discernible through the use of the refined photogravure process. A brief comparison of the two editions leaves little doubt that the photogravures used for the deluxe edition better replicated the aesthetic quality of Ulmann's photographs of her African American subjects than the rather crude halftone reproductions used for the trade edition, thus reestablishing the integrity and quality of Ulmann's photography.[131]

———

While Ulmann continued to photograph New York subjects and develop prints from previous work in January, Niles practiced and performed at different venues, including the Town Hall Club (of which Ulmann was a member), the American Dalcroze School in New York, and also in Groton, Connecticut.[132] Moreover, he continued to serve as Ulmann's secretary and assistant. Nonetheless, it was evident that the intimacy between them was rapidly diminishing. Ulmann alluded to this in correspondence with Olive Dame Campbell on January 25: "Jack and I are so busy when in New York that we do not seem to have time to visit—whenever we see each other we are always doing something and when through with our job or whatever it is (social things are often jobs of the worst kind) we both run to our work."[133]

Continuing his contact with Rena Lipetz, Niles's behavior suggested his relationship with Ulmann had changed.[134] However, Ulmann remained deeply interested in helping Niles and enjoyed the times when they were able to work together, as she indicated in correspondence in February with Olive Campbell: "Jack is progressing steadily—I believe that his work is becoming more widely known and that he is receiving the appreciation which he deserves. Elizabeth Burchenel has been after Jack and me. . . . She wants Jack to sing next Sunday at the opening of an Exhibition of American Folk Arts—and also wants some of my pictures. . . . Tomorrow morning Jack and I are to call on her at her office—can you imagine what we will do to her? We'll have a good laugh afterwards."[135]

Ulmann's increasing attachment to Olive Campbell and others at the Campbell Folk School undoubtedly helped ease the pain she must have felt from the change in her relationship with Niles. In a letter to Campbell, Ulmann admitted her feelings about Campbell and those associated with the Folk School: "You see, you have become part of my life and it means a great deal to me to see these

objects [carved wooden animals that had been made by Folk School carvers] when I cannot possibly see you. And I do miss you—and am looking forward to our next meeting. . . . Please give my love to Marguerite, Louise,—Nina, Gin, Maud, George of course, and all the others. For yourself a great deal of love and devotion."[136]

Ulmann's feelings about Campbell and the Folk School also made her a good advocate for it, and she unabashedly sought to promote the school. Ulmann proudly recounted one such effort in correspondence with Olive Campbell on February 28. "Last night we saw Mrs. Issacs, editor of the *Theatre Arts Monthly*—she wants to use some pictures of Brasstown for her magazine. She selected a number of things. . . . She wants to run an article about your nativity play with emphasis on the people of the mountains, next November or December. . . . Didn't your ears burn last night? You can imagine how Jack and I spoke of you and the work which you are doing."[137]

The third week of March 1934, Ulmann and Niles drove to Washington in Niles's Chevrolet, which Ulmann had purchased for the musician. Here, Niles had the opportunity to perform folk songs for President and Mrs. Roosevelt and to present a copy of the limited edition of *Roll, Jordan, Roll*, which Ulmann had numbered "1." In a letter to Olive Campbell on the evening of his performance Ulmann expressed her excitement about the opportunity and spoke of Niles's anxiety:

> Jack is singing at the White House—you can imagine how eager I am to hear about his experience. The White House car fetched him—he left in his evening clothes, a gardenia in his button hole, 2 dulcimer cases containing 4 dulcimers and all your animals and No. 1 volume of the limited edition of *Roll, Jordan, Roll* which he intends to present to Mrs. Roosevelt. I was around all day, but did not disturb him—let him come to talk to me when he felt so inclined. He was subconsciously excited—he said that he was not nervous,—but when I took him to the elevator after the White House Chauffeur had telephoned to his room, he said, "O, it's awful, awful—I'll be glad when this is over—I made him laugh and that's all!"[138]

Niles's performance and Ulmann's gift moved Eleanor Roosevelt. Within a few days, she extended another invitation to Niles to return to the White House and asked that he bring Ulmann as well.[139] Roosevelt also visited the exhibition of Ulmann's photography at the Library of Congress. She was very pleased with what she saw and indicated her pleasure to Leicester Holland, the Curator of Fine Arts at the library. In later correspondence with John Jacob Niles, Holland remarked that he had received a note from Mrs. Roosevelt about the exhibit of Ulmann's photographs and expressed his plans to keep the exhibit up until May 1.[140] This was incredible news for Ulmann and a tremendous honor.

Chapter Four
The Last Trip

Following their return to New York City, Ulmann and Niles spent several days preparing for her upcoming photographic expedition to North Carolina, Tennessee, and Kentucky. During this time she also met with Allen Eaton and discussed the people, activities, and objects he wished her to photograph on the next southern trip.

Once they had completed their preparations, Ulmann and Niles headed south for their first destination—Washington, D.C. They arrived at the Raleigh Hotel in Washington, D.C., on Saturday, April 14. Later in the day, she wrote to Olive Campbell, informing her of her current activities and their schedule. "Mrs. Kellog communicated with me soon after I had received your letter and I promptly made the glossy prints [of the Campbell Folk School] for her, so I hope that the pictures will appear in the May issue of *The Survey Graphic.* She wanted to use four pictures. . . . Mrs. Isaac's of the *Theatre Arts Magazine* has 6 pictures which she wants to use soon. . . . We plan to be at Murphy either Tuesday or Wednesday and will call you as soon as we arrive."[1]

The next day, Ulmann and Niles had dinner with President and Mrs. Roosevelt at the White House. At the request of the Roosevelts, Niles once again sang and played the dulcimer. Honored as Ulman felt to be invited to the White House, she was initially apprehensive about the visit. However, the visit with the Roosevelts went very well. Writing to Allen Eaton several days later, she reported, "Our evening at the White House was much more enjoyable than I had expected and it was a most interesting experience."[2]

A few days later, Ulmann was back in her beloved Brasstown, spending as much time as she could with Olive Campbell and with the Folk School's staff and students. She also continued her documentation of the people and activities of the school and area. However, Ulmann's previous commitment to Dr. Hutchins and the staff at Berea College limited the time she could spend at the Campbell Folk School. She lamented this in correspondence with Allen Eaton on April 24, writing from Boone Tavern in Berea: "Our visit at Mrs. Campbell's was delight-

ful and it nearly broke our hearts to leave. I did a few days work at Brasstown and think that I ought to have some interesting things. How I do love Mrs. Campbell and all her people!"[3] Ulmann continued in the same manner with Campbell herself two days later:

> There is just one difficulty in spending a few days with you and that is leaving,—I never want to go away and it always makes me very unhappy when the time comes to leave. Jack and I had a delightful visit with you and I am so grateful to you for all that you do to make us happy. I hope that I have succeeded in making a few good pictures of the interesting people whom we visited. Now I am looking forward to the time when we will be with you again—later in the summer. . . . [Berea] is a delightful place but I cannot tell you how I am missing you and your family. We cannot laugh quite as we do with you—and then your tea parties are not to be found. In fact, I know that they cannot be found anywhere, they are just yours.[4]

But as disappointed as Ulmann was to leave Brasstown, she had long wanted to continue her work and documentation at Berea and in the surrounding Kentucky highlands. After stopping at Knoxville, she and Niles arrived in Berea on April 23.[5] They spent the next few days organizing Ulmann's photographic equipment, meeting with Dr. Hutchins, and meeting with faculty and staff who had agreed to serve as their guides in the eastern mountains of Kentucky and Tennessee. Ulmann also corresponded with Allen Eaton and repeated her desire to do everything possible to find the subjects and materials he needed for his book on the highlands:

> I have been tremendously interested in the outline of your book—it will be a wonderful piece of work and I can only hope that I will be able to finish the illustration part as you should like to see it. There are a number of things which I have noticed which I have not done—will you not send me a list of the pictures of subjects that are lacking? . . . I hope you will write soon again and let me know the things that are lacking for your book. I do hope that I will be able to find all the important and interesting things here.[6]

Once Ulmann and Niles had finished their preparations and made the needed contacts, they left Berea and headed for Norris, Tennessee. Here they met Helen Dingman, a professor of sociology at Berea. Dingman had gone to Norris a couple of days earlier to make arrangements for Ulmann and Niles. After they arrived, Dingman guided them in Norris and the surrounding area. This offered Ulmann many additional opportunities to photograph mountain

people, activities, and crafts. It also gave her a chance to meet and photograph Evelyn Bishop, director of the Pi Beta Phi Settlement School of Gatlinburg, Tennessee.[7]

On April 30, Ulmann, Niles, and Dingman returned to Berea. Ulmann worked daily to document the staff, students, activities, and industries at the college.[8] Among others, Ulmann photographed Mr. and Mrs. Anderson (Mrs. Mary Anderson was a noted weaver and teacher of weaving) at Grant House; President Emeritus William Frost, and his wife Eleanor; and Anna Ernberg (a native of Sweden and an experienced teacher of handicrafts) and her students at the Fireside Industries. She also photographed students working at many of the other "industries" of the college. These photographs provided extensive documentation of the college's famous work-study programs.[9]

Most of Ulmann's photographs of students working at Berea College's industries in April and May of 1934 are of a documentary character (fig. 43). Nonetheless, several of her Berea images reveal that the pictorialist aesthetic remained an important force in the life of the photographer, as can be seen in her extraordinary images of hands (fig. 44).[10]

In Ulmann's mind, her work at Berea was both profitable and enjoyable. But the visit had had limited value for Niles, which Ulmann mentioned in correspondence with Allen Eaton on May 24: "We have continued our work at Berea and are hoping to finish here in a few days. . . . Jack has been singing to different groups of students who are always delighted with his songs. However, Jack has not found any material here—and in this respect our stay has not been successful for him. . . . We are planning a two-day trip to Highland [Kentucky]—leaving tomorrow and expecting to be back Saturday. I am hoping for something interesting there."[11]

Ulmann was particularly hoping Niles would have an opportunity to find some new folk lyrics and music, but there is no indication he did so during their two-day visit at the Highlands Settlement School. By May 27, Ulmann and Niles were back in Berea, where they remained until leaving for the Pine Mountain Settlement School in Harlan County, Kentucky, on June 3. Upon completing her work at this school, Ulmann and Niles traveled down to Morristown, Tennessee, an old community located in the heart of eastern Tennessee some thirty-five miles northeast of Knoxville. Guided by Sarah Dougherty, the director of the Shuttle-Crafters, a craft guild in nearby Russellville, Ulmann found many opportunities to photograph residents and craftspeople.[12]

Using the Hotel Kingmyer in Morristown as their headquarters, Sarah Dougherty escorted Ulmann and Niles throughout the area. On June 9, they traveled to Lincoln Memorial School in the historic town of Cumberland Gap, some sixty miles north, where Niles was scheduled to perform. Here, they met the director of the Pine Mountain Settlement School, May Stone, who acquiesced to Ulmann's request to photograph her (fig. 45). On June 11, Sarah

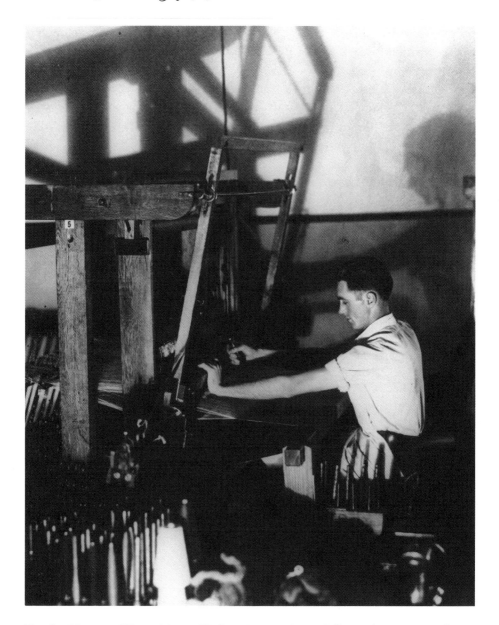

Fig. 43. *Mountain Weaver Man at Work on Loom at Berea College Industries, Kentucky*, ca. 1933–1934. Posthumous gelatin silver print. Printed by Samuel Lifshey, ca. 1934–1937. Stamped signature of Doris Ulmann. Berea College and the Doris Ulmann Foundation, No. 379.

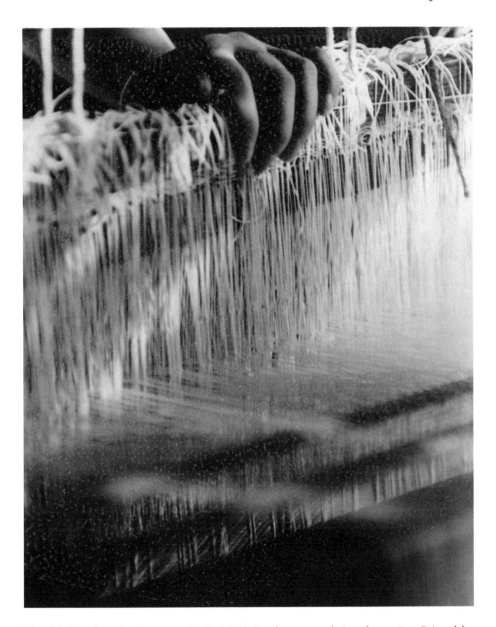

Fig. 44. *Hand on the Loom*, ca. 1933–1934. Posthumous gelatin silver print. Printed by Samuel Lifshey, ca. 1934–1937. Stamped signature of Doris Ulmann. Berea College and the Doris Ulmann Foundation, No. 1219.

Dougherty led Ulmann and Niles to the historic town of Jonesborough, about sixty miles east of Morristown. The next day, the expedition pushed farther east to Mountain City. Under Dougherty's direction, Ulmann and Niles covered a substantial portion of the eastern Tennessee highlands and found numerous opportunities for photography and collecting music. Ulmann appreciated Dougherty's help and expressed her appreciation to Allen Eaton, who had arranged for Dougherty to assist them: "We find material here very interesting and very valuable and we are staying longer than we had planned. Miss Dougherty is a charming person and she knows the country. She has been good enough to go with us on our expeditions, which naturally is a great help. We are staying over Sunday because on Monday we expect to go to Grassy Valley near Trade, North Carolina, where Miss Dougherty knows some very typical old people."[13]

On June 13, Ulmann and Niles headed southeast to Gatlinburg, home of the Pi Beta Phi Settlement School, which Allen Eaton described as "one of the largest and most important weaving centers in the Southern Highlands."[14] They established headquarters at the Mountain View Hotel, where the Settlement School had a showroom, and they attended the town's "Old Timer's Day" Festival and visited several different weaving and craft sites. This gave Ulmann the opportunity to document more highland craftspeople and their handicrafts. While staying at the hotel, Ulmann set up an exhibit of her photographs of "mountain folk and mountain scenes" for the hotel guests. Though the heat "succeeded in dampening their spirits on occasions," Ulmann and Niles worked in the Gatlinburg area for several days.[15]

On June 24, the two headed for Lexington, Kentucky, where Niles was scheduled to give a concert at the University of Kentucky. Ulmann was also scheduled to exhibit some of her work at the institution. They reached their destination the next day and checked into the Hotel Phoenix. During their stay they visited with several members of the faculty and staff at the University of Kentucky, including President and Mrs. McVey, and the Dean of Women, Sarah Blanding.[16] In addition to meeting Blanding at a formal gathering at the university, Ulmann and Niles spent an evening with her and her mother and sister in their Lexington home.[17] Though Ulmann's contacts with Blanding were brief, they were indicative of the way Ulmann often responded to people whom she sensed were of "kindred spirit" and sought, as did Ulmann, the recognition and affection of others. Several days after their visit in Lexington, Ulmann wrote to Blanding.

Dear Sarah,

How I wish it were possible for me to see you at least one time of the ten times that I think of you! My image of you at present,—is of a lovely young woman adored by a flock of young, attractive girls

Fig. 45. *May Stone, Co-founder of Hindman School, Hindman, Kentucky,* ca. 1932–1933. Posthumous gelatin silver print. Printed by Samuel Lifshey, ca. 1934–1937. Doris Ulmann Collection, Special Collections and University Archives, University of Oregon, U 4392.

who are enjoying every minute of an active delightful day, and who are all eager for a word of understanding from this woman, and these girls are never disappointed. However, this woman is weary and perhaps hungry for a word of understanding herself,—so intensively busy herself that she has not time to think of her own desires. . . . What a delightful, peaceful, and interesting evening we had with you and your mother and sister. . . .

Take care of yourself, do not work too hard and be happy.[18]

Following their short stay in Lexington, Ulmann and Niles continued south, making brief stops in Knoxville and Chattanooga, Tennessee.[19] South of Chattanooga, in Ringgold, Georgia, Ulmann "stumbled" upon "a very good tufted spread maker" named Ethel May Stiles. Ulmann recounted their meeting to Allen Eaton: "I worked with her and in my pictures tried to show the process of making a tufted spread. Her children, a little girl nine years old and one five, also work at these spreads,—these people were very lovely and co-operated with us in a delightful way."[20]

After a "dangerous" night trip over a road under construction, Ulmann and Niles arrived in Murphy, North Carolina, on June 30 and checked into the Hotel Regal.[21] The next day, they drove the few miles to Brasstown, where they spent the day "with Mrs. Campbell and her family," discussing, among other things, suggestions Allen Eaton had sent to Ulmann for further photography and documentation. Though Ulmann was thinking about other work she needed to complete while she was in the western North Carolina area, she spent several days photographing at the Folk School and in the immediate vicinity. She also took time to join in the Folk School's "Old Timer Day" festivities on July 4 and found it to be a joyful celebration. Ulmann described the event in a letter to Sarah Blanding: "Today they had an 'Old Timer Day'—I wish you could have seen this gathering of mountain people, mostly old folks,—they came from all parts of the country. They were happy and made everybody else happy—happy, perhaps, . . . with a philosophy of life gained by rich experience. Many of the people I knew, because I had worked with them last year,—their greeting was a joy."[22]

But Ulmann's joy was interrupted the next day by a letter from Allen Eaton and, two days later, by a second letter. Eaton's letters expressed his reservations about relying solely on Ulmann's photographs to illustrate his book on the handicrafts of the southern highlands. He also told Ulmann she needed to travel to many more sites in order to record the subjects and objects he desired. Eaton's letters offended and angered the photographer and taxed her normally gracious demeanor. Feeling the need to defend the integrity and quality of her work and the extraordinary efforts she had made in order to assist Eaton, Ulmann fired a response back to him on July 9. Writing from the Hotel Regal in Murphy, she said:

I can so well understand how you must feel working intensively at your book,—and this means work, I know, and still being uncertain of the outcome of all this effort. Too bad the Foundation places you in this position. Now about my pictures—I feel that there ought to be all of my pictures as illustrations or none at all. I would not care to have some of my pictures used and some done by somebody else. After all the rather intensive work of last year and this year I do think that you will find enough subjects from which to choose. I have been doing the best I can in getting the material and I have tried to cover the ground as you suggest it. . . . You ask about Virginia and West Virginia, Alabama and South Carolina,—I know that I could not attempt these states at present, because it would be too fatiguing and would take too much time. Besides, personally, I think there is always more value in doing one thing thoroughly and as well as possible than in spreading over a larger area and getting just a little of many things. In this way it is impossible to procure the best there is.[23]

Realizing he had hurt and angered the weary artist, Eaton sought to clarify his position in his next letter, to acknowledge her efforts, and to make amends. While Eaton still hoped Ulmann would push on and photograph most of the subjects he requested, he realized he had been insensitive to Ulmann's physical limitations. He indicated this in a note to his close friend, Clementine Douglas, of The Spinning Wheel in Asheville, North Carolina: "Among the reasons [I have not answered your good letter] is that I have been a little worried about Mrs. Ulmann who has been working very hard and whose schedule kept her a little longer in Tennessee and Georgia than I thought it would. I have just revised the list of subjects somewhat, as I found that I was really asking Mrs. Ulmann to cover too much, but it includes nearly all the subjects which you and I have written about."[24] Ulmann was pleased with Eaton's conciliatory letter and responded on July 22 in her characteristically gracious spirit:

When I saw Mrs. Campbell, she was good enough to show me your letter and I have been wanting to tell you that I think that I understand the rather trying circumstances under which you are obliged to work. I think that I have always more or less understood this and I want you to know that you need never worry about this part of the situation. Your work is a difficult problem any way, and I do not want you to add any burdens to those already existing. So please, always realize that you can talk to me, and together I am sure that we'll be able to accomplish that which we desire. . . . I think that your plan of presenting your book with the selected pictures is a good one,—probably the best way of handling the situation. I am looking forward to

your letter giving us detailed information of Asheville and surroundings. . . . Please take care of yourself and do not go too hard in this hot weather.[25]

It is doubtful Eaton had understood how sick the photographer was when he had written to her in early July, but in a special tribute to Ulmann in his book, *Handicrafts of the Southern Highlands,* he acknowledged her commitment, despite her physical limitations and health problems, to his efforts and to the highland peoples.

> I believe that no one has ever done a series of photographs of rural people in relation to their handicrafts which in scope, sympathetic interpretation, and artistic treatment equals the collection from which 58 of the subjects in this volume have been chosen. In one sense this book is a memorial to her . . . because it brings together studies of many people for whom she cared and who cared for her. . . .
>
> Unforgettable is the eagerness with which she responded to an offer to help her continue her journeys into the Highlands under more favorable conditions than she could alone command. "If you will make the contacts for me," she said, "I will be able to get the subjects that I want most and I will photograph the people working with handicrafts that you want," adding that she would do this at her own expense.
>
> Few persons have ever undertaken a work and pursued it with clearer purpose and stronger will. Always frail, never enjoying good health, she continued to push on despite the entreaties of friends to rest a while, until she had covered most of the territory . . . and had secured many more subjects than had appeared possible. The quality of her work speaks for itself. To those closely associated with her it seemed that she was racing against time and that, measured in terms of achievement, she clearly won the race.[26]

On the evening of July 24, Ulmann and Niles quietly set out on their journey to Asheville, leaving behind dear friends at the John Campbell Folk School. Their drive was, as Ulmann later recounted to Olive Campbell, "the most unbelievably beautiful drive" in which "the moonlight was so bright [it] . . . made me wonder even more than ordinarily what makes the world so pretty and so stupid: all these foolish things that bother us, become so unimportant when one sees such grandeur." It was also a sad drive for Ulmann: "As usual the trouble about visiting you is leaving you,—it did hurt to leave you yesterday afternoon and the oftener I come to see you the harder it becomes to say goodbye. . . . And

your whole family make such a beautiful group—so beautiful that the world seems cold and without spirit when one comes away from your hearth."

While it is doubtful that Ulmann realized she would never return to Brasstown, she was very aware that her days were numbered. This certainly increased her sadness about her departure from those she had come to deeply respect and love, and it increased her desire to thank them for what they had meant to her. She made this evident in the final section of her July 25th letter to Olive Campbell: "I do want to leave a remembrance to the school. . . . Would you please think of something that you would like to have from me? I would appreciate it more than I can tell you."[27]

Ulmann repeated her request a couple of days later: "I truly would appreciate it, if you were to express some wish,—what I wrote in my letter, I meant sincerely."[28] A few days later, Campbell visited Ulmann in Asheville. It was probably at this time that she finally responded to Ulmann's request that Campbell identify something Ulmann could leave as a "remembrance at the school," and probably requested Ulmann provide financial assistance for the construction of "the boys' building and the little hotel."

Writing to Campbell several days later, Ulmann reminded her how much she meant to the photographer: "Your two lovely letters reached me before we left Asheville. I also have tucked away your visit with us at Asheville as a precious thing—it is something that not anybody can take away from us—and then your letter after you had heard of my illness."[29]

By the next day, Ulmann had caught up with Clementine Douglas, whom Eaton had asked to make arrangements for Ulmann's work in the Asheville area. A small woman with a twisted spine, Clementine Douglas had, like Ulmann, grown up in an affluent home. She had also attended the prestigious Pratt Institute in New York City and taught in a private girl's school. But in 1918, when Douglas was twenty-six, she heard an inspirational speech by Helen Dingman (at the time a mission worker for the Home Missions Board of the Presbyterian Church) about the need for mission volunteers and money to assist in the Presbyterian Church's mission at the Smith Community Life School in the mountain village of Smith in Harlan County, Kentucky. Deeply affected by Dingman's words, Douglas had volunteered to help at the Smith Community Life School during the summers of 1919, 1920, and 1921, and taught arts and crafts to children and teenagers. During her first summer in Harlan County, she had several opportunities to see many beautiful antique woven coverlets (called "coverlids," "kiverlids," or "kivers" by the Kentucky highlanders). Though the weaving of coverlets had been a historic craft and tradition in the highlands in the nineteenth century, Douglas could find no one who remained engaged in the craft. Desiring to rekindle an interest in the craft, Douglas "had a loom sent down from Massachusetts [the next summer, 1920] and she soon had young girls coming to her to learn to weave. Some of the older women . . . who had

done some weaving in their youth helped to add to the pool of weaving knowledge. Slowly the craft was revived and Douglas encouraged and supervised the repairing of looms and the rescue of old "drafts and patterns."

Encouraged by her experiences in Kentucky, Douglas spent the next few years studying weaving in Scotland and in a variety of other places. In 1925, she established a center for weaving and the sale of mountain handicrafts—The Spinning Wheel in Asheville. At this unique meeting place Douglas "trained young girls to become weavers" and sold their woven coverlets and handicrafts as well as "pottery, metalworks, cornshuck dolls, woodcarving, rugs and even some furniture."[30]

In requesting Douglas's help, Eaton did what he had done for Ulmann on numerous occasions. He contacted a a highland worker in an area where he had asked Ulmann to photograph and discussed with them the subjects and materials he desired Ulmann to photograph. Once Eaton and the worker had come to a consensus about the subjects and materials that Ulmann needed to photograph, he sent Ulmann a list from which she could work. Eaton's July 24 letter to Clementine Douglas illustrates how he often assisted the photographer:

> In order that you may know about what I have included from our combined list I am sending you the following which I think is complete, but I have asked Mrs. Ulmann to talk things over with you, Miss Goodrich, and Mrs. Loeffler and use her judgement about any subjects I have not mentioned.
>
> You are so good to look over the roads as to their condition for Mrs. Ulmann going to Saluda and to take your rug makers.
>
> Now I want to say to you what I am writing to Mrs. Ulmann. Please do not undertake anything that is hard or inconvenient. I mean I do not want you to help with anything that amounts to that.
>
> The working list of subjects by me and you is as follows:
>
> 1. Miss Douglas at spinning wheel
>
> 2. Interior of cabin showing old loom and girl weaving (excuse me for forgetting her name)
>
> 3. Views of the weaving room if it looks as you would like to have it with the lovely skeins of yarn which I can still see in the background and the girls at the looms.
>
> 4. Anderson or Ardeley families working on hooked rugs. I think we have no hooked rug pictures yet and I would rather have yours than anybody's. So if convenient figure out what you think would be a nice picture of nice folks at work and if appropriate with one or more of your nice rugs in the background, maybe on the wall. I have seen that nice one you have on the cabin a hundred times when I have recalled that attractive place. I am really anxious for Mrs. Ulmann

to get this subject not only because it is good but because the great majority of her studies are of single people and I like to get records of workers and handicrafts as well as of the folks who do them.

5. Mr. Stephens and Mr. Bachelder I have included in Mrs. Ulmann's list but I have omitted Anthony Lord and Daniel Boone, and Mrs. W. J. Angel, weaver and spinner. I thought it might be difficult to set the blacksmiths although it ought to be a stunning picture and if the matter should come up and in your judgment it would not be too much of a strain for Mrs. Ulmann I wish you would suggest them to her, and feel free about any important scenes which we may have overlooked.

Since I know that Mrs. Ulmann has made a number of interesting spinning and weaving studies I omitted Mrs. Angel, but as I told her, if there is something special about her you will let her know.

I am sure you will be invaluable to Mrs. Ulmann and Mr. Niles and of course to me and I just hope this will not amount to an imposition at this time when I am sure you will be busy. Mrs. Ulmann will of course get in touch with Miss Goodrich. Now if you should not like the idea I suggested about being taken at the Spinning Wheel please fix it up any way you care to with Mrs. Ulmann. What I do want is for Mrs. Ulmann to get a portrait of you while she is there and I thought of the spinning wheel because I once saw a lovely picture of you taken in this way in your fascinating cabin.[31]

Clementine Douglas was, as Eaton had predicted, "invaluable" to Ulmann and, as Ulmann herself noted, "very helpful and kind." Ulmann spent July 26 photographing at The Spinning Wheel and discussing her itinerary with Douglas. She also got an opportunity to meet the founder of an organization known as Allanstand Cottage Industries—Frances Goodrich—and her sister.[32]

By the time Ulmann came to photograph Frances Goodrich, she had undoubtedly heard numerous stories about the humble and generous seventy-eight-year-old Presbyterian mountain missionary (fig. 46). Goodrich had first come to the mountains in 1890. Over the ensuing decades, she had worked in several mountain communities around Asheville, founded Allanstand Cottage Industries, and directed the annual exhibitions of Allanstand handicrafts. A few years before she sat for Ulmann, Goodrich gave Allanstand Cottage Industries to the fledgling Southern Highland Handicraft Guild. This gift provided the young organization with the financial and operational foundations it needed.[33]

After photographing Frances Goodrich, Ulmann headed out to photograph O.L. Bachelder, the founder and sole potter of Omar Khayyam Pottery, just south of Asheville in the small community of Candler, and also Bachelder's fellow potter, W.B. Stephens, the founder and sole potter of Pisgah Forest Pottery in West Asheville.[34]

Fig. 46. *Frances Goodrich, Social Worker, Women's Board of Home Missions, Presbyterian Church, and Founder of Allanstand Cottage Industries, North Carolina*, 1934. Posthumous gelatin silver print. Printed by Samuel Lifshey, ca. 1934–1937. Stamped signature of Doris Ulmann. Collection of University of Kentucky Art Museum, No. 98.6.150.

On July 29, Ulmann and Niles headed southeast to the community of Saluda, North Carolina, near the border with South Carolina, in order to photograph the Anderson family. The Andersons were known for their fine hooked rugs, and Eaton was, by his own admission, "really anxious for Mrs. Ulmann to get this subject."[35] Ulmann did find and photograph the Anderson family, and Eaton included one of her photographs of the family in his text on handicrafts.[36]

Although these trips around Asheville and to and from Saluda were very productive, they took their toll on both Ulmann and Niles and left Ulmann in a very poor state of health. Upon their return to the Battery Park Hotel in Asheville on July 31, Niles wrote Rena Lipetz and described their journey as "five days in mud and underbrush."[37] Exhausting as their journey had been, it induced Ulmann and Niles to reflect on the future. Niles noted this in his field notebook on the same day. His remarks provide important insights into the photographer's concerns. "Today Doris and I talked a long while, while resting, about next years work. God knows what will happen to me. My opera may never come back to me at all. . . . Doris wants to live through next year so she can see the dedication of the Berea Gallery, although only a few pictures will be finished. She wants to see the premiere of my opera and also see that Mrs. J. C. [Olive Campbell at the John C. Campbell Folk School] has the money to build the boys' building and the little hotel."[38]

With Niles's increasing help, Ulmann worked around Asheville for a few more days. Nonetheless, her health got progressively worse, and she became unable to use her camera. Finally, at the insistence of the private nurse who had traveled with the photographer most of the summer, Niles contacted Ulmann's personal physician, who was vacationing in Scranton, Pennsylvania. He instructed Niles and the nurse to bring Ulmann to him as soon as possible.[39] That night, with chauffeur George Uebler and her servants following in her large Lincoln, Niles drove Ulmann to a hotel in Winston-Salem, North Carolina. The next day, they traveled through Martinsville, Roanoke, Lexington, Stanton, and Harrisonburg, and stopped at a hotel in Winchester, Virginia.[40]

On the tenth of August, they drove to Harrisburg, the capital of Pennsylvania, where they stayed at the Harrisburger Hotel. Writing to Olive Campbell the next morning, Ulmann seemed resigned to her situation:

We have done the only sensible thing which is to get within reach of my Doctor. It seems too bad that when there was just a little work to be done, I had to succumb to all this nonsense and simply could not go on. I know that you really ought not do anything when running a temperature. I fear that I have given everybody a great deal of trouble on this trip northward—Jack has been very sweet and thoughtful and I fear that I have worried him a few times. We will arrive at Scranton this afternoon and then I shall be able to see my Dr. Hensel.

He may not be particularly pleased with me but I know that he will help me. My writing is scrimbly because I am writing in bed.[41]

Once Ulmann and her party arrived in Scranton, they checked into the Hotel Casey. Her personal physician stabilized the photographer as best he could, but her rapid deterioration continued, bringing a sense both of despair and of fatalism to her companion, John Jacob Niles. In correspondence with Rena Lipetz on August 13, he wrote from Scranton: "Ulmann is frightfully ill and had to be taken to her doctor. . . . My car being a closed car was selected . . . and as usual I have the nerve-rack of taking a practically dying woman to Scranton and then to New York. . . . I expect to be in New York by the end of this week, or maybe Monday for sure. If Doris Ulmann does not get better she will have to go to the local hospital. . . . If she gets better she goes home to New York. . . . If she dies, . . then that is all there is to it."[42]

Though Niles was undoubtedly "very sweet and thoughtful," as Ulmann recounted in their journey from Asheville, her deteriorating health made him reevaluate the security of his future.[43] Over the past couple of years, he had become financially dependent on Ulmann and had come to enjoy her patronage and support. Being anxious about Ulmann's future and his own, Niles pressed the photographer to prepare a testamentary document in order to make some provision for him. The same day Niles wrote Rena Lipetz, Ulmann composed a brief bequest for the musician.[44] George Uebler later mailed a copy of this document to Ulmann's friend Lyle Saxon. It was Uebler's hope that this document would entice Saxon to join him in challenging Niles's claim to this bequest.[45] Though Saxon did initially respond to Uebler, he appears to have avoided the later legal feud over the authenticity of Ulmann's bequest to Niles.[46] The extant copy of this handwritten bequest indicates that it consists of three sheets of stationery from the Hotel Casey of Scranton, Pennsylvania. These three sheets (two smaller than the other) appear to have been adhered to each other. There is a deep and distinctive crease that crosses the center of the two largest sheets. At the very top of the sheets is written "Room 818" (possibly in the hand of a witness). In the center of the documents is written, "Last Will and Testament" in Ulmann's hand, and beneath this the following words: "All my plates, prints, and photographic outfit is to go to John Jacob Niles 26 East 94th Street. As it will be expensive to arrange all this, I wish $10,000 to be left to John Jacob Niles. Doris Ulmann," also in Ulmann's hand. Directly beneath Ulmann's signature appears the signature and address of the witness to this act, first on the same sheet in which the will was written and then on another sheet that has been adhered. Both attestations are by the same hand, very likely the same hand that wrote at the top of the larger sheet. The signature and address read: "John Pavick [or Panick] 701 Main St., Duryer, Pa."[47]

What Uebler did not tell Saxon was that he had also threatened to black-

mail Ulmann about some incident in the past in order to get monies for himself.[48] This threat devastated the photographer, evoking anger as well as guilt. She revealed this in a hastily scribbled note to Niles written four days before her death. "Never never do anything in your life that will lay you open to the kind of crucifixion I am going through at this very moment. But if I die, for God's sake let me rot in Peace for I'll put a voodoo curse on anyone who ———— me out or drags my reputation or my sister's peace of mind into an unfortunate and undignified position."[49]

Although George Uebler later protested to Lyle Saxon that the bequest composed for Niles in Scranton had been coerced (and it is likely Niles had pushed Ulmann to put something in writing), Ulmann's positive remarks about Niles, her continued association with him, and her previous generosity to the musician suggest she had always intended to include him in her final will and testament. Ulmann verified this on August 21 when she signed a much more complete will that a lawyer had devised at her request.[50]

Seven days later, in the early hours of the morning of August 28, 1934, the fifty-two-year-old Ulmann passed away in her apartment at 1000 Park Avenue. Dr. Joseph Goldstone, the attending physician, reported the cause of death to be a kidney abscess and blood poisoning.[51]

The following day, in accord with her personal wishes and Jewish tradition, Ulmann's body was interred in crypt 2 in the Ulmann family mausoleum in plot 15 of section 6 of the historic Mt. Pleasant Cemetery in Hawthorne, Westchester County, New York, a resting place for many Jewish families, only some thirty-five minutes from downtown Manhattan.[52]

News of Doris Ulmann's death spread quickly among those who had known her. Her end brought an outpouring of emotion from many different people. Writing to John Jacob Niles a few days after the photographer's death, Dr. William J. Hutchins, president of Berea College, offered a poignant eulogy: "In Miss Ulmann one found a singular gentleness and grace, a self-abnegation joined with an amazing human interest. I question whether any woman has walked under the trees of our campus or visited our home who has identified herself more closely than she with the lives of our boys and girls. It is fortunate indeed that before her passing she was able to capture and hold forever before the American public these portraits of types which may pass all too soon from the American scene." An article in the *Pictorial Photographers of America Bulletin* focused more on her professional accomplishments.

> In the passing of Miss Ulmann the world and America . . . lost one of the most valuable and best photographers of this decade. She has been valuable to America because she has not only made splendid, faithful photographs of a great many of the important men of our time but for years has taken trips through the Carolinas, Alabama,

Tennessee, Virginia, and other states to study and photograph the white mountaineers and the negroes.

. . . Miss Ulmann was a charter member of the Pictorial Photographers of America, The Town Hall Club, and American Women's Association.[53]

Various accounts of Ulmann's last days, of her relationship with John Jacob Niles, and of the cause of her death also spread. Unfortunately, self-interest and rationalization dominated some of these reports. This is particularly obvious in the stories of Ulmann that Peterkin shared in her correspondence with their mutual friends. Peterkin's guilt over her separation from Ulmann during the last years of Ulmann's life led her to portray herself as "the source" for "the truth" about Ulmann's relationship with Niles, the photographer's final days, and her death.

In Peterkin's first letter to Lyle Saxon, she recounted that Dr. Arnold Koffler (Ulmann's former boyfriend) had initially contacted her. Writing to Saxon on September 12, 1934, Peterkin wrote: "I left Bread Loaf [Bread Loaf Conference Center for Writers], Vermont as soon as a message from Arnold Koffler told me she [Ulmann] was near death. . . . she was dead when I got to her . . . I came on home after seeing her body placed in a receiving vault [the family mausoleum] away out in the country. I loved Doris. I shall miss her sadly even though I realized two years ago that our paths lay far apart. I know too that she loved me."[54]

The day after Peterkin wrote Saxon, she received correspondence from him indicating he had received from George Uebler a letter about Ulmann's relationship with Niles. She responded to Saxon that day:

I'm sorry George wrote you . . . about Doris. It is simply too painful to think about. I think she did love me right up to the last, but she was not allowed to see me. I was to blame, maybe, but I could not help resenting the man who seized upon her like some horrible leech, never to let go until he had gotten what he aimed from the start to get, her property. I plead with her once, only once, to save herself from his clutches. Poor child, she had not the strength, maybe not even the will to do so. . . .

Of course, it seems a pity that a scoundrel should have all her work in his filthy hands, but even that seems better to me than to have her name and reputation smirched more than it already is. . . . Never as long as I live shall I forget how her little dead face looked. So puzzled, so hurt, so pitifully fragile.[55]

Peterkin continued her dramatic portrayal of the death of Ulmann in another account she prepared for Cammie Henry, the owner of Melrose Plantation

in Louisiana, around the same time. Responding to a letter of condolence from Henry, Peterkin wrote:

> Doris left a will made within an hour of her death leaving all she had to the gigolo. Only yesterday did I get a contract dividing *Roll, Jordan, Roll* into two shares which allowed me to own alone the trade edition and to release to her estate the deluxe one. That whole circumstance, in fact her last days are still incredible to me. I know the newspapers are forever filled with accounts of wickedness, but for defenseless little Doris to be the victim of a scoundrel is so shocking to me still, I cannot make my mind take it in.[56]

John Jacob Niles's different versions of Ulmann's last days also reveal the musician's self-interest. Once Niles realized Ulmann was near death, he began to keep a journal of each day's events. In this record, typed in part on Western Union telegram forms, Niles chronicled Ulmann's declining health, his activities with her and her entourage as they made their way back to her residence in New York, her construction of a new will, and his visit with the photographer at her Park Avenue apartment. Though certainly slanted in its author's favor, this early journal provides the most complete report of the last two weeks of Doris Ulmann's life. Niles's account of the last nine days, from August 20 to August 28, is especially informative:

> Monday: She spoke to me about the Lawyer and I called a friend of mine and asked him to suggest a lawyer . . . he said I should go to Charles Furnald Smith at 40 Broadway. I called him. Tuesday afternoon Doris was so well that the lawyer and his Sect and I called on Doris and she went thru the will and made the necessary changes and signed it and it was notarized and all settled.
> Wednesday: She was quite well.
> Thursday: The same.
> Friday: She was perhaps not so well. The Doctor was at a loss to understand what was the matter with her . . . he said she had not energy to come back . . . The thing that hung over her was the threat of George, who said he had something on her and that he could prove it in black and white . . . she worried all the time about this. On this afternoon . . . she dictated me a lot of directions for Harry Necarsulmer . . . I took them down on a sheet of her paper.
> Friday night: She is much worse . . . she has a definite pilitous and is very ill.
> Saturday: Very much worse . . . I brought in my dulcimer and played music for her. I discovered to day that she wanted to talk to Mooney about firing George. . . .

Sunday: Telegram that Doris was very low. . . . Come at once Doris going . . . Saw her a little while . . . Dr. G. says she can not last three days more.

Monday: They did many things for her to day. . . . blood transfusion and water in the tissues and stimulants every half hour in hyperdermic form. . . . I saw her for one brief moment. She recognized me and reached to put her arms around me. It was too heart breaking. I had to go at once . . . Johanna would not let me stay as she feared trouble with George. . . .

Tuesday morning: 2:40 a.m. . . . Doris Ulmann died quietly. Johanna called me and said . . . It's all over. . . .[57]

A much later account of these events, written by John Jacob Niles as part of his autobiography, is substantially different from his earlier version. In a typed and edited section entitled "Last Chapter in Volume One," composed in January 1976, when Niles was eighty-three years old, Niles substantially embellished his role in the drama of the final two days of Ulmann's life through the means of both narrative and poetry.

The day of August 27th, 1934 arrived with a hot clear sky . . . I arrived at Doris's apartment at 8:00 a.m. As I entered the elevator I saw that Doris's doctor was there, too. So, before I went into her room the doctor and I had a long talk. He told me that at her state of illness and with such an advanced case of uremic poisoning, there was not much medicine could do but try to keep her comfortable. He intended to ban all callers from here on, except me, Doris's niece, the lawyer who drew up her will, an estate agent, and Mrs. John C. Campbell if she arrived in time.

August 27, 1934, was the last day of Doris Ulmann's life.
It was also the longest day in my life.
It seemed to be a day that had no beginning,
But it was a day that had a tragic conclusion.
On August 27, 1934
I had my first opportunity to observe death,
Death creeping slowly over a loved one.
I was quite sure that death was in the room with us.
In the early part of the day Doris seemed
A little more alert than she'd been before.
But as the sun settled down among the smoky fogs
That forever clutter Manhattan's lower horizon
Doris's coherence became less and less.

I sat on the right-hand side of her bed.
Her right hand lay quietly in my left.
I read all the Poems I had ever written.
Some of them were the poems I had read to Gertrude Stein.
A few had been written during my first days in Manhattan.
Several of them had suffered the Algonquin ridicule.
There was no ridicule on the evening of the 27th of August.
The nurse had been on duty a space of time.
I indicated her to go aside and rest.
The stillness was uncanny beyond description.
My listening was sharp to find a disturbing note.
I imagined myself once more a boy at home,
Where accommodations were simple, even stark,
Where hounds oft bayed their problems to the moon.
But here no sound of horn that might encourage hound
To lacerate the earth where walked Renard,
No wail of child a searching mother's breast,
Nothing in or out of Music's fine tune,
Nothing came to my ears but the city's hum.
I heard only silence that now was solitude,
And knowing how cruel solitude could ever be,
I waited hoping for a sound that might slowly seep
Through a slaunchwise tear in destiny's thin tissue.
Seconds hastened minutes, and minutes hastened hours,
And I began repeating half-aloud, The lyrics of a song I had just written:
>I pronounced your name,
>But the city and the leaden sky were ever the same,
>Unmoved and ever so silent of reply . . .
>But, my love, it shall not ever be,
>Even though the nextest tick of time's your last,
>Though the hand that holds my hand so tenderly . . .
>Is destined to surrender all its strength
>And, lifeless lie . . . limply in my warm hand.
The bell in St. Patrick's Cathedral had chimed away the night.
When a nurse appeared with a goblet of water and a tablet.
With a nurse's intuition she put down the glass,
She put down the useless tablet, too.
And down went the nurse's hand to catch the dying pulse,
And down went my heart as I watched the nurse's face.
The nurse went out, and a worried doctor came in.
His stethoscope studied Doris's heart with care.
And then he studied the pulse in her feet.

And suddenly there was nothing for medicine to do.
No elixir, no bandage, no poltice and nary a pill.
Only her right hand taken from my left
And laid gently beside the dead body of a wonderful woman,
And a linen sheet draped lightly up over her face.
The end had come and it seemed ever so sudden,
Though it had been coming a long, long while. . . .
I walked out of the house and I walked northward on Park Avenue.
And paused a moment in quiet contemplation:
A young man and a young woman stood in a tiny patch of darkness
Tightly twined as if they were but one.
Behind me in an apartment house numbered one thousand.
Doris, my love, lay dead, while a few yards further north, Youth was
sweetly planning to encumber the world. With a new life to take the
place of the old. I looked at my watch. It was exactly 2:00 o'clock.
August 28th had just begun.[58]

Interestingly enough, George Uebler's account to Lyle Saxon, self-interested as it is as well, seems to provide several significant facts about Niles's relationship with Ulmann. He had first contacted Saxon on September 4, but Saxon, either unable to read Uebler's handwriting or to understand the broken English in his letter, had asked Uebler to get someone to help him rewrite it.[59] On September 10, Uebler mailed Saxon a new letter. Among other things Uebler wrote:

I was traveling with my Miss Ullmann from April 15th till August 16th and I was in Kentucky, Tennessee, Murphy, N.C., Ashville. Mr. Niles was Miss Ullmann's friend 2 and ½ years, the right name of this Gentleman is Gigolo, and you know why. This man takes all money, automobile, apartment for $125.— a month, telephone, all food, clothing, neckties, shoes and a charge account on Miss Ullmann's bank, from Ullmann's money. That's a Gigolo. He treats my Miss like a dog. He makes out in Scranton a testament for himself all pictures and photograph apparatus (valued $40,000.— and $10,000.— in cash, when Miss Ullmann died.) Miss Ullmann was not fit. She looks dopey. The man John Panick in the Hotel must sign this testament. The man called me and said to me; "what's the matter with the Lady? She is [very] sick! I signed the paper." I go to Miss Ullman's room and Mr. Niles was in there, and I said; "what's going on here?" You make a monkey business of this Testament; the Lady is not fit." Miss Ullmann asked him to return the papers, which he refused to do and tore up the paper. She gave it back to Niles and he gave it to me and he said to me; "now go back to this boy downstairs, and tell him it's

no more good." I put the pieces together and enclosed I send you a copy of the original, which I have in my possession. This way I am saving $50,000.— for Miss Ullmann's sister.

You asked me about Mrs. Peterkin? She knows everything about this matter, and if you write to her you can get the necessary information directly. Miss Ullmann broke her nice friendship with Mrs. Peterkin on account of latter's warning to her about the character of this man. Same way Dr. Koffler at 302 W. 86th St. N.Y.C. warned her about this man.

My Miss Ullmann paid a high prize for this friendship. She had an abscess in her left side and was undernourished and died August 28th of this year. Except the Doctor and nurse, no relatives or any other person was at her bedside when she died.

Mr. Saxon, I am glad that you will come to New York next October and I hope that we shall meet, while you are here. I hope that Miss Ullmann left something for us too in her "will."[60]

Because Henry and Edna Necarsulmer had been in England since April, they were unaware that Ulmann had prepared a new will that substantially changed her 1927 will. In her 1927 will, Ulmann had established her sister Edna as the primary beneficiary. Other beneficiaries had included several relatives: her niece, Evelyn Necarsulmer; her cousin, Doris Gertrude Ulmann; relatives Karl Josephthal and Annelise Josephthal; her former servant and friend Katchen Schunk; her servants Elsa Pechner, Dora Hechtle, and Clara Hechtle; and several Manhattan institutions, including Lenox Hill Hospital, the Society For Ethical Culture, the Hudson Guild, the Haven Kindergarten, and the Art Center. In contrast to this earlier will, Ulmann's new will included few of these beneficiaries and established several new ones.[61]

There is no question that these substantial changes shocked Edna and Henry Necarsulmer, led them to assume Ulmann's association with Niles had permitted him to manipulate her, and led them to contest the new will. As her older sister and primary beneficiary, Mrs. Necarsulmer felt her younger sister should have consulted her. As her legal executor and brother-in-law, Mr. Necarsulmer undoubtedly felt the same way.

Among other things, Ulmann's new will suggested Ulmann and her sister had grown apart since the first will had been constructed. The changes also indicated that Ulmann herself had changed and had come to believe her substantial estate should be used to do more than satisfy the wishes of her sister and brother-in-law. Her sister had already been a primary beneficiary in their father's estate and in their uncle Ludwig Ulmann's estate, and she had received hundreds of thousands of dollars from each.[62] Ulmann's new will revealed she had come to believe that others needed her money more than her family. Time and again this

had been made clear to her, particularly as she traveled through the back roads of Appalachia. And it was Olive Dame Campbell and the people she had seen on her journeys in the mountains who had really helped her see this.

Despite the vociferous protest of her sister and her brother-in-law, there is no evidence that Ulmann's final written will, prepared but a few days before her death, represented anything but her own wishes. It was her desire that Berea College in Kentucky be a repository for her Appalachian photographs and have the financial means to construct a permanent gallery to house and exhibit them. It was her wish to give her companion and lover of the past two and a half years, John Jacob Niles, her photographs and photographic equipment and an annual supplement to the small income he garnered from musical performances and from royalties for his compositions. She loved him, for all his flaws. His companionship had meant much to her and had sustained her in the very trying times of the past few years. Ulmann indicated this very clearly in a note she composed to the musician on August 24, only days before her death. She wrote: "Make people happy as you have made me happy."[63]

Most of all, Ulmann hoped to help Olive Dame Campbell and the Appalachian boys and girls who attended the John C. Campbell Folk School in the mountains of southwestern North Carolina. In the John C. Campbell Folk School in Brasstown, North Carolina, Ulmann found a community of people and an institution where she could help and could make a lasting contribution. As impressed as she had been with President Hutchins and the distinguished faculty of Berea College, the community and leadership of Berea had not moved her and touched her as had the community and leadership of the John C. Campbell Folk School. This is why Ulmann left the preponderance of her estate to the Folk School. She wanted to do so. Because the personalities of the mountain people who lived around it and the personalities of its director, Olive Dame Campbell, and the assistant director, Marguerite Butler, who had united with the highland people around Brasstown to found a school for the development and study of indigenous mountain arts and crafts, had had a profound impact on the photographer.

The serious conflict over Ulmann's final will continued into the fall of 1934. Edna Necarsulmer, Ulmann's sister, tried to get Julia Peterkin to help her contest the will, but Peterkin refused. Writing on October 3 to Irving Fineman, Peterkin complained: "Doris' sister writes urging me to meet her in Washington. She wants to talk to me since she wants Doris's will . . . broken. I'm not interested. It's none of my business and I shall keep out of it entirely."[64]

John Jacob Niles also did everything he could to protect his own position. Writing to Dr. Hutchins of Berea in the middle of November, Niles complained about Ulmann's relatives and asked Hutchins to send him any letters she had

written either to him or to Helen Dingman, who taught sociology at the college. "We are still having trouble with the few remaining relatives of Doris Ulmann. They took no interest in her work during her life, but seem now to desire to run her affairs . . . so they are trying to halt the procedure of probating her will. . . . It will help matters if you would send me any letters Miss Ulmann wrote you." Hutchins responded quickly and sent Niles "copies of all communications received from you [Niles] and from Doris Ulmann."[65]

Niles also wrote to others he thought might be able to provide assistance and support in his legal struggle with Ulmann's relatives, including Sarah Gibson Blanding, Dean of Women at the University of Kentucky. In a response to his query, dated November 25, 1934, Blanding offered to send two letters Ulmann had written her and gave support and encouragement to the musician. She wrote:

How utterly wretched to be having difficulties over the settlement of Doris's estate. If there is anyone among my acquaintances who knows her mind as completely as Doris Ulmann did hers, I fail absolutely in remembering her. I have two notes of hers which I am sending you. I doubt if there is anything in them which will be of use but I am sending them on nonetheless. . . . I resent the fact that any of her wishes should be frustrated. I know too, without ever being told, that she was utterly and completely devoted to you and to the sort of thing you were accomplishing. She glorified so in it all! I remember, so well, the tone of her voice as we drove over from Berea . . . when she spoke to me of you and the joy she took in your work.[66]

By early February 1935, the attorneys for the Necarsulmers (Doris Ulmann's closest relatives), John Jacob Niles, the John C. Campbell Folk School, and the United States Trust Company had formulated "written agreements" that they believed would satisfy the four respective parties and settle the controversy over the final will.[67] As president of the board of directors of the Campbell Folk School, Olive Dame Campbell called for a special meeting of the school's board in order for the board to approve or disapprove these "written agreements."[68] The meeting took place on February 7, 1935, in the office of the school's attorney, Ralph Rounds, in New York.

According to the handwritten notes of board member J.R. Pitman, the Folk School board approved these "written agreements" at this meeting. Pitman outlined what he labeled "Essential Features" in his notes.

Essential Features
15,000 to Berea-fund for special purpose
10,000 to Fund to care for Mrs. Ulmann's photos
80,000 Trust Fund for J. J. Niles—to yield yearly income $3,500.

Of the residual Estate—
> 25% goes to Mrs. Necarsulmer (sister)
> 75% to the School (in trust)
> Note—the School's portion estimated to rep. at least $200,000
> net. Niles share and the School's to be held as a common trust
> fund by the U.S. Trust Co.—Niles to receive income $3,500 per
> year, balance to School

At Niles' death his Trust Fund is divided—
> 25% to Mrs. Necarsulmer
> 75% to the School

Cost of legal expense for School in securing settlement $15,000 +
expenses

The fund and use of photos to be handled by a committee of five—
> Mrs. J. C. Campbell; Miss Marguerite Butler, Mr. Eaton, Jack
> Niles, and some one to be appointed by Mr. Necarsulmer. Nega-
> tives, probably, to be stored at Columbia.

<div align="right">J.R.P.[69]</div>

Although the Agreement of Settlement diminished the total amount of monies Ulmann's August 1934 will had stipulated that the John C. Campbell Folk School receive, Olive Campbell and the school's board of trustees were pleased with the settlement.

Campbell was not surprised that Ulmann had, as she had said, "remembered" the school. Ulmann had repeatedly expressed her affection for Campbell and the staff and students, and in her last few letters to Campbell and in their last meeting, Ulmann had expressed her desire to provide substantial help to the struggling institution.

But it is unlikely, however, that Campbell had had any idea that Ulmann had made provisions to "remember" the Folk School in her will as she did and to bequeath as much as she did to the institution. Certainly the "details" of Ulmann's will came as a surprise and made them open to negotiation with the Necarsulmers.

In the end, the Campbell Folk School received over four hundred hundred thousand dollars, a tremendous amount of money in the Depression years of the mid-1930s.[70]

The interest income from the Ulmann bequest made a significant contribution to the school's annual budget from the very beginning.[71] Most importantly, along with the numerous platinum and gelatin silver photographs that line the wall of the Keith House at the school and are in the school museum, Doris Ulmann's bequest has served as a living legacy of her affection for a people and a place that brought her a sense of peace and hope in the last years of her life.[72]

—⁓—

Once John Jacob Niles's bid as a legitimate claimant to Ulmann's estate had been legally established in the compromise legal agreement of February 1935, he felt he had escaped serious scrutiny about his relationship with Ulmann and his role in her work. Guaranteed a certain amount of income each year, as well as a role on the board of the Doris Ulmann Foundation, Niles could easily have taken the money, turned his back on the past, and let the truth be buried with the artist. Certainly, Niles must have thought about this. He was quiet about his relationship to the artist for many years. But he seemed unable to maintain this posture—either for reasons of guilt or because he felt a desire to exaggerate his role in her work, or perhaps both. In any case, he was inadvertently assisted by the early deaths of Edna and Henry Necarsulmer, Ulmann's closest relatives.[73] By the mid-1950s, following the transfer of thousands of Ulmann's extant glass-plate negatives and several photograph proof books to the Special Collection Department of the University of Oregon, Allen Eaton's alma mater, and the resurgence of interest in Ulmann's work, Niles began to speak about the details of his involvement with her and her photography.[74] Over a period of years, Niles also composed his autobiography, which included a section on his association with the photographer that contained a number of embellishments. Among other things, Niles wrote that he and Ulmann began their association and intimate relationship a few days after their first purported meeting at the Grand Street Follies in 1925.[75] Niles further claimed he and Ulmann began to make journeys into Appalachia in the summer of 1928.[76] He also declared that he was Ulmann's primary guide on most of her photographic expeditions into Appalachia as well as on most of the trips she made to South Carolina and Louisiana during this six year period.[77] The sum of Niles's assertions were both bold and imaginative—essentially he said that without him as her guide, Ulmann would never have photographed the Appalachian and southern peoples she did, and the world would never have discovered these wonderful vanishing types of the true America.

Unfortunately, many people and scholars believed Niles's tales of his relationship, role, and work with Ulmann.[78] Niles maintained that the photographer seldom engaged in written correspondence and implied that he, as Ulmann's longtime associate and confidant, was the only person who could provide an accurate account of her story.[79] This led to many incomplete and inaccurate reports about Ulmann, her art, and her relationship with Niles. But it did what Niles desired. It allowed him to control the story and kept him in the very spotlight that he so desperately loved. However, Niles's accounts provided only a preliminary sketch of the artist's life, personality, and work and significantly distorted the truth.

Ulmann's and Niles's actual correspondence, as well as other pertinent documents, suggest a very different picture from the one constructed by Niles's later accounts. They suggest that a close association between Ulmann and Niles only began in early 1932, some seven years later than Niles stated.[80] They also sug-

gest, as noted earlier, that Niles's personal commitment to Ulmann was less than he claimed.[81]

Still, there is no question that Niles did much to assist Ulmann in her later photographic expeditions into the mountains and helped her maintain her determination to provide important social documents of a generation of Americans who were rapidly disappearing. A photograph of Niles carrying Ulmann across Cutshin Creek in Kentucky is indicative of the physical contribution he made to the photographer, who had, by the time of the photograph, become quite frail. Although at times Niles did go off on his own in search of new mountain songs and ballads, he was often a "workhorse" for Ulmann's expeditions, driving her in the new Chevrolet she had purchased for him, or in another car, or riding on horseback with her to isolated locations, carrying boxes of her glass plates and her camera and other photographic apparatus, enabling her to travel deep into the hills and mountains in order to get photographs of unrecognized artisans and their handicrafts.[82]

Niles also acted as an amanuensis for Ulmann, communicating on her behalf with William J. Hutchins, Allen Eaton, Orie Latham Hatcher, as well as others about travel plans, prospective photographic subjects, exhibits, and other matters. This permitted the photographer to save her energies for the work before her and to focus on her principal mission.[83]

Despite his obvious personal flaws and the limitations of his personal commitment to Ulmann, Niles also unquestionably provided company for her, intimate physical and psychological companionship, offering some of the attention and affection she sought. He also understood and appreciated the photographer's work, which he felt to be beautiful and important. Ulmann was well aware of Niles's weaknesses: his propensity for exaggeration and braggadocio, his ability to offend her friends and acquaintances, and his self-centeredness. Nonetheless, "Johnnie," as Ulmann often called Niles, was great company to have around, and it flattered her that he stayed with her, putting up with the difficulties of her own life and the idiosyncratic behavior of her servants and friends.[84]

<div align="center">⇥⇤</div>

Shortly after the "written agreements" pertaining to the settlement of Ulmann's estate were approved by the respective parties in early February of 1935, Allen Eaton—a member of the advisory committee that the agreements had established and a staff member of the Russell Sage Foundation—sent notice to other members of the advisory committee that a meeting of the committee would be held at the office of New York attorney Ralph Rounds on February 28. According to Eaton, the purpose of the meeting was "to provide for the organization of the Committee, the adoption of by-laws or rules of procedure, and to take action upon such other matters, as may be brought before the Committee."[85]

Only three members of the advisory committee (Allen Eaton, Henry

Necarsulmer, and John Jacob Niles) were able to be present in New York for this first meeting. Olive Dame Campbell and Helen Dingman were present by proxy that they had given to Allen Eaton and the attorney. In the meeting, the "written agreements" between the respective parties, designated as the "Deed of Trust," which had been approved on February 7, were "presented and examined" and placed into "the minutes of this meeting."[86]

Following this, the advisory committee discussed and unanimously approved several resolutions. Among other things, these resolutions reconstituted the advisory committee as the Doris Ulmann Foundation, established Olive Dame Campbell as permanent chairman of the foundation, Allen Eaton as vice chairman and treasurer, and John Jacob Niles as secretary, and adopted a "Plan of Procedure for the activities of the Foundation."[87]

The foundation's Plan of Procedure called for the completion of several tasks, including the following:

> The exposed plates of the 1934 season be developed and a set of permanent proofs of good negatives made. Finished prints from the 1934 negatives shall be made as soon as possible to meet the needs of the Russell Sage Foundation, Berea College, and the John C. Campbell Folk School, and to present to those who posed for or assisted in the making of the portraits and any other prints needed to carry out Mrs. Ulmann's commitments.
>
> The negatives taken by Mrs. Ulmann during the season of 1933 (all of which we think she developed) shall be like-sized numbered and permanent proofs made from all those which the Foundation shall choose, and the negatives and prints filed as in the case of the 1934 subjects.
>
> One set of finished prints of handicraft and related subjects shall be made available to the Sage Foundation as soon as possible, and the Foundation shall make arrangements for others (as necessary for Berea College and the John Campbell Folk School).
>
> All other negatives in Mrs. Ulmann's collection shall be numbered and permanent proofs made from the good negatives to guide the Foundation in selecting subjects for whatever purposes, and for permanent record.
>
> In the above suggestions it is intended to cover the completion of all undeveloped negatives and the making of one permanent proof from each of Mrs. Ulmann's important negatives. The Foundation will have to decide what the important negatives are and while the simplest way would seem to be to have a print made from each negative, it being understood that in a number of cases there are duplicates and possibly imperfect plates which it will seem desirable to

discard. Some of this can perhaps be done without making proofs from every negative, through the co-operation of the photographer who does the work, but proofs should be made of every subject about which there is any doubt. By this method the Foundation will have before it proofs of all Mrs. Ulmann's important work.

The Foundation should choose all the prints that will be needed to carry out the conditions of the will and what is thought to be Mrs. Ulmann's wish in regard to disposing of prints to special individuals.

The only prints to be given away, without further order of the Foundation, are those for Berea College, the John C. Campbell Folk School, the Russell Sage Foundation, the prints for the subjects of the photographs and the sixty prints to be selected by Mrs. Necarsulmer's family. . . .

The prints formerly sent to the Library of Congress and now held By the American Railway Express Company shall be given to the Library of Congress, except so far as the Library may be entirely satisfied to release a part to the Foundation.

Berea College is to have as complete a collection of prints as it desires, to be made at its expense. We should encourage this to be a definitive collection of Mrs. Ulmann's work.

All the prints which were made by Mrs. Ulmann should be given a distinctive mark [a grayish-black raised ink stamp of the name Doris Ulmann] so that they will not be confused with prints made later by others from her negatives.[88]

After the foundation's members had agreed on their Plan of Procedure, they examined "samples of the proofs and prints" that the accomplished Brooklyn portrait photographer Samuel H. Lifshey had created "in the development and printing of Mrs. Ulmann's plates" and discussed "a memorandum stating the terms on which he is willing to continue to work under the supervision of the Foundation." Following their examination of his work, the members unanimously agreed to employ Lifshey "to continue the work of developing and printing."[89]

Once Lifshey and the committee of the foundation had come to terms, he began the work of producing prints from the approximately three thousand undeveloped plates exposed on Ulmann's last trips into the mountains of western North Carolina and eastern Tennessee and Kentucky.[90] Lifshey also developed a complete set of proof prints from Ulmann's previously developed and undeveloped glass plates.[91] However, two obvious encumbrances lay before him. First, unlike Ulmann, for whom expense had never been an object, the committee's financial constraints limited the effort Lifshey could put into his processing of the proofs and prints and also the materials he could use to print the photographs from the three thousand plates from Ulmann's last work. Second, unlike

Ulmann, who took a great deal of time to develop proofs and final prints from her glass plates, Lifshey faced time constraints, which the committee had established in order to carry out some of the stipulations of Ulmann's will. The several thousand proofs and the few thousand prints had to be finished within a relatively short period.

Despite these and other limitations, Lifshey fulfilled his commitment to the committee of the Doris Ulmann Foundation and accomplished an important task that enabled later students of Ulmann to gain a fuller understanding of her personality, aesthetic philosophy, and photographic oeuvre. He did an extraordinary job of processing the large volume of Ulmann's undeveloped glass-plate negatives, and, as can be seen in the images that have been preserved, capturing her singular sense of light, mood, and character.[92] His efforts, fostered by the request in Ulmann's will, and by the foundation committee which hired him, have never been fully recognized and appreciated.[93] They deserve further study and evaluation.

The first meeting of the foundation also included a discussion of the storage of the photographic plates and prints. Although these items were being stored at Columbia University, University officials had asked that the items be moved by the end of 1935.[94] In light of this, the foundation members authorized Eaton and Niles to make "arrangements with the University authorities and/or with others for the care and safeguarding of the plates, prints, photogravure plates, frames, cardboard, materials and other things received from Mr. Henry Necarsulmer and now in custody of the University, and of any other plates and prints which may be received by the Foundation, and may themselves, or by their authorized agent, take and remove any or all of said articles in the custody of the University."

Once this authorization had been granted, the subject of photographs for Berea College was discussed. "Mr. Niles presented a letter to him from President Hutchins of Berea College, dated January 21, 1935, which makes it clear that the College plans to pay the cost of printing the pictures to be given to the College, using for that purpose a part of its bequest; and Mr. Niles stated that he believed this was Mrs. Ulmann's wish and understanding."

After the matter was clarified, the foundation board "resolved, that for the present, and subject always to vote of the members of the Foundation, John Jacob Niles is authorized to take on behalf of the Foundation such steps as are necessary to carry out the 'Plan of Procedure' adopted, subject to the directions given by the Foundation."[95]

While all the members of the Doris Ulmann Foundation initially sought to honor their commitment to the foundation, distance limited the frequency with which Olive Dame Campbell and Helen Dingman could attend meetings, and thus limited their direct influence on the actions of the board.[96]

The second meeting of the foundation, on March 14, was less lengthy.

Only two members were able to be present (Allen Eaton and John Jacob Niles). Olive Dame Campbell and Helen Dingman were again represented by a proxy that they had given to Allen Eaton and the attorney, Ralph Rounds. Henry Necarsulmer was present by a proxy that he had given to Charles Looker.

In this meeting, the foundation's board concurred with Eaton's decision that withdrawal of the Ulmann photographic plates be limited to John Jacob Niles, Samuel Lifshey, and Eaton himself. The board further "resolved that the John C. Campbell Folk School is authorized to make use or publication as it may wish of any prints which it now has" in its brochures and leaflets.[97]

The third meeting of the foundation, on May 13, was also limited in its scope. Only three members—Allen Eaton, Henry Necarsulmer, and John Jacob Niles—were able to be present. For the third time, Olive Dame Campbell and Helen Dingman were present by a proxy given to Allen Eaton and the attorney, Ralph Rounds. In the absence of Campbell, Eaton once again acted as chairman of the board, reporting that he had visited the Library of Congress and had examined the Ulmann prints the foundation had given to the library and that he had removed some photographs of handicrafts and other subjects. At the same meeting, the board authorized John Jacob Niles to assist Mrs. Frederick Issacs, editor of the *Theater Arts Magazine,* in preparation for a memorial issue in honor of Doris Ulmann.[98]

The fourth meeting of the Doris Ulmann Foundation took place on July 12, 1935. Only Allen Eaton and John Jacob Niles were able to be present for the meeting. Curiously, neither Henry Necarsulmer nor his proxy was present for this meeting.

Eaton requested the foundation provide financial assistance to the Russell Sage Foundation for the reproduction of Ulmann photographs for his forthcoming book, *Handicrafts of the Southern Highlands.* In response to his request, the board "Resolved that the Doris Ulmann Foundation request the Russell Sage Foundation to make the regular edition of the Handicraft book as adequate in illustrations, both as to number and type of reproduction as is consistent with the objective of the book and that the Doris Ulmann Foundation cooperate as far as it is able to help bring about such a publication." They also agreed to help pay for the illustrations if their costs exceeded expectation. The members of the foundation also authorized Eaton to select at his discretion several of the prints for reproduction in two or three of the most likely processes, so as to determine the best method of reproduction for the proposed book. The expenses for this were to be paid out of the funds of the foundation.

Following the resolution, Eaton reported on the work Lifshey and Niles were doing with the Ulmann negatives. He praised their work and expressed his belief that "the development is completed and more than half of the proofs have been printed from the plates."[99]

Another meeting of the Doris Ulmann Foundation took place on October 15,

1935. Allen Eaton and John Jacob Niles were the only members of the Foundation able to be present in person. As was customary by this point, Olive Campbell and Helen Dingman were unable to attend and thus represented through a proxy that they had given to John S. Chapman Jr. Henry Necarsulmer was once again present by proxy that he had given to Charles Looker. Eaton began the meeting by reporting that Samuel Lifshey had almost completed developing the plates and making proofs.

Later, on behalf of Henry Necarsulmer, Looker "stated that it was Mr. Necarsulmer's suggestion that the prints signed by Doris Ulmann . . . be turned over to Berea College as part of its collection. The meeting endorsed this in principle, but both Mr. Eaton and Mr. Niles pointed out the fact that some of the signed prints might be of such quality that a new print would be preferable for Berea College's collection, and also that some of the signed prints might be of subjects not desired by Berea."

The foundation met only occasionally after this time, and few records of these meetings remain.[100]

Despite repeated requests from officials at Columbia that the foundation remove the thousands of glass-plate negatives, albums of proof prints, photographs, and other materials stored at the university library, the items remained there until 1954.[101] Faced with an ultimatum from library officials in 1953, Allen Eaton authorized Samuel Lifshey to sort and destroy many of Ulmann's glass-plate negatives.[102] While it is tragic that thousands of Ulmann's plates were destroyed, it is possible that *all* of the plates and proof prints would have been destroyed if Eaton had not acted as he did.

After Lifshey had completed his work at the library, Eaton arranged for the shipment of seventy-three albums of proof prints, 150 mounted vintage photographs, and over three thousand glass-plate negatives to the Special Collections Department of his alma mater, the University of Oregon in June 1954.[103] A short time later, at the invitation of Columbia's Assistant Director of Libraries Charles Mixer (and certainly with the blessing of Allen Eaton), officials of the New-York Historical Society removed over three thousand vintage photographs taken by Ulmann.[104]

Unfortunately, the distribution of Ulmann's works by the Doris Ulmann Foundation divided most of the collection among three geographically distant centers: Berea College in Berea, Kentucky; the New-York Historical Society in New York City; and the University of Oregon in Eugene. However, under the guidance of Allen Eaton and the Doris Ulmann Foundation, much of the work of this extraordinary photographer was preserved for posterity.

~--~

In her art and in her life, Doris Ulmann sought, as Felix Adler had suggested, to convert reality "by active intervention" and thus to "reconstruct" what she be-

lieved to be an unjust and inequitable society. Through her photographic por-
trayal of "various American types" and her bequests to two Appalachian schools,
Ulmann affirmed her "faith in the worth of every human being" and her belief
that "differences of type contribute importantly to a democratic society."[105]

It was this faith and belief that led her to look beyond the common preju-
dices of her day, to step beyond the walls of her comfortable world, and to take
repeated journeys between 1925 and 1934 into the villages, hamlets, and homes
of Appalachians, African Americans, and Native Americans. It was this faith and
belief that led her to seek to reveal to her affluent world the humanity and dig-
nity of the people she met and photographed. Her work, her photography, her
art, demonstrate that she fulfilled her goal and accomplished this task and was,
as Allen Eaton wrote, "an American artist of ability and devotion who found in
the people of her country, regardless of their station and circumstances, inspira-
tion and hope which she has interpreted through a medium that we can all
understand."[106]

Catalogue of Images

Note: Catalogue images without measurments given are 8½" x 6½" or 6½" x 8½".

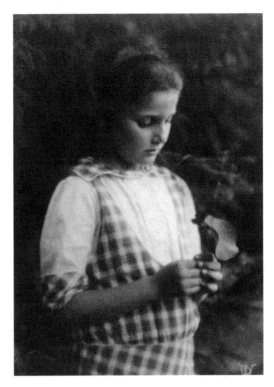

Plate 1. *Evelyn Necarsulmer Holding Leaves*, 1916. Platinum print. $6^9/_{16}$" x $4^{11}/_{16}$". Audio-Visual Archives, Special Collections and Archives, University of Kentucky Libraries, 96 PA 104, Box 1, No. 17.

Plate 2. Dr. Royal Whitman, 1916. Platinum print. 5" x 7". Audio-Visual Archives, Special Collections and Archives, University of Kentucky Libraries, 96 PA 104, Box 3, No. 88.

Plate 3. *In Salem*, 1917. Platinum print. Private collection, Paris, Kentucky.

Plate 4. *Young African American Dockworker,* 1917. Platinum print. 6⁵/₈" x 4¹¹/₁₆". Audio-Visual Archives, Special Collections and Archives, University of Kentucky Libraries, 96 PA 104, Box 3, No. 107.

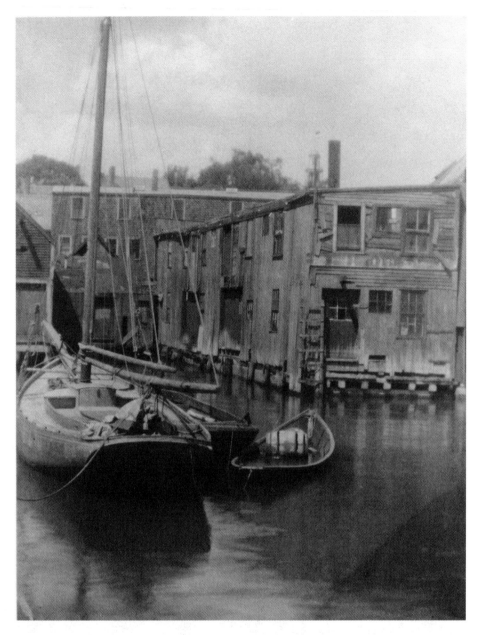

Plate 5. *Harbor, Gloucester, Massachusetts*, ca. 1917–1920. Platinum print. Audio-Visual Archives, Special Collections and Archives, University of Kentucky Libraries, 96 PA 104, Box 1, No. 52.

Plate 6. *Youth Working on Docks, Gloucester, Massachusetts*, ca.1917–1920. Platinum print. Audio-Visual Collections, Special Collections and Archives, University of Kentucky Libraries, 96 PA 104, Box 2, No. 60.

Plate 7. *At Work,* ca. 1918–1919. Oil transfer print. Collection of the University of Kentucky Art Museum, No. 88.10.52.

Plate 8. *Young Boy with Sailboat*, ca. 1918–1921. Platinum print. Audio-Visual Collections, Special Collections and Archives, University of Kentucky Libraries, 96 PA 104, Box 1, No. 31.

Plate 9. *Columbia University in the City of New York*, ca. 1918–1920. Platinum print. John C. Campbell Folk School.

Plate 10. *Playing on the Dock*, ca. 1916–1925. Oil pigment print. Collection of the University of Kentucky Art Museum, No. 88.10.49.

Plate 11. *The Poem,* ca. 1918–1925. Oil transfer print. Private collection.

Plate 12. *Young Boy on Wagon*, ca. 1918–1925. Oil pigment print. Private collection, Paris, Kentucky.

Plate 13. *Shadows in the Light*, ca. 1918–1925. Oil pigment print. John C. Campbell Folk School.

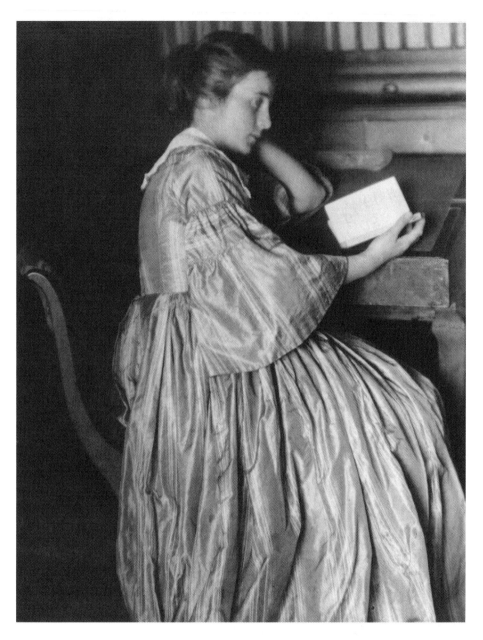

Plate 14. *Young Woman at Desk*, ca. 1916–1925. Platinum print. Collection of the University of Kentucky Art Museum, No. 88.10.17.

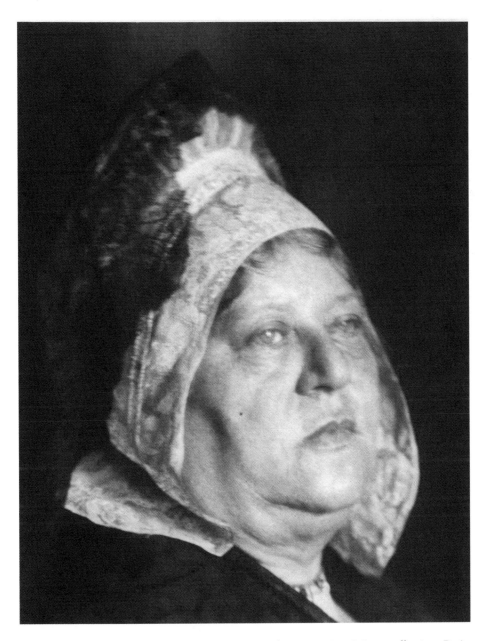

Plate 15. *Woman with Headdress*, ca. 1918–1925. Platinum print. Private collection, Paris, Kentucky.

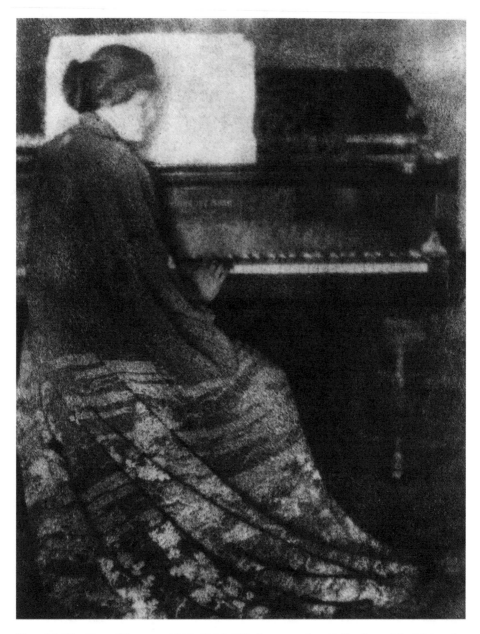

Plate 16. *The Piano Player*, ca. 1918–1926. Oil pigment print. Collection of the University of Kentucky Art Museum, No. 87.39.6.

Plate 17. *Young Woman, First View*, ca. 1916–1925. Oil pigment print. Collection of the University of Kentucky Art Museum, No. 87.39.4.

Plate 18. *Young Woman, Second View*, ca. 1916–1925. Oil pigment print. Collection of the University of Kentucky Art Museum, No. 88. 10.18.

Plate 19. *Rabindranath Tagore, Hindu Poet, Scholar, and Artist*, ca. 1920s. Platinum print. Audio-Visual Archives, Special Collections and Archives, University of Kentucky Libraries, 96 PA 104, Box 4, No. 122.

Plate 20. *H.M. Wharton, Civil War Veteran, Writer, and Presbyterian Minister*, ca. 1920s. Platinum print. Private collection.

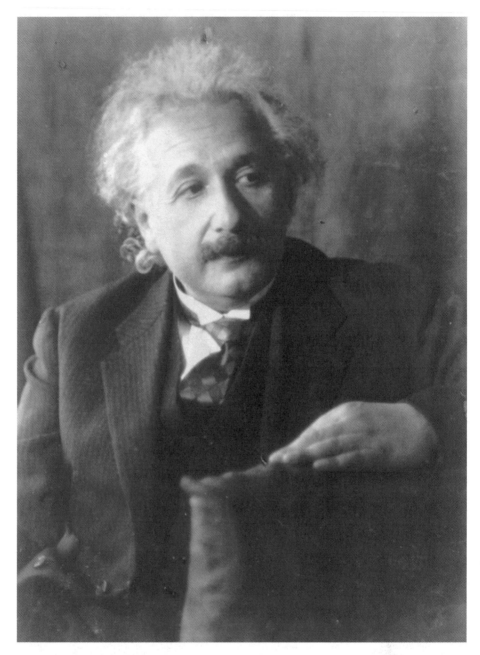

Plate 21. *Albert Einstein*, 1920–1925. Platinum print. Doris Ulmann Collection, Special Collections and University Archives, University of Oregon, CN 1417, No. 61.

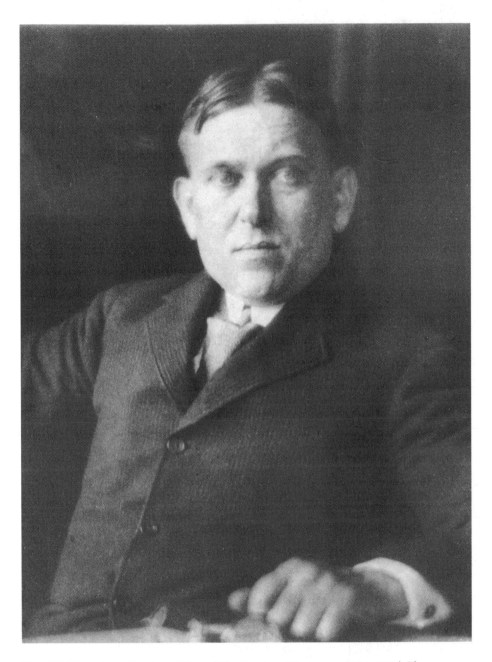

Plate 22. *Henry Louis Mencken, Editor of The American Mercury*, ca. 1923–1924. Photogravure after a platinum print. Published in *A Portrait Gallery of American Editors, Being a Group of XLIII Likenesses by Doris Ulmann*. John Jacob Niles Collection, Special Collections and Archives, University of Kentucky Libraries.

Plate 23. *Aunt John*, ca. 1925–1926. Platinum print. Collection of the University of Kentucky Art Museum, No. 87.39.60.

Plate 24. *Sisters Sarah and Adelaide, Shaker Settlement, Mount Lebanon, New York*, ca. 1925–1926. Platinum print. Collection of the University of Kentucky Art Museum, No. 88.10.62.

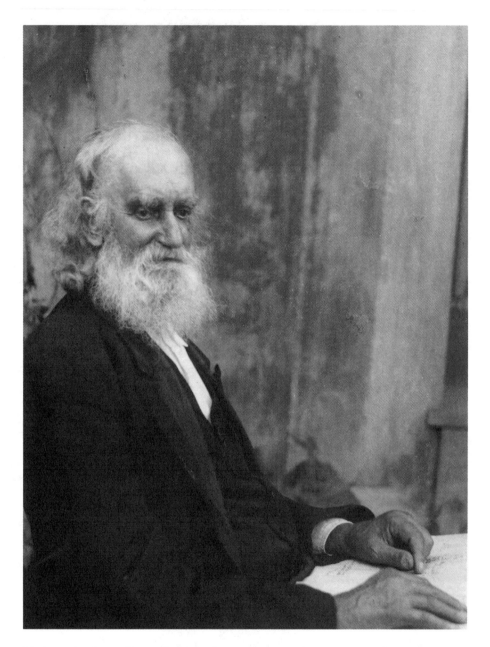

Plate 25. *Brother William, Shaker Settlement, Mount Lebanon, New York*, ca. 1925–1926. Platinum print. Collection of the University of Kentucky Art Museum, No. 87.39.30.

Plate 26. *Shaker Sister Adelaide of Mt. Lebanon, New York*, ca. 1925–1926. Platinum print. Private collection, Paris, Kentucky.

Plate 27. *Mennonite Woman,* ca. 1925–1926. Oil pigment print. Private collection, Paris, Kentucky.

Plate 28. *Mennonite Man,* ca. 1925–1926. Oil pigment print. Private collection.

Plate 29. *Monday,* ca. 1925–1929. Platinum print. Collection of the University of Kentucky Art Museum, No. 87.39.49.

Plate 30. *Old Gentleman*, ca. 1925–1930. Platinum print. Collection of the University of Kentucky Art Museum, No. 87.39.50.

Plate 31. *Richard Harrison, African American Actor*, ca. 1925–1932. Platinum print. Audio-Visual Archives, Special Collections and Archives, University of Kentucky Libraries, 96 PA 104, Box 3, No. 92.

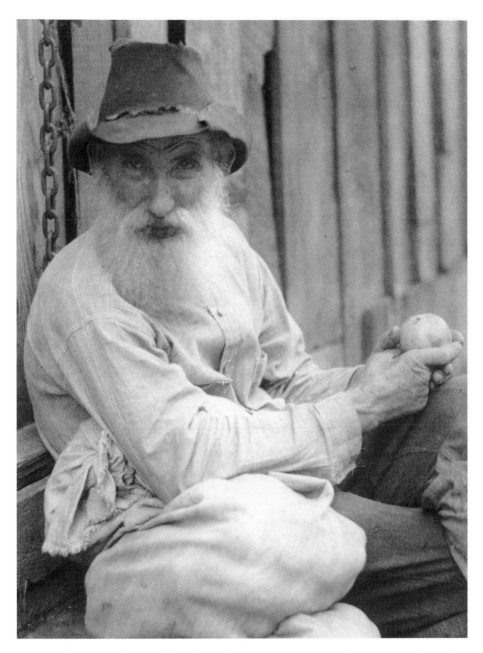

Plate 32. *The Apple Man*, ca. 1925–1933. Platinum print. Private collection, Paris, Kentucky.

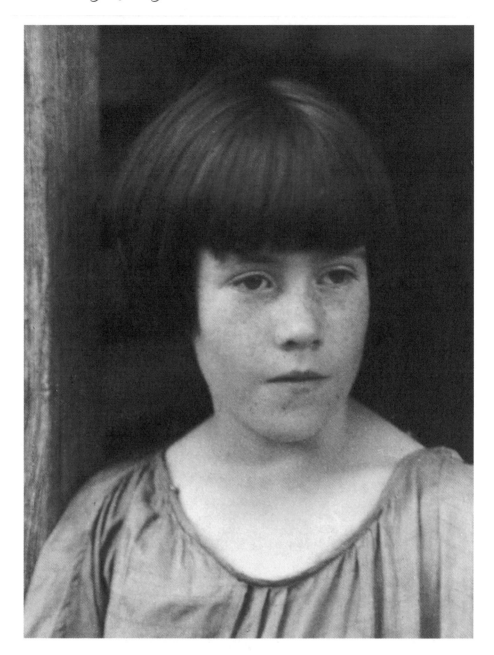

Plate 33. *Young Girl,* ca. 1926–1933. Platinum print. Collection of the University of Kentucky Art Museum, No. 87.39.12.

Plate 34. *The Gang, South Carolina*, ca. 1929–1932. Platinum print. South Carolina Historical Society, No. 33–110–45.

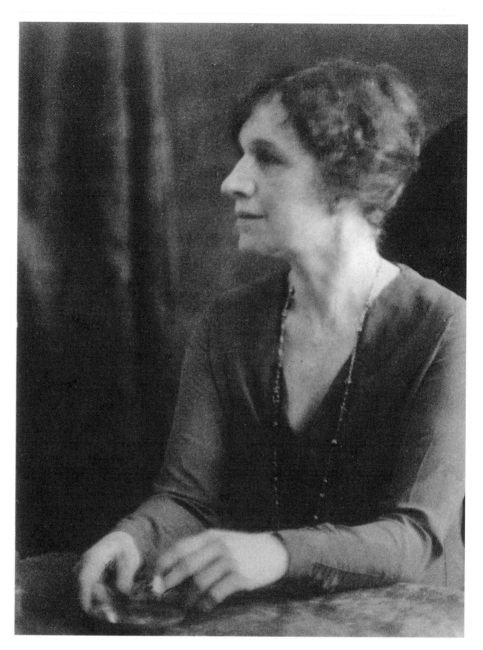

Plate 35. *Julia Peterkin, Pulitzer Prize–winning South Carolina Novelist*, ca. 1929–1931. Platinum print. South Carolina Historical Society, No. 33–110–17.

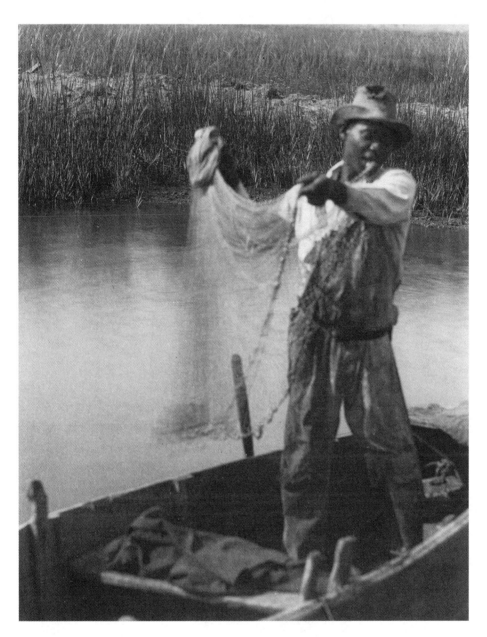

Plate 36. *African American Fisherman, South Carolina*, ca. 1929–1931. Platinum print. Collection of the University of Kentucky Art Museum, No. 88.10.65.

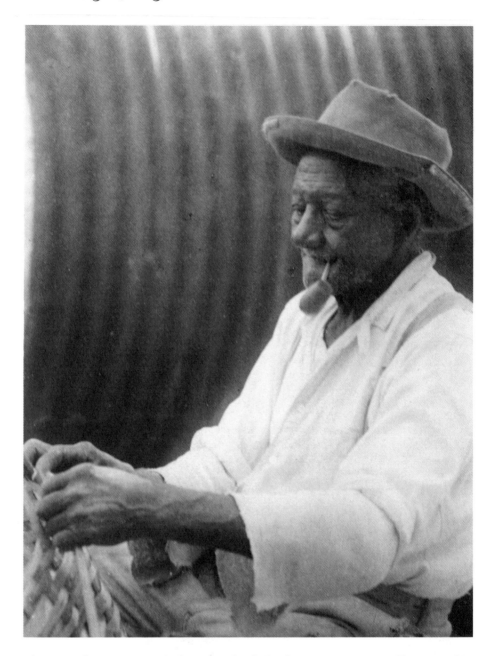

Plate 37. *African American Basketmaker, South Carolina*, ca. 1929–1931. Platinum print. Private collection, Paris, Kentucky.

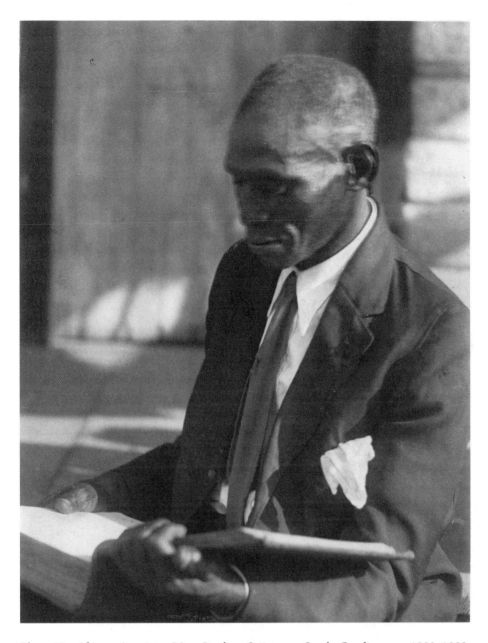

Plate 38. *African American Man Reading Scriptures, South Carolina,* ca. 1929–1932. Platinum print. Collection of the University of Kentucky Art Museum, No. 88.10.70.

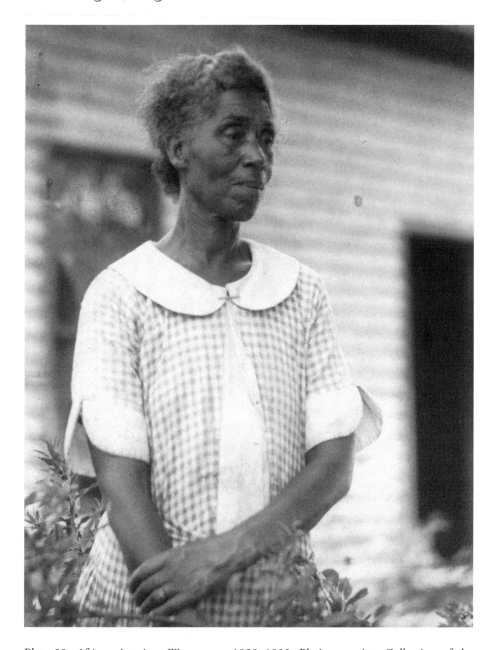

Plate 39. *African American Woman*, ca. 1929–1932. Platinum print. Collection of the University of Kentucky Art Museum, No. 88.10.66.

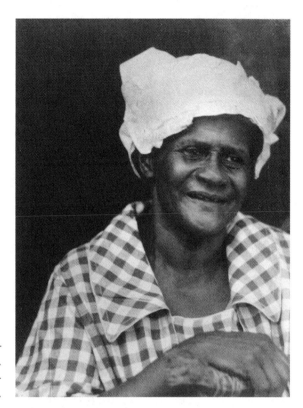

Plate 40. *African American Woman,* ca. 1929–1932. Platinum print. Collection of the University of Kentucky Art Museum, No. 88.10.19.

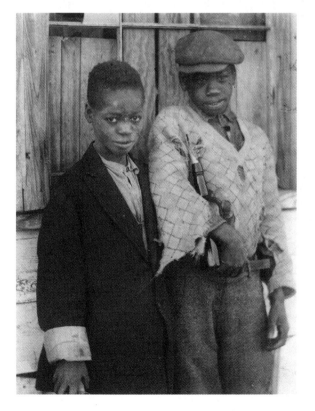

Plate 41. *African American Youth, South Carolina,* ca. 1929–1932. Platinum print. Collection of the University of Kentucky Art Museum, No. 88.10.22.

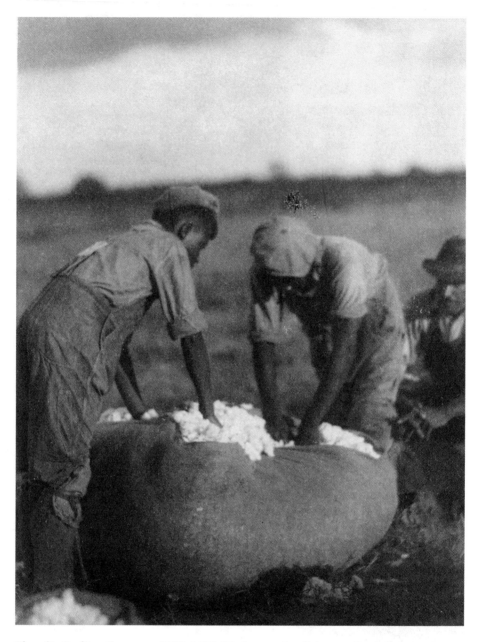

Plate 42. *Packing Cotton*, ca. 1929–1932. Platinum print. Private collection.

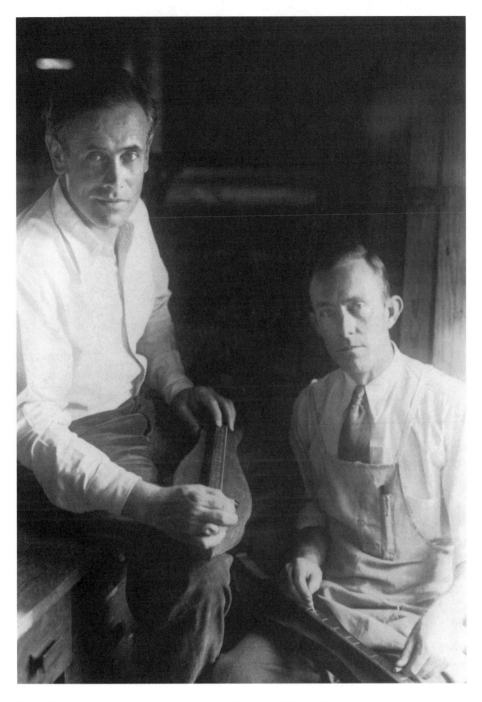

Plate 43. *Jethro Amburgey and John Jacob Niles,* ca. 1932–1934. Posthumous gelatin silver print. Printed by Samuel Lifshey, ca. 1934–1937. Doris Ulmann Collection, Special Collections and University Archives, University of Oregon, U 2655.

Plate 44. *John Jacob Niles Playing the Piano*, ca. 1932–1933. Platinum print. Audio-Visual Archives, Special Collections and Archives, University of Kentucky Libraries, 96 PA 104, Box 2, No. 68.

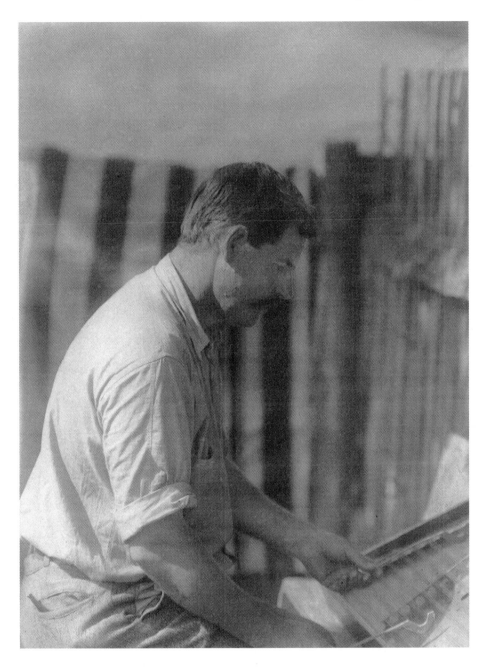

Plate 45. *Appalachian Man Playing Hammer Dulcimer*, 1932–1934. Platinum print. Private collection.

Plate 46. *Brasstown Baptist Church Sunday School Class*, 1933. Platinum print. Collection of the University of Kentucky Art Museum, No. 88.10.13.

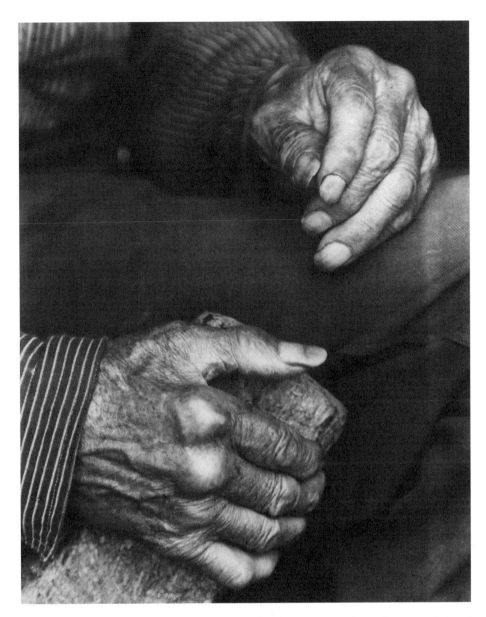

Plate 47. *Hands, Appalachian Man*, ca. 1933–1934. Posthumous gelatin silver print. Printed by Samuel Lifshey, ca. 1934–1937. Stamped signature of Doris Ulmann. Berea College and the Doris Ulmann Foundation, No. 2468.

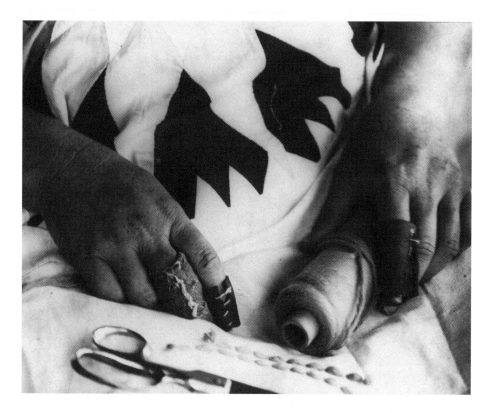

Plate 48. *Hands, Ethel May Stiles, Quilter, Ringgold, Georgia*, 1934. Posthumous gelatin silver print. Printed by Samuel Lifshey, ca. 1934–1937. Stamped signature of Doris Ulmann. Berea College and the Doris Ulmann Foundation, No. 44.

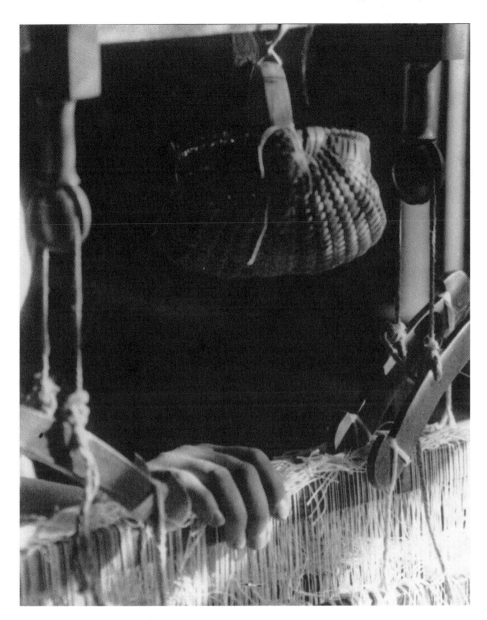

Plate 49. *Hand on the Loom, Berea, Kentucky*, ca. 1933–1934. Posthumous gelatin silver print. Printed by Samuel Lifshey, ca. 1934–1937. Stamped signature of Doris Ulmann. Berea College and the Doris Ulmann Foundation, No. 1290.

Plate 50. *Hands, John Jacobs Niles's and Louise Wilson's*, ca. 1933–1934. Posthumous gelatin silver print. Printed by Samuel Lifshey, ca. 1934–1937. Stamped signature of Doris Ulmann. Berea College and the Doris Ulmann Foundation, No. 6606.

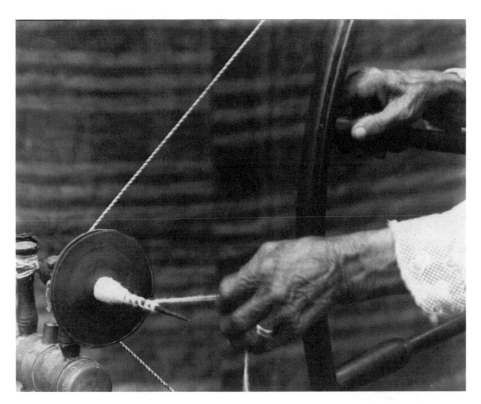

Plate 51. *Hands, Aunt Didie Netherly, Appalachian Weaver,* ca. 1933–1934. Posthumous gelatin silver print. Printed by Samuel Lifshey, ca. 1934–1937. Stamped signature of Doris Ulmann. Berea College and the Doris Ulmann Foundation, No. 2067.

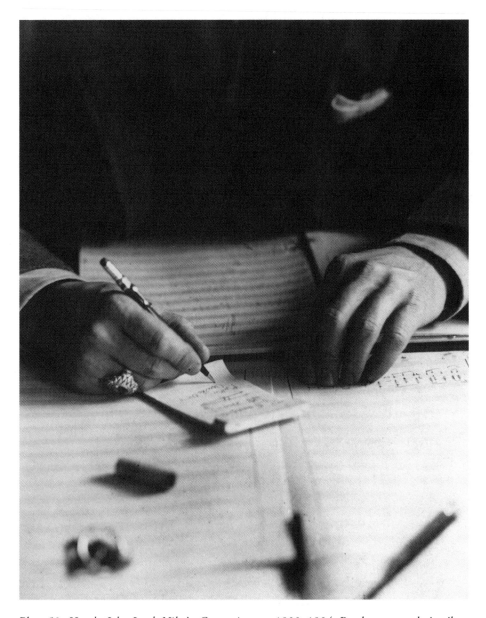

Plate 52. *Hands, John Jacob Niles's, Composing*, ca. 1933–1934. Posthumous gelatin silver print. Printed by Samuel Lifshey, ca. 1934–1937. Stamped signature of Doris Ulmann. Berea College and the Doris Ulmann Foundation, Berea, Kentucky, No. 1601.

Plate 53. *Men at Scroggs's Store, Brasstown, North Carolina*, ca. 1933–1934. Platinum print. John C. Campbell Folk School.

Plate 54. *Meader Family, Potters, North Georgia*, ca.1933–1934. Posthumous gelatin silver print. Printed by Samuel Lifshey, ca. 1934–1937. Doris Ulmann Collection, Special Collections and University Archives, University of Oregon, U 3244.

Plate 55. *Mrs. William J. Hutchins Looking at Album of Ulmann's Photographs,* ca. 1933–1934. Platinum print. Collection of the University of Kentucky Art Museum, No. 87.39.7.

Plate 56. *Anne May Hensley, Brasstown, North Carolina*, ca. 1933–1934. Platinum print. John C. Campbell Folk School.

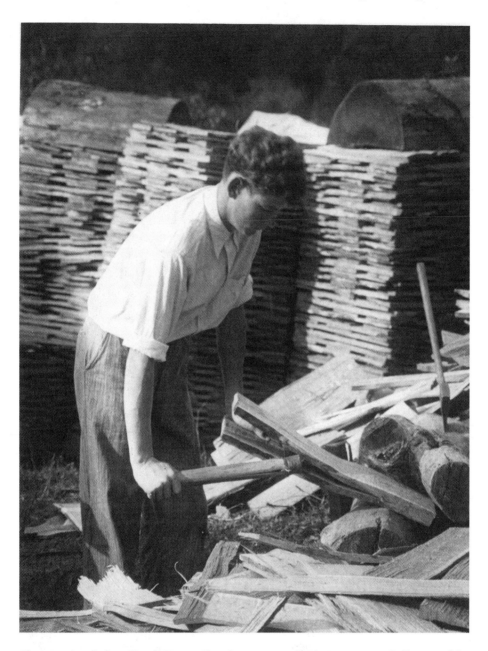

Plate 57. *Appalachian Youth Cutting Shingles*, 1933–1934. Platinum print. Collection of the University of Kentucky Art Museum, No. 88.10.38.

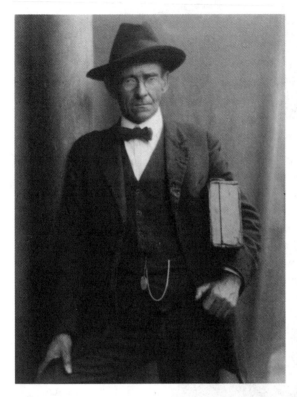

Plate 58. *Appalachian Minister*, ca. 1933–1934. Posthumous gelatin silver print. Printed by Samuel Lifshey, ca. 1934–1937. Audio-Visual Archives, Special Collections and Archives, University of Kentucky Libraries, 78 PA 101, No. 25.

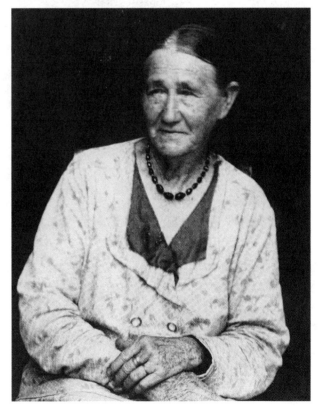

Plate 59. *Aunt Cord Ritchie, Kentucky,* ca. 1933–1934. Posthumous gelatin silver print. Printed by Samuel Lifshey, ca. 1934–1937. Private collection, Paris, Kentucky.

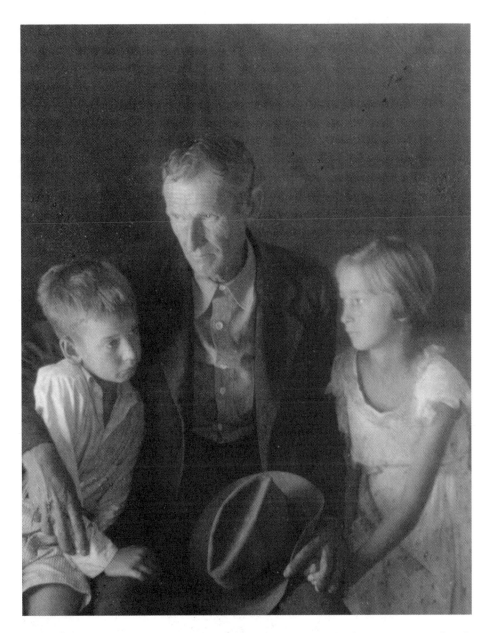

Plate 60. *Sam Carringer with Grandchildren*, ca. 1933–1934. Platinum print. John C. Campbell Folk School.

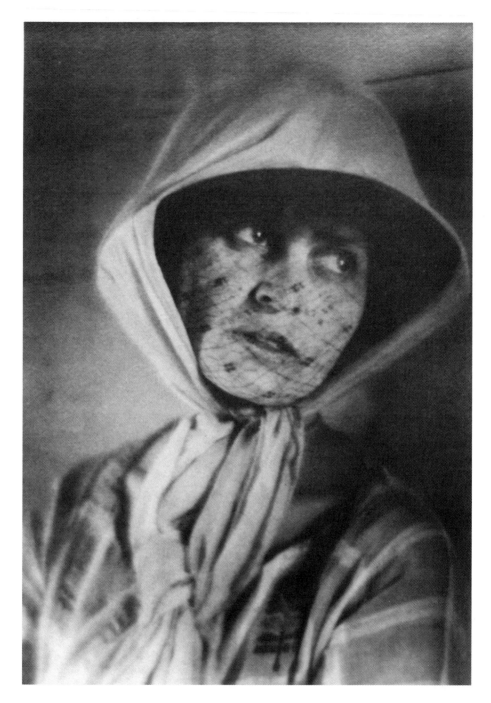

Plate 61. *Doris Ulmann in Veil*, 1933. Gelatin silver print. Carl Van Vechten. John Jacob Niles Collection, Special Collections and Archives, University of Kentucky Libraries.

Appendix One

A Selective List of Public and Private Collections Containing Photographs, Books, and Archives By and About Doris Ulmann

Arizona

Center for Creative Photography
The University of Arizona
Tucson, Ariz.
5 platinum photographs and photographic equipment, including tripods, lenses, film holders, 4" x 5" camera, 6½" x 8½" contact printing frame. Some of these materials were used by Ulmann, but some were bought for her late associate, John Jacob Niles. His wife, Rena Niles, donated the materials to the Center for Creative Photography in 1981.

California

Department of Photography
Los Angeles County Museum of Art
Los Angeles, Calif.
30 photogravures from the limited photogravure edition of *Roll, Jordan, Roll*.

J. Paul Getty Museum
Department of Photographs
Santa Monica, Calif.
171 platinum photographs, 1 limited photogravure edition of *A Portrait Gallery of American Editors*, and 1 limited photogravure edition of *A Book of Portraits of the Faculty of the Medical Department of the Johns Hopkins University, Baltimore*.

San Francisco Museum of Modern Art
Department of Photography
San Francisco, Calif.
2 platinum and 5 gelatin silver photographs and 1 photogravure.

Stanford University
Stanford, Calif.
1 copy of the limited photogravure edition of *A Portrait Gallery of American Editors*.

Connecticut

Yale University
Medical School Library
New Haven, Conn.
1 copy of the limited photogravure edition of *A Book of Portraits of the Faculty of the Medical Department of the Johns Hopkins University, Baltimore.*

University of Connecticut
Storrs, Conn.
1 copy of the limited photogravure edition of *Roll, Jordan, Roll.*

District of Columbia

Archives of American Art
Smithsonian Institution
Washington, D.C.
9 platinum photographs.

The Library of Congress
Prints and Photographs Division
Washington, D.C.
154 platinum photographs, mostly of Appalachian subjects; 1 copy of the limited photogravure edition of *Roll, Jordan, Roll,* and 37 photogravures from the limited photogravure edition of *A Book of Portraits of the Faculty of the Medical Department of the Johns Hopkins University, Baltimore.*

Library of Congress
Rare Books Division
Washington, D.C.
4 copies of the limited photogravure edition of *Roll, Jordan, Roll.*

National Portrait Gallery
Washington, D.C.
21 platinum photographs and 1 photogravure of Robert Frost from *Robert Frost,* by Sidney Cox.

Georgia

University of Georgia
Athens, Ga.
1 copy of the limited photogravure edition of *Roll, Jordan, Roll.*

High Museum of Art
Atlanta, Ga.
5 platinum photographs.

Illinois

Art Institute of Chicago
Chicago, Ill.
1 platinum photograph, 10 posthumous gelatin silver photographs, and 91 photogravures from the limited photogravure edition of *Roll, Jordan, Roll.*

University of Chicago
Chicago, Ill.
1 copy of the limited photogravure edition of *A Book of Portraits of the Faculty of the Medical Department of the Johns Hopkins University, Baltimore.*

Indiana

Indiana University
Bloomington, Ind.
1 copy of the limited photogravure edition of *A Portrait Gallery of American Editors.*

Kansas

University of Kansas
Medical Center Library
Kansas City, Kans.
1 copy of the limited photogravure edition of *Twenty-Four Portraits of the Faculty of Physicians and Surgeons of Columbia University.*

Kentucky

Doris Ulmann Photographic Collection and Doris Ulmann Manuscript Collection
Berea College
Berea, Ky.
2 platinum photographs, 3,160 posthumous gelatin silver photographs, and the archives, letters, and files of the Doris Ulmann Foundation.

Special Collections and Archives
King Library
University of Kentucky
Lexington, Ky.
203 platinum and gelatin silver photographs, 1 limited photogravure edition of *A Portrait Gallery of American Editors,* and archive of letters and files of John Jacob Niles Collection.

University of Kentucky Art Museum
Lexington, Ky.
332 platinum photographs, 23 oil pigment photographs, and 150 gelatin silver photographs.

John Jacob Niles Center for the Study of American Music
University of Kentucky
Lexington, Ky.
4 platinum photographs and 1 gelatin silver photograph.

Private Collection
Paris, Ky.
82 platinum photographs, 1 copy of the limited photogravure edition of *A Portrait Gallery of American Editors,* and 1 copy of the limited photogravure edition of *Twenty-Four Portraits of the Faculty of Physicians and Surgeons of Columbia University.*

Louisiana

Cammie G. Henry Research Center
Eugene P. Watson Memorial Library
Northwestern State University of Louisiana
Natchitoches, La.
17 platinum photographs, 1 copy of the limited photogravure edition of *Roll, Jordan, Roll,* and archive of letters and files.

The Historic New Orleans Collection
New Orleans, La.
53 platinum photographs, primarily of the Order of the Sisters of the Holy Family and of the Ursuline Sisters, two Catholic orders in New Orleans.

New Orleans Museum of Art
New Orleans, La.
4 posthumous gelatin silver photographs, 1 photogravure, and 1 incomplete copy of the limited photogravure edition of *Roll, Jordan, Roll* with only 75 photogravures.

Maryland

The Alan Mason Chesney Medical Archives
The Medical Department of the Johns Hopkins University
Baltimore, Md.
6 platinum photographs and 6 copies of the limited photogravure edition of *A Book of Portraits of the Faculty of the Medical Department of the Johns Hopkins University.*

Massachusetts

Museum of Fine Arts, Boston
Boston, Mass.
3 platinum photographs and 26 photogravures from the limited photogravure edition of *Roll, Jordan, Roll.*

Boston Public Library
Boston, Mass.
1 copy of the limited photogravure edition of *Roll, Jordan, Roll.*

Michigan

University of Michigan
Ann Arbor, Mich.
1 copy of the limited photogravure edition of *Twenty-Four Portraits of the Faculty of Physicians and Surgeons of Columbia University.*

The Colville Collection
1028 Stratford Place
Bloomfield Hills, Mich.
4 platinum photographs, 1 gum bichromate photograph, 2 lantern slides, and 1 limited photogravure edition of *A Portrait Gallery of American Editors.*

Minnesota

The Givens Collection
Special Collections and Rare Books Department
University of Minnesota Library
University of Minnesota
Minneapolis, Minn.
1 copy of the limited photogravure edition of *Roll, Jordan, Roll.*

New Mexico

Private Collection
Santa Fe, New Mex.
14 platinum photographs, 2 copies of the limited photogravure edition of *Roll, Jordan, Roll,* 1 copy of the limited photogravure edition of *A Portrait Gallery of American Editors,* and 1 copy of the limited photogravure edition of *Twenty-Four Portraits of the Faculty of Physicians and Surgeons of Columbia University.*

New York

Cornell University
Ithaca, N.Y.
1 copy of the limited photogravure edition of *Roll, Jordan, Roll.*

Rare Book Library
Columbia University
New York, N.Y.
1 copy of the limited photogravure edition of *Roll, Jordan, Roll* and 1 copy of the limited photogravure edition of *Twenty-Four Portraits of the Faculty of Physicians and Surgeons of Columbia University.*

International Center of Photography
New York, N.Y.
4 posthumous gelatin silver photographs and 26 photogravures from the limited photogravure edition of *Roll, Jordan, Roll.*

The Metropolitan Museum of Art
Department of Photographs
New York, N.Y.
5 platinum photographs, 1 bromoil photograph, and 1 photogravure from the limited photogravure edition of *Roll, Jordan, Roll.*

Museum of Modern Art
New York, N.Y.
3 platinum photographs, 1 gelatin silver photograph, and 91 photogravures from the limited photogravure edition of *Roll, Jordan, Roll.*

New-York Historical Society
New York, N.Y.
About 2,900 platinum photographs, about 100 oil photographs, and about 50 photogravures.

New York Public Library for the Performing Arts
New York, N.Y.
28 platinum photographs.

New York Public Library
Rare Books and Manuscripts Division
New York, N.Y.
1 copy of the limited photogravure edition of *Roll, Jordan, Roll*, 2 copies of the limited photogravure edition of *Twenty-Four Portraits of the Faculty of Physicians and Surgeons of Columbia University*, and 1 copy of the limited photogravure edition of *A Book of Portraits of the Faculty of the Medical Department of the Johns Hopkins University, Baltimore*.

New York Public Library
Schomburg Center for Research in Black Culture
New York, N.Y.
120 platinum photographs of African Americans and 1 copy of the limited photogravure edition of *Roll, Jordan, Roll*.

New York Public Library
U.S. History, Local History, and Genealogical Division
New York, N.Y.
1 copy of the limited photogravure edition of *Roll, Jordan, Roll*.

George Eastman House
Rochester, N.Y.
66 platinum photographs, 81 gelatin silver photographs, 1 copy of the limited photogravure edition of *Roll, Jordan, Roll*, and 1 copy of the limited photogravure edition of *A Portrait Gallery of American Editors*.

Syracuse University
Syracuse, N.Y.
1 copy of the limited photogravure edition of *A Portrait Gallery of American Editors* and 1 copy of the limited photogravure edition of *Twenty-Four Portraits of the Faculty of Physicians and Surgeons of Columbia University*.

North Carolina

John C. Campbell Folk School
Special Collections
Brasstown, N.C.
85 platinum photographs, 20 posthumous gelatin silver photographs, 15 oil pigment photographs, and archives of letters and files.

Private Collection
Brasstown, N.C.
26 platinum photographs, 22 gelatin silver photographs, 1 photogravure Christmas card, and 1 limited photogravure edition of *Roll, Jordan, Roll*.

Private Collection
Asheville, N.C.
4 posthumous gelatin silver photographs and 1 copy of the limited photogravure edition of *Roll, Jordan, Roll*.

Manuscripts Department
Library
University of North Carolina at Chapel Hill
Chapel Hill, N.C.
19 gelatin silver photographs.

Photographic Archives
University of North Carolina at Chapel Hill
Chapel Hill, N.C.
5 platinum photographs.

Wilson Library
Photographic Services Section
University of North Carolina at Chapel Hill
Chapel Hill, N.C.
3 platinum photographs.

Duke University Library
Special Collections Department
Durham, N.C.
40 platinum photographs of eastern Kentucky youth and adults taken in the summer of 1932 for the Southern Woman's Educational Alliance, and archives with letters and other materials pertaining to Ulmann's work in the Alliance for the Guidance of Rural Youth Collection.

Duke University Medical School Library
Durham, N.C.
1 copy of the limited photogravure edition of *Twenty-Four Portraits of the Faculty of Physicians and Surgeons of Columbia University and 1 copy of the* limited photogravure edition of *A Book of Portraits of the Faculty of the Medical Department of the Johns Hopkins University, Baltimore.*

North Carolina Division of Archives and History
Raleigh, N.C.
100+ copy negatives from an exhibit in the late 1970s.

Ohio

University of Cincinnati
Cincinnati, Ohio
1 copy of the limited photogravure edition of *A Portrait Gallery of American Editors.*

Cleveland Public Library
Cleveland, Ohio
1 copy of the limited photogravure edition of *Roll, Jordan, Roll.*

Ohio State University
Columbus, Ohio
1 copy of the limited photogravure edition of *Roll, Jordan, Roll.*

Oklahoma

University of Oklahoma Museum of Art
Fred Jones Jr. Memorial Art Center
Norman, Okla.
2 platinum photographs.

Oregon

University of Oregon
Special Collections
Eugene, Oreg.
10,200 proof prints in 75 albums and 5,168 glass plate negatives. I am unaware of any other holder of glass plate negatives. It was once believed that there was a substantial number of platinum and posthumous gelatin silver images in this collection, but the library staff has been unable to locate them.

Pennsylvania

Haverford College
Magill Library
Special Collections
Haverford, Pa.
1 platinum photograph, 1 copy of the limited photogravure edition of *Roll, Jordan, Roll,* and 1 copy of the limited photogravure edition of *A Portrait Gallery of American Editors.*

Athenaeum of Philadelphia
Philadelphia, Pa.
1 copy of the limited photogravure edition of *Roll, Jordan, Roll.*

Philadelphia Museum of Art
Alfred Stieglitz Center
Philadelphia, Pa.
15 gelatin silver photographs of Carl Van Vechten and 1 copy of the limited photogravure edition of *Roll, Jordan, Roll.*

Rosenbach Museum and Library
Philadelphia, Pa.
1 copy of the limited photogravure edition of *Roll, Jordan, Roll.*

University of Pennsylvania
Philadelphia, Pa.
2 platinum photographs, 1 copy of the limited photogravure edition of *A Portrait Gallery of American Editors,* and 2 letters.

Swarthmore College
Swarthmore, Pa.
1 copy of the limited photogravure edition of *A Portrait Gallery of American Editors.*

South Carolina

The Gibbes Museum
Charleston, S.C.
2 posthumous gelatin silver photographs and 2 photogravures.

South Carolina Historical Society
Charleston, S.C.
169 platinum photographs and 1 copy of the limited photogravure edition of *Roll, Jordan, Roll.*

South Caroliniana Library
The University of South Carolina
Columbia, S.C.
1 copy of the limited photogravure edition of *Roll, Jordan, Roll.*

Texas

Amon Carter Museum
Department of Photography
Fort Worth, Tex.
3 platinum photographs.

Menil Foundation
Houston, Tex.
2 platinum photographs and 1 posthumous gelatin silver photograph.

Washington

University of Washington
Seattle, Wash.
1 copy of the limited photogravure edition of *A Book of Portraits of the Faculty of the Medical Department of the Johns Hopkins University, Baltimore.*

Australia

National Gallery of Australia
Canberra, Australia
60 platinum photographs of African Americans.

Appendix Two

1916

An Exhibition of Photography, under the auspices of the American Institute of Graphic Arts. Main Gallery of the National Arts Club, East Nineteenth Street, New York, New York. October 4 to November 10, 1916. Exhibited: *The Blacksmith.*

1917

Exhibition of Photographs by the Alumni Association of the Clarence H. White School of Photography. The Print Gallery, 707 Fifth Avenue, New York, New York. February 1917. Exhibited: *Substance and Shadow* and *The Coal Worker.* This exhibition later traveled to The Neighborhood Playhouse, New York City; Princeton University; Vassar College; Normal College, Oneonta, New York.

An Exhibition of Pictorial Photography by American Artists [Western Group], Pictorial Photographers of America. The Minneapolis Institute of Arts, Minneapolis, Minnesota. September 1917. Exhibited: *Substance and Shadow, Dr. Jacobi, Dr. F. Adler.*

An Exhibition of Pictorial Photography by American Artists [Eastern Group], Pictorial Photographers of America. Newark Museum Association, Newark, New Jersey. October 1917. Exhibited: *The Gangway* and *Professor F. Adler.*

An Exhibition of Pictorial Photography by American Artists [Western Group], Pictorial Photographers of America. The Milwaukee Art Institute, Milwaukee, Wisconsin. October 1917. Exhibited: *Substance and Shadow, Dr. Jacobi,* and *Dr. F. Adler.*

An Exhibition of Pictorial Photography by American Artists [Western Group], Pictorial Photographers of America. Chicago Art Institute, Chicago, Illinois. November 1917. Exhibited: *Substance and Shadow, Dr. Jacobi,* and *Dr. F. Adler.*

An Exhibition of Pictorial Photography by American Artists [Eastern Group], Pictorial Photographers of America. New Britain Institute, New Britain, Connecticut. November 1917. Exhibited: *The Gangway* and *Professor F. Adler.*

An Exhibition of Pictorial Photography by American Artists [Western Group], Pictorial Photographers of America. City Art Museum, St. Louis, Missouri. December 1917. Exhibited: *Substance and Shadow, Dr. Jacobi,* and *Dr. F. Adler.*

An Exhibition of Pictorial Photography by American Artists [Eastern Group], Pictorial Photographers of America. Worcester Art Museum, Worcester, Massachusetts. December 2 to December 30, 1917. Exhibited: *The Gangway* and *Professor F. Adler.*

An Exhibition of Pictorial Photography of the Alumni of the Clarence H. White School of Photography. Clarence H. White School of Photography, 122 East Seventh Street, New York, New York. December 18, 1917, to January 12, 1918. Exhibited: *Peace and Sunshine, Design, The Old Wharf, Eventide,* and *Portrait.*

1918

An Exhibition of Pictorial Photography by American Artists [Eastern Group], Pictorial Photographers of America. Syracuse Museum of Fine Arts, Syracuse, New York. January 1918. Exhibited: *The Gangway* and *Professor F. Adler.*

An Exhibition of Pictorial Photography by American Artists [Western Group], Pictorial Photographers of America. Toledo Museum of Art, Toledo, Ohio. January 1918. Exhibited: *Substance and Shadow, Dr. Jacobi,* and *Dr. F. Adler.*

An Exhibition of Pictorial Photography by American Artists [Eastern Group], Pictorial Photographers of America. Guild of Allied Arts, Buffalo, New York. February 1918. Exhibited: *The Gangway* and *Professor F. Adler.*

An Exhibition of Pictorial Photography by American Artists [Western Group], Pictorial Photographers of America. Detroit Museum of Art, Detroit, Michigan. February 1918. Exhibited: *Substance and Shadow, Dr. Jacobi,* and *Dr. F. Adler.*

An Exhibition of Pictorial Photography by American Artists [Eastern Group], Pictorial Photographers of America. Grand Rapids Art Association, Grand Rapids, Michigan. March 1918. Exhibited: *The Gangway* and *Professor F. Adler.*

An Exhibition of Pictorial Photography by American Artists [Western Group], Pictorial Photographers of America. Cleveland Museum of Art, Cleveland, Ohio. March 1918. Exhibited: *Substance and Shadow, Dr. Jacobi,* and *Dr. F. Adler.*

An Exhibition of Pictorial Photography by American Artists [Eastern Group], Pictorial Photographers of America. New Orleans Art Association, New Orleans, Louisiana. April 1918. Exhibited: *The Gangway* and *Professor F. Adler.*

An Exhibition of Pictorial Photography by American Artists [Western Group], Pictorial Photographers of America. Cincinnati Museum of Art, Cincinnati, Ohio. April 1918. Exhibited: *Substance and Shadow, Dr. Jacobi,* and *Dr. F. Adler.*

Fifth Annual Pittsburgh Salon of Photography. Carnegie Institute, Department of Fine Arts, under the auspices of the Photographic Section of the Academy of Science and Art, Pittsburgh, Pennsylvania. March 4 to March 31, 1918. Exhibited: *The Orphan, The New Boat, The Beachcomber,* and *Wilfred, The Lute Player.*

1919

Sixth Annual Pittsburgh Salon of Photography. Carnegie Institute, Department of Fine Arts, under the auspices of the Photographic Section of the Academy of Science and Art, Pittsburgh, Pennsylvania. March 3 to March 31, 1919. Exhibited: *The Smith, Reverie, Long, Long Ago, At Work,* and *High Noon.*

An Exhibition of Pictorial Photography by Members of the Pictorial Photographers of America. Clarence H. White School of Photography, 122 East Seventh Street, New York, New York. April 1919. Exhibited: Oil and bromoil photographs in a group exhibition.

Second Annual Exhibition. Art Alliance of America and the American Institute of Graphic Arts, 10 East Forty-seventh Street, New York, New York. April 30 to May 24, 1919. Exhibited: Portrait photography in a group exhibition.

An Exhibition of 100 Prints from the 1920 Pictorial Photographers of America Annual, under the auspices of the Pictorial Photographers of America. Herron Art Institute, Indianapolis, Indiana. November 7 to December 7, 1920. Exhibited: *Portrait of a Child.*

An Exhibition of 100 Prints from the 1920 Pictorial Photographers of America Annual, under the auspices of the Pictorial Photographers of America. Michigan Art Association, Jackson, Michigan. December 10, 1919, to January 5, 1920. Exhibited: *Portrait of a Child.*

1920

Third International Photographic Salon, Camera Pictorialists of Los Angeles, under the auspices of the Gallery of Fine and Applied Arts. Museum of History, Science, and Art, Exposition Park, Los Angeles, California. January 3 to January 31, 1920. Exhibited: *Masts, Poplars, Gloucester, Frederick Villiers, At the Water Front,* and *Sunlight and Shadow.*

An Exhibition of Pictorial Photography, under the auspices of The Pictorial Photographers of America. The Art Museum, Portland, Oregon. January 10 to February 1, 1920. Exhibited: *Fish Handler* and *Reflections.*

An Exhibition of 100 Prints from the 1920 Pictorial Photographers of America Annual, under the auspices of the Pictorial Photographers of America. Boston Society of Arts, Boston, Massachusetts. January 15 to January 30, 1920. Exhibited: *Portrait of a Child.*

An Exhibition of 100 Prints from the 1920 Pictorial Photographers of America Annual, under the auspices of the Pictorial Photographers of America. Mechanics Institute of Rochester, Rochester, New York. February 5 to February 27, 1920. Exhibited: *Portrait of a Child.*

Seventh Annual Pittsburgh Salon of Photography. Carnegie Institute, Department of Fine Arts, under the auspices of the Photographic Section of the Academy of Science and Art, Pittsburgh, Pennsylvania. March 3 to March 31, 1920. Exhibited: *An Illustration.*

An Exhibition of 100 Prints from the 1920 Pictorial Photographers of America Annual, under the auspices of the Pictorial Photographers of America. Arnot Art Gallery, Elmira, New York. March 11 to March 28, 1920. Exhibited: *Portrait of a Child.*

An Exhibition of Pictorial Photography, under the auspices of The Pictorial Photographers of America. Dubuque Art Association, Dubuque, Iowa. April 1920. Exhibited: *Fish Handler* and *Reflections.*

An Exhibition of 100 Prints from the 1920 Pictorial Photographers of America Annual, under the auspices of the Pictorial Photographers of America. New Bedford, Massachusetts. April 13 to April 28, 1920. Exhibited: *Portrait of a Child.*

An Exhibition of 100 Prints from the 1920 Pictorial Photographers of America Annual, under the auspices of the Pictorial Photographers of America. The University of Virginia, Charlottesville, Virginia. May 9 to June 1, 1920. Exhibited: *Portrait of a Child.*

An Exhibition of Pictorial Photography, under the auspices of the Pictorial Photographers of America. Colorado Springs, Colorado. June 1920. Exhibited: *Fish Handler* and *Reflections.*

An Exhibition of Pictorial Photography, under the auspices of the Pictorial Photographers of America. Denver, Colorado. July 1920. Exhibited: *Fish Handler* and *Reflections.*

An Exhibition of Pictorial Photography, collected under the auspices of the Pictorial Photographers of America. Copenhagen Photographic Amateur Club, Copenhagen, Denmark. August 25 to September 10, 1920. Exhibited: *Portrait of a Child, Masts, The War Correspondent, An Illustration, Interior,* and *Circles.*

A Solo Exhibition of Photography by Doris Ulmann at the Opening of the New Offices of the Clarence H. White School of Photography. Clarence H. White School of Photography, 460 West 144th Street, New York, New York. November 29 to December 30, 1920. Exhibited: Numerous photographs and photogravure text on the faculty of the College of Physicians and Surgeons at Columbia University.

1921

International Exhibition of the London Salon of Photography. Galleries of the Royal Society of Painters in Water-Colours, 5a, Pall Mall East, London, England. September 12 to October 10, 1925. Exhibited: *The War Correspondent, Frederick Villiers.*

Exhibition of Photographs by Alumni, under the auspices of the Clarence H. White School of Photography. Clarence H. White School of Photography, 460 West 144th Street, New York, New York. Late summer or early fall, 1921. Exhibited: Three portrait photographs.

Exhibition by Pictorial Photographers of America on the Occasion of the Opening of the Building of the Art Center. 65-67 East Fifty-sixth Street, New York, New York. October 31 to November 30, 1921. Exhibited: *High Noon, Columbia At Night,* and *The War Correspondent.*

Exhibition of female photographers, including Ulmann, in November 1921.

1922

Exhibitions of Pictorial Photography from the October to November 1921 Pictorial Photographers of America exhibit at the Art Center, under the auspices of the American Federation of Arts, in Corvallis, Oregon; Emporia, Kansas; College Station, Texas; Greeley, Colorado; Muncie, Indiana; Washington, D.C.; Oxford, Ohio; Peoria, Illinois; Sioux Falls, South Dakota; Birmingham, Alabama; and Albany, New York; from January to May, 1922. Exhibited: *High Noon, Columbia At Night,* and *The War Correspondent.*

Ninth Annual Pittsburgh Salon of Photography. Carnegie Institute, Department of Fine Arts, under the auspices of the Photographic Section of the Academy of Science and Art, Pittsburgh, Pennsylvania. March 1 to March 31, 1922. Exhibited: *Gossip* and *Portrait—Mr. Warner.*

First Annual International Exhibition of Pictorial Photography, Pictorial Photographic Society of San Francisco. Palace of Fine Arts, San Francisco, California. May 20 to June 18, 1922. Exhibited: *Long, Long Ago*.

An Exhibition of the Pictorial Photographers of America. The Art Center, 65-67 East Fifty-sixth Street, New York, New York. October 1922. Exhibited: Limited edition photogravure book entitled *A Book of Portraits of the Medical Department of the Johns Hopkins University.*

1923

Tenth Annual Pittsburgh Salon of Photography. Carnegie Institute, Department of Fine Arts, under the auspices of the Photographic Section of the Academy of Science and Art, Pittsburgh, Pennsylvania. March 2 to March 31, 1923. Exhibited: *Portrait—Mr. Hoag, Curls, The Shadow on the Wall,* and *The Old Door.*

International Salon of the Pictorial Photographers of America. Art Center, 65 East Fifty-sixth Street, New York, New York. May 3 to May 31, 1923. Exhibited: *Portrait—Mr. G., The Shadow on the Wall,* and *The Old Door.*

1924

Fourth Annual Exhibition of the Kodak Park Camera Club.

Eighth International Salon of Photography, under the auspices of the Camera Pictorialists of Los Angeles. Los Angeles Museum, Exposition Park, Los Angeles, California. October 14 to November 3, 1924. Exhibited: *The Mill.*

1925

Twelfth Annual Pittsburgh Salon of Photography. Carnegie Institute, Department of Fine Arts, under the auspices of the Photographic Section of the Academy of Science and Art, Pittsburgh, Pennsylvania. March 3 to March 31, 1925. Exhibited: *Young Girl* and *The Selectman.*

An Exhibition of Photographs by the Students and Alumni of the Clarence H. White School of Photography. Clarence H. White School of Photography, Art Center, New York, New York. March 16 to March 21, 1925. Exhibited: *Hands, New England Type 1, South Canaan, New England Type 2,* and *New England Type 3.*

Second International Salon of Pictorial Photographers of America. Art Center, 65 East Fifty-sixth Street, New York, New York. May 19 to June 15, 1925. Exhibited: *Still Life-Autumn, Laborer's Hands,* and *The Black Laborer.*

1926

An Exhibition of Photographs by the Pictorial Photographers of America, under the auspices of the Pictorial Photographers of America. Art Center, New York, New York. February 1926. Unknown image.

Thirteenth Annual Pittsburgh Salon of Photography. Carnegie Institute, Department of Fine Arts, under the auspices of the Photographic Section of the Academy of Science and Art, Pittsburgh, Pennsylvania. March 14 to April 18, 1926. Exhibited: *Virginia Landscape* and *Old Virginia Type-1.*

A Solo Exhibition of Photographs by Doris Ulmann, under the auspices of the Pictorial Photographers of America. Art Center, New York, New York. November 1926.

1928

The International Press Exhibition. Cologne, Germany. May to October, 1928. Exhibited: Limited edition photogravure text, *A Book of Portraits of the Medical Department of the Johns Hopkins University.*

1929

Third International Salon of the Pictorial Photographers of America, under the auspices of the Pictorial Photographers of America. Art Center, 65 East Fifty-sixth Street, New York, New York. April 15 to April 27, 1929. Exhibited: *The Mountain Family, Monday,* and *The Voodoo Doctor.*

An Exhibition of Pictorial Photography, under the auspices of The Pictorial Photographers of America. Carnegie Institute, Pittsburgh, Pennsylvania. October 28 to November 12, 1929. Exhibited: *Monday.*

A Solo Exhibition of Photographs by Doris Ulmann, under the auspices of the Delphic Studios. Delphic Studios, 9 East Fifty-seventh Street, New York, New York. November 1929. Exhibited: 129 photographs: "'thirteen . . . of Negro Baptisms and Spirituals,' fifty-four 'In South Carolina,' thirty-six 'Kentucky Mountains,' and twenty-six portraits of interesting and prominent people . . . printed on platinum."

1930

An Exhibition of Photographs by the Pictorial Photographers of America, under the auspices of the Pictorial Photographers of America. Art Institute of Dayton, Dayton, Ohio. January 1930. Exhibited: *Monday.*

An Exhibition of Photographs by the Pictorial Photographers of America, under the auspices of the Pictorial Photographers of America. Art Museum of St. Louis, St. Louis, Missouri. February 1930. Exhibited: *Monday.*

An Exhibition of Photographs by the Pictorial Photographers of America, under the auspices of the Pictorial Photographers of America. Art Museum of Denver, Denver, Colorado. March 1930. Exhibited: *Monday.*

A Solo Exhibition of Photographs by Doris Ulmann, under the auspices of the Southern Mountain Workers Conference. Second Presbyterian Church, Knoxville, Tennessee. Spring 1930. Exhibited: Several Appalachian photographs.

An Exhibition of Photography entitled "Photography 1930," under the auspices of the Harvard Society for Contemporary Art. Cambridge, Massachusetts. November 7 to November 29, 1930. Exhibited: Several photographs.

An Exhibition of Photography entitled "Photography 1930," under the auspices of the Harvard Society for Contemporary Art. Wadsworth Atheneum, Boston, Massachusetts. December 1930. Exhibited: Several photographs.

1932

An International Exhibition of New Pictures of American Types, under the auspices of the Pictorial Photographers of America. Brooklyn Museum of Art and Science, Brooklyn, New York. March 8 to March 31, 1932.

A Traveling Salon Exhibition of Fifty Photographs by Imogene Cunningham, Laura Gilpin, and Doris Ulmann, under the auspices of the Pictorial Photographs of America. 1932.

A Solo Exhibition of *Portraits of Mountain Young People,* under the auspices of the Southern Woman's Educational Alliance at the annual meeting of the Executive Board and New York Branch of the Southern Woman's Educational Alliance. St. Regis Hotel, New York City. October 31, 1932.

1933

An Exhibition of Modern American Photography, under the auspices of the College Art Association. Spring 1933. Exhibited: *Boats, Baptism, The Shaker, Sister Mary, Cherokee Indian, Max Weber, and Old Mammy.*

A Solo Exhibition of Photographs, under the auspices of the Hotel Grand, Hazard, Kentucky. August 22 to August 25, 1933.

A Solo Exhibition of Photographs. Pittsfield, Massachusetts. Exhibited: Several photographs.

A Solo Exhibition of *Portrait Studies of Mountain People,* under the auspices of the Richmond Branch of the Southern Woman's Educational Alliance. A.A. Anderson Gallery, Richmond, Virginia. October 22 to October 29, 1933.

A Solo Exhibition of Photographs, under the auspices of Berea College. Berea College, Berea, Kentucky. October 26 to October 28, 1933. Exhibited: Several photographs.

A Solo Exhibition of Photographs, under the auspices of the Delphic Gallery. Delphic Gallery, 9 East Fifty-seventh Street, New York, New York. 1933. Exhibited: Several photographs.

An Exhibition under auspices of Russell Sage Foundation. Corcoran Gallery, Washington, D.C. Exhibited: Several photographs.

1934

A Solo Exhibition of Photographs, under the auspices of the Library of Congress, Washington, D.C. February to May 1934. Exhibited: Forty images.

A Solo Exhibition of Photographs at the Exhibition of American Folk Arts, under the auspices of Elizabeth Burchenal. March 1934. Exhibited: Several photographs.

A Solo Exhibition of Photographs, under the auspices of the University of Kentucky. University of Kentucky, Lexington, Kentucky. June 24 to June 26, 1934. Exhibited: Several photographs.

A Group Exhibition of Photographs of the Medical Faculty of Johns Hopkins University under the auspices of Johns Hopkins University. September 1934.

1936

A Solo Exhibition of the Mountain Photography of Doris Ulmann and Bayard Wooten, under the auspices of Berea College. Berea College, Berea, Kentucky. April 23 to April 26, 1936.

1937

Fourth International Salon by the Pictorial Photographers of America. American Museum of Natural History, New York, New York. March 29 to April 17, 1937. Exhibited: Two photographs, both titled *Clarence H. White.*

An Exhibit of the Visual Arts Held in Connection with the 75th Anniversary of the Founding of the Department of Agriculture, 1862-1937, under the auspices of the U.S. Department of Agriculture. Administration Building, U.S. Department of Agriculture, Washington, D.C. November 14 to December 5, 1937. Several enlarged reproductions of Ulmann's photographs were shown in a group exhibition with photographs by Bayard Wooten and Carl Mydans.

1946

A Solo Exhibition of the Photography of Doris Ulmann, under the auspices of the Winston-Salem Department of Recreation. Fourth Annual Piedmont Festival of Music and Art, Reynolds Auditorium, Winston-Salem, North Carolina. June 24 to June 30, 1946. Exhibited: Fifty photographs.

1955

An Exhibition of the Family of Man, under the auspices of the Modern Museum of Art, New York, New York. January 24, 1955. Exhibited: *Mr. Meaders and Family, Cleveland, Georgia,* and *Gullah African Americans at Worship.*

1973

A Group Exhibition of documentary photography, under the auspices of the Art Institute of Chicago. April 14 to June 17, 1973. Exhibited: Works of Doris Ulmann, Timothy O'Sullivan, Lewis Hine, Edward Curtis, and Martin Schneider.

1974

A Solo Exhibition of the photographs of Doris Ulmann, under the auspices of the Witkin Gallery, New York, New York. December 12, 1974, to January 18, 1975.

1975

A Group Exhibition of *Women of Photography,* under the auspices of the San Francisco Museum of Modern Art, San Francisco, California. April 18 to June 15, 1975. Exhibited: Several works by Ulmann included.

1976

A Retrospective Exhibition of *Photographs of Appalachian Craftsmen by Doris Ulmann,* under the auspices of Western Carolina University Art Gallery. Belk Building, Western Carolina University, Cullowhee, North Carolina. April 6 to May 1, 1976. Exhibited: Thirty images of individuals associated with the John C. Campbell Folk School, Brasstown, North Carolina.

1978

An Exhibition of the photography of Doris Ulmann at the *Dedication of the Doris Ulmann Gallery,* under the auspices of Berea College. Doris Ulmann Gallery, Traylor Art Building, Berea, Kentucky. April 11, 1978.

A Library of Congress traveling exhibition: *Women Look at Women,* under the auspices of the Library of Congress, Washington, D.C. 1978. Exhibited: *Women with Dahlias, Negro Woman with Scrubboard, Old Woman in Sunbonnet, No. 2,* and *Negro Woman in Large Hat.*

1979

A Group Exhibition of *American Photographs, 1900-1930,* under the auspices of the Whitney Museum of American Art, New York, New York. September 19 to November 25, 1979.

A Group Exhibition of *Amerika: Photographie 1920-1940*, under the auspices of the Kunsthaus, Zurich, Switzerland. August 23 to October 28, 1979.

1981

A Solo Exhibition of *Photographs by Doris Ulmann: The Gullah People*, under the auspices of the New York Public Library Astor, Lenox, and Tilden Foundations. Schomburg Center for Research in Black Culture, New York, New York. June 1 to July 31, 1981.

A Solo Exhibition of photographs, *Doris Ulmann*, under the auspices of Yuen Lui Gallery, Seattle, Washington. October 6 to November 7, 1981.

1982

A Retrospective Exhibition of the photography of Doris Ulmann, under the auspices of the Berea College Appalachian Museum. Berea College, Berea, Kentucky. July to September 26, 1982.

A Solo Exhibition of the photography of Doris Ulmann, *Doris Ulmann's Photographs*, under the auspices of the Morlan Gallery. Mitchell Fine Arts Center, Transylvania University, Lexington, Kentucky. October 21 to November 22, 1982.

1984

A Solo Exhibition of *The Subjects of Doris Ulmann: An Exhibit of Her Brasstown Works*, under the auspices of the John C. Campbell Folk School, Brasstown, North Carolina. February 4, 1984. Exhibited: Over 100 images.

1986

An Exhibition of the photography of Edward Curtis and Doris Ulmann, *Edward Curtis, Doris Ulmann: The Last Photographs*, under the auspices of Comfort Gallery. Haverford College, Haverford, Pennsylvania. October 18 to November 16, 1986. Exhibited: Thirty-four images.

1989

A Solo Exhibition of the photography of Doris Ulmann, *The Techniques of Doris Ulmann*, under the auspices of the Doris Ulmann Gallery. Berea College, Berea, Kentucky. October 1 to October 25, 1989. Exhibited: Twenty images.

A Solo Exhibition of the photography of Doris Ulmann, *Photographs by Doris Ulmann*, under the auspices of the University of Kentucky Art Museum. University of Kentucky, Lexington, Kentucky. November 19, 1989, to February 4, 1990. Exhibited: Twenty-four images.

1994

A Solo Exhibition of the photography of Doris Ulmann, *Doris Ulmann: Photographs from Appalachia and the Gullah Region of South Carolina, 1925– 1934*, under the auspices of 292 Gallery and Keith de Lellis Fine Art Photography. 292 Gallery, New York, New York. October 28 to December 3, 1994. Exhibited: Forty-three images.

A Group Exhibition, *Art and the Camera, 1900-1940*, under the auspices of the National Portrait Gallery, Washington, D.C. Exhibited: Seven images.

1996

A Solo Exhibition of the photography of Doris Ulmann, *Doris Ulmann,* under the auspices of the Huntington Museum of Art, Huntington, West Virginia, 1996. Exhibited: Forty images.

A Group Exhibition, *American Photographs: The First Century, from the Issacs Collection in the National Museum of American Art,* under the auspices of the National Museum of American Art. Smithsonian Institution, Washington, D.C. November 22, 1996, to April 20, 1997. Exhibited: Three images.

1997

A Solo Traveling Exhibition of the photography of Doris Ulmann, *Light Days, Dark Nights: The Carolina Photographs of Doris Ulmann,* under the auspices of the South Carolina Historical Society. The Gibbes Museum of Art, Charleston, South Carolina, November 1, 1997, to January 2, 1998; the Appalachian Folk Center, Asheville, North Carolina, April to August 1998; the South Carolina State Museum, Columbia, South Carolina, April to June 1999; and Erskine College, Due West, South Carolina, June 2000 to September 2000; and Museum of the New South, Charlotte, North Carolina, October 2001 to December 2001. Exhibited: Forty images.

1998

A Group Exhibition, *Roots and Reeds: The Amazing Grace of the Gullah People,* under the auspices of the Bertha and Karl Leubsdorf Art Gallery. Hunter College of the City University of New York, New York, New York. February 3 to March 21, 1998. Exhibited: Six images.

A Group Exhibition of the photography of Chansonetta Stanley Emmons, Doris Ulmann, and Bayard Wootten, *Documenting A Myth: The South as Seen by Three Women Photographers,* under the auspices of the Douglas F. Cooley Memorial Art Gallery. Reed College, Portland, Oregon. April 7 to June 14, 1998.

Appendix Three

Published Photographs

"Portrait: Prof. Felix Adler" in *Photo=Graphic Arts,* October 1917.

"In a Canaan Garden" in *Clarence H. White Summer School Prospectus,* summer 1918.

Twenty-five photogravures in *The Faculty of the College of Physicians and Surgeons, Columbia University in the City of New York,* 1919.

"High Noon" in *American Photography,* October 1919.

"The Smith" in *American Photography,* December 1919.

"Portrait of a Child" in *Pictorial Photography in America,* 1920.

"An Illustration" in *American Photography,* August 1920.

"Portrait of a Child—Photo" in *Era,* 1920. [from Pictorial Photographers of America annual].

"The Urns" and "Illumination" in *Columbia University Photographic Studies,* 1920.

"Portrait" (seated man with cane and high hat) in *Pictorial Photography in America,* 1921.

"The New Boat" (two boys with toy boat) in *Camera,* April 1921.

"Gossip" in *Camera,* May 1922. (fr. Pittsburgh Salon).

Thirty-six photogravures in *A Book of Portraits of the Faculty of the Medical Department of the Johns Hopkins University, Baltimore,* 1922.

"Village Smith" in *Camera Pictures,* 1924.

Forty-three photogravures in *A Portrait Gallery of American Editors,* 1925.

"Woman Reading" in *Art Center Bulletin,* November 1926.

"An Old Virginia Type" in *Pictorial Photography in America,* 1926.

"Devout Dunkard Reading Her Bible," "A Mennonite Woman of Virginia," "Brother William of the Shaker Settlement, Mt. Lebanon, New York," "The Minister at Ephrata, Pennsylvania," "A Venerable Dunkard of the Shenandoah Valley," "Two Sisters of the Shaker Settlement (Sister Sarah and Sister Adelaide)," "Aunt John," and "A Pioneer Pair in Far West Virginia" in *The Mentor,* July 1927.

Seven photographs of "the mountaineers of Kentucky" in *Scribner's Magazine,* June 1928.

Several photographs of "Southern Mountaineers" in *The Mentor,* August 1928.

"Thornton Wilder" in Thornton Wilder, *The Angel That Troubled the Waters and Other Plays* (only in American limited editions, one edition limited to 775 copies, another to 2,000 copies).

"Ethel Durant" and "Will and Ethel Durant" in *The American Magazine,* March 1929.

"Dr. Harry Allen Overstreet," "Helen Keller and Miss Sullivan," and "Helen Keller" in *The American Magazine,* June 1929.

"Monday" in *Pictorial Photography in America,* 1929.

"Mrs. Calvin Coolidge" (3 photos) in *The American Magazine,* September 1929.

"Hamlin Garland" and "Robert Nathan" in *The Bookman,* October 1929.

"Mrs. Calvin Coolidge" and "George Grey Barnard" (5 photos) in *The American Magazine,* October 1929.

"Stuart Sherman" in *The Bookman,* November 1929.

"The Barn Door" in *Light and Shade,* December 1929.

"Robert Frost," "Sinclair Lewis," "Glenway Westcott," "Lizette Wordsworth Reese," "Zona Gale," "Struthers Burt," "Dubose Heyward," "James Welden Johnson," "Thornton Wilder," "Edwin Arlington Robinson," "Anne Parrish," "Sherwood Anderson," "Julia Peterkin," "Wilbur Daniel Steele," and "Thomas Wolfe" in *The Bookman,* December 1929.

"Robert Frost" in Sidney Cox, *Robert Frost, Original "Ordinary Man,"* 1929.

"Country Store," "Catawba Indian," "South Carolina 'Turk,'" "Kentucky Mountain Girl," "Mammy," "The Printer," "South Carolina 'Cracker,'" and "Convict Gang" in *Theatre Arts Monthly,* February 1930.

"Angna Enters" (2 photos) in *Theatre Arts Monthly,* 1930.

"Joseph Hergesheimer," "S.S. Van Dine," "Waldo Frank," "Esther Forbes," "Oliver La Farge," "Blair Niles," "Carl Van Vechten," "Margaret Ayer Barnes," and "Gamaliel Bradford" in *The Bookman,* October 1930.

"Dancer" and "Katharine Cornell" in *Theatre Arts Monthly,* February 1931.

"Fisherman at Charleston," "Gullah Negro Woman," "Nessie," "Imogene, Tub and Pipe," "Sunday Afternoon," "Baptism," and "Homeward" in *Wings,* September 1931.

"Paul Green," "Julia Peterkin," "Carl Van Vechten," and "Joseph Hergesheimer" in Emily Clark, *Innocence Abroad,* 1931.

"Gamaliel Bradford" in *The Bookman,* May 1932.

"Julia Peterkin" in *Theatre Arts Monthly,* July 1932.

"African American grandmother and child" in *Etat de la Photographie,* 1932.

"John Galsworthy" in *The Bookman,* December 1932.

Seventy-two photographs of southern African American subjects in Julia Peterkin and Doris Ulmann, *Roll, Jordan, Roll* (trade edition), 1933.

"James Weldon Johnson" in James Weldon Johnson, *Along This Way: The Autobiography of James Weldon Johnson,* 1933.

"Mrs. Luce Scroggs" and "Singing Games" in *The Bulletin of the John C. Campbell Folk School,* December 1933.

Ninety-one photogravures of southern African American subjects in Julia Peterkin and Doris Ulmann, *Roll, Jordan, Roll* (limited edition), January 1934.

"James Weldon Johnson," "Thomas Wolfe," "Sinclair Lewis," "Carl Van Doren," and "Julia Peterkin" in *Wings,* August 1934.

Seven photographs of Brasstown, North Carolina, western North Carolina, and north Georgia subjects in *The Theatre Arts Monthly,* August 1934.

"Hayden Hensley" and "Carved Geese" in *The Bulletin of the John C. Campbell Folk School,* April 1935.

"Lucius L. Scroggs" in *The Bulletin of the John C. Campbell Folk School,* November 1935.

"Wanda Scroggs" and "Mrs. Hannah Smith and Douglas Smith, Her Grandson" in *The Bulletin of the John C. Campbell Folk School,* May 1936.

Seven photographs of Berea College students in *The Chimes,* 1937.

"A Potter's Daughter" (dust jacket photo) and fifty-eight photographs in text in Allen H. Eaton, *Handicrafts of the Southern Highlands,* 1937.

"Practical Lessons in Keith House" and "Woman with Coverlets and Blankets" in *The Bulletin of the John C. Campbell Folk School,* April 1937.

"Man Working on a Machine" and "Grandmother and Granddaughter Ginning Cotton on a Hand-Made Gin" in *The Bulletin of the John C. Campbell Folk School, October 1937.*

"Wilma Creech," "Mountain Cabin," "Tennessee Mountain Girl with Dulcimer," and several other photographs in *An Exhibition of the Rural Arts: Held in Connection with the 75th Anniversary of the Founding of the Department of Agriculture, 1862-1937,* 1937.

"Wilma Creech" in *New York Times Magazine,* November 28, 1937.

"Hayden and Bonnie Hensley" in *The Bulletin of the John C. Campbell Folk School,* May 1941.

"Wilma Creech," "The Young Potter," and "The Tanner" in *Rural Handicrafts in the United States,* 1946.

"African Americans in Worship" and "Mr. Meaders and His Children" in *The Family of Man,* 1955.

"Sherwood Anderson," "Charlie Gayhart," "Dillard Carriger," "Doris Ulmann," "Bee Stand," "Crossing Cut Shine Creek" in *The Call Number,* spring 1958.

"Struthers Burt" in *The Princeton University Library Chronicle,* Volume XIX, 1958.

"Hayden Hensley," "A Young Potter," "Charles Wesley Allen," "Cheever Meaders and Seven of His Children," "Mrs. Anderson and Her Son," "Potter O. L. Bachelder," "Making a Quilt," and two other images in *Craft Horizons,* 1966.

Sixty-three photographs in John Jacob Niles, *The Appalachian Photographs of Doris Ulmann,* 1971.

Eighty-five photographs in William Clift and Robert Coles, *The Darkness and the Light,* 1974.

"Balis W. Ritchie" and "Uncle Will Singleton" in Jean Ritchie, *The Dulcimer Book,* 1974.

"Berry Pickers" and "Bell Ringer Outside Church" in Corcoran Gallery of Art, *A Book of Photographs From the Collection of Sam Wagstaf,* 1977.

"Clementine Douglas" in *The Arts Journal,* July 1979.

"Old Woman With a Pipe" in Bruce Bernard, *Photodiscovery,* 1980.

"Baskets" and "Mr. and Mrs. Newt Mann of Holston, Washington County, Virginia" in Ian Jeffrey, *Photography, a Concise History,* 1981.

"Uncle Luce Scroggs" and "Hayden Hensley" in David E. Whisnant, *All That Is Native and Fine,* 1983.

Ninety-one photographs in David Featherstone, *Doris Ulmann, American Portraits,* 1985.

"Sacred Image Maker" in Frank De Caro, *Folklife in Louisiana Photography,* 1990.

"Aunt Lou Kitchen" and "Mac Carter" in Janet Kardon, ed., *Revivals! Diverse Traditions, 1920-1945: The History of Twentieth-Century American Craft,* 1994.

"Mrs. Hayden Hensley and Child" in Naomi Rosenblum, *A History of Women Photographers,* 1994.

"A Young Woman in Go-to-Town Dress" in Weston Naef, *The J. Paul Getty Museum Handbook of the Photographs Collection,* 1995.

"Abstraction," "Clarence H. White," "Southern Mountaineer," "The Poem," and "Frank Crowninshield, Editor, *Vanity Fair*" in Marianne Fulton, ed., *Pictorialism into Modernism: The Clarence H. White School of Photography,* 1996.

Fifty-seven Photographs in Weston Naef, gen. ed., *In Focus: Doris Ulmann,* 1996.

"Julia Peterkin and Doris Ulmann," "Julia Peterkin and Fishermen," "Irving Fineman," and "Asparagus Packer at Lang Syne Plantation" in Susan Millar Williams, *A Devil and a Good Woman Too: The Lives of Julia Peterkin,* 1997.

"Man and Boy with Boat" in Ian Jeffrey, ed., *The Photograph Book.* 1997.

Fifteen photographs in Susan Millar Williams and Philip Walker Jacobs, *Carologue,* autumn 1997.

"The Back Stairs," "Scene at Georgetown Island, Maine," "Elizabeth Maddox Roberts," "Nancy Greer, Trade, Tennessee," "Christopher Lewis, Wooten, Kentucky," "Doris Ulmann and Julia Peterkin," "Man Standing in Boat Fishing," "Man with Sacred Image," "Hands of Lucy Lakes, Berea, Kentucky," "Aunt Cord Ritchie, Basketmaker, Knott County, Kentucky," "Mrs. C. O. Wood, Dalton, Georgia," and "Wilma Creech, Pine Mountain, Kentucky" in Melissa A. McEuen, *Seeing America: Women Photographers Between the Wars,* 1999.

Appendix Four

The Medium, Edition, Identification, and Rarity of Doris Ulmann's Photographs

Between 1915 and 1934, Doris Ulmann created more than ten thousand photographs. She used view format cameras, soft-focus lenses, and 6½" x 8½" gelatin dry-plate negatives to create most of these images. She did use 5" x 7" gelatin dry-plate negatives for a brief time to create some early images and 8" x 10" plate negatives for a few later pieces. Ulmann also photographed a handful of images with a small camera in December 1933. From these negatives she developed and hand-printed her platinum, oil pigment, oil transfer, and gelatin silver prints. Aside from her oil pigment and transfer images, which are, by definition, monotypes, most of her platinum and gelatin silver images also appear to be monotypes. Few examples exist of duplicate or multiple images. This is even true for the images that were developed and printed after her death.

Most of the images she developed and printed are platinum. Approximately 4,500 of these are extant. Between 1918 and 1926 she also created a number of oil pigment and oil transfer prints. Around 150 of these remain. She also made a small number of gelatin silver images in the last year of her life. At present only 300 to 400 of these vintage Ulmann images appear to be in private hands. The rest are in institutional collections.

Ulmann identified her work in four different ways. Her earliest images were usually signed in pencil in her married name, "Doris U. Jaeger," in the lower right corner of the mat to which the photograph was adhered. Some of these images were also signed by the photographer on the image itself with a red ink monogram that united the first letters of each word of her married name, DUJ, usually in the lower right or left corner of the image. Following her separation and divorce in 1921, Ulmann signed her prints in pencil in her maiden name, "Doris Ulmann," again, in the lower right corner of the mat to which her image was adhered. She also erased her married name from some of her earlier prints and re-signed them with her maiden name. This signature remained the primary means by which she identified her work in the 1920s and 1930s, though she did complement it with a red ink monogram (now just uniting the letters DU) in at least one series: her prints of her close friend, novelist Julia Peterkin, produced around 1929. While it is important to be aware of the different ways Ulmann identified her work, it is essential to note that she did not sign most of her photographs, and evidence of this is readily accessible in the New-York Historical Society collection, where most of the images are unsigned. But this should not be understood to suggest the photographer disdained these images. While some of the photographs in this New York collection (and in other collections) do not represent her best work, many of them are excellent examples of her skill. This brings one to the conclusion that she must have only signed those works that she used for exhibition or that she believed she might use for exhibition.

Following her death in 1934 the Doris Ulmann Foundation hired noted Brooklyn photogra-

pher Samuel Lifshey to print proof prints of most of her extant gelatin dry-plate negatives for an album collection and to develop and print finished gelatin silver photographs of her undeveloped plates for Berea College in Kentucky, the John C. Campbell Folk School in North Carolina, the Russell Sage Foundation in New York, and several families and individuals who had sat for Ulmann. He worked at this project for two and one-half years. In order to distinguish the later posthumous prints of Lifshey from the vintage prints of Ulmann and also distinguish these posthumous images from later (post-1937) images, the Foundation created a grayish-black raised ink facsimile stamp of Doris Ulmann's pencil signature that was applied to the mats of the images Lifshey printed.

While the University of Oregon (10,200 proof prints and 5,168 glass plate negatives) and Berea College (3,160 posthumous gelatin silver photographs) have the largest collections of Ulmann images and give the most complete picture of the breadth and diversity of the photographer's work, the New-York Historical Society (approximately 2,900 platinum images and 100 oil images), the University of Kentucky Art Museum (332 platinum images, 23 oil images, and 150 gelatin silver images), the Audio-Visual Archives of the Special Collections Department of the University of Kentucky Libraries (203 platinum and gelatin silver images), the Getty Museum of Art (171 platinum images), the George Eastman House (147 platinum and gelatin silver images), the South Carolina Historical Society (169 platinum images), the Library of Congress (154 platinum images), and the Schomburg Center of the New York Public Library (120 platinum images) hold the largest collections of prints created by the photographer. Therefore, these institutions provide the scholar and connoisseur with the best opportunity to understand the photographer and her aesthetic philosophy and goals.

Appendix Five

A Selective Index of Doris Ulmann's Photographic Subjects

Abel, Dr. John J., *Baltimore, Maryland*
Adam, Corey(?)
Adams, Ansel
Adams, Mr. and Mrs. Ben, *Whitesburg, Kentucky*
Adams, Bertha, *Whitesburg, Kentucky*
Adams, Bird Potter, *Berea, Kentucky*
Adams, Nicodemus Demon, *Banner, Virginia*
Adams family, *Whitesburg, Kentucky*
Adler, Felix, *New York, New York*
Allen, Charles Wesley, *Berea, Kentucky*
Allen, Everett, *Ary, Kentucky*
Allen, Lizzie May, *Berea, Kentucky*
Allen, Willie Fay, *Homeplace, Kentucky*
Amburgey, Jethro, *Hindman, Kentucky*
Anderson, Mr. and Mrs., *Berea, Kentucky*
Anderson, Mrs., *Saluda, North Carolina*
Anderson, (Ms.), *Big Hill, Kentucky*
Anderson, John, *Berea, Kentucky*
Anderson, Mrs. John, *Berea, Kentucky*
Anderson, Mary, *Berea, Kentucky*
Anderson, Ned, *Saluda, North Carolina*
Anderson, Ned (children), *Saluda, North Carolina*
Anderson, Paul
Anderson, Mrs. Sarah Owen , *Saluda, North Carolina*
Anderson, Sherwood, *Troutdale, Virginia*
Anderson, Brother William, *Mt. Lebanon, New York*

Bachelder, Oscar Lewis, *Candler, North Carolina*
Back, Estil, *Berea, Kentucky*
Baer, Dr. William Stevenson, *Baltimore, Maryland*
Baetjer, Dr. Frederick Henry, *Baltimore, Maryland*
Baird, Dean Jesse, *Berea, Kentucky*
Baker, Dr. Allison, *Berea, Kentucky*
Barker, Dr. Lewellys Franklin, *Baltimore, Maryland*
Barnard, George Grey

Barnes, Mr., *Quicksand, Kentucky*
Barnes, Margaret Ayer, *Mattapoisett, Massachusetts*
Barnett, Tom, *Brasstown, North Carolina*
Beardin, Mrs., *Dalton, Georgia*
Beech, Granny, *Brasstown, North Carolina*
Begley, Jeanett, *Berea, Kentucky*
Begley, Judge, *Hyden, Kentucky*
Begley, Mary Elizabeth, *Pine Mountain, Kentucky*
Begley, Ruth, *Wooten, Kentucky*
Begley, Sue, *Wooten, Kentucky*
Bell, Leonard, *Allanstand, North Carolina*
Bell, Mrs. Nora, *Berea, Kentucky*
Benét, Stephen Vincent
Benfield, Martin, *Hayesville, North Carolina*
Bennett, John, *Charleston, South Carolina*
Bidstrup,Georg, *Brasstown, North Carolina*
Bishop, Evelyn, *Norris, Tennessee*
Blaine, Rev. Corey R.
Blanding, Ellen, *Lexington, Kentucky*
Blanding, Sarah Gibson, *Lexington, Kentucky*
Blondin(?), (Mrs.), *Dalton, Georgia*
Bloodgood, Dr. Joseph Colt, *Baltimore, Maryland*
Blue, Gertrude, *Pembroke, North Carolina*
Boggs, Dr. Thomas Richard, *Baltimore, Maryland*
Botzaris, Sava
Bowersox, Katharine, *Berea, Kentucky*
Boyd, James, *Southern Pines, North Carolina*
Bradford, Gamaliel
Bradford, Roark
Bragg, Laura, *Charleston, South Carolina*
Brendle, Fanny Kate, *Brasstown, North Carolina*
Bridges, Robert, *New York, New York*
Bright, Mary, *Berea, Kentucky*
Brock, Louise Garner, *Berea, Kentucky*
Broedel, Max, *Baltimore, Maryland*
Brown, E.H., *Whitesburg, Kentucky*
Brown, E.W., *Whitesburg, Kentucky*
Brown, P.M., *Whitesburg, Kentucky*
Bryan, Nina P., *Brasstown, North Carolina*
Bryant, Mr., *Brasstown, North Carolina*
Bullard, Jacquelyn, *Hazard, Kentucky*
Burkhard, Fred, *Berea, Kentucky*
Burnett, Ray (Mrs.), *Kentucky*
Burt, Bobby, *Berea, Kentucky*
Burt, Struthers, *Southern Pines, North Carolina*
Burton-Opitz, Dr. Russell, *New York, New York*
Butler, Marguerite, *Brasstown, North Carolina*
Butler, Dr. Nicholas Murray, *New York, New York*

Callahan, Boone C., *Pine Mountain, Kentucky*
Campbell, Emery, *Ary, Kentucky*
Campbell, Olive Dame, *Brasstown, North Carolina*
Campbell, Orvie, *Ary, Kentucky*
Campbell, Aunt Sophie, *Gatlinburg, Tennessee*

Campbell, Uncle Tom, *Gatlinburg, Tennessee*
Candler, Mrs. Anne Abbott, *Brasstown, North Carolina*
Cantrell, Oscar, *Brasstown, Kentucky*
Carol, Dr. Alexis
Carpenter, Mattie, *Berea, Kentucky*
Carringer, Dillard, *Brasstown, North Carolina*
Carringer, Henry, *Brasstown, North Carolina*
Carringer, Sam, *Brasstown, North Carolina*
Carroll, Arbelle Prewitt, *Berea, Kentucky*
Carter, Ethel, *Asheville, North Carolina*
Cauldler, Anne Abbott (Mrs.)
Chafer, Mary Alice, *Gatlinburg, Tennessee*
Chase, Edna Woolman
Chase, Jane A., *Brasstown, North Carolina*
Clark, Samuel, *Berea, Kentucky*
Clarke, Emily
Clayton, Bill, *Brasstown, North Carolina*
Clayton, Mrs. Bill, *Brasstown, North Carolina*
Clayton, Dimple, *Brasstown, North Carolina*
Clayton, Quinton, *Brasstown, North Carolina*
Cleugh, Sophia
Cobb, Anne, *Hindman, Kentucky*
Cobb, Irvin S., *New York, New York*
Coffman, John Andrew, *Russellville, Tennessee*
Coffman, Miss Mannie, *Russellville, Tennessee*
Coker, Cora, *Brasstown, North Carolina*
Collins, Dave, *Whitesburg, Kentucky*
Collins, Sister Sarah, *Mt. Lebanon, New York*
Combs, Mr., *Berea, Kentucky*
Combs, Mrs., *Puncheon Camp Creek, Kentucky*
Combs, Cornelia, *Berea, Kentucky*
Combs, George, *Puncheon Creek Camp, Kentucky*
Combs, Grace, *Hindman, Kentucky*
Combs, John S., *Hazard, Kentucky*
Combs, S., *Puncheon Camp Creek, Kentucky*
Connelly, Delia Stalcup, *Murphy, North Carolina*
Connelly, Miss Sarah, *Brasstown, North Carolina*
Coolidge, Calvin
Coolidge, Grace
Cornelison, Walter, *Bybee, Kentucky*
Cornelison, Webb, *Bybee, Kentucky*
Cornell, Katharine
Cornett, Mrs. Ed, *Kingdom Come, Kentucky*
Cornett, Truett, *Homeplace, Kentucky*
Cornwell, Gwen, *Brasstown, North Carolina*
Covey, Odom, *Hamblen County, Tennessee*
Cowley, Dr. Robert, *Berea, Kentucky*
Cox, Maud, *Brasstown, North Carolina*
Coy, George J., *Baltimore, Maryland*
Craft, Capt. and Mrs., *Millstone, Kentucky*
Creech, Betty, *Pine Mountain, Kentucky*
Creech, Granny, *Pine Mountain, Kentucky*
Creech, Wilma, *Pine Mountain, Kentucky*
Croly, Herbert, *New York, New York*

Crowe, Dr. Samuel James, *Baltimore, Maryland*
Crowninshield, Frank, *New York, New York*
Crumlege, Ms.
Crumley, Clarice, *Berea, Kentucky*
Cullen, Dr. Thomas Stephen, *Baltimore, Maryland*
Cunliff, Ralph
Curtis, Amos, *Brasstown, North Carolina*
Curtis, Aunt Mindy, *Brasstown, North Carolina*
Cutting, Elizabeth Brown

Darrach, Dr. William, *New York, New York*
Davis, Ed, *Berea, Kentucky*
Davis, Mrs. Ed, *Berea, Kentucky*
Davis, Isaac, *Blue Lick, Kentucky*
Davis, Robert H., *New York, New York*
Dawes, Charles
Day, James William, *Ashland, Kentucky*
 (Blind Bill Day recorded music under the name of Jilson Setters)
Day, Lindie, *Berea, Kentucky*
Day, Louise, *Pine Mountain, Kentucky*
Day, Nance, *Pine Mountain, Kentucky*
Day, Red Sol, *Pine Mountain, Kentucky*
Day, Rosie, *Ashland, Kentucky*
Day, Sal, *Berea, Kentucky*
Dean, Omer, *Berea, Kentucky*
Deschamps, Carol, *Brasstown, North Carolina*
Deschamps, Clothild, *Brasstown, North Carolina*
Deschamps, Leon, *Brasstown, North Carolina*
Dewey, John
Dey, Magelee, *Martin, Kentucky*
Dickey family, *Murphy, North Carolina*
Dingman, Helen, *Berea, Kentucky*
Dobie, J. Frank
Donaldson, Mrs. (Granny), *Brasstown, North Carolina*
Donaldson, Mr. Quinten, *Brasstown, North Carolina*
Dougherty (Ms.), *Russellville, Tennessee*
Dougherty, Betsy, *Russellville, Tennessee*
Dougherty, Mrs. Leah Adams, *Russellville, Tennessee*
Dougherty, Sarah, *Russellville, Tennessee*
Douglas, Miss Alice Kate, *Berea, Kentucky*
Douglas, Clementine, *Asheville, North Carolina*
Drinkwater, John
Duck, Maum, *South Carolina*
Duff, James, *Hazard, Kentucky*
Duffield, Miss Georgia, *Gatlinburg, Tennessee*
Durant, Ethel, *New York, New York*
Durant, Will, *New York, New York*
Durham, John Willie, *Berea, Kentucky*
Dysart, Flora, *Bartow County, Georgia*
Dysart, Lena, *Bartow County, Georgia*

Eastman, Max
Eaton, Allen
Einstein, Albert

Elliot, Charles
Engel, Carl
Engel, Lysette
Enters, Angna
Ernberg, Anna, *Berea, Kentucky*
Eversole, Mr., *Hazard, Kentucky*

Fagote, Dunie
Farrar, John, *New York, New York*
Faulkner, Barbara, *Pine Mountain, Kentucky*
Faulkner, Mildred, *Berea, Kentucky*
Fee, Florence, *Berea, Kentucky*
Feltner, Aunt Winnie, *Hyden, Kentucky*
Field, Mrs. Zachariah, *Russellville, Tennessee*
Fineman, Irving
Finney, Dr. John Miller Turpin, *Baltimore, Maryland*
Fishel, Daniel, *Middletown, Pennsylvania*
Fisher, Rev. Park, *Brasstown, North Carolina*
Flynn, Donald Luther, *Sevierville, Tennessee*
Follis, Dr. Richard Holden, *Baltimore, Maryland*
Forbes, Esther
Ford, Mrs., *Wooten, Kentucky*
Fordyce, Dr. John A., *New York, New York*
Fortner, Anna Lea, *Berea, Kentucky*
Frank, Waldo
French, Mr.
Friedman, Mrs. Harry G.
Friedrich, Louise, *Berea, Kentucky*
Frost, Robert
Frost, William Goodell, *Berea, Kentucky*
Futcher, Dr. Thomas Barnes, *Baltimore, Maryland*

Gailbreath (Mrs.), *Mooresburg, Tennessee*
Gale, Zona
Galsworthy, John
Garland, Hamlin
Gayheart, Carolyn Ruth, *Wooten, Kentucky*
Gayheart, Charles, *Wooten, Kentucky*
Gayheart, William Edward, *Wooten, Kentucky*
Geraghty, Dr. John Timothy, *Baltimore, Maryland*
Gibbs, Hamilton and Jeannette
Gibson, Charles Dana
Gies, Dr. William J., *New York, New York*
Gilchrist, Dr. Thomas Caspar, *Baltimore, Maryland*
Gilliam, David, *Berea, Kentucky*
Gish, Lillian
Glasgow, Ellen
Goodnow, Dr. Frank Johnson, *Baltimore, Maryland*
Goodrich, Bernice, *Berea, Kentucky*
Goodrich, Frances L., *Allanstand, North Carolina*
Goudy, Frederic and Bertha
Graham, Martha, *New York, New York*
Green, Mrs., *Brasstown, North Carolina*
Green, Abraham Lincoln, *Brasstown, North Carolina*

Green, Mary, *Berea, Kentucky*
Green, Opal, *Brasstown, North Carolina*
Green, Paul, *Chapel Hill, North Carolina*
Green, Mrs. Serina, *Brasstown, North Carolina*
Green, Mr. Tom, *Brasstown, North Carolina*
Greer, Granny Nancy, *Trade, Tennessee*
Greer, Old Man, *Hazard, Kentucky*
Greer, Taft, *Trade, Tennessee*
Gunn, Mrs. Julia R., *Hindman, Kentucky*

Hadden, Briton, *New York, New York*
Hale, Lee, *Ary, Kentucky*
Hale, Lula, *Ary, Kentucky*
Hall, Miss Mabel C., *Berea, Kentucky*
Hamman, Dr. Louis Virgil, *Baltimore, Maryland*
Hampton, Uncle John, *Brasstown, North Carolina*
Hardin, Enos, *Breathitt County, Kentucky*
Hardin, Lewis, *Breathitt County, Kentucky*
Harriman, Karl Edwin, *New York, New York*
Harriman, William Averell
Harris, Bernice, *Berea, Kentucky*
Harrison, Richard, *New York, New York*
Hart, Violet, *Wooten, Kentucky*
Haskins, Dolly, *Wooten, Kentucky*
Hassam, Childe
Hatcher, Sarah Alice, *Wears Valley, Tennessee*
Hatchett, Granny, *Brasstown, North Carolina*
Hawk, Mr., *Whitesburg, Kentucky*
Hayes, Della, *Hindman, Kentucky*
Hayes, Mrs. Frank (Susan B.), *Berea, Kentucky*
Hayes, Wilmuth F. Hayes, *Berea, Kentucky*
Hays, Aunt Tish, *Hindman, Kentucky*
Henderson, Frank, *Brasstown, North Carolina*
Hensel, Dr.
Hensley, Anne May, *Brasstown, North Carolina*
Hensley, Hayden, *Brasstown, North Carolina*
Hensley, Mrs. Hayden (Bonnie) and baby (John), *Brasstown, North Carolina*
Hergesheimer, Joseph, *West Chester, Pennsylvania*
Heyward, Dubose, *Charleston, South Carolina*
Hibbs, Dr. Russell A., *New York, New York*
Higgins, Lulu, *Berea, Kentucky*
Hillard, Nora, *Berea, Kentucky*
Hilton, Mr., *Hickory, North Carolina*
Hilton, Mrs., *Hickory, North Carolina*
Hipps, Ada, *Turkey Mountain, North Carolina*
Hipps, Arthur, *Turkey Mountain, North Carolina*
Hipps, James M., Sr., *Turkey Mountain, North Carolina*
Hipps, Ms. James M., *Turkey Mountain, North Carolina*
Hoag, Mr.
Hodges, Granny, *Berea, Kentucky*
Hoffman, Prof. E.M., *Berea, Kentucky*
Hoffman, Malvina
Holcomb, Beth, *Whitesburg, Kentucky*
Holcomb, Ethel, *Kingdom Come, Kentucky*

Holcomb, Gatel, *Kingdom Come, Kentucky*
Holcomb, Mrs. Katie, *Kingdom Come, Kentucky*
Holcomb, Marion, *Berea, Kentucky*
Holcomb, Solomon, *Whitesburg, Kentucky*
Holden, Johanna
Holt, Dr. L. Emmett, *New York, New York*
Home, Mary, *Washington, D.C.*
Hooker, Dr. Donald Russell, *Baltimore, Maryland*
Howard, Nora, *Berea, Kentucky*
Howard, Virginia, *Brasstown, North Carolina*
Howe, Mary, *Washington, D.C.*
Howell, Dr. William Henry, *Baltimore, Maryland*
Howland, Dr. John, *Baltimore, Maryland*
Hughes, Henry
Hughes, Victor, *Near Ary, Kentucky*
Humphrey, Doris
Huntington, Dr. George S., *New York, New York*
Huntington, Margaret, *Berea, Kentucky*
Huntington, Seth Romen, *Berea, Kentucky*
Hurd, Dr. Henry Mills, *Baltimore, Maryland*
Hurst, Fannie
Hutchins, Mrs. William J., *Berea, Kentucky*
Hutchins, Mrs. R.G., *Berea, Kentucky*
Hutchins, Dr. William J., *Berea, Kentucky*
Hyatt, Betsey, *Berea, Kentucky*

Ingram, Peter, *Berea, Kentucky*
Ito, Michio, *New York, New York*

Jacobi, Dr. Abraham, *New York, New York*
Jaeger, Dr. Charles H., *New York, New York*
James, Mrs. Clyde, *Berea, Kentucky*
Jason, Reed, *North Georgia*
Jobling, Dr. James W., *New York, New York*
Johns, Elbert, *Berea, Kentucky*
Johnson, Emmanuel, *Brasstown, North Carolina*
Johnson, Gyp, *Brasstown, North Carolina*
Johnson, James Weldon
Johnson, Lillie, *Berea, Kentucky*
Johnson, Mrs. Sarah Jane, *Brasstown, North Carolina*
Jones, Dr., *Huntington, West Virginia*
Jones, Mr. Clyde, *Berea, Kentucky*
Jones, Mrs. Elsie, *Berea, Kentucky*
Jones, Miss Katy, *South Carolina*
Jones, Mr. and Mrs. Ralph, *Berea, Kentucky*
Jones, Dr. Walter, *Baltimore, Maryland*
Joseph, Nola, *Wooten, Kentucky*
Justice, Delia, *Gainesville, Georgia*

Keller, Helen
Kelly, Dr. Howard Atwood, *Baltimore, Maryland*
Kennedy, Ashford, *Berea, Kentucky*
Key, Magilee, *Martin, Kentucky*
Kincer, Ben, *Mayking, Kentucky*

Kincer, Mrs. Ben, *Mayking, Kentucky*
Kitchen, Aunt Lou, *Shooting Creek, North Carolina*
Knapp, Dr. Arnold, *New York, New York*
Krutch, Joseph Wood

La Farge, Oliver
Lakes, Edward, *Berea, Kentucky*
Lakes, Mrs. Lucy, *Berea, Kentucky*
Lamb, Elizabeth, *Berea, Kentucky*
Lambert, Dr. Adrian Van Sindern, *New York, New York*
Lambert, Dr. Samuel W., *New York, New York*
Laney, Floyd, *Brasstown, North Carolina*
Laney, Aunt Mollie, *Brasstown, North Carolina*
Lan-fang, Mei
Leamon, George, *Gatlinburg, Tennessee*
Ledford, Bess, *Berea, Kentucky*
Ledford, Tess, *Berea, Kentucky*
Lee, Dr. Frederic S., *New York, New York*
Lee, Mary
Leland, Dr. Waldo, *Washington, D.C.*
Leoman, George, *Gatlinburg, Tennessee*
Lewellyn, Elbert, *Berea, Kentucky*
Lewis, Mr., *Hyden, Kentucky*
Lewis, Christopher, *Wooten, Kentucky*
Lewis, Judge, *Hyden, Kentucky*
Lewis, Maggie, *Pine Mountain, Kentucky*
Lewis, Sinclair, *New York, New York*
Lilner, Lottie, *Ringgold, Georgia*
Linger, Hanna Smith, *Berea, Kentucky*
Locklear, Malinda, *Pembroke, North Carolina*
Locklear, Rhoda, *Pembroke, North Carolina*
Loeffler, Agnes
Loeffler, W.E.
Logan, John Drew, *Brasstown, North Carolina*
Long, Frank, *Berea, Kentucky*
Longcope, Dr. Warfield T., *New York, New York*
Lord, Anthony, *Asheville, North Carolina*
Lord, Dr. Jere Williams, *Baltimore, Maryland*
Lowery, (child), *Brasstown, North Carolina*
Lowery, Mrs., *Brasstown, North Carolina*
Lowes, John Livingstone
Lucas, E.V.
Lunn, Miss Julie, *Hindman, Kentucky*
Lurich, Ray, *Berea, Kentucky*

Mac Callum, Dr. William George, *Baltimore, Maryland*
MacIntosh, Emery, *Breathitt County, Kentucky*
MacIntosh, Sam, *Breathitt County, Kentucky*
Maddox, Hurley, *Berea, Kentucky*
Magee, Mrs. Leslie, *Berea, Kentucky*
Mann, Mr. and Mrs. Newt, *Holston, Virginia*
Martin, W.J., *Brasstown, North Carolina*
Martin, Mrs. W.J. (Mary F.), *Brasstown, North Carolina*
Marty, Mr., *Middletown, Pennsylvania*

Ownby, James, *Gatlinburg, Tennessee*
Ownby, Mary, *Gatlinburg, Tennessee*
Ownby, Preacher Pink, *Gatlinburg, Tennessee*
Ownby, Mrs. Pink, *Gatlinburg, Tennessee*

Page, Ruth, *New York, New York*
Paine, Albert Bigelow
Painter, Dr. Harry McMahon, *New York, New York*
Palmer, Dr. Walter W., *New York, New York*
Patton, Mrs. Bird, *Brasstown, Kentucky*
Parker, Dorothy
Parrish, Anne
Partin, Mr., *Ringgold, Georgia*
Partin, Frances, *Ringgold, Georgia*
Paterson, Isabel
Patton, Mrs. Adams, *Brasstown, Kentucky*
Pavlova, Anna
Penland, Hollis, *Brasstown, North Carolina*
Penland, J.O., *Brasstown, North Carolina*
Penland, Mrs. J.O., *Brasstown, North Carolina*
Penland family, *Brasstown, North Carolina*
Penniman, Mr., *Berea, Kentucky*
Penniman, Dr. Henry M.
Pennington, Heloise, *Berea, Kentucky*
Peterkin, Julia
Pettit, Katharine, *Pine Mountain, Kentucky*
Phipps, Osciola, *Whitesburg, Kentucky*
Pickelseimer, Earl, *Berea, Kentucky*
Pittman, Louise, *Brasstown, North Carolina*
Pless, Mrs. Rosalie, *Russellville, Tennessee*
Portin, Mr., *Ringgold, Georgia*
Powys, Llewelyn
Price, Charlie
Prudden, Dr. T. Mitchell, *New York, New York*
Pruitt, Grace, *Berea, Kentucky*

Raine, Dr. James Watt, *Berea, Kentucky*
Ramsey, Lydia, *Gatlinburg, Tennessee*
Raper, Porter, *Brasstown, North Carolina*
Reed, Jason, *North Georgia*
Reese, Lizette Woodworth
Regan, Emma, *Gatlinburg, Tennessee*
Regan, Aunt Lizzie, *Gatlinburg, Tennessee*
Richardson, Jesse E., *Hazard, Kentucky*
Riggs, Stuart Earl, *Russellville, Tennessee*
Ritchie, Aunt Cord, *Knott County, Kentucky*
Ritchie, Edna, *Viper, Kentucky*
Ritchie, Frank, *Monroe County, Kentucky*
Ritchie, Jason, *Mud Lick, Kentucky*
Ritchie, Mrs. Orlenia, *Perry County, Kentucky*
Roberts, Elizabeth Maddox
Robeson, Paul
Robinson, Boardman
Robinson, Edwin Arlington

Robinson, Mike, *Jackson, Kentucky*
Rogers, Nelse, *Shooting Creek, North Carolina*
Rowen, Seth, *Berea, Kentucky*
Rowlette, Marie, *Berea, Kentucky*
Russell, Sam, *Marion, Virginia*
Russell, Dr. William Wood, *Baltimore, Maryland*

Sabin, Dr. Florence Rena, *Baltimore, Maryland*
Sanders, Ellis, *South Carolina*
Sanders, Martha, *South Carolina*
Savage, Mrs., *Murphy, North Carolina*
Saxon, Lyle, *New Orleans, Louisiana*
Scroggs, Blanche, *Brasstown, North Carolina*
Scroggs, Bob, *Brasstown, North Carolina*
Scroggs, Fred O., *Brasstown, North Carolina*
Scroggs, Lucius, *Brasstown, North Carolina*
Scroggs, Mrs. Lucius (Lillie), *Brasstown, North Carolina*
Scroggs, Mercer, *Brasstown, North Carolina*
Scroggs, Wanda, *Brasstown, North Carolina*
Seabrook, W.B.
Seedy, W.K., *Middletown, Pennsylvania*
Sheean, Vincent
Shell, John B., *Pine Mountain, Kentucky*
Shelton, Mrs. Anne, *Allanstand, North Carolina*
Sherman, Stuart
Shipman, Louis
Shook, Robert, *New Found Creek, North Carolina*
Silver, Mrs. Lottie, *Ringgold, Georgia*
Singleton, Will, *Viper, Kentucky*
Smith, Miss, *Berea, Kentucky*
Smith, Dale, *Hindman, Kentucky*
Smith, Ed (Mrs.), *Ringgold, Georgia*
Smith, H.H., *Hindman, Kentucky*
Smith, Hannah, *Brasstown, North Carolina*
Smith, Hannah, *Russellville, Tennessee*
Smith, Lon, *Pittman Center, Tennessee*
Smith, Sam, *Sevierville, Tennessee*
Smith, Dr. Winford Henry, *Baltimore, Maryland*
Smith-Zathers, Mrs.
Squier, Dr. J. Bentley, *New York, New York*
Stairs, Roberta, *Hazard, Kentucky*
Stalcup, Hugh, *Brasstown, North Carolina*
Stalcup, Pauline, *Brasstown, North Carolina*
Stamper, Ed, *Hindman, Kentucky*
Stapleton, Dr., *Line Fork, Kentucky*
Stapleton, Dr. and Mrs., *Gillie Post Office, Letcher, Kentucky*
Stapleton, Mrs.
Stapleton, Robert, *Gillie Post Office, Letcher, Kentucky*
Starr, Mr., *Hindman, Kentucky*
Starr, Dr. M. Allen, *New York, New York*
Steele, Wilbur Daniel
Stefansson, Vilhjalmur
Steins, Roberta, *Hazard, Kentucky*
Stephens, Mr. W.B., *West Asheville, North Carolina*

Stevens, Alonzo, *Berea, Kentucky*
Stewart, Mr., *Brasstown, North Carolina*
Stewart, Elsie, *Brasstown, North Carolina*
Stewart, Rachel, *Brasstown, North Carolina*
Stewart family, *Brasstown, North Carolina*
Stiles, Ethel May, *Ringgold, Georgia*
Stiles, Frances, *Ringgold, Georgia*
Stiles, Wilma, *Ringgold, Georgia*
Stinett, Nina, *Berea, Kentucky*
Stone, May, *Hindman, Kentucky*
Storr, Mr., *Hindman, Kentucky*
Strong, Alta, *Berea, Kentucky*
Strong, Beulah, *Berea, Kentucky*
Strong, Hazel, *Berea, Kentucky*
Sullivan, Miss

Tagore, Rabindranath
Taulbee, Molly, *Berea, Kentucky*
Taulbert, Richard, *Lexington, Kentucky*
Taylor, Bristol, *Berea, Kentucky*
Taylor, Howard, *Berea, Kentucky*
Taylor, Lerena, *Berea, Kentucky*
Taylor, Serena, *Berea, Kentucky*
Taylor, Thomas, *Berea, Kentucky*
Teems, Mr., *Brasstown, North Carolina*
Teems, Mrs., *Brasstown, North Carolina*
Thayer, Dr. William Sydney, *Baltimore, Maryland*
Theobald, Dr. Samuel, *Baltimore, Maryland*
Thomas, Dr. Henry, *Baltimore, Maryland*
Thomas, Jean
Thomas, Susan, *Wooten, Kentucky*
Tilney, Dr. Frederick, *New York, New York*
Tomlinson, H.M.
Trentham, Georgia, *Gatlinburg, Tennessee*
Trentham, Laura, *Gatlinburg, Tennessee*

Ulmann, Bernhard
Ulmann, Doris
Untermeyer, Louis

Van Dine, S.S.
Van Doren, Carl
Van Dyke, Henry
Van Vechten, Carl
Vaughn, Marshall, *Berea, Kentucky*
Vaughn, Smith, *Mooresburg, Tennessee*
Villiers, Frederick
Viner, Mrs., *Saluda, North Carolina*
Viner, Sandy, *Saluda, North Carolina*
Viner, Stone, *Saluda, North Carolina*

Waldroup, Nancy Sue, *Brasstown, North Carolina*
Wall, Mary, *Berea, Kentucky*
Wall, Sarah, *Russellville, Tennessee*

Notes

Key to Abbreviations

BC-SAA Doris Ulmann Manuscript Collection, Southern Appalachian Archives, Hutchins Library, Berea College, Berea, Kentucky

CU Archives, College of Physicians and Surgeons, Central Records, Columbia Medical Center, Columbia University, New York, New York

DU Alliance for Guidance of Rural Youth papers, Special Collections, Duke University, Durham, North Carolina

IU Bobbs-Merrill papers, Lilly Library, Indiana University, Bloomington

JCFS John C. Campbell Folk School, Brasstown, North Carolina

JH The Alan Mason Chesney Medical Archives, The Medical Department of the Johns Hopkins University, Baltimore, Maryland

NSUL Melrose Collection, Cammie G. Henry Research Center, Watson Memorial Library, Northwestern State University of Louisiana, Natchitoches

NYHS Doris Ulmann Photograph Collection, Department of Prints and Photographs, New-York Historical Society, New York, New York

SCHS-JP Julia Peterkin papers, South Carolina Historical Society, Charleston

SHHG Archives, Southern Highland Handicraft Guild, Montreat, North Carolina

SU Irving Fineman papers, Department of Special Collections, Syracuse University Library, Syracuse, New York

UK-JJN John Jacob Niles Collection, Special Collections, King Library, University of Kentucky, Lexington

Preface

1. Dale Warren, "Doris Ulmann: Photographer in Waiting," *The Bookman* 72 (October 1930), 136.

2. Gertrude Käsebier, in Giles Edgerton [Mary Fanton Roberts], "Photography as an Emotional Art: A Study of the Work of Gertrude Käsebier," *Craftsman* 12 (April 1907), 88, reprinted in Rosenblum, *History of Women Photographers,* 77.

3. William Clift and Robert Coles, *The Darkness and the Light* (New York: Aperture, 1974), 7.

4. David Featherstone, *Doris Ulmann, American Portraits* (Albuquerque: Univ. of New Mexico Press, 1985), 43–44.

5. Martha Sandweiss, *Masterworks of American Photography* (Birmingham, Ala.: Oxmoor, 1982), 22.

6. James Guimond, *American Photography and the American Dream* (Chapel Hill: Univ. of North Carolina Press, 1991), vii, and Mabel Goodlander, "The First Sixty Years: The Ethical Culture School" (unpublished essay, 1939), iii.

7. John Szarkowski, *Looking at Photographs: 100 Pictures from the Collection of The Museum of Modern Art* (New York: The Museum of Modern Art, 1973), 52.

8. Ruth Banes, "Doris Ulmann and Her Mountain Folks," *Journal of American Culture* 8 (spring 1985), 29.

9. Ibid., 38.

10. Plutarch, Translated by B. Perrin, *Alexander the Great,* vol. 7 (Cambridge, Mass.: Loeb Library), 225.

11. James Guimond, *American Photography,* 85, 86, and 6.

12. Frederick Buechner, *Listening to Your Life* (San Francisco: Harper, 1992), 51–52.

Chapter One: Beginnings

1. "Return of Birth," Card 339246, Bureau of Vital Statistics, New York Health Department, dated June 1, 1882, for the birth of a daughter of Bernhard Ulmann listed as "Dora Ulmann." This card was filled out by Bernhard Ulmann. Doris Ulmann was named after her father's mother. Hans Josephthal, *Stammbaum der Familie Josephthal* (Berlin: Louis Lamm, 1932), Tafel 5.

2. Doris Ulmann's great-grandfather, Bernhard Ulmann, for whom her father was named, was born in 1751, most likely near Prague. It was as a youth there that he "acquired considerable Hebrew and Jewish learning at the Academy in Prague." As an adult, Doris Ulmann's great-grandfather was a successful merchant in the imperial city of Augsburg. However, since he was a Jew, he had to reside in the village of Pfersee, outside the walls of the imperial city. Here he officiated "as an Elder and the head of his religious community" (the Orthodox Jewish synagogue in Pfersee), where he was widely respected and "practiced . . . the religious rite of circumcision." Though he was a leader in both the Jewish and Gentile communities, he faced the same anti-Semitism as other Jews of his period. In 1803, he and several other Jewish leaders in the area around Augsburg were arrested while they were worshiping in their synagogues. They were accused of counterfeiting banknotes and distributing them in the empire of Francis II. Though Ulmann and the other Jews finally were exonerated of all charges, they remained in prison for over seven months. He recounted these events in a German–Yiddish autobiographical narrative entitled, in English, *Chronicle of Ber Bernhard Ulmann.* In 1837, after serving his Orthodox synagogue for over fifty years, Doris Ulmann's great-grandfather died at the age of eighty-six.

Like his father before him, Moritz Ulmann, Doris Ulmann's grandfather, was a successful merchant. The second oldest of the six children of Bernhard, he was born in Pfersee on June 8, 1814. Around 1844, he met and married Doris Kleefeld of Fuerth, Mittelfranken, Bavaria, for whom Doris Ulmann was named. Their family resided in Fuerth for many years. On April 9, 1845, in Fuerth they gave birth to their first son, Bernhard, Doris Ulmann's father. He was the first of nine children. In an effort to appear more German, Moritz Ulmann selected German names for his children. Bernhard Ulmann's siblings were named Ludwig, Sophie, Berta, Hedwig, Johann, Felix, Carl, and Emil, all popular German first names.

Unlike his Orthodox father, Moritz Ulmann was an adherent of the ideas and reforms of the early nineteenth-century German Jewish lay leader Israel Jacobson, a follower of the eighteenth-century German Jewish philosopher Moses Mendelssohn. A scholastic record for Bernhard Ulmann connects Moritz Ulmann and his family to Reform Judaism. It indicates that Bernhard Ulmann received instruction at the Jewish "Religionsschule" at Fuerth and was "confirmed" at age thirteen. The history of Doris Ulmann's family in Europe is documented in the following sources: "Religionsschule" confirmation certificate for Bernhard Ulmann, copy in private collection; Ber Bernhard Ulmann, *Chronicle of Ber Bernhard Ulmann,* translated and introduced by Carl J. Ulmann (New York: Carl J. Ulmann, 1928), 3–10; and Josephthal, *Familie Josephthal,* Tafel 5. The emigration of Bernhard Ulmann and his brother Ludwig is well documented in the following sources: Ira Glazier and P. William Filby, *Germans To America: Lists of Passengers Arriving at U.S. Ports* (Wilmington, Del.: Scholarly Resources,

Inc., 1991), 19:433, 20:92, and 20:95; "Bernhard Ulmann," Card U455, 1880 Census Index, Bureau of Census, U.S. Department of Commerce, Washington, D.C.; "Bernhard Ulmann," Card U4585, 1900 Census Index, Bureau of Census, U.S. Department of Commerce, Washington, D.C.; and "Bernhard Ulmann's Funeral," *New York Times,* December 3, 1915.

Though Doris Ulmann did not attempt to hide the fact she was Jewish, as fellow photographer Margaret Bourke-White did (see Vicki Goldberg, *Margaret Bourke-White,* 41-44), she showed little interest in Jewish subjects. Whether her disinterest was the result of a conscious and rational effort to distance herself from the reform and orthodox Judaism of her ancestors or a reaction to the anti-Semitism of her day is unclear. Anti-Semitism was a very strong force in America and Europe in the first three decades of the twentieth century. During this time American Jews were sometimes blamed and attacked for the social and financial problems of the country by such infamous organizations as the Ku Klux Klan and such famous personalities as Detroit auto magnate Henry Ford and Boston Brahmin Henry Adams. While Ulmann was certainly aware of this and aware of the increase in anti-Semitism in Europe in the 1920s and early 1930s, she never mentioned the influence of these things on the shape and direction of her photography. In contrast, the influence of Felix Adler and the Ethical Culture Society was clear and evident in her concern for and focus on "various types" in American society. As much as traditional Jewish moral teaching must have consciously and subconsciously guided the photographer, Ulmann felt more comfortable with the eclecticism and openness of Adler's philosophy. Unlike the proponents of orthodox and reform Judaism, Adler encouraged the exploration of the ideas and rituals of other faiths, including Christianity. This permitted Ulmann to express her own general religious sensibilities and passion in her study of different Christian individuals and groups, and enabled her to create remarkable portrayals of them.

3. Hasia R. Diner, *A Time for Gathering: The Second Migration, 1820–1880* (Baltimore, Md.: Johns Hopkins Univ. Press, 1992), 169–70.

4. Allan Nevins and Henry Steele Commager, *A Pocket History of the United States* (New York: Pocket Books, 1992), 236–37.

5. F. Trow and H. Wilson*, Trow's New York City Directory* (New York City: The Trow City Directory Co., 1867), 1024.

6. Ibid., (1869), 1095.

7. Ibid., (1871), 1225.

8. Ibid., (1880), 1526.

9. Ibid., (1875), 1323; (1876), 1347; (1877), 1386; (1878), n.p.; (1879), 1479; and "Return of Birth" for "Dora Ulmann."

10. "Bernhard Ulmann," 1900 Census Index; "Married by Rabbi Gottheil," *New York Times,* November 28, 1884; "Return of Birth," for "Dora Ulmann"; "Ulmann" [Gertrude Maas Ulmann], *New York Times,* February 24, 1913; Josephthal, *Familie Josephthal,* Tafel 5; and "Gertrude M. Ulmann," Certificate of Death No. 6290, February 23, 1913, Department of Health of the City of New York, Bureau of Records.

11. "Bernhard Ulmann," 1880 Census Index; "Bernhard Ulmann," 1900 Census Index; and Josephthal, *Familie Josephthal,* Tafel 5.

12. "Return of Birth" for "Dora Ulmann"; Albert N. Marquis, ed., *Who's Who In America* (Chicago: A.N. Marquis Co., 1930–1934), 16:2228 and 17:2319; and Josephthal, *Familie Josephthal,* Tafel 5.

13. 1890 New York City Census (35th Election District, 19th Assembly District, 26th Police Precinct, Book 651, 91), New York City Department of Records, Municipal Archives.

14. W. Phillips, *Phillips' Elite Directory of Private Families and Ladies* (New York City: W. Phillips and Company), (1893), 394; (1894), 426; (1898), 536; (1902), 425; (1903), 441; (1906), 551; (1908), 381. Bernhard Ulmann's business, Bernhard Ulmann and Company, was also listed in W. Phillips's complementary publication, *Phillips' Business Directory of New York City:* (1900), 1296; (1902), 1296; (1903), 1393; (1910), 1143; (1911), 1165; (1913), 1177; and (1914), 1169. See also W. Andrew Boyd, *Boyd's Greater New York Co-Partnership Directory* (New York City: W. Andrew Boyd and Co., 1899), 1113.

15. Dau, *Dau's New York Blue Book* (New York City: Dau Publishing Co.), (1907), 263; (1909), 262; (1910), 251; (1911), 614; (1912), 305; (1913), 305; and (1914), 302. Ludwig Ulmann, Bernhard

Ulmann's younger brother, a banker, was also listed in prominent social registers. Aside from his membership in the National Arts Society, he was a member of the Century Country Club; the Royal Club, London; the Royal Motor Yacht Club, London; and St. Stephen's Club, London. (*Society—List and Club Register* [New York: Society—List and Club Register, 1915], 414.)

16. "Bernhard Ulmann," 1900 Census Index; John Jacob Niles, "Remembrance," *The Appalachian Photographs of Doris Ulmann* (Penland, N.C.: Jargon Society, 1971); Surrogates' Court of the County of New York, "Exhibit B" (Last Will and Testament of Doris Ulmann, June 29, 1927), Agreement of Settlement, between Edna Necarsulmer, and Evelyn Necarsulmer and Henry Necarsulmer, and John Jacob Niles, and John C. Campbell Folk School, and United States Trust Company of New York, February 7, 1935, Doris Ulmann Collection, John C. Campbell Folk School, Brasstown, N.C.; Dale Warren, "Doris Ulmann: Photographer in Waiting," *The Bookman* 72 (October 1930), 129–44; Olive D. Campbell, "Doris Ulmann," *Mountain Life and Work* (October 1934), 11; William J. Hutchins to John Jacob Niles, September 1, 1934, Doris Ulmann Manuscript Collection, Southern Appalachian Archives, Hutchins Library, Berea College, Berea, Kentucky; Josephthal, *Familie Josephthal,* Tafel 5; and *Boyd's* (1899), 1113; *Dau's* (1910), 251; (1911), 614; (1912), 305; (1913), 305; (1914), 302; and (1915), 304.

17. In regard to Ulmann's uncle, Carl Ulmann, see the following: "Carl Ulmann Left $500,000 Estate," *New York Times,* January 9, 1929, and Ulmann, *Chronicle of Ber Bernhard Ulmann,* 3-10. Carl Ulmann was a serious bibliophile. His book collection was sold by his family in New York at Parke-Bernet Galleries on April 15 and 16, 1952. The title of the sale catalogue is *The Notable Collection of Incunabula and Early Printed Books of the Late Carl J. Ulmann.* He was also a member of the Grolier Club. See Allen Asaf and Lynda Wornom, *Members of the Grolier Club: 1884–1984* (New York: The Grolier Club, 1986), 136. It is also significant to note that, like his niece Doris, Carl Ulmann took photography courses with Clarence White at the Extension Division of the Teacher's College at Columbia University. A handwritten list of "Mr. White's Students in Teacher's College," covering the courses for the periods 1916–1917 and 1917–1918, contains the name of Carl Ulmann (Clarence H. White Collection, The Art Museum, Princeton University, Princeton, New Jersey [hereafter, PU]). In regard to Ulmann's personal collection of contemporary authors' works, see Warren, "Doris Ulmann: Photographer in Waiting," 129, 144.

18. "Bernhard Ulmann," 1900 Census Index; *Boyd's* (1899), 1113; *Dau's* (1910), 251; (1911), 614; (1912), 305; (1913), 305; (1914), 302; and (1915), 304; and Josephthal, *Familie Josephthal,* Tafel 5.

19. Louis Shipman, "By Way of Preface," in *A Portrait Gallery of American Editors, Being a Group of XLIII Likenesses by Doris Ulmann,* Doris Ulmann (New York: William Edwin Rudge, 1925), vi; Niles, "Remembrance"; Warren, "Doris Ulmann: Photographer in Waiting," 129–44; Allen Eaton, *Handicrafts of the Southern Highlands* (New York: Russell Sage Foundation, 1937), 17–19; Campbell, "Doris Ulmann," 11; Marquis, *Who's Who* (1930–1934), 16:2228 and 17:2319; Student and Membership Archives, Ethical Culture Society, New York City; and "Doris Ulmann Dead: Noted Photographer," *New York Times,* August 29, 1934.

20. Robert S. Guttchen, *Felix Adler* (New York: Twayne Publishers, 1974), 15, 17.

21. "The Temple Emanu-el Sermon," 1873, Ethical Culture Society Archives.

22. Howard Radest, "Felix Adler: A Biographical Sketch," in *Adler* by Robert S. Guttchen, 24–25.

23. Ibid., 29.

24. Mabel Goodlander, "The First Sixty Years: The Ethical Culture School" (unpublished essay, 1939), iii.

25. Radest, "Felix Adler," 17–46.

26. Goodlander, "First Sixty Years," 1.

27. Ibid.

28. Felix Adler, *The Ethical Record* (1901), 107, as quoted in Howard Radest, *Toward Common Ground: The Story of the Ethical Societies in the United States* (New York: Frederick Ungar Publishing Company, 1969), 97, 103; and Goodlander, "First Sixty Years," 42–43.

29. Toby Himmel to Monika Half, February 8, 1999, author's records. According to Ms. Himmel, director of Alumni Relations, Ulmann "entered the Ethical Culture School, Normal Department on October 3, 1900, and graduated from the Teacher Training course in June of 1903."

30. Archives, Ethical Culture Society, and Adler, *The Ethical Record,* 107. Several scholars have suggested that Ulmann studied photography or took courses with Lewis Hine at the Ethical Culture School. See, among others, William Clift and Robert Coles, *The Darkness and the Light* (New York: Aperture, 1974), 8; David Featherstone, *Doris Ulmann, American Portraits* (Albuquerque: Univ. of New Mexico Press, 1985), 10; Ruth Banes, "Doris Ulmann and Her Mountain Folk," *Journal of American Culture* 8 (spring 1985), 34; Michele and Michel Auer, eds., *Photographers Encyclopaedia International, 1839 to the Present,* s.v., "Ulmann, Doris" (Hermance, Switzerland: Editions Camera Obscura, 1985), n.p.; Naomi Rosenblum, *A History of Women Photographers* (New York: Abbeville Press, 1994), 323; Melissa McEuen, "Doris Ulmann and Marion Post Wolcott," *History of Photography* 19, no. 1 (Oxford, England: Taylor and Francis, Ltd., spring 1995), 4–12; Merry A. Foresta, *American Photographs: The First Century* (Washington, D.C.: National Museum of American Art and Smithsonian Institution Press, 1996), 25 and 150; Helen Goldman, "Photographers," *Jewish Women in America* (New York: Routledge, 1997), 2:1058–64; Christian Peterson, *After the Photo-Secession* (New York: W.W. Norton and Company, 1997), 206; and Judith Fryer Davidov, "Picturing American Types: Doris Ulmann among the Gullahs," *Women's Camera Work* (Durham, N.C.: Duke Univ. Press, 1998), 184. There is no evidence Ulmann was taught by Hine. There are no extant records that indicate Hine taught in the Normal Department of the Ethical Culture School where Ulmann was a student. The Normal Department was located in a rented space in a building on West Fifty-fourth Street, several blocks from where Hine taught. Lewis Hine came to the Ethical Culture School in order to work as an "assistant teacher of nature study and geography" in the elementary and high school programs in the fall of 1901 at the request of his former mentor and principal of the school, Frank Manny. Hine did not take up photography until sometime between 1903 and 1904, when Manny approached him to "assume the position of school photographer and to document classroom activities." Hine only began to teach a course in photography for the students of the elementary and high school programs in 1904, a year after Ulmann had finished her study in the Normal Department. Nonetheless, it is likely that Ulmann did eventually become familiar with Hine's work and that their paths crossed because of their similar social concerns and their connections with the work of Felix Adler, the Ethical Culture Society, and the Russell Sage Foundation. See Daile Kaplan, *Lewis Hine in Europe: The Lost Photographs* (New York: Abbeville Press, 1988), 15–18; Judith Mara Gutman, *Lewis W. Hine and the American Social Conscience* (New York: Walker and Company, 1967), 16–18; and Verna Posever Curtis and Stanley Mallach, *Photography and Reform: Lewis Hine and the National Child Labor Committee* (Milwaukee, Wis.: Milwaukee Art Museum, 1984), 20–21 and 31–32.

31. Interview with Sidonie Gruenberg (1964), as quoted in Radest, *Toward Common Ground,* 102.

32. "Exhibit B" (Last Will and Testament of Doris Ulmann, June 29, 1927). This influence was also evident in the life of her sister, Edna Necarsulmer. See "Mrs. Henry Necarsulmer: Women's Conference Chairman of Society for Ethical Culture," *New York Times,* July 5, 1936. Ulmann's niece, Evelyn Necarsulmer, also attended the Ethical Culture School.

33. According to "An Exhibition of Pictorial Photography of American Artists," September 1917–May 1918, organized by the Pictorial Photographers of America, Ulmann showed (under her married name, Jaeger) a photograph of Dr. Felix Adler in both of the Pictorial Photographers' traveling exhibits. These shows traveled to several museums, including the Art Institute of Chicago, the Cleveland Art Museum, the Cincinnati Museum of Art, the New Orleans Art Association, the Minneapolis Institute of Arts, the University of Oklahoma, and the Newark Museum. A copy of this photograph was reproduced in the journal *Photo=Graphic Art,* vol. 3, no. 2 (October, 1917), n.p.

34. Radest, "Felix Adler," 36.

35. Goodlander, "The First Sixty Years," iii.

36. This is evident in the documents and texts that testify to Ulmann's commitment to attempt both to create art and to convert the reality of the lives of those for whom she felt "life had not always been a dance," Hamlin Garland, "Doris Ulmann's Photographs," *The Mentor* (July 1927), 41–48. See especially: Surrogates' Court of the County of New York, "Exhibit A" (Last Will and Testament of Doris Ulmann, August 21, 1934), and "Exhibit B" (Last Will and Testament of Doris Ulmann, June 29, 1927), *Agreement of Settlement,* February 7, 1935; Radest, "Felix Adler," 36 and 41; Julia Peterkin and Doris Ulmann, *Roll, Jordan, Roll* (New York: Robert O. Ballou, 1933); and Eaton, *Handicrafts,*

17–19. Note also that her photographs were used in brochures and publications produced by several southern charitable and educational organizations, including the John C. Campbell Folk School, the Alliance for the Guidance of Rural Youth, the Southern Woman's Educational Alliance, and Berea College.

37. *Thomas' Register of American Manufacturers, 1905–1906* (New York: Thomas Publishing Company, 1905), 935, 1157.

38. Ibid. In the last years of Bernhard Ulmann's management of his company, it published the following large manuals: *The Glossilla Book of Crochet Novelties: A Collection of Original and Popular Designs with Full Working Instructions* (1912); *Cro-knitting: the New Art of Worsted Work, Also Crocheted Lattice Work, Presenting a Collection of Original and Attractive Designs with Full Working Directions* (1914); and the *Bucilla Library of Art Needlework,* 6 volumes (1914–1916). Few copies of publications by Bernhard Ulmann and Company exist. Two examples of the trade catalogues noted above can be found in the Library of Congress: *The Glossilla Book of Crochet Novelties* (1912) and *Cro-Knitting: The New Art of Worsted Work* (1914). Running between fifty and sixty pages in length, each volume contains detailed instructions for making a variety of handicrafts, including glossilla crochet bags and purses, crocheted belts, infants' caps, sweaters, and scarves, as well as numerous photographs of the handicrafts in finished form. During the same period, under the name of the company's subsidiary, Bear Brand Yarn Manufacturers, Ulmann and Company also produced a large volume on knitting and crocheting, entitled, *Bear Brand Manual of Handiwork.* It was advertised to have "many beautiful pictures . . . of garments photographed on living models."

39. *Dau's* (1907, for 1906), 263. Edna Ulmann married Manhattan attorney Henry Necarsulmer in 1907.

40. Josephthal, *Familie Josephthal,* Tafel 5.

41. Photographic album, private collection.

42. Evelyn Necarsulmer Stiefel, interviews with author, September 1996 and October 1997.

43. Photographic album, 18–21, 24–29.

44. Photograph, private collection, Paris, Kentucky.

45. Photograph, Collection of the University of Kentucky Art Museum, Lexington, Ky.

46. Photographic album, 16, 18–21, and *Dau's* (1907), 263.

47. Photographic album, 26–31, and "Bernhard Ulmann's Funeral," *New York Times,* December 3, 1915. The photograph of Ulmann and her family provides the earliest portrait of the photographer of which I am aware.

48. Photographic album, 2, 17, and 23.

49. Ulmann, *Chronicle of Ber Bernhard Ulmann,* 3–10. See also Mordecai Kaplan, "What Is Traditional Judaism?" in *The World Treasury of Modern Religious Thought,* edited by Jaroslav Pelikan (Boston: Little, Brown, 1990), 343–44, and also the following: "Bernhard Ulmann's Funeral"; "Estates Appraised—Bernhard Ulmann," *New York Times,* November 9, 1917; "Carl Ulmann Left $500,000 Estate," *New York Times,* January 9, 1929; "Charities Benefit by Ulmann Will," *New York Times,* November 19, 1929; and "Ulmann Estate: $1,355,521," *New York Times,* January 1, 1930.

50. Ulmann, *Chronicle of Ber Bernhard Ulmann,* 3–10.

51. Ibid., 4. In his introduction to his grandfather's *Chronicle,* Carl J. Ulmann reports that he possessed the original nineteenth-century Yiddish text of the *Chronicle* as well as a later German translation from which he produced his English translation. He adds that his uncle Jonas Ulmann made the German translation about 1860. In regard to Ber Bernhard Ulmann's *Chronicle,* see Steven Lowenstein, "The Yiddish Written Word in Nineteenth-Century Germany," *Leo Baeck Institute Yearbook* 24 (1979): 179–92.

52. Ulmann, *Chronicle of Ber Bernhard Ulmann,* 5, 8–10.

53. "Estates Appraised—Bernhard Ulmann"; and "Bernhard Ulmann and Co.," *Corporate Directory for City of New York,* volumes for 1909, 1918–1919, and 1921–1922.

54. Bernhard Ulmann Company, Inc., Board of Directors, "Minute" (January 20, 1916), 4–5.

55. "Estates Appraised—Bernhard Ulmann." In addition to the Ethical Culture Society and the German Hospital Dispensary, Bernhard Ulmann also left monies for the following organizations: United Hebrew Charities, Mount Sinai Hospital, Hebrew Orphan Asylum, Montefiore Home, Hospital for Chronic Diseases, Home for Aged Hebrews, and the Home for Hebrew Infants.

56. Warren, "Doris Ulmann: Photographer in Waiting," and *Who's Who* (1930–1934), 16:2228 and 17:2319.

57. *Dau's* (1906), n.p., and "Bernhard Ulmann," 1910 Census Report, Bureau of Census, U.S. Department of Commerce, Washington, D.C.

58. Warren, "Doris Ulmann: Photographer in Waiting," 142, and *Who's Who* (1930–1934), 16:2228 and 17:2319.

59. "Bernhard Ulmann," 1910 Census Report.

60. Ibid.

61. "Ulmann" [Gertrude Maas Ulmann], and "Gertrude M. Ulmann," Certificate of Death, February 23, 1913, Department of Health of City of New York, No. 6290. This certificate notes that Gertrude Ulmann had been seriously ill for three years prior to her death.

62. According to her death record, Gertrude Ulmann died as a result of chronic nephritis. Dr. Alicia Jenkins, a research specialist at the Medical University of South Carolina, described chronic nephritis to the author in a phone conversation on February 12, 1999.

63. According to the October 15, 1914, *New York City Telephone Directory,* Mrs. Charles H. Jaeger resided at 129 West Eighty-sixth Street.

64. Ulmann often wrote of her health problems in her correspondence. They seem to have remained with her all her life, affecting her physical strength and also her appearance. Decades after her death, her last male companion, John Jacob Niles, recalled in *The Appalachian Photographs of Doris Ulmann* that as a young girl "Doris developed a stomach ulcer and although she went through several sieges of corrective surgery, she never completely recovered." Though it is impossible to determine if her early medical difficulties were associated with her later problems, they certainly brought her substantial suffering, shaped her understanding of herself and her work, and made her sensitive to the frailty and suffering of others.

65. According the *Society—List and Club Register* (New York: Society—List and Club Register, 1915), 215 and 414, Jaeger and Ludwig Ulmann were both members of the National Arts Society. "Dr. Charles H. Jaeger," Archives, New York Academy of Medicine.

66. Among other things, Charles Jaeger's boldness, passion, and diverse interests attracted Ulmann. Along with his significant work in the fields of medicine and photography, he also broached the fields of city politics and architectural development. See Charles Herman Jaeger, *The New Court House for New York City* (New York: Charles H. Jaeger, n.d.) and "Dr. Charles H. Jaeger is exhibiting models and plans for a proposed suburban art center . . . ," *New York Times,* February 17, 1924. Information about Jaeger's study and work at the College of Physicians and Surgeons, Columbia University, can be found in C.H. Jaeger," *American Medical Directory* (Chicago: American Medical Association, 1912), 860, and (1914), 1031, and "Dr. Charles H. Jaeger," Archives, College of Physicians and Surgeons, Central Records, Columbia Medical Center.

67. "Charles H. Jaeger, Orthopedist, Dies," *New York Times,* September 14, 1942.

68. "C. H. Jaeger," *American Medical Directory* (1912), 860, and (1914), 1031.

69. "Charles H. Jaeger, Orthopedist, Dies."

70. "Dr. Charles H. Jaeger," CU. In the same year, 1901, Jaeger (along with his colleague J. Hilton Waterman) presented a paper before the American Orthopaedic Association entitled "Caries of the Spine: An Analysis of a Thousand Cases." The paper was later published in *The New York Medical Journal* (New York: A.R. Elliott Publishing Company, 1901), 1–10. Two years later, in 1903, *The New York Medical Journal* published two papers by Jaeger entitled "The Lorenz Hip Redresser" and "Lorenz Spica."

71. *Phillips' Business Directory* (1904), 679, and (1906), 910. After 1909, Jaeger moved his private medical office to 471 Park Avenue. The *American Medical Directory* for 1914 and 1918 listed Jaeger's office address as 471 Park Avenue. In 1918, it listed his home address as 129 West Eighty-sixth Street.

72. "Dr. Charles H. Jaeger," CU, and "Dr. Charles H. Jaeger," Archives, New York Academy of Medicine.

73. "Work They Can Do Taught to Cripples: Bronx Hospital of Hope Aims to Make Maimed Independent and Useful," *New York Times,* October 18, 1914.

74. Ibid.

75. Ibid.

76. Ibid. Ulmann would have certainly been impressed with Jaeger's involvement with the Trade School of the Hospital of Hope. It fit her Adlerian commitment to help establish places and programs for people of "all types" to succeed and affirm their importance within democratic society.

77. Ibid.

78. Ibid.

79. Charles H. Jaeger, "Trade Training For Adult Cripples," *American Journal of Care for Cripples* 1 (New York: Federation of Association for Cripples, 1914), 70–73.

80. Ibid., Plates 1 and 2.

81. *American Journal of Care for Cripples,* 1: title page, 1–2. Jaeger's trade school is listed as a member of the federation. Later in the same year, on October 18, 1914, "Work They Can Do Taught to Cripples" appeared in the *New York Times.* The *Times* article reiterated much of the information provided in Jaeger's article in the *American Journal of Care for Cripples* and provided some extensive quotations from the physician.

82. "Dr. Charles H. Jaeger," CU, and Dr. Charles H. Jaeger, "Flexion Deformity of the Knee. An Improved Method of Correction," *American Journal of Surgery* (January 1916): 15–16.

83. Jaeger, "Flexion Deformity," 15–16.

84. "Dr. Charles H. Jaeger," CU, and "C.H. Jaeger," *American Medical Directory* (Chicago: American Medical Association, 1929), 1032. Among his other medical accomplishments, Jaeger also discovered a nonsurgical method for curing congenital hip dislocation in children that he presented to the orthopedic surgery section of the New York Academy of Medicine, "Uses Brace to Cure Dislocation of Hip," *New York Times,* May 16, 1925.

85. New York Telephone Company, *New York City Telephone Directory* (October 15, 1914), 307; (February 4, 1915), 313; (May 16, 1915), 309; and (October 14, 1915), 263.

86. Featherstone, *Doris Ulmann, American Portraits,* 12–13. The photographs that Jaeger exhibited during his marriage to Ulmann reveal some of the sites and places the couple visited in their European travels. See notes 136, 152, 164, 168, 169, 175, 184, and 191 in this chapter.

87. "Bernhard Ulmann's Funeral."

88. Rosenblum, *History of Women Photographers,* 74–75.

89. Ibid., 71. See also the series of four articles by photographer Henry Troth in *The Ladies Home Journal* in the January, February, March, and April 1897 issues, entitled, "Amateur Photography at Its Best."

90. Rosenblum, *History of Women Photographers,* 71.

91. Ibid., 56–58, 71, 77–78, and 81.

92. Frances Benjamin Johnston, "What a Woman Can Do with a Camera," *Ladies Home Journal* 14 (September 1897), 6.

93. Ibid., 6–7.

94. Gertrude Käsebier, in Giles Edgerton [Mary Fanton Roberts], "Photography as an Emotional Art: A Study of the Work of Gertrude Käsebier," *Craftsman* 12 (April 1907), 88; reprinted in Rosenblum, *History of Women Photographers,* 77.

95. Rosenblum, *History of Women Photographers,* 71, and *Who's Who* (1930–1934), 16:2228 and 17:2319.

96. According to Ulmann, she took up photography as a hobby and looked upon it in this way for some time (Doris U. Jaeger to Dr. William Halsted, November 15, 1920, The Alan Mason Chesney Medical Archives, The Medical Department of the Johns Hopkins University, Baltimore, Md. [hereafter, JH]). Ulmann's friend, Pulitzer Prize—winning novelist Julia Peterkin, reiterated this in a much later letter, some years after Ulmann's death (Peterkin to Hartman, August 31, 1942, South Caroliniana Library, University of South Carolina, Columbia). Ulmann's obituary in the *Pictorial Photographers of America Bulletin* (October 1934) also recorded her early interest in photography. Her earliest dated photograph (located in The Doris Ulmann Collection, The New-York Historical Society) is a portrait dated 1915, which shows significant artistry and skill. It is likely she began her first formal training with Clarence White in classes sponsored by the Extension Division of the Teacher's College at Columbia University. Some lists in the Clarence H. White Collection, The Art Museum, Princeton University, Princeton, N.J. provide particular information about Ulmann's and her husband's study at

both Teacher's College and the Clarence H. White School of Photography. A handwritten list of "Mr. White's Students in Teacher's College" for 1915–1917 contains the names of both Doris Jaeger (Ulmann) and Charles Jaeger (Ulmann's husband). A typed list of the students of the "Clarence H. White School of Photography" for the 1915–1916 school year also has the names of Doris Jaeger and Charles Jaeger. However, a handwritten list of "C. H. White School Alumni" indicates that Mrs. Charles Jaeger "attended" in 1916 (and presumably 1917 as well) and "graduated" in 1918. The same list provides no information on the dates Charles Jaeger attended and graduated. It is likely that he simply took additional courses with his wife at the school during the 1915–1916 term. See also Bonnie Yochelson and Kathleen A. Erwin, *Pictorialism into Modernism* (New York: Rizzoli International Publications, 1996), 199; Featherstone, *Doris Ulmann, American Portraits,* 12; and *Dau's* (1916), 176.

97. Dorothy Norman, *Twice-A-Year,* 1942. Reprinted in William Crawford, *The Keepers of the Light* (Dobbs Ferry, N.Y.: Morgan and Morgan, 1979), 97.

98. Maynard P. White Jr., "Clarence H. White: A Personal Portrait," Ph.D. diss., University of Delaware, 1975 (Ann Arbor, Mich.: University Microfilms International, 1975), 103–19 and 162–68, and Maynard P. White, *Symbolism of Light: The Photographs of Clarence H. White* (Wilmington: Delaware Art Museum, 1977), 14–20.

99. White, "Clarence H. White," 94–96, 120–23, and 124–30, and White, *Symbolism of Light,* 25–27. For additional information on the relationship between Stieglitz and White, Käsebier, and other pictorialists, see Richard Whelan, *Alfred Stieglitz: A Biography* (Boston: Little, Brown, 1995), 288–92.

100. Yochelson and Erwin, *Pictorialism,* 40, 42, and 48. It is interesting to note that Melbert B. Cary Jr., in *A Bibliography of The Village Press* (New York: The Press of the Woolly Whale, 1938), 111–12, states that this exhibition "was the first annual exhibition of the Pictorial Photographers of America."

101. Yochelson and Erwin, *Pictorialism,* 42.

102. Ibid., 48, 50 and 117, note 56.

103. Ibid., 50.

104. White, "Clarence H. White," 213; White, *Symbolism of Light,* 22–25; and Yochelson and Erwin, *Pictorialism,* 54.

105. White, "Clarence H. White," 180; White, *Symbolism of Light,* 22–25; and Yochelson and Erwin, *Pictorialism,* 54.

106. Yochelson and Erwin, *Pictorialism,* 132.

107. Ibid., 144.

108. Ibid. Anderson published several of his lectures from the White School in *Pictorial Photography: Its Principles and Practice* (Philadelphia: J.B. Lippincott, 1917).

109. Yochelson and Erwin, *Pictorialism,* 144. Weber also published a number of his lectures in *Essays on Art* (New York: William E. Rudge, 1916). The publisher, Rudge, was a friend of Clarence White.

110. Max Weber, "The Filling of Space," *Platinum Print* 1, no. 2 (December 1913): 6.

111. André Malraux, *The Voices of Silence,* translated by Stuart Gilbert (Princeton, N.J.: Princeton Univ. Press, 1978), 312.

112. Ibid.

113. Yochelson and Erwin, *Pictorialism,* 32.

114. White, "Clarence H. White," 192–94.

115. *Columbia University Photographic Studies* (New York: Columbia Univ., 1920).

116. Malraux, *Voices of Silence,* 281.

117. Ibid., 317.

118. Milton Meltzer, *Dorothea Lange: A Photographer's Life* (New York: Farrar Straus Giroux, 1978), 30–31.

119. Ibid., 30.

120. Paul Hill and Thomas Cooper, eds., *Dialogue with Photography* (New York: Farrar Straus Giroux, 1979), 284.

121. Johnston, "What a Woman Can Do," 6; William Innes Homer, *A Pictorial Heritage: The Photographs of Gertrude Käsebier* (Wilmington: Delaware Art Museum, 1979), 32–33; and John Wallace Gillies, *Principles of Pictorial Photography* (New York: Falk Publishing Company, 1923), 85–86. Early in her study (between 1915 and 1917) Ulmann used a 5" x 7" view camera, which permitted her to

learn how to make contact prints and prepared her for work with the 6½" x 8½" plates she came to prefer. Later she also occasionally used an 8" x 10" glass-plate tripod-mounted folding view camera. Several of her 5" x 7" images remain (in the Special Collections and Archives, University of Kentucky Libraries). But few of her 8" x 10" images remain. The photographer also bought a Graflex camera (which would have made her work much easier and was the camera of choice for many of her contemporaries, including Lewis Hine) while she was in California in 1921 but, according to Antoinette Hervey, "didn't like it at all and sold it out there" (Antoinette Hervey to Laura Gilpin, November 20, 1921, Laura Gilpin papers, Amon Carter Museum Archives). View cameras are still widely used today.

122. Homer, *Pictorial Heritage,* 32–33 and Gillies, *Principles,* 85–86. Martha Sandweiss makes this remark in her discussion of Gilpin's and Ulmann's use of the large-format view camera (*Laura Gilpin: An Enduring Grace,* 58).

123. William Clift and Robert Coles, *The Darkness and the Light: Photographs by Doris Ulmann* (New York: Aperture, 1974), 11. John Jacob Niles, "Doris Ulmann: Preface and Recollections," *The Call* (Eugene, Ore.: University of Oregon, spring 1958), 19:4–9; Niles, "Remembrance," 14; and Homer, *Pictorial Heritage,* 33. Though there is no extant evidence that Gertrude Käsebier and Ulmann had a teacher-student relationship as Käsebier had with some female photographers (phone conversation between author and Käsebier biographer, Barbara Michaels, spring 1999), her influence may be present in Ulmann's "delicate use of natural light" and in Ulmann's early series of photographs of young women in antique dress. See Homer's reference to Käsebier's use of "natural side light" and his reference to Käsebier's early series of "female subjects in antique dresses" in *Pictorial Heritage,* 14–15.

124. Homer, *Pictorial Heritage,* 32–34.

125. Ibid., 33–34.

126. Gillies, *Principles,* 115.

127. Ibid.

128. Yochelson and Erwin, *Pictorialism,* 50–56.

129. Ibid., 50.

130. In what may be only a minor difference of interpretation, Maynard P. White Jr. ("Clarence H. White," 227–28 and 264, note 13) says that the Pictorial Photographers of America were "founded on November 15, 1915, and held [their] first formal meeting on January 15, 1916." He adds that documentation for this can be found in "separate entries for November 15, 1915, and January 15, 1916, in the Diary of Jane Felix White from November 2, 1915, through December 14, 1919." He further states that both Charles H. Jaeger and Ulmann "were intimates of the Whites." See also the additional account of the founding of this group in *Pictorial Photographers of America Yearbook* (New York: The Pictorial Photographers of America, 1917), 8.

131. *PPA Yearbook,* (1917), 6.

132. Ibid., 8.

133. Ibid., 8–9. It is interesting to note that medical doctors played a significant role in the early days of the Pictorial Photographers of America. Aside from Jaeger, two other members of the executive committee in 1916 were physicians: Dr. A.D. Chaffee and Dr. D.J. Ruzicka. Several other doctors were also active members in the organization.

134. American Institute of Graphic Arts, *An Exhibition of Photography: October 4 to November 10, 1916* (New York: American Institute of Graphic Arts, 1916), n.p. Jaeger's work was listed as "Group of Small Prints."

135. *PPA Yearbook* (1917), 10.

136. Clarence H. White School of Photography, *Exhibition of Photographs by the Alumni Association of the Clarence H. White School of Photography,* February 1917 (New York: Clarence H. White School, 1917), 3. Three prints by Jaeger were selected for this exhibit: "Market Day, Brittany," "Dordrecht," and "Cathedral Spires."

137. Alumni Association of the Clarence H. White School of Photography, *Bulletin* 2 (June 1, 1917), n.p.

138. *PPA Yearbook* (1917), 11–16.

139. Colin Ford, ed., *An Early Victorian Album: The Photographic Masterpieces of David Octavius Hill and Robert Adamson* (New York: Knopf, 1976), 14–64. Photographic historian and critic A.D. Coleman first suggested the similarity between Ulmann's photos and the work of Hill and Adamson.

140. Whelan, *Alfred Stieglitz,* 203.

141. J. Craig Annan, "David Octavius Hill, R. S. A., 1802–1870," *Camera Work* 10 (April 1905), plates I–IV, 17–21.

142. Whelan, *Alfred Stieglitz,* 203–4, and David Calvin Strong, "Sidney Carter and Alfred Stieglitz," *History of Photography* 20, no. 2 (Oxford, England: Taylor and Francis, Ltd., 1996), 160–62.

143. Whelan, *Alfred Stieglitz,* 282 and 289.

144. *Camera Work,* 37–40, plates I–IX, 48; Whelan, *Alfred Stieglitz,* 334; and Arnold Gassan, *A Chronology of Photography: A Critical Survey of the History of Photography as a Medium of Art* (Athens, Ohio: Handbook Company, 1972), 336.

145. Whelan, *Alfred Stieglitz,* 282 and 289. Ulmann acknowledged that she had "spent much time in Europe studying the paintings of the great masters for suggestions in her photograph art." See "Art Photography Exhibit Arranged," *The Richmond News Leader,* October 25, 1933.

146. *PPA Yearbook* (1917), 14.

147. Ibid., 16–17.

148. Ibid., 16–18.

149. Ibid., 19–20; and Pictorial Photographers of America, *An Exhibition of Pictorial Photography by American Artists,* September 1917 (New York: Pictorial Photographers of America, 1917), 5.

150. Pictorial Photographers of America, *An Exhibition of Pictorial Photography By American Artists,* October 1917 (New York: Pictorial Photographers of America, 1917), 5.

151. Photographer Laura Gilpin recalled that it was during this time, when she was a student at the White School, then located at the Washington Irving House at 122 East Seventeenth Street, that Ulmann gave occasional photographic presentations and lectures. See Martha A. Sandweiss, *Laura Gilpin: An Enduring Grace* (Fort Worth, Tex.: Amon Carter Museum, 1986), 30–31. Ulmann was again recognized at the eighth regular meeting of the Association of the Pictorial Photographers of America in November when she, along with Thomas Coke Watkins and Arthur D. Chapman, was selected to serve on the association's nominating committee.

152. Clarence H. White School of Photography, *An Exhibition of Pictorial Photography,* December 18, 1917, to January 12, 1918 (New York: Clarence H. White School of Photography, 1917), 11. Jaeger's five prints in the show were: "The River Lahn," "Gossip," "The Day Is Done," "Rothenburg Rampart," and "The Schooner." They were bromide photographs.

153. *PPA Yearbook* (1917), 20; and "Estates Appraised—Bernhard Ulmann," *New York Times,* November 9, 1917.

154. Photographic Section of the Academy of Science and Art, *Catalogue of the Fifth Annual Pittsburgh Salon of Photography,* March 4 to 31, 1918 (Pittsburgh: Carnegie Institute, Department of Fine Arts, 1918), 6. This exhibit and all other exhibits of the Pittsburgh Salon were held under the auspices of The Photographic Section of the Academy of Science and Art of Pittsburgh, Pennsylvania. Two of Jaeger's prints were also selected for this particular show: "The Little Street" and "The Entrance."

155. Doris U. Jaeger, *The Faculty of the College of Physicians and Surgeons, Columbia University in the City of New York: Twenty-Four Portraits* (New York: P.B. Hoeber, 1919).

156. Cary, *Bibliography of The Village Press,* 51–52. Shortly after finishing this publication, the Goudys moved the press to Hingham, Massachusetts. Two years later, they moved it again—to New York City. In 1913, the Goudys relocated the press to Forest Hills Gardens, New York. Ten years later, they moved it to Marlborough-on-Hudson, New York. (See ibid., 153.)

157. Ibid., 103–4.

158. Ibid., 111–12. Six years later, in 1918, about the time of their collaboration with Ulmann, the Goudys again assisted the Pictorial Photographers of America. In November, they printed and published five hundred copies of an eight-page pamphlet for a photographic exhibition held at Columbia University from November 11 to November 30, "Exhibitions of Pictorial Photographs." (See ibid., 136.)

159. Alvin Langdon Coburn, *Men of Mark* (London: Duckworth, 1913).

160. Yochelson and Erwin, *Pictorialism,* 50, 52, 70, 152 and 154.

161. A specialist in medical texts, P.B. Hoeber was a natural choice for the publication of *The*

Faculty of the College of Physicians and Surgeons. Within the same period he also published *Contributions to Medical and Biological Research,* a memorial to Sir William Osler, and a quarterly, *The Annals of Medical History,* which were also designed by Frederic Goudy. Hoeber was also, as were Goudy, Clarence H. White, William Edwin Rudge, and Henry Marchbanks, a member of the American Institute of Graphic Arts and the Stowaways, a group dedicated to work in the graphic arts. Arthur W. Dow, "Mrs. Gertrude Käsebier's Portrait Photographs, From a Painter's Point of View," *Camera Notes* 3, no. 1 (July 1899), 22.

162. Doris Jaeger to Dr. William Halstead, April 2, 1920, and Dr. William Halstead to Mrs. Charles Jaeger, April 27, 1920, Archives, the Medical Department of the Johns Hopkins University, Baltimore, Maryland (hereafter cited as JH). Following the publication of *The Faculty of the College of Physicians and Surgeons* in the spring of 1920, it was exhibited by Frederic and Bertha Goudy in an exhibition of printing held by the American Institute of Graphic Arts at the National Arts Club in New York City from May 5 to June 1, 1920.

163. Contrary to David Featherstone's assertion (*Doris Ulmann,* American Portraits), Jaeger's involvement in the Pictorial Photographers of America continued for some time, long after his separation and divorce from Ulmann. Journals and catalogues of the Pictorial Photographers of America document that Jaeger remained actively involved in the organization into the 1930s. References to Jaeger participation can be found in the following documents, as well as others: *Light and Shade,* January 1930, 6, February 1930, 7, and the catalogue of the *Second Travel Salon of the Pictorial Photographers of America, 1931–1932,* January 18 to January 30, 1932, n.p.

164. Photographic Section of the Academy of Science and Art, *Catalogue of the Sixth Annual Pittsburgh Salon of Photography,* March 3 to 31, 1919 (Pittsburgh: Carnegie Institute, Department of Fine Arts, 1919), 6. Three of Jaeger's prints were also selected for this exhibit: "After the Blizzard," "Memorial Gate," and "Brittany Street."

165. "Oil Prints," *The Photo Miniature* 15, no. 174 (New York: Tennant and Ward, May 1919), 278–79. Barbara Lovejoy, Registrar of the University of Kentucky Art Museum, notes in her thesis, "The Oil Pigment Photography of Doris Ulmann" (Master's thesis, University of Kentucky, 1993, 55), that Ulmann and other pictorialists were attracted to oil-pigment printing because it enabled them "to mirror the fine arts of drawing and painting and afforded more control over the final products." Lovejoy goes on to state these facts about oil printing (56–68):

> The technique of oil printing, like lithography, is based on one simple fact—that oil and water do not mix. Briefly, a sheet of paper with a coat of gelatin is sensitized with potassium dichromate, then exposed in contact with a negative under strong ultraviolet light. The gelatin becomes hardened in proportion to the amount of light that it receives. Thus, in the light areas of the negative (the shadows of the positive) the gelatin hardens, while it remains soft in the dark areas (the highlights of the positive).
>
> After exposure, the paper is soaked in cool water, which causes any unhardened gelatin to swell. Very light areas swell the most, gray areas not as much, and black areas not at all. The gelatin matrix is then wiped surface-dry and inked with stiff oil-based lithographic ink with brushes. Because water and oil do not mix, the ink sticks in the dark shadow areas which did not absorb water and least in the highlight areas which absorbed a great deal. . . .
>
> Ulmann seems to have used the same type of paper in all the oil prints . . . a medium weight, slightly textured, cream-colored art paper. . . . Viewing the coating on Ulmann's oils under magnification reveals uneven "blobs" of gelatin in some areas and a layer quite a bit thicker than occurs on the commercial paper. This uneven coating suggests that the paper has been hand-coated. There are two ways this can be accomplished, either by soaking the paper in a warm gelatin solution or by pinning the paper to cardboard and applying the gelatin with a sponge. Considering the uncoated reverse and the presence of pinholes in the corners of her untrimmed prints, Ulmann must have used the second method.
>
> Inking the print is the most difficult part of the process, requiring a great deal of practice and time. For the initial inking, either a brush or a brayer can be used. Ulmann

used a brush exclusively on these prints, a determination made by viewing the borders of the untrimmed prints. The wide marks and hard edges of a brayer would be obvious in the white margins beyond the image, but in Ulmann's oils, only the feathery marks of a brush are visible.

There are three basic actions of the brush in inking a print: slow dabbing to deposit the ink over the entire print, fast dabbing to deposit ink in shadows and remove it from highlights, and hopping to remove ink from highlights and shadows. All three actions are used intermittently throughout the process until the desired effects are achieved. A stiff lithographic ink is the most suitable, especially for the initial inking, while a softer ink may be used later for highlight detail. Although an artist could produce prints in any color of ink available at the time, Ulmann chose black ink for the majority of her prints. . . .

The identification of the Ulmann oil prints . . . was based on several pieces of evidence, the most important being the inscriptions made by the artist on the mounts. One print, mounted untrimmed to tissue with glassine tape, then attached to the mount, is labelled "oil print." . . . Several are marked with "op [oil print]." Two other prints, trimmed and mounted to cardboard, then attached to tissue and the mount, are marked "oil p [print]." . . . Ulmann used these two mounting techniques exclusively for her oil prints.

166. Art Alliance of America and the American Institute of Graphic Arts, *Second Annual Exhibition,* April 30 to May 24, 1919 (New York: American Institute of Graphic Arts, 1919), 26–27.

167. Pictorial Photographers of America, *Pictorial Photography in America: 1921* (New York: The Pictorial Photographers of America, 1920), 73.

168. Camera Pictorialists of Los Angeles, *Third International Photographic Salon,* January 3 to 31, 1920 (Los Angeles: Museum of History, Science and Art, 1920), n.p. Jaeger's works shown in this exhibit were: "After the Blizzard," "Through the Arch," "The Spires of Morlaix," "The Setting Sun," "Feudal Tower," and "Of a Past Century."

169. Pictorial Photographers of America, *An Exhibition of Pictorial Photograph,* January 10 to February 1, 1920 (Portland, Ore.: The Art Museum, 1920), n.p. The exhibition also included four images by Jaeger: "The Day is Done," "Clearing Skies," "Brittany Streets," and "Of a Past Century."

170. Pictorial Photographers of America, *Pictorial Photography in America, 1920* (New York: The Pictorial Photographers of America, 1919), 59.

171. Ibid., 6.

172. See Dr. William Halsted to Doris Jaeger, February 28, 1920; Jaeger to Halsted, March 1, 1920; Halsted to Jaeger, March 29, 1920; Jaeger to Halsted, April 2, 1920; Halsted to Jaeger, April 5, 1920; Halsted to Jaeger, April 6, 1920; Lord Baltimore Press to Halsted, April 5, 1920; Jaeger to Halsted, April 11, 1920; Halsted to Jaeger, April 13, 1920; Halsted to Jaeger, April 27, 1920; Halsted to Jaeger, June 19, 1920; Jaeger to Halsted, June 25, 1920; Jaeger to Halsted, October 4, 1920; Halsted to Jaeger, October 13, 1920; Halsted to Jaeger, October 26, 1920; Jaeger to Halsted, November 15, 1920; Jaeger to Dr. William Welch, November 21, 1920; Jaeger to Dr. Mac Callum, February 24, 1921; Doris Ulmann to Welch(?), January 5, 1922; and Ulmann to Mac Callum, April 3, 1922, JH.

173. Doris Ulmann to Dr. Mac Callum, April 3, 1922, JH.

174. Doris Jaeger to Dr. William Halsted, November 15, 1920, JH.

175. Photographic Section of the Academy of Science and Art, *Catalogue of the Seventh Annual Pittsburgh Salon of Photography,* March 3 to 31 (Pittsburgh: Carnegie Institute, Department of Fine Arts, 1920), 7; and Doris Ulmann, *A Book of Portraits of the Faculty of the Medical Department of the Johns Hopkins University, Baltimore* (Baltimore, Md.: Johns Hopkins Univ. Press, 1922), n.p. Some months later, in August, Ulmann and Jaeger were again honored. Twelve of their photographs were selected for inclusion in a group exhibition of the Pictorial Photographers of America at the Copenhagen Photographic Amateur Club Exhibition in Denmark. Ulmann's exhibited works were *Portrait of a Child* (oil), *Masts* (platinum), *The War Correspondent* (platinum), *An Illustration* (oil), *Interior* (platinum), and *Circles* (platinum). They reflected the diversity of her photographic interests and subjects at this time and her continuing interest in both platinum and oil processes. Pictorial Photographers of

America, *Copenhagen Photographic Amateur Club, Exhibition 1920,* August 25 to September 10 (Copenhagen: Pictorial Photographers of America, 1920), n.p. Jaeger's works in the show were *Gossip* (bromide), *Through the Arch* (bromide), *The Spires of Morlaix* (bromide), *After the Blizzard* (gum), *Boats* (gum), and *Columbia University* (gum).

176. White, "Clarence H. White," 182, and White, *Symbolism of Light,* 22.

177. Clarence H. White School of Photography, *The Bulletin of the Alumni of the Clarence H. White School: House Warming Number* (New York: Clarence H. White School of Photography, 1920), 3 and 6. Ulmann also had her work featured in a pamphlet, *Columbia University in the City of New York, Photographic Studies,* in the same year. A reproduction of her architectural photograph *The Urns* illustrates the front cover of the text. An additional reproduction of her photograph *Illumination* is featured in the body of the text along with the works of several other fellow pictorialists. Columbia University, *Columbia University in the City of New York: Photographic Studies* (New York: Columbia University, 1920), front cover and 9.

178. "Charles H. Jaeger," 1920 Census Report, Bureau of Census, U.S. Department of Commerce, Washington, D.C.

179. *Exhibition of Photographs by Alumni, Clarence H. White School of Photography, 460 West 144th, New York.* 1921.

180. *Pictorial Photography in America, 1921,* 43.

181. London Salon of Photography, *Catalogue of the International Exhibition of the London Salon of Photography: 1921* (London: London Salon of Photography, 1921), 23, 32.

182. Ulmann to Dr. William H. Welch, November 21, 1920, and Ulmann to Dr. Mac Callum, February 24, 1921, JH. Nevada required only six months' residence in order to obtain a legal divorce (Russell R. Elliott, *History of Nevada* [Lincoln: Univ. of Nebraska Press, 1987], 248). Amy Harvey, County Clerk, Washoe County, Reno, Nevada, was unable to find a reference to Ulmann's divorce in the records of the most populated counties in Nevada (Amy Harvey to author, November 16, 1999). Antoinette Hervey, a fellow pictorialist, made mention of Ulmann's divorce in correspondence with Laura Gilpin (Antoinette Hervey to Laura Gilpin, November 20, 1921, Laura Gilpin Papers, Amon Carter Museum, Fort Worth, Texas).

There are no records of Ulmann and Jaeger's divorce in Manhattan. The circumstantial evidence (noted in the narrative) suggests Ulmann procured her divorce in Nevada or California. Absent a definitive record, it is impossible to be certain about the reason for Ulmann's divorce from Jaeger. However, adultery seems a plausible reason. This explanation was first suggested to the author by an archivist in Manhattan who had substantial knowledge of this topic and period. He noted that Manhattan statutes prohibited divorce on any grounds other than adultery and required that divorces be publicly recorded in local newspapers. Ulmann would have found such publicity hurtful, obtrusive, and unseemly, and so, as many New Yorkers of the period, would have sought to have this legal matter handled in another jurisdiction. The occurrence of adultery would also help explain why neither Ulmann nor Jaeger made mention of their marriage after the divorce.

183. Clarence H. White School of Photography, *The Bulletin of the Alumni,* fall and winter number, November 1921 (New York: Clarence H. White School of Photography, 1921), 4.

184. Florence N. Levy, ed., *Bulletin of the Art Center* 8, no. 8, May 1930 (New York: Art Center, 1930), 101; and Pictorial Photographers of America, *Catalogue of Exhibition by Pictorial Photographers of America: October 31 to November 30, 1921* (New York: Pictorial Photographers of America, 1921), n.p. Jaeger had three photographs in this exhibit: *Street Scene, Gruyeres, The Wayside Shrine,* and *Under the Pier.*

185. Antoinette Hervey to Laura Gilpin, November 20, 1921, Laura Gilpin papers, Amon Carter Museum, Fort Worth, Texas.

186. Hamlin Garland, "Doris Ulmann's Photographs," *The Mentor* (July 1927), 42.

187. Numerous vintage photographs in various public and private collections reveal signs of this erasure and resigning. According to later correspondence by her brother-in-law, Henry Necarsulmer, Ulmann initiated divorce proceedings and "divorced her husband, after which she resumed her maiden name and was known as Mrs. Doris Ulmann." See Henry Necarsulmer to Dr. William Hutchins, July 10, 1935, BC.

188. The absence of any mention of the other in Ulmann's and Jaeger's obituaries and in Ulmann's

interview with Dale Warren in 1930 ("Doris Ulmann: Photographer in Waiting") further testifies to the estrangement of the former couple.

189. Pictorial Photographers of America, *The Bulletin* (January, February, March 1922) (New York: Pictorial Photographers of America, 1922), n.p.

190. Photographic Section of the Academy of Science and Art, *Catalogue of the Ninth Annual Pittsburgh Salon of Photography,* March 1 to 31, 1922 (Pittsburgh: Carnegie Institute, Department of Fine Arts, 1922), 13.

191. Pictorial Photographic Society of San Francisco, *Catalog of Exhibits: First Annual International Exhibition of Pictorial Photography,* May 20 to June 18, 1922 (San Francisco: Pictorial Photographic Society of San Francisco, 1922), n.p. Five chloride photographs by Jaeger were also exhibited in this show: *Streamers, The Lute Player, Where the Boat Lands, Bermuda, Gossip-Bruges,* and *The Day Is Done.*

192. Pictorial Photographers of America, *Pictorial Photography in America, 1922* (New York: The Pictorial Photographers of America, 1921), 22.

193. Ulmann, *A Book of Portraits . . . Johns Hopkins University,* n.p. The copyright page of this text states that Bertha Goudy composed the type for it at The Village Press at Forest Hills Gardens, New York, in "newstyle" types designed by Frederic W. Goudy. It also indicates that the book was printed at the shop of William E. Rudge in Mt. Vernon, New York. Harry Phillips, who did the photogravure reproduction for the book (and may have done the reproductive work for *The Faculty of the College of Physicians and Surgeons*), also produced photogravures for Ulmann's mentor, Clarence H. White. See American Institute of Graphic Arts, Art Center, New York, April 1923, "Keepsake," Frederic Goudy Collection, Rare Books Division, Library of Congress.

194. Florence N. Levy, *Bulletin of the Art Center* 1, no. 4, November 1922 (New York: The Art Center, 1922), 60–61.

Chapter Two: Moving On

1. The Park Avenue building in which Ulmann resided still stands. It is a turn-of-the-century multistoried structure of eclectic design, located a couple of blocks east of the Metropolitan Museum of Art. The reference to her specific apartment can be found in the John C. Campbell Folk School Archives, Brasstown, North Carolina. A letter written by Ulmann in April 1922 verifies that the photographer was still living on West Eighty-sixth Street at that time. See Doris Ulmann to Dr. Mac Callum, April 3, 1922, JH.

2. Photographic Section of the Academy of Science and Art, *Catalogue of the Tenth Annual Pittsburgh Salon of Photography,* March 2 to 31, 1923 (Pittsburgh: Carnegie Institute, Department of Fine Arts, 1923), 13.

3. Pictorial Photographers of America, *International Salon of the Pictorial Photographers of America,* May 3 to May 31, 1923 (New York: The Pictorial Photographers of America, 1923), n.p. Ulmann also had a new opportunity to promote her work in June in the "Exhibition of Photographs by Alumni, Clarence H. White School of Photography." Five of her pieces were selected for this show: *The Old New Englander, Portrait—Dr. J. Frankel, Portrait—Mr. Warner, A Sunny Morning,* and *Church Interior,* Clarence H. White School of Photography, *An Exhibition by Alumni, Clarence H. White School of Photography,* June 1923 (New York: The Clarence H. White School of Photography, 1923), n.p.

4. Dale Warren, "Doris Ulmann: Photographer in Waiting," 139; and Ulmann, *A Portrait Gallery of American Editors,* v–vii.

5. Ulmann, *Portrait Gallery of American Editors,* v.

6. Ibid., vi.

7. Ibid., title page and vi. According to Max Weber, who taught at the White School, William Rudge was "the finest printer in the United States" at the time. See Max Weber, "Max Weber Memoir: An Interview Conducted By Carol S. Gruber" (New York: Columbia University Oral History Collection, 1958), 279. Rudge printed or printed and published numerous limited edition books, including *Essays on Art* by Max Weber, *Modern Photography,* edited by Rudge, himself, *Considerations on Engraving* by Timothy Cole, *Gilbert Stuart* by Lawrence Park, John Hill Morgan, and Royal Cortissoz (two volumes), and *Honoré Daumier: Appreciations for His Life and Work.*

8. Several mats in the Doris Ulmann Collection, Department of Prints and Photographs, New-York Historical Society, New York City, New York (hereafter, NYHS), autographed and dated by Ulmann's sitters, reveal both the names of the sitters and the dates they were photographed.

9. Ulmann, *Portrait Gallery of American Editors,* v.

10. Ibid., vii.

11. True and significant as Shipman's characterization of the photographer was, his final allusion to Ulmann's passion for "a fast-disappearing species" was prophetic, an appropriate prediction of her forthcoming work with various "vanishing types," including unusual religious types and Appalachian, African American, and American Indian peoples. Ulmann's passion for literary types is documented in Warren, "Doris Ulmann: Photographer in Waiting," 129–44. Doris Ulmann to Theodore Dreiser, October 15, 1930, Special Collections, Van Pelt-Dietrich Library Center, University of Pennsylvania, Philadelphia. Though Dreiser did respond to Ulmann's letter, he turned down her offer (Theodore Dreiser to Doris Ulmann, October 16, 1930).

12. Warren, "Doris Ulmann: Photographer in Waiting," 129–44.

13. Ibid., 139.

14. William E. Leuchtenberg, *The Perils of Prosperity, 1914–1932* (Chicago: Univ. of Chicago Press, 1993), 150.

15. Alumni Association, Clarence H. White School of Photography, *Camera Pictures* (New York: L.F. White Company, 1924), n.p.

16. Camera Pictorialists of Los Angeles, *Eighth International Salon of Photography,* October 14 to November 3, 1924 (Los Angeles: Camera Pictorialists of Los Angeles, 1924), n.p.

17. Yochelson and Erwin, *Pictorialism,* 162. Ulmann was further honored in another way during this time. Sometime before his death in the summer of 1925, Clarence White selected sixty photographic prints to be reproduced for study by amateur and professional photographers. Two of the images were by Ulmann: "Laborer's Hands" and "Black Laborer." Under White's direction, George W. Harting and Salome E. Marckwardt made lantern slides of these images and offered them to national affiliates of the Pictorial Photographers of America, *Bulletin of the Art Center,* June 1925, 278; December 1925, 120–22; and March 1926, 222.

18. Photographic Section of Academy of Science and Art, *Twelfth Annual Pittsburgh Salon of Photographic Art,* March 3 to 31, 1925 (Pittsburgh: Carnegie Institute, Department of Fine Arts, 1925), 13, and Clarence H. White School of Photography, *Exhibition of Photographs by the Students and Alumni of the Clarence H. White School of Photography,* March 16 to March 23, 1925 (New York: Clarence H. White School of Photography, 1925).

19. Pictorial Photographers of America, *Second International Salon of Pictorial Photography,* May 19 to June 15, 1925 (New York: Pictorial Photographers of America, 1925), n.p.

20. Clarence White died in Mexico on July 7, 1925. See Lucinda Barnes, *A Collective Vision: Clarence H. White and His Students* (Long Beach, Calif.: University Art Museum, California State University, 1985), 14. Following his death, Ulmann, Laura Gilpin, and Bernard Horne were selected by the Clarence White School Alumni Association to form a committee to prepare a memorial book of White's work. This selection constituted both an acknowledgment of Ulmann's relationship to White and of her knowledge of his body of work and an affirmation of her aesthetic sensibilities. However, the book never came to fruition because certain other members of the Pictorial Photographers of America decided that they wanted their larger group to prepare a memorial volume. See Sandweiss, *Laura Gilpin,* 323, note 46.

21. Maynard P. White Jr. notes that his grandfather "celebrated his family." He writes: "His family was his art." See "Clarence H. White," 220.

22. Clara Sipprell and Laura Gilpin also felt impelled to concentrate their attention in other directions. See Mary Kennedy McCabe, *Clara Sipprell: Pictorial Photographer* (Fort Worth, Tex.: Amon Carter Museum, 1990), and Sandweiss, *Laura Gilpin.* In many respects, the actions of Ulmann, Sipprell, and Gilpin complemented each other and indicated the support and encouragement Clarence White had given them.

23. Leuchtenberg, *Perils of Prosperity,* 1–10.

24. Ibid., 1–2.

25. Ibid., 151–52 and 228–29; Hamlin Garland, "Doris Ulmann's Photographs," *The Mentor*

(July 1927), 42–47; and Doris Ulmann, "Among the Southern Mountaineers," *The Mentor* (August 1928), 23–32.

26. Warren, "Doris Ulmann: Photographer in Waiting," 139. The photographs used to illustrate the *Mentor* article by Hamlin Garland, "Doris Ulmann's Photographs," also substantiate her attraction to older people. See particularly the illustrations on pages 41 and 43–47.

27. *Who's Who* (1930–1934), 16:2228 and 17:2319.

28. Leuchtenberg, *Perils of Prosperity,* 225–26.

29. Ibid.

30. Garland, "Doris Ulmann's Photographs," 41–47; and Karl Davis Robinson, "Pictorial Photographers of America," *Bulletin of the Art Center* 5, no. 4 (New York: Art Center, December 1926): 65. Among the illustrations in Garland's article was an image Ulmann took of two female residents of the Mt. Lebanon, New York, Shaker community, named *Sister Sarah and Sister Adelaide,* and an image she took of *Brother William.* Sister Sarah (Sister Sarah Collins) was later featured on the dust jacket and in the text of *The Shaker Chair* by Charles R. Mullen and Timothy D. Rieman. An early image of Brother William (Brother William Anderson) also appeared in this book.

31. Photographic Section of Academy of Science and Art, *Thirteenth Annual Pittsburgh Salon of Photographic Art,* March 14 to April 18, 1926 (Pittsburgh: Carnegie Institute, Department of Fine Arts, 1926), 18.

32. Pictorial Photographers of America, *Pictorial Photography in America,* (New York: The Pictorial Photographers of America, 1926), 51.

33. Robinson, "Pictorial Photographers of America."

34. Garland, "Doris Ulmann's Photographs," 42 and 44. Shortly before this article came out Ulmann composed a will. A simple and straightforward document, it exemplified her attachment to her sister, certain German relatives, and select Manhattan institutions. The will is dated June 29, 1927. In it she appointed her sister, Edna Necarsulmer, and her brother-in-law, Henry Necarsulmer (a lawyer), as executors. She designated her sister as the primary beneficiary of her large estate. In addition she bequeathed her jewelry to her niece, Evelyn; $5,000 to her cousin Doris Gertrude Ulmann of Munich, Germany; $5,000 to Karl Josephthal, and $10,000 to Annelise Josephthal, relatives in Berlin, Germany; $1,000 to her friend Katchen Schunk of Nürnberg, Germany; $2,000 to Mrs. Elsa Pechner, a servant; $3,000 to Dora Hechtle, a servant; and $10,000 to Clara Hechtle, also a servant. She also bequeathed $10,000 to Lenox Hill Hospital of the City of New York; $5,000 to the Society for Ethical Culture; $2,500 to the Hudson Guild; $l,000 to The Haven Kindergarten; and $1,000 to the Art Center, Inc. "Exhibit B" (Last Will and Testament of Doris Ulmann, June 29, 1927).

35. Edward Curtis, *The North American Indian* (Seattle: Edward S. Curtis, 1907–1930).

36. Karl Moon's photographs can be seen at the Southwest Museum in Los Angeles, California, and at The Huntington Library in San Marino, California. Adam Clark Vroman's photographs can be examined at the Southwest Museum in Los Angeles, the Pasadena Public Library, and the National Anthropological Archives of the Smithsonian Institution, Washington, D.C. Frank Albert Rhinehart's American Indian images can also be found at the Southwest Museum in Los Angeles and the National Anthropological Archives of the Smithsonian.

37. Pete Daniel and Raymond Smock, *A Talent for Detail: The Photographs of Miss Frances Benjamin Johnston, 1889–1910* (New York: Harmony Books, 1974), 87, 95–96, 111, and 115–17. See also James Guimond, *American Photography and the American Dream* (Chapel Hill: Univ. of North Carolina Press, 1991), 21–53.

38. Edith M. Dabbs, *Face of an Island: Leigh Richmond Miner's Photographs of Saint Helena Island* (Columbia, S.C.: The R.L. Bryan Company, 1970). See also The Charleston Communication Center, *Low Country Photographs by Leigh Richmond Miner 1864–1922,* April 1 to April 30, 1977 (Charleston, S.C.: Communications Center, 1977), 1–3, and Mary Moore Jacoby, "The Photographic Work of Leigh Richmond Miner at Hampton University and St. Helena Island, South Carolina" (Master's thesis, Virginia Commonwealth University, Richmond, 1990). Ulmann's interest in African American subjects was also shared by contemporary African American photographers such as Harlem photographer James Van Der Zee and South Carolina photographer Richard Samuel Roberts, who spent their lives photographing members of the African American community. However, Ulmann's work is more pictorial than that of Van Der Zee and Roberts.

39. However, the earlier photographic work of William Barnhill and Margaret Morley, and the later work of Lewis Hine, Bayard Wootten, Marion Post Wolcott, and Walker Evans, in Appalachia was very different from that of Ulmann. Wootten's work shared the most similarities with Ulmann's. See Jerry Cotton, *Light and Air: The Photography of Bayard Wootten.*

40. Doris Ulmann, "The Mountaineers of Kentucky: A Series of Portrait Studies by Doris Ulmann," *Scribner's Magazine,* June 1928, n.p.; and Ulmann, "Among the Southern Mountaineers," 23–32.

41. Ulmann was also enjoying significant professional success at this time. In March of 1929 *The American Magazine* (with a circulation of more than 2 million) published an article by the popular Columbia University philosopher Will Durant. It was illustrated with two photographs by Ulmann. The first illustration was of Durant's daughter, Ethel. The second was of Durant and Ethel together. See Will Durant, "How a Great Scholar Brings Up His Child," *The American Magazine,* March 1929, 40–41. Aside from *The Mentor, Scribner's Magazine, The American Magazine, The Bookman, Spur, Vanity Fair,* and *Theatre Arts Monthly,* Ulmann's work also appeared in the Sunday rotogravure pages of many metropolitan newspapers. Between April 15 and April 27, three of Ulmann's photographs were also exhibited in a group exhibition of the Pictorial Photographers of America at the Art Center in New York City. The exhibit was called "Third International Salon of the Pictorial Photographers of America." Ulmann's three platinum photographs were *The Mountain Family, Monday,* and *The Voodoo Doctor.* See Pictorial Photographers of America, *Third International Salon of the Pictorial Photographers of America,* April 15 to April 27, 1929 (New York: The Pictorial Photographers of America, 1929) n.p. H.L. Mencken, *My Life as Author and Editor* (New York: Alfred A. Knopf, 1993), 374.

42. Though Ulmann was reluctant to permit others to photograph her, she did permit John Jacob Niles to do so in 1933 and 1934 and let the photographer and writer Carl Van Vechten photograph her in April 1933. One of the images Van Vechten took is reproduced in Keith F. Davis, *The Passionate Observer: Photographs by Carl Van Vechten* (Kansas City, Mo.: Hallmark Cards, 1993), 27.

43. Julia Peterkin was officially awarded the Pulitzer Prize on May 13, 1929 (Susan Millar Williams to author, phone conversation, June 1999). A letter from a friend of Peterkin's to the novelist, written on May 3, 1929, indicates that Ulmann was visiting South Carolina at the time and was staying in the coastal community of Beaufort (——— to Julia Peterkin, May 3, 1929, Special Collections, Clemson University Library, Clemson University, Clemson, South Carolina). Some of Ulmann's earlier oil-pigment photographs of Charleston architectural sites indicate she had previously visited South Carolina in the late 1910s or early 1920s (Special Collections Department, University of Kentucky, Lexington, and Art Museum, University of Kentucky, Lexington). The quote "drama from the ordinary" is taken from a remark by early American film maker John Grierson, who said that the idea of "documentary" emerged from "a desire to make a drama from the ordinary." This is noted in James Guimond's *American Photography and the American Dream,* 6.

44. M.K. Wisehart, "The Kind of Poise that Gives You Power," *The American Magazine,* June 1929, 13.

45. Helen Keller, "I Am Blind—Yet I See, I Am Deaf—Yet I Hear," *The American Magazine,* June 1929, 44–45.

46. Irving Fineman to Julia Peterkin, June 24, 1929, Julia Peterkin papers, South Carolina Historical Society, Charleston, S.C. (hereafter, SCHS-JP).

47. Susan Millar Williams provides substantial details of Peterkin's relationship with Irving Fineman in her biography on Peterkin, *A Devil and a Good Woman, Too: The Lives of Julia Peterkin* (Athens: Univ. of Georgia Press, 1997). In regard to the first years of Peterkin and Fineman's relationship, see chapter seven of Williams's text.

48. "Robeson Indians Studied By Woman of National Fame," *The Robesonian* (Lumberton, N.C.), September 30, 1929, 2.

49. Ibid.

50. Doris Ulmann to Averell Broughton, October 4, 1929, private collection.

51. Warren, "Doris Ulmann: Photographer in Waiting," 136.

52. *The Bookman* 68 (October 1929), 181, 191.

53. Mrs. Calvin Coolidge, "How I Spent My Days at the White House," *The American Magazine,* October 1929, 16. An image by Ulmann of Calvin Coolidge was later published in this periodi-

cal. See Bruce Barton, "Back in Ward Four," *The American Magazine,* March 1931, 15. Also see M.K. Wisehart, "You May Be Young in Years—But Old in Hours, If You Do Not Waste Your Time," *The American Magazine,* October 1929, 52–53. Ulmann's *Monday* was also selected for a Pictorial Photographers of America exhibit at the Carnegie Institute in Pittsburgh in October. The exhibit ran from October 28 through November 12, 1929. A reproduction of *Monday* can be found in Pictorial Photographers of America, *Light and Shade* (New York: Pictorial Photographers of America, November 1929), 4.

54. John K. Galbraith, *The Great Crash, 1929* (Boston: Houghton Mifflin Company, 1961), 103–04.

55. Ibid., 116.

56. Pictorial Photographers of America, *Light and Shade,* December 1929 (New York: Pictorial Photographers of America, 1929), 9. A photograph of Stuart Sherman by Ulmann was also published in *The Bookman* in November 1929. See *The Bookman* 69, 291. Substantial discussions of Alma Reed and Jose Clemente Orozco can be found in Alma Reed, *Orozco!* (New York: Oxford Univ. Press, 1956), 90–148, and Mackinley Helm, *Man of Fire: J. C. Orozco* (Westport, Conn.: Greenwood Press, 1971), 45–53.

57. PPA, "The Doris Ulmann Exhibition," *Light and Shade,* December 1929, 9.

58. "Charities Benefit by Ulmann Will."

59. Reed, *Orozco!,* 149–52. According to Reed, many artistic and literary figures attended the event at Ulmann's Park Avenue apartment, including Reed herself and Julia Peterkin.

60. Doris Ulmann, "Portrait Photographs of Fifteen American Authors," *The Bookman* 70, December 1929, 417–32.

61. Peterkin to Fineman, December 18, 1929, Irving Fineman papers, Department of Special Collections, Syracuse University Library, Syracuse, N.Y. (hereafter, SU).

62. Ulmann to Averill Broughton, December 29, 1929, private collection.

63. "The Stuff of American Drama in Photographs by Doris Ulmann," *Theatre Arts Monthly* 14 (February 1930), 132–46.

64. Eaton, *Handicrafts,* 243–44, and William J. Hutchins to Ulmann, March 28, 1930, BC-SAA. Snapshots of Ulmann's photographs at this exhibit can be found in the archives of the Southern Highland Handicraft Guild, Montreat, North Carolina.

65. Eaton, *Handicrafts,* 243–44, and David B. Van Dommelen, "Allen H. Eaton: Dean of American Crafts," unpublished manuscript, 1977, 16–17 and 45, copy in Archives, Southern Highland Handicraft Guild, Montreat, North Carolina (hereafter, SHHG). Eaton also shared Ulmann's appreciation for the principles and values of the Ethical Culture Society. A longtime member of the New York Ethical Culture Society in Manhattan, he served as an Honorary Trustee on the Society's Board of Trustees. A memorial service was held in his honor at the New York Society on the day of his death, December 7, 1962. Van Dommelen, "Allen H. Eaton," 178.

66. John M. Glenn, Lilian Brandt, and F. Emerson Andrews, *Russell Sage Foundation: 1907– 1946* (New York: Russell Sage Foundation, 1947), 1: 62, 115–24.

67. Ibid., 11.

68. Eaton, *Handicrafts,* 237–39.

69. Ibid., 242. This motion also laid the groundwork for Ulmann's later cooperation with Eaton and her extensive documentation of handicraft workers and handicrafts in Appalachia.

70. Glenn, Brandt, and Andrews, *Russell Sage Foundation,* 282, and Eaton, *Handicrafts,* 243– 44. In regard to Eaton's solicitation of Ulmann's photographs, see also Marguerite Butler to Janie Butler (her sister), July 1933, JCFS.

71. William Hutchins to Ulmann, March 28, 1930, BC-SAA.

72. Ibid., May 9, 1930, BC-SAA.

73. Allen Eaton to Hutchins, July 21, 1930, BC-SAA.

74. Hutchins to Eaton, July 23, 1930, BC-SAA.

75. *American Medical Directory,* s.v., "Arnold Koffler" (Chicago: American Medical Association, 1918), 1125, and (1929),1034.

76. "Arnold Koffler" (1918), 1125.

77. "Arnold Koffler" (1925), 1139.

78. Peterkin to Fineman, April 2, 1930, SU.

79. Ulmann to Peterkin, April 23, 1930, SCHS-JP.

80. Peterkin to Albert Bigelow Paine, May 2, 1930, Albert Bigelow Paine papers, Henry Huntington Library, San Mateo, Cal. and Peterkin to Fineman, May 5, 1930, SU.

81. Ulmann to Fineman, May 9, 1930, SU.

82. Peterkin to Fineman, May 12(?), 1930, SU.

83. Ibid., May 16, 1930, SU.

84. Ibid., June 21, 1930, SU.

85. Ibid., June 21, July 1, July 6, and July 9, 1930, SU.

86. Ibid., July 9, 1930, SU.

87. Ibid., August 27 and September 19, 1930, SU.

88. Ibid., September 20, 1930, SU.

89. Ibid., September 25, 1930, SU.

90. Warren, "Doris Ulmann: Photographer in Waiting," 129–44.

91. Ibid., 129.

92. Ibid., 131.

93. Ibid., 142. It is unfortunate that Melissa McEuen chose to title her recent chapter on Ulmann "Documentarian with Props," in *Seeing America: Women Photographers Between the Wars* (Lexington: Univ. Press of Kentucky, 1999), 9. This title leaves the impression that Ulmann's work was "contrived" instead of "composed" and, ironically, runs contrary to many good and insightful things McEuen does have to say about the photographer. It also ignores Ulmann's own statements and letters, where she explains her philosophy and methodology of portraiture.

94. Warren, "Doris Ulmann: Photographer in Waiting," 129–44. While most of the literary figures Ulmann photographed seemed to have been pleased with the results of her efforts, some were not. In a letter to Eugene Saxton, dated October 10, 1936, Edna St. Vincent Millay recalled her displeasure with Ulmann's work: "I did not much like any of the photographs done of me by Doris Ulmann, certainly not enough to have one of them reproduced in . . . a conspicuous position," Allan Ross Macdougall, ed., *Letters of Edna St. Vincent Millay* (New York: Harper and Brothers, 1952), 285.

95. Ibid., 136.

96. Ibid., 139.

97. Peterkin to Fineman, October 15(?) and October 18, 1930, SU.

98. Ibid., October 24, 1930, SU.

99. Maria Morris Hambourg and Christopher Phillips, *The New Vision: Photography Between the World Wars* (New York: The Metropolitan Museum of Art, 1989), 43–44 and 282, footnote 170. Hambourg and Phillips note that Alma Reed of the Delphic Studios lent Kirstein photographs by Ulmann and Edward Weston.

100. Ibid., 43–45. See *Exhibition Catalogue for the 1930 Photography Exhibit of the Harvard Society for Contemporary Art* (Cambridge, Mass.: Harvard Society for Contemporary Art, 1930).

101. Ibid., 44.

102. Ibid.

103. Ibid., 43, 52, 283 (footnotes 210, 211, 212), and 284 (footnote 216).

Chapter Three: Photographing the South

1. In *The New Vision: Photography Between the World Wars,* Hambourg and Phillips provide an excellent account of the focus of the majority of Ulmann's peers on contemporary American architecture, technology, and design.

2. Lyle Saxon to Carrie Dormon, May 28, 1931, Carrie Dormon Collection, Cammie G. Henry Research Center, Watson Memorial Library, Northwestern State University of Louisiana, Natchitoches.

3. *New Orleans Times-Picayune,* December 25, 1931, Melrose Collection, Cammie G. Henry Research Center, Watson Memorial Library, Northwestern State University of Louisiana, Natchitoches (hereafter, NSUL).

4. Saxon to Dormon, May 28, 1931, NSUL.

5. Ibid. James W. Thomas, *Lyle Saxon* (Birmingham, Ala.: Summa Publications, 1991), 126–27.

6. Saxon to Dormon, May 28, 1931, NSUL.

7. Ulmann corresponded with Henry on several occasions between their first meeting in May 1931 and Ulmann's last Christmas card to Henry in December 1933. See my reference to the letters in the notes below. This correspondence can be found in the Melrose Collection in the Cammie G. Henry Research Center at the Watson Memorial Library, NSUL.

8. Doris Ulmann to Cammie Henry, May 31, 1931, NSUL.

9. Ibid., June 12, 1931, NSUL.

10. Julia Peterkin to Irving Fineman, June 5, 1931, SU.

11. Ulmann to Henry, August 23, 1931, NSUL.

12. Peterkin to Fineman, August 31, 1931, SU. In September nine reproductions of her photographs were published in the monthly issue of *Wings,* a widely distributed publication of the Literary Guild of America. They reflected her continuing interest in "vanishing types." One of the photographs is a portrait of the southern writer Roark Bradford. The other eight photographs are portraits of African Americans in the rural South. The titles of these portraits are *Fishermen at Charleston, Gullah Negro Woman, Nessie, Imogene, Tub and Pipe, Sunday Afternoon, Baptism,* and *Homeward. Wings, the Official Publication of the Literary Guild of America* (September 1931), 3–15.

13. Pictorial Photographers of America, *Light and Shade,* December 1931 (New York: Pictorial Photographers of America, 1931), 9.

14. Peterkin to Fineman, November 24, 1931, SU.

15. Ibid.

16. Ibid., December 14, 1931, SU.

17. Ulmann to Henry, December 19, 1931, NSUL.

18. Ibid.

19. Ibid., December 24, 1931, NSUL. While celebrating Christmas with Peterkin and Saxon, Ulmann sent a telegraph message to Cammie Henry at Melrose Plantation. She wrote: "Julia and Lyle and I have been speaking of you and are wishing you a happy Christmas," December 25, 1931, NSUL.

20. *New Orleans Times-Picayune,* December 25, 1931, NSUL.

21. Peterkin to Fineman, January 1, 1932, SU.

22. Ibid., January 6, 1932, SU.

23. Peterkin to Miss Kersey at Bobbs-Merrill publishing company, January 18(?), 1932, Special Collections, Clemson University Library, Clemson, South Carolina. Ulmann returned Peterkin's generosity by lending some of her images of the people of Lang Syne to Bobbs-Merrill for window displays and other advertising. D. Laurance Chambers to Peterkin, September 20, 1932, Special Collections, Clemson University Library, Clemson, South Carolina.

24. Peterkin to Fineman, February 4, 1932, SU.

25. Ibid., February 22, 1932, SU.

26. Ibid., March 7, 1932, SU. While Ulmann was taking care of Saxon in New Orleans, a new photographic exhibit opened at the Brooklyn Museum that included five photographs by the artist. The show, "International Exhibition of New Pictures of American Types," ran from March 8 to March 31.

27. Ibid., March 23 and March 30, 1932, SU.

28. Ulmann to Henry, March 30, 1932, NSUL. Following Peterkin's and Ulmann's performance in *Hedda Gabler* in Charleston, South Carolina, they returned to New York (Peterkin to Fineman, March 30, 1932, SU)

29. Francis Frost to Fineman, May 13, 1932, NSUL, and Peterkin to Fineman, May 23, 1932, NSUL. It should also be noted that Ulmann's photograph of Gamaliel Bradford that had been initially printed by *The Bookman* in October 1930 was reprinted in the May 1932 (p. 144) edition of this periodical.

30. George Uebler to Lyle Saxon, September 4 and September 10, 1934, NSUL. Note *Scribner's* articles about Ulmann and Niles from this period. Ulmann to Hatcher, June 12, 1932; Ulmann to Hatcher, July 3, 1932; and Ulmann to Hatcher, July 5, 1932, all in the Alliance for Guidance of Rural Youth papers, Special Collections, Duke University, Durham, N.C. (hereafter, DU). See also Ulmann to Henry, June 22, 1932 and October 31, 1932, NSUL.

31. Niles also had a good understanding of the physical limitations Ulmann faced. He had been "partly paralyzed and dependent on braces and a cane for seven years" following an airplane accident in Europe during World War I. "John Jacob Niles Legacy," *Beaux Arts* (summer 1981), 18. See entry in Niles's notes, "Whitesburg, Ky., July the 6th 1932," John Jacob Niles Collection, Special Collections, King Library, University of Kentucky, Lexington, (hereafter, UK-JJN). Little is known about Marion Kerby. I have recently discovered a collection of letters by Kerby to Marian Anderson, in the Marian Anderson Collection at the Van Pelt Library at the University of Pennsylvania. Among other things, this material reveals that Kerby continued her musical career after she and Niles ended their professional partnership. Like Niles, she also, curiously, began to collect Appalachian and African American music and adapt, edit, and publish it. These letters also show that she, like John Jacob Niles, could be quite presumptuous and flamboyant.

32. There are many photographs of Niles in the "Proof Albums" at the University of Oregon in Eugene. The number and composition of these images and the bequest of her photographs leaves no doubt that Ulmann was in love with John Jacob Niles. However, despite what Niles later wrote and stated, it is uncertain whether the musician loved Ulmann. He did dedicate *Hinky Dinky Barley Brew: A Cry From the Heart* (edited by his wife Helene Niles and published by Old Grist Mill Press) to the photographer in 1932, whom he only identified as, "D.U." But I am unaware of any record of either contemporary music or poetry in which Niles revealed passion and love for Ulmann as he did for his second wife, Helene Niles, or his third wife, Rena Niles. Niles dedicated two publications to Helene in 1929: *Seven Negro Exaltations* (New York: G. Schirmer, 1929) and *The Songs My Mother Never Taught Me* (New York: Gold Label Books, 1929) and numerous others to Rena. Ulmann's bequest to Niles is found in "Exhibit A" (Last Will and Testament of Doris Ulmann, August 21, 1934).

33. "Annotated Program for the Annual Meeting of the General Executive Board of the Southern Woman's Educational Alliance, St. Regis Hotel, New York City, October 30—November 1, 1932," DU; and "Woman's Group Plans Forum on Rural Girl," *Richmond Times-Dispatch,* October 15, 1933, DU.

34. "Local Woman Forms Society to Aid Girls," *Richmond Times-Dispatch,* July 24, 1932, DU, and "Biographical Note: Orie Latham Hatcher," DU.

35. Doris Ulmann to Dr. Orie Latham Hatcher, June 12, 1932, DU.

36. Ulmann to Hatcher, July 3, 1932, DU.

37. Ibid.

38. Ibid., July 5, 1932, DU.

39. John Jacob Niles, "Whitesburg, Ky., July the 6th 1932," Notebooks, UK-JJN.

40. Ibid.

41. Ulmann to Hatcher, July 24, 1932, DU.

42. Ibid.

43. Chairman, Southern Woman's Educational Alliance Finance Committee to Ulmann, July 29, 1932, DU.

44. Ronald Allen Pen, "A Chronology of the Life of John Jacob Niles."

45. "Minutes of the Eighteenth Annual Meeting of the Executive Board of the Southern Woman's Educational Alliance, St. Regis Hotel, New York City, October 31–November 1, 1932," DU.

46. Ulmann to Henry, October 31, 1932, NSUL.

47. Photograph of John Galsworthy, *The Bookman,* December 1932, 777.

48. Ulmann to Henry, December 22, 1932, NSUL.

49. Ulmann to Henry, October 31, 1932, and February 7, 1933, NSUL. See also Ulmann to Lyle Saxon, March 26 and April 10(?), 1933, NSUL. Later that spring Ulmann also reported to Peterkin that she had had a fall and hurt her arm and shoulder (Peterkin to Fineman, May 23, 1933, SU).

50. Ulmann to Saxon, June 1, 1933, NSUL.

51. Pen, "A Chronology of the Life of John Jacob Niles."

52. Peterkin to Fineman, February 27, 1933, SU.

53. Peterkin remarked on the lack of contact between her and Ulmann and Ulmann's preoccupation with Niles and other matters in correspondence with Fineman in 1933. See Peterkin to Fineman, July 24, 1933, and August 5, 1933, SU.

54. Peterkin to Saxon, August (?), 1934, and September 12, 1934, NSUL; Peterkin to Henry, n.d., 1934, NSUL; and Peterkin to Fineman, October 4, 1934, NSUL.

55. Pen, "A Chronology of the Life of John Jacob Niles."

56. Ulmann to Saxon, March 26, 1933, NSUL.

57. Ibid., April 10(?), 1933, NSUL. Around this time, six of Ulmann's photographs were selected for exhibition in a group show sponsored by the College Art Association. The show was "An Exhibition of Modern American Photography." The six images represented the breadth of her photographic work, covering the period from the teens to the early 1930s. They were: *Boats; Baptism; The Shaker, Sister Mary; Cherokee Indian; Max Weber;* and *Old Mammy. An Exhibition of Modern American Photography,* College Art Association, n.d., copy in Clarence H. White Collection, The Art Museum, Princeton University, Princeton, New Jersey.

58. Ulmann to William Hutchins, April (?), 1933, BC-SAA.

59. Ulmann to Saxon, June 5, 1933, NSUL. See also Niles to Hatcher, July 12, 1933, DU.

60. Ulmann to Saxon, June 5, 1933, NSUL.

61. Pen, "A Chronology of the Life of John Jacob Niles." See also Niles to Hatcher, July 12, 1933, DU.

62. John C. Campbell, *The Southern Highlander and His Homeland,* (Lexington: Univ. Press of Kentucky, 1969), xxix.

63. Ibid.

64. Robert Stanley Russell, "The Southern Highland Handicraft Guild: 1928–1975," Ph.D. dissertation, Columbia University, 1976, 42.

65. Ibid., 43.

66. Glenn, Brandt, and Andrews, *Russell Sage Foundation,* 282.

67. Russell, "Southern Highland Handicraft Guild," 43–45.

68. The development of the John C. Campbell Folk School in its first decade is recounted in several resources, including: Freida Morgan Terrell, "An Historical and Contemporary Study of the John C. Campbell Folk School, Brasstown, North Carolina" (Master's thesis, University of Tennessee, 1969), and Russell, "The Southern Highland Handicraft Guild: 1928–1975."

69. Ulmann to Saxon, July 9, 1933, NSUL. See also Niles to Hatcher, July 12, 1933, DU.

70. Allen Eaton to Olive Dame Campbell, July 13, 1933, Olive Dame Campbell Collection, Archives, John Campbell Folk School, Brasstown, N.C. (hereafter, JCFS).

71. Ulmann to Eaton, July 16, 1933, BC-SAA.

72. Ulmann to Saxon, July 20, 1933, NSUL.

73. Ulmann to Eaton, July 24, 1933, BC-SAA. See also Ulmann to Henry, July 26, 1933, NSUL.

74. Campbell to ——— at Berea College, Berea, Kentucky, July 25, 1933, BC-SAA.

75. Campbell to Lula Hale, August 10, 1933, BC-SAA. Though Ulmann did seek to photograph people as they lived and worked, she occasionally wandered from this goal. One of the most striking examples of this is reproduced in Allen Eaton's *Handicrafts of the Southern Highlands*: Wilma Creech of Pine Mountain, who later became a physician and did not wear madder-dyed dresses and go without shoes.

76. Ulmann to Campbell, August 7, 1933, JCFS.

77. Ibid., August 14, 1933, JCFS.

78. Ibid., August 19, 1933, JCFS.

79. Ibid.

80. Ibid., August 14 and August 20, 1933, JCFS.

81. Hutchins to John Jacob Niles, August 11, 1933, BC-SAA.

82. Niles to Hutchins, August 16, 1933, BC-SAA.

83. Ulmann to Campbell, August 20, 1933, JCFS.

84. Ulmann to Eaton, August 25, 1933, BC-SAA.

85. Niles to Hutchins, September 20(?), 1933, BC-SAA.

86. Hutchins to Niles, September 30, 1933, BC-SAA.

87. In a journal entry on the evening of his first solo concert, Niles angrily celebrated his freedom from his former musical partner: "First performance without Kerby A definite success No

fights No bickering No profits But success I don't need the Diva anymore . . . No more vomit at intermission . . . No more lesbian s——t No more teaching 160 pound contralto how to sing on pitch" (Niles journal sheet, October 20, 1933). Rena Niles stated she only met John Jacob Niles after Ulmann's death in "John Jacob Niles Legacy," *Beaux Arts* (summer 1981), 18.

88. Rena Niles recalled this in a taped interview with Niles's biographer Dr. Ronald Pen, Department of Fine Arts, University of Kentucky, in the early 1990s; Pen, "A Chronology of the Life of John Jacob Niles." A copy of this tape is in the possession of Dr. Pen.

89. Niles to Rena Lipetz, October 23, 1933, UK-JJN.

90. Ibid., October 31, 1933, UK-JJN.

91. Ibid., April 16, 1934, UK-JJN.

92. Ibid., April 23, 1934, UK-JJN.

93. Ibid., May 5, July 8, July 25(?), and August 13, 1934, UK-JJN.

94. Ibid., December 23 and 30, 1933; July 8 and August 13, 1934, UK-JJN.

95. Ronald Allen Pen, "The Biography and Works of John Jacob Niles" (Ph.D. dissertation, University of Kentucky, 1987), 1:62, UK-JJN, and Niles to Lipetz, October 23, 1933, UK-JJN. The following references provide information about Ulmann and Niles's visit to Richmond in October 1933: "Branch News Items," No. 2, October 1, 1933, and "SWEA Service in Virginia," November 25, 1933, Southern Woman's Educational Alliance, Richmond, Va.; "Artists to Be Honor [Honored?] Guests at Reception," October 19, 1933, and "Portrait Studies of Rural Folk to Feature Forum Here Today," October 22, 1933, and "Alliance Holds Forum on Rural Youth in State," *Richmond Times-Dispatch,* October 23, 1933; and "Personals," *Academy News,* vol. 2, no. 2, December 1933, Richmond Academy of Arts.

96. Niles to Hutchins, October 25, 1933, BC-SAA.

97. Niles to Lipetz, October 29, 1933, and October 31, 1933, UK-JJN.

98. Ulmann to Hutchins, November 3, 1933, BC-SAA. See also Ulmann to Mrs. Gould of Berea College, November 20, 1933, BC-SAA.

99. Ulrich Keller and Gunther Sander, *August Sander, Citizens of the Twentieth Century: Portrait Photographs 1892–1952* (Cambridge, Mass.: MIT Press, 1986), 12–15.

100. Ibid., 27-28.

101. Ibid., 29. In contrast to Keller, I believe Sander, like Ulmann, desired to "pay homage" as well as "analyze." Sander's work reveals he had a tremendous respect for his sitters. For Keller's point, see 3–4.

102. Other photographers had also conceived and completed volumes that focused on specific groups or types. It is possible Ulmann had knowledge of the photographic volumes produced in Germany in the late 1920s and early 1930s by Erich Retzlaff (*The Face of Age, Men at Work,* and *Those of the Soil*), Erna Lendwai Dircksen (*German Folk Faces*), and Sander (*Face of the Time*).

103. Keller and Sander, *August Sander,* 4, 5, and 51.

104. Ibid., 34, 36, 37, 39, 41, and 42.

105. Ibid., 3, 5, 6, 12–19, and 43–53. Sander's earlier volume, *Face of the Time* (*Antlitz der Zeit*), published in 1929, shares more similarities with Ulmann's work in *Roll, Jordan, Roll* and *Handicrafts of the Southern Highlands* than his later volumes.

106. Peterkin to D. Laurance Chambers, April 29, 1933, Bobbs-Merrill papers, Lilly Library, Indiana University, Bloomington (hereafter, IU). Peterkin to George Shively (also of Bobbs-Merrill), May 1, 1933, IU, and Warren, "Doris Ulmann: Photographer in Waiting," 139; Peterkin to Shively, May 1, 1933, IU; and Peterkin to Fineman, May 19, 1933; June 2, 1933; June 15, 1933; and August 29, 1933, SU. In regard to this matter, see also Michelle C. Lamuniere, "*Roll, Jordan, Roll* and the Gullah Photographs of Doris Ulmann," *History of Photography* 24, no. 4, winter 1997, 294–302. Professor James B. Meriwether of the English Department of the University of South Carolina made many of the same points Lamuniere makes in his 1983 lecture entitled "No Finer Collaboration," (Columbia: Institute for Southern Studies, University of South Carolina, 1983), copy at SCHS-JP.

107. Chambers to Peterkin, May 1, 1933, IU.

108. Peterkin to Fineman, May 19, 1933, SU.

109. Ibid., June 2, 1933, SU.

110. Peterkin to Fineman, June 15, 1933, SU.

111. Ibid., July 24, 1933, SU.

112. Ibid., August 5, 1933, SU.

113. Ibid., August 15, 1933, and August 29, 1933, SU.

114. *Publishers Weekly,* December 6, 1933, 2085, and Walter White to Harry Sherman, November 13, 1933.

115. Peterkin and Ulmann, *Roll, Jordan, Roll.* In a note in Cammie Henry's copy of the trade edition of *Roll, Jordan, Roll,* dated August 30, 1934, Lyle Saxon identified six portraits that Ulmann had taken at Henry's Melrose Plantation in May 1931: "'Sis' page 12, 'Melrose mules' page 47, 'Puny' page 54, 'War Baby' page 60, 'Mary and RE' page 64, 'Dan's legs and War Baby' page 67," copy at NSUL.

By the time Ulmann had finished her work on *Roll, Jordan, Roll,* she had already made plans to work with Ballou on another project—a juvenile "book of children's folksongs from the south with Doris' photographs," to which Niles would contribute the musical scores. See Robert O. Ballou to Julia Peterkin, December 5, 1933, and "Portrait Studies of Rural Folk To Feature Forum Here Today," *Richmond Times-Dispatch,* October 22, 1933. Irritated as Peterkin was with Ulmann at the time, this news must have further angered the novelist.

116. Johnson's, Hansen's, and Brickell's remarks can be found on the inside of the dust jacket of the trade edition of *Roll, Jordan, Roll.* Johnson had very positive feelings about Ulmann's work. He included a portrait the photographer took of him in his 1933 autobiography, *Along This Way: The Autobiography of James Weldon Johnson.*

117. Peterkin to Fineman, December 16, 1933, SU. Though Peterkin did write this to Fineman in December, she had expressed a very positive opinion of Ulmann's South Carolina photographs in previous correspondence. See Peterkin to Carl Sandburg, June (?) 1933, University of Illinois Library, Urbana, Illinois.

118. John Chamberlin, "Books of the Times," *New York Times,* December 15, 1933.

119. Dorothy Van Doren, [Review] *The Nation,* January 24, 1934, 106–07.

120. Williams, *A Devil and a Good Woman, Too: The Lives of Julia Peterkin,* 220. The trade edition of *Roll, Jordan, Roll* also had a longer life than some of its critics may have imagined. According to a published lecture by Professor Meriwether titled "No Finer Collaboration," the trade edition was reissued by Ballou in January 1934; by Jonathan Cape, an English firm, later that year; and by the Bobbs-Merrill Company in 1936.

121. Ulmann to Saxon, December 31, 1933, NSUL.

122. Pen, "A Chronology of the Life of John Jacob Niles."

123. Ulmann to Cammie Henry, December 18, 1933, NSUL.

124. Olive Dame Campbell to Ralph Rounds, December 22, 1933, JCFS.

125. Niles to Lipetz, December 23, 1933, UK-JJN.

126. Ulmann to Campbell, January 25, 1934, JCFS.

127. Ulmann to Saxon, December 31, 1933, NSUL.

128. Ibid. See also Ulmann to Campbell, January 4, 1934, JCFS.

129. Ulmann's and Niles's January 1934 visit to Richmond is detailed in the following information: "Critics Visit City to See Heaven Bound," January 1, 1934, *Richmond Times-Dispatch,* and "Critics to Witness Rehearsal of Play," January 2, 1934, *The Richmond News Leader;* and Ulmann to Campbell, January 4, 1934, JCFS.

130. Ulmann to Campbell, January 4, 1934, JCFS.

131. The colophon page of this deluxe edition states the following: "Of this special edition of *Roll, Jordan, Roll,* 350 copies, each numbered and signed by Julia Peterkin and Doris Ulmann, have been printed by letterpress and copper-plate photogravure. Of these 327 are for sale. Letterpress by The Maple Press Company. Photogravure by the Photogravure and Colour Company. Binding by the J. F. Tapley Co. This copy is number ___." This number of the copy was handwritten, as were the signatures of the author and the photographer, just beneath this text.

Copies of this edition of *Roll, Jordan, Roll* are scattered throughout the country in both institutional and private collections. (See a list of these private and institutional collections in the appendix on collections.) Boxed in plain brown paper–covered cases, they were offered for sale for $25 per copy by publisher Robert Ballou in January 1934. However, it does not appear that many copies had been

sold by the time Ulmann died in August 1934. According to Julia Peterkin, "When *Roll, Jordan, Roll* was published, Doris had thirty copies of the expensive limited edition while I had only three. She suggested that she would send copies to our mutual friends so that I might give mine to members of my family. You were supposed to get one among the very first. God alone knows why you did not. Neither did Arnold Koffler, I discover," Peterkin to Lyle Saxon, September 13, 1934, NSUL.

Following Ulmann's death, unsold copies of this limited edition became the property of Henry and Edna Necarsulmer (Ulmann's brother-in-law and sister). In a letter to William J. Hutchins, president of Berea College, dated December 26, 1935 (now in the archives of Berea College), Henry Necarsulmer spoke about the way he and his wife had distributed the remaining copies of the deluxe edition:

> A comparatively few copies of this edition have been or are being sent to a few libraries, to members of Mrs. Ulmann's family and to a few of her intimate friends. The balance of this edition has been given to Tuskegee Institute, which will sell the same for its own benefit, as thereby we felt that we would help an outstanding institution interested in the Southern negro and incidentally have the book reach people who have a similar interest. This project we had long in mind and will explain to you why so few copies were available for distribution to any other individuals or institutions.

Earlier, on June 16, 1935, Henry and Edna Necarsulmer had assigned all their rights and interests in the copyright that Ulmann and Peterkin had shared on the trade edition of *Roll, Jordan, Roll* to Peterkin. See "Assignment of Copyright," (28-614-14), SCHS-JP.

132. Pen, "A Chronology of the Life of John Jacob Niles." See also Ulmann to Campbell, January 25, 1934, JCFS. Among other subjects, Ulmann photographed Allen Eaton during this month and discussed the progress of her photographic work for his book on the people and handicrafts of Appalachia.

133. Ulmann to Campbell, January 25, 1934, JCFS. In the first two months of 1934, Niles initiated, received, and responded to correspondence from Leicester Holland, chief of the Division of Fine Arts at the Library of Congress, Professor Helen Dingman of Berea College, Professor B.A. Botkin of the Department of Anthropology of the University of Oklahoma, music publisher Carl Engel, and Olive Dame Campbell of the John Campbell Folk School, among others.

134. Niles to Lipetz, February 13, 1934, UK-JJN.

135. Ulmann to Campbell, February 28, 1934, JCFS.

136. Ibid., January 25, 1934, JCFS.

137. Ibid., February 28, 1934, JCFS.

138. Ibid., March 22, 1934, JCFS. A program from this concert can be found in the John Jacob Niles Collection at the University of Kentucky. See also William Reilly (Undersecretary of State) to Niles, March 27, 1934, UK-JJN.

139. Edith Helm to Niles, March 29, 1934, UK-JJN.

140. Leicester Holland to Niles, April 11, 1934, UK-JJN.

Chapter Four: The Last Trip

1. Ulmann to Campbell, April 14, 1934, JCFS.

2. Ulmann to Eaton, April 24, 1934, UK-JJN, and Niles to Lipetz, April 16, 1934, UK-JJN.

3. Ibid.

4. Ulmann to Campbell, April 26, 1934, JCFS.

5. Ulmann to Eaton, April 24, 1934, UK-JJN, and Ulmann to Campbell, April 26, 1934, JCFS.

6. Ulmann to Eaton, April 24, 1934, UK-JJN.

7. Ulmann to Campbell, April 26, 1934, JCFS.

8. Ulmann to Eaton, May 6, 1934, UK-JJN.

9. Ibid.

10. Berea College, *The Chimes* (1937 Yearbook), (Berea, Ky.: Berea College Press, 1937).

11. Ulmann to Eaton, May 24, 1934, UK-JJN.

12. Ibid., and Niles to Lipetz, June 1 and June 8, 1934, UK-JJN. See also Ulmann to Campbell, May 22, 1934, JCFS.

13. Ulmann to Eaton, June 8, 1934, UK-JJN, and Niles to Lipetz, June 8, 1934, UK-JNN.

14. Eaton, *Handicrafts,* 105.

15. Ulmann to Saxon, June 14, 1934, NSUL; Ulmann to Eaton, June 26, 1934, UK-JJN; and Helen Pernice to H.E. Taylor, September 19, 1934, BC-SAA.

16. Ulmann to Sarah Blanding, June 21(?), 1934, UK-JJN. See also Ulmann to Eaton, June 26, 1934, UK-JJN.

17. Ulmann to Blanding, June 21(?) and July 4, 1934, UK-JJN.

18. Ulmann to Blanding, July 4, 1934, UK-JJN.

19. Ulmann to Eaton, June 26, and July 1, 1934, UK-JJN.

20. Ibid., July 1, 1934, UK-JNN.

21. Ibid.

22. Ibid., and Ulmann to Blanding, July 4, 1934, UK-JJN.

23. Ulmann to Eaton, July 9, 1934, UK-JJN.

24. Eaton to Clementine Douglas, July 24, 1934, Clementine Douglas Collection, SHHG.

25. Ulmann to Eaton, July 22, 1934, UK-JJN. 26. Eaton, *Handicrafts,* 17–18.

27. Ulmann to Campbell, July 25, 1934, JCFS. Though Ulmann did not live long enough to return to the Folk School at Brasstown, Niles returned and purchased property nearby. He only resided in the area for a short time, however.

28. Ibid., July 27, 1934, JCFS.

29. Ibid., August 11, 1934, JCFS. See also John Jacob Niles, Field Notebook, July 31, 1934, UK-JJN, where he notes that Ulmann wants to "see that Mrs. J.C. has the money to build the boys' building and the little hotel."

30. Russell, "Southern Highland Handicraft Guild," 48–52.

31. Eaton to Clementine Douglas, July 24, 1934, SHHG.

32. Ulmann to Campbell, July 27, 1934, JCFS.

33. A good summary of Goodrich's work in the North Carolina mountains can be found in Russell, "Southern Highland Handicraft Guild," 54–60. A more complete account can be found in Frances Louisa Goodrich, *Mountain Homespun,* with an introduction by Jan Davidson (Knoxville: Univ. of Tennessee Press, 1989).

34. Ulmann to Campbell, July 27, 1934, JCFS, and Eaton to Douglas, July 24, 1934, SHHG.

35. Eaton to Douglas, July 24, 1934, SHHG.

36. Ibid., and Eaton, *Handicrafts,* 158.

37. Niles to Lipetz, July 31, 1934, UK-JJN.

38. Niles, Field Notebook, July 31, 1934, UK-JJN.

39. Niles, "Remembrance," and Ulmann to Campbell, August 11, 1934, UK-JJN.

40. Niles, "Remembrance," and "Western Union Notes," 1934, UK-JJN.

41. Ulmann to Campbell, August 11, 1934, JCFS.

42. Niles to Lipetz, August 13, 1934, UK-JJN.

43. Ulmann to Campbell, August 11, 1934, JCFS.

44. Niles to Lipetz, August 13, 1934, UK-JJN.

45. George Uebler to Lyle Saxon, September 4, 1934, NSUL. Saxon was unable to understand all of Uebler's first letter because of the German chauffeur's poor English. He asked Uebler to get someone to assist him in his composition. Uebler did this, and the result is a second letter. See Uebler to Saxon, September 10, 1934, NSUL.

46. Ibid.

47. A copy of this handwritten bequest can be found at NSUL.

48. Niles, "Western Union Notes," 1934, UK-JJN.

49. This handwritten note was written on an envelope by Ulmann a short time before her death. The original note can be found at UK-JJN.

50. Ulmann to Campbell, August 11, 1934, JCFS; Uebler to Saxon, September 4 and 19, 1934, NSUL; and "Exhibit A" (Last Will and Testament of Doris Ulmann, August 21, 1934).

51. "Doris Ulmann," Certificate of Death, August 28, 1934, Department of Health of The City of New York, Registered Number 19458.

52. Phone conversations with the staff at Mt. Pleasant Cemetery in Hawthorne in Westchester

County, N.Y., in 1995 and 1996 revealed that Doris Ulmann was buried in crypt 2 in the Ulmann family mausoleum. According to the records at the cemetery, Ulmann's brother-in-law, Henry Necarsulmer, is buried in crypt 1; her sister Edna, in crypt 3; her mother Gertrude, in crypt 4; the husband of her niece Evelyn, Ruddy Stiefel, in crypt 5; her father Bernhard, in crypt 6; her aunt Agnes Ulmann, in crypt 8; and her uncle Emil Ulmann, in crypt 10. The cremated remains of several other relatives—Elizabeth Josephthal, Charles Josephthal, Wilhelm Josephthal, Ludwig Ulmann, Victor Cranley, and Margot Cranley—are also located in several of the niches within the mausoleum.

53. William Hutchins to John Jacob Niles, September 1, 1934, BC-SAA. The account of the Pictorial Photographers can be found in the *Pictorial Photographers of America Bulletin* (October 1934). For other accounts see *New York Times,* August 29, 1934, 17; Olive D. Campbell, "Doris Ulmann," *Mountain Life and Work* (October 1934): 11, and *American Photographer* (December 1934): 779.

54. Julia Peterkin to Lyle Saxon, September 12, 1934, NSUL.

55. Ibid., September 13, 1934, NSUL.

56. Peterkin to Cammie Henry, September (?), 1934, NSUL.

57. Niles, "Western Union Notes," 1934, UK-JJN.

58. John Jacob Niles, "Autobiography" (Last Draft), 1976, UK-JJN. This litany demonstrates Niles's conviction that a good storyteller should "never let the dull facts get in the way of a good yarn." Dr. Ron Pen to the author, April 1996.

59. George Uebler to Saxon, September 4, 1934, NSUL.

60. Ibid., September 10, 1934, NSUL.

61. "Exhibit A" (Last Will and Testament of Doris Ulmann, August 21, 1934) and "Exhibit B" (Last Will and Testament of Doris Ulmann, June 29, 1927).

62. "Estates Appraised—Bernhard Ulmann," *New York Times,* November 9, 1917, and "Charities Benefit by Ulmann Will," *New York Times,* November 19, 1929.

63. The original of this text is at UK-JJN. Berea College did not construct a facility for the storage and exhibition of Ulmann's work until 1978, when the Taylor Art Building was completed. Within this building are both galleries named for Doris Ulmann and a Doris Ulmann storage room. It did exhibit Ulmann's photographs in the Berea College Appalachian Museum until it closed a few years ago.

64. Peterkin to Irving Fineman, October 3, 1934, SU.

65. Niles to Hutchins, November 15(?), 1934, BC-SAA, and Hutchins to Niles, November 20, 1934.

66. Sarah Gibson Blanding to Niles, November 25, 1934, UK-JJN.

67. These agreements are detailed in the *Agreement of Settlement* of February 7, 1935, JCFS.

68. Olive Dame Campbell to members of the Board of Directors of the John C. Campbell Folk School, "Notice of Special Meeting," February 2, 1935, JCFS, and Ralph Rounds to J. R. Pitman, February 2, 1935, JCFS.

69. J.R. Pitman, "Settlement of Doris Ulmann's Will," handwritten notes on "Essential Features" of the Agreement of Settlement presented at the Campbell School Board of Directors Meeting on February 7, 1935, in the law office of Ralph Rounds in New York City, JCFS.

70. "406,578" for School: Bulk of Doris Ulmann Estate Willed to Carolina Folk Center," *New York Times,* January 17, 1936.

71. The data in the "Statement of Operations: March 1, 1935, to February 29, 1936," *Report of Examination, J.C. Campbell Folk School,* JCFS, indicate that over one-fifth of the total annual income of the school came from the "Doris Ulmann Fund." A later account, "Statement of Income and Expense for the Fiscal Year Ended February 29, 1940," *Report of Examination, J.C. Campbell Folk School,* JCFS, indicates that over one-third of the total annual income of the school came from this fund.

72. In an October 15, 1996, telephone conversation with the author, Dr. Jan Davidson, executive director of the Campbell Folk School, said that the Ulmann bequest remains the foundation of the school's endowment and continues to provide a significant contribution to the annual budget.

73. "Edna Necarsulmer," *New York Times,* July 6, 1936, and "Henry Necarsulmer," *New York Times,* September 2, 1938.

74. John Jacob Niles, "Doris Ulmann: Preface and Recollections," *The Call* 19, no. 2 (spring 1958), 4–9.

75. John Jacob Niles, "Autobiography" (Last Draft), 509–11, UK-JJN; Featherstone, *Doris Ulmann,* 39–40 and 72, footnote 36; and "John Jacob Niles Legacy," *Beaux Arts* (summer 1981): 18.

76. Niles, "Autobiography" (Last Draft), 524–30, 1976, UK-JJN. Niles himself provided contradictory information about the period of his work with Ulmann. This is illustrated in two different typed outlines of his autobiography that he prepared some time before he began to actually compose it. In one account he wrote: "Chapter XII. Doris Ulmann. She was my employer from about 1927 to her death, in 1935. Intermittently, that is. . . . I worked as her guide, assistant, and pack-mule. . . . We spent 4 or 5 months out of every year in the south." In another account, also labeled, "Chapter XII. Doris Ulmann," Niles wrote: "I work as her assistant in photography. . . . She wants to travel the southern mountains for photos. For 4 consecutive summers, I am her guide, pack-mule, . . . and body-guard." These accounts can be found in Box 62, UK-JJN.

77. Niles, "Autobiography" (Last Draft), 513 and 530, 1976, UK-JJN; Featherstone, *Doris Ulmann,* 35–36, 42, and 49–50; and Rena Niles, "Inner Spirit: Doris Ulmann's Photography," *High Roads Folio* 8 (1984), 14–17. Niles's wife Rena reiterated the musician's claim in this last reference. She wrote: "Without Johnnie Niles' knowledge of the Southern Mountains and his willingness to serve as mentor . . . it is doubtful that a woman as frail as Doris Ulmann could have traveled to the remote coves and cabins where she found her best subjects."

The real level of Niles's guidance of Ulmann is clarified, in part, in his account of his own difficulties in collecting ballads in the Appalachian mountain region. In the introduction to his songbook, *The Ballad Book of John Jacob Niles,* Niles admitted he often needed help from others in order to collect ballads and folk songs in the highlands. On page xix he wrote:

> In the early days of my career as a collector of folklore, I discovered the importance of having the help of a native man or woman who understood something of the habits and tendencies of the community. In this way, I saved myself weeks of time. . . .
>
> I usually started at the top and went down the list, and as a rule the people at the bottom of the list were the most helpful. First, it was the county judge and the county sheriff. Next in order came the county school superintendent (he or she was usually helpful), the county health nurse (if there was one), the county agent, the county road supervisor, the county jailer, the county truant officer, and last the county dogcatcher.
>
> The dogcatchers were wonderful people. Being a foxhound fancier myself, I found that we had much in common. But county officials were busy people, even in the sleepy mountain counties. If there was a political campaign going on, the politicians were more than willing. Out of election season, they were only mildly interested. This situation usually led me to engage a local character who had time on his hands and was willing to work for a small, stipulated fee. I referred to these characters as my "contact men."

78. See, among others, Featherstone, *Doris Ulmann, American Portraits;* Banes, "Doris Ulmann and Her Mountain Folk"; Lovejoy, "The Oil Pigment Photography"; Rosenblum, *History of Women Photographers;* McEuen, "Doris Ulmann and Marion Post Wolcott"; Foresta, *American Photographs;* Judith Keller, "Doris Ulmann," *Doris Ulmann: Photography and Folklore* (Malibu, Cal.: The J.P. Getty Museum, 1996); and Davidov, "Picturing American Types"; and Naomi Rosenblum and Susan Fillin-Yeh, *Documenting a Myth* (Seattle: Univ. of Washington Press, 1999).

79. Featherstone, *Doris Ulmann: American Portraits,* 43–44 and 72, footnote 38; Niles, "Doris Ulmann: Preface and Recollections," 4–9 and "Remembrance."

80. Ulmann's chauffeur, George Uebler, who had worked for her for several years, unabashedly states that Mr. Niles was Miss Ulmann's friend 2 and ½ years . . . ," in George Uebler to Lyle Saxon, September 10, 1934, NSUL. Aside from Niles's own written and typed recollections, which are all dated within this period (beginning with the summer of 1932) or much later (the fall of 1976), all the other relevant documentary materials verify Uebler's statement. Critical examination of Niles's own publications (see note 32 in chapter three) and published recollections also indicate the musician had little knowledge of the photographer's life prior to 1932. In this regard, see his accounts in "Doris Ulmann: Preface and Recollections," *The Call* 19 (spring 1998), and *The Appalachian Photographs of Doris Ulmann.* In this regard, see also John Jacob and Rena Niles's catalogue of the first 1,500 posthumous photographs produced by Samuel Lifshey at the behest of the Doris Ulmann Foundation for Berea College, Berea, Kentucky, "To the Art Department . . . Berea College," BC-SAA. The list,

prepared by the Nileses in October 1936, indicates that John Jacob Niles had no knowledge of anyone who was photographed prior to the summer of 1932. Other catalogues suggest the same thing. See the larger catalogues of photographs in the Doris Ulmann collections at Berea College and the University of Oregon.

There is no evidence to indicate any of Ulmann's family, close friends, associates, and contacts had knowledge of Niles prior to 1932. Julia Peterkin, whom Ulmann had known since the spring of 1929, gave no indication Niles had been associated with the photographer before 1932 (Peterkin to Irving Fineman, February 27, 1933, and Peterkin to Lyle Saxon, September 12, 1934, NSUL). Likewise, Lyle Saxon, one of Ulmann's oldest friends and correspondents, was shocked at her death to find out that she had been associated with Niles (George Uebler to Lyle Saxon, September 4, 1934, and September 10, 1934, NSUL; and Julia Peterkin to Lyle Saxon, September 12, 1934, NSUL). Further, Allen Eaton, who had had contact with Ulmann for some time, seems to know little about Niles as late as the summer of 1933 (Allen Eaton to Olive Dame Campbell, July 13, 1933, JCFS). Ulmann's sister and brother-in-law were also unaware of Niles (Peterkin to Irving Fineman, October 3, 1934, SU). The differences between Ulmann's earlier will, composed in 1927 (see chapter 2, note 34), and her later will, composed just before her death, came as a great surprise to Ulmann's sister and brother-in-law.

81. The limits of Niles's commitment to Ulmann are substantiated, in part, in Niles's correspondence with Rena Lipetz. See the following letters: Niles to Lipetz, October 23, 29, 31, 1933; December 23 and 30, 1933; and February 13, April 16 and April 23, May 5, July 8 and 25(?), and August 13, 1934, UK-SAA.

82. Eaton, *Handicrafts,* 19, and Ulmann to Dr. Orie Latham Hatcher, June 12, 1932, DU; Niles to William J. Hutchins, August 16, 1933, BC-SAA; Niles to Hutchins, September 20(?), 1933, BC-SAA; Ulmann to Allen Eaton, May 24, 1934, UK-JJN; Niles to Rena Lipetz, July 31, 1934, UK-JJN; Ulmann to Olive Dame Campbell, August 11, 1934, JCFS; and Sarah Gibson Blanding to Niles, November 25, 1934, UK-JJN.

83. John Jacob Niles to Dr. Orie Latham Hatcher, July 12, 1933, DU; Niles to Dr. William J. Hutchins, August 16, 1933, BC-SAA; Eleanor Morgenthau to Niles (telegram), August 18, 1933, UK-JJN; Niles to Carl Engel, December 1933, UK-JJN; and Leicester Holland to Niles, January 18, 1934, and April 11, 1934, UK-JJN.

84. Niles's understanding and appreciation of Ulmann's work is evident in this correspondence with Hatcher. He wrote: "Miss Ulmann has done some of the most fantastic work with the negro play *Run Little Chillun'* and also with several dancers. . . . Her work is really like nothing on earth." See Niles to Hatcher, July 12, 1933, DU.

However, toward the end of her life, Ulmann was aware that she and the musician had grown apart. In a letter to Olive Dame Campbell, she wrote: "Your suggestion about Jack is strangely the thing which I had planned to do. Before we enter New York . . . I have planned to speak to him—tell him that I know that he wants to be by himself, that I'll not disturb him or call on him in any way and that if he should want to see me, he knows where to find me. He's been pretty good—and even now, I leave him to himself as much as possible,—the amusing part . . . is that when I do this, he is usually running after me," Ulmann to Campbell, July 27, 1934, JCFS. Nonetheless, Ulmann's appreciation for Niles remained strong to the end. In another letter to Campbell, dated just days before her death, Ulmann expressed her continued affection for her associate. "Jack has been very sweet and thoughtful and I fear that I have worried him a few times," Ulmann to Campbell, August 11, 1934, JCFS.

85. Allen Eaton to members of the Advisory Committee of the soon-to-be-established Doris Ulmann Foundation, February 21, 1935, JCFS.

86. Doris Ulmann Foundation, "Minutes of February 28, 1935 Meeting," New York City, JCFS.

87. Ibid., 2.

88. Ibid., 4–6. See also William Hutchins to Henry Necarsulmer, December 30, 1935, BC-SAA. In this letter, Hutchins informed Necarsulmer that Eaton and Niles were selecting photographs to send to Berea in order to fulfill the commitment Ulmann had made to the Kentucky institution. He wrote: "Allen Eaton and Jack Niles are generously selecting for us the pictures which they believe we would like, with the understanding that I can run through the entire mass of pictures if I so choose. These pictures which we receive will be placed in appropriate files, and groups of these pictures will always be on exhibit in the beautiful auditorium of the present Art Building."

89. Doris Ulmann Foundation, "Minutes, February 28, 1935 Meeting," 6–7, JCFS. In many respects, Samuel Hector Lifshey (1871–1954) was a natural choice for the task of developing and printing Ulmann's undeveloped glass-plate negatives and printing proof prints from all of her extant glass-plate negatives. The German-born Lifshey, who had been an apprentice of New York portrait photographer, B.J. Falk, was both a disciple of the pictorialist movement and a master photographic technician. This can be seen in reproductions of photographs he made of two young girls and a woman that were published in *The American Annual of Photography* 22 (New York: Tennant and Ward, 1907), 136; Vol. 27 (New York: The American Annual of Photography, Inc., 1912); and Vol. 28 (New York: The American Annual of Photography, Inc., 1913), 49. Many of Lifshey's pictorialist photographs were reproduced in prominent photographic journals in the first two decades of the twentieth century. In regard to Lifshey's photography, see also "Photographers I Have Met: S. H. Lifshey," *Abel's Photographic Weekly,* February 18, 1911, 134. The largest collection of Lifshey's work is at the George Eastman House, Rochester, New York.

90. Following her studies in art at the Pratt Institute, Käsebier, a Brooklyn resident, spent some months in 1896 studying with the Brooklyn photographer. By her own account, Lifshey helped her establish a darkroom at her home and taught her how to develop, print, tone, mount, and retouch photographs, Barbara Michaels, *Gertrude Käsebier: The Photographer and Her Photographs* (New York: Harry N. Abrams, Inc., 1992), 26 and 168, note 8, and William Innes Homer, *A Pictorial Heritage: The Photographs of Gertrude Käsebier* (Wilmington, Delaware: Delaware Art Museum, 1979), 14–15.

91. "Minutes of February 28, 1935 Meeting," 6–7, JCFS, and Doris Ulmann Foundation "Meeting of October 15, 1935 Meeting," 1–2, JCFS.

92. "Minutes of February 28, 1935 Meeting," 4–7, JCFS. It took approximately two and one half years for Lifshey to develop Ulmann's undeveloped negatives and complete a set of proof prints. In the "Minutes of July 20, 1937," Allen Eaton "reported that the classification of the negatives was progressing and that he expected to have this completed by September [1937] with albums containing at least one proof of all important subjects," pp. 3-4, JCFS.

93. Surrogates' Court of the County of New York, "Exhibit A" (Last Will and Testament of Doris Ulmann, August 21, 1934) and "Exhibit C" (Deed of Trust between Edna U. Necarsulmer, John Jacob Niles, Columbia University, and Olive Dame Campbell, Helen Dingman, Allen Eaton, Henry Necarsulmer, and John Jacob Niles), *Agreement of Settlement,* February 7, 1935. See also Doris Ulmann Foundation, "Minutes of February 28, 1935 Meeting," 1–11, JCFS.

94. "Minutes of February 28, 1935 Meeting," 8, JCFS, and Allen Eaton to Frank D. Fackenthal, Columbia University, March 5, 1935, NYHS.

95. "Minutes of February 28, 1935 Meeting," 6–11, JCFS.

96. See the minutes of the February 28, March 14, May 13, July 12, and October 15, 1935, meetings of the Doris Ulmann Foundation, JCFS.

97. "Minutes of March 14, 1935 Meeting," 1–3, JCFS.

98. "Minutes of May 13, 1935 Meeting," 1–3, JCFS.

99. "Minutes of July 12, 1935 Meeting," 1–3, JCFS. Eaton's book, *Handicrafts of the Southern Highlands,* published in the late summer of 1937, was well received. A promotional brochure featured Ulmann's photograph *A Potter's Daughter* and noted that the "lavish illustration . . . was made possible through a special grant from the Doris Ulmann Foundation." It also made this special offer: "Any purchaser of this volume who desires one or more photographic prints from the book can obtain them at a special price from the Doris Ulmann Foundation, in care of the Russell Sage Foundation, New York City." A critic in *The New York Times* wrote that Eaton's "text presents the results of an exhaustive survey and is of very great interest and value. And Doris Ulmann's photographs . . . add their own human information and suggestiveness," The New York Times Book Review, December 19, 1937. As one would expect, a very positive response also came from the Appalachian region. Writing in the journal *Mountain Life and Work,* Olive Dame Campbell wrote:

> We can only rejoice that our long expectations are so richly fulfilled; that we have such a thorough, sympathetic, and delightful study of the handicrafts of the Southern Highlands bound in so worthy a setting of cover, print and illustrations.
>
> Naturally, the illustrations make the first impression, especially the fine reproduc-

tions of Doris Ulmann's photographs. True and beautiful portrayals of mountain character and industry, they bring the reader at once into the Highland land of handicrafts, and into the spirit of the one who is writing about them. Mrs. Ulmann had a remarkable faculty for entering into and revealing the life and character of the people whom she photographed. She was both an artist and an understanding human being, sensitive to beauty, strength, humor, and suffering wherever she found them. (October 1937, 28)

In correspondence with Louise Pitman, Director, Southern Highland Handicraft Guild, some years later, Eaton wrote with pride of the number of copies that had been printed and sold. He wrote: "The Foundation has printed and sold something over 10,000 copies in five different printings: August 1937, November 1937, May 1939, March 1946, January 1948. It has also been, through selection by the Library of Congress, made into a 'Talking Book' for the Blind; and it was one of a hundred American books of the last ten years selected by the American Institute of Graphic Arts for the quality of their design, format and workmanship." (See Eaton to Louise Pitman, October 3, 1955, SHHG).

100. "Minutes of October 15, 1935 Meeting," 1–3, JCFS. There are records for meetings of the Doris Ulmann Foundation on Nov. 20, 1935 and July 20, 1937, copies at JCFS.

101. C. C. Williamson, director of libraries, Columbia University, to Allen Eaton, January 14, and March 4, 1943, NYHS; and Allen Eaton to C. C. Williamson, March 15, 1943, NYHS.

102. Charles W. Mixer, assistant director of libraries, Columbia University, to Allen Eaton, December 14, 1953, and September 14, 1954, NYHS. While it is hard to determine how many of the glass negatives were destroyed, it is clear Eaton asked Lifshey to destroy thousands, including most of the negatives containing African American images. The University of Oregon has 5,168 glass plate negatives from Ulmann's personal collection, which is believed to have included more than 10,000 negatives.

103. Ibid., September 14, 1954, NYHS.

104. Ibid. Librarian Charles W. Mixer was a real hero in the story of the preservation of Ulmann's vintage photographs. In his September 14, 1954, letter to Allen Eaton, Mixer acknowledged that Eaton had given him permission "to destroy the balance of approximately 5,000 photographic prints" which Eaton had not removed from the Columbia University library. However, Mixer was not comfortable with Eaton's authorization. He wrote Eaton: "Although your letter gave us authority to destroy the balance . . . it seemed to us that we ought not to take that action unless we were unable to find some home for them. Having heard that the New-York Historical Society collected pictures, I telephoned Mr. R.W.G. Vail, the Director, to see whether the Society would be interested in acquiring the remaining prints. He said that they would be glad to have them and would send a truck for them. They were removed on September 9." It is possible that the figure of five thousand is a typographical error. According to the curator of photography at the New-York Historical Society, only three thousand prints are extant in their collection. It is possible that John Jacob Niles took one thousand to two thousand images from the group that was stored at the library at Columbia University before they were given to the Historical Society. Ulmann bequeathed all her remaining photographs to the musician in her final will.

105. Radest, "Felix Adler," 36, and Goodlander, "The First Sixty Years," iii.

106. Eaton, *Handicrafts*, 19.

Bibliography

Agee, James, and Walker Evans. *Let Us Now Praise Famous Men.* Boston: Houghton, Mifflin, 1969.

"The Aims of the Pictorial Photographers of America." *Pictorial Photographers of America* [Annual Report]. New York: Pictorial Photographers of America, 1917, 6.

Allen, Frederick Lewis. *Only Yesterday: An Informal History of the 1920s.* New York: Harper, 1931.

———. *Since Yesterday: The Nineteen-Thirties in America.* Garden City, N.Y.: Blue Ribbon Books, 1943.

Alliance for Guidance of Rural Youth. Richmond, Va.: Alliance for Guidance of Rural Youth [after November 1937]. A pamphlet illustrated with three reproductions of photographs of children by Doris Ulmann.

Alliance for Guidance of Rural Youth: Some Achievements, Some Plans Ahead. Richmond, Va.: Alliance for Guidance of Rural Youth [after June 1938]. A pamphlet illustrated with one reproduction of a photograph of a child by Doris Ulmann.

"Alliance Holds Forum on Rural Youth in State." *Richmond Times-Dispatch.* October 23, 1933.

Alumni Association, Clarence H. White School of Photography. *Camera Pictures.* New York: L.F. White Company, 1924.

———. *Camera Pictures.* New York: L.F. White Company, 1925.

The American Annual of Photography. Vol. 22 (New York: Tennant and Ward, 1907); Vol. 27 (New York: The American Annual of Photography, Inc., 1913); and Vol. 28 (New York: The American Annual of Photography, Inc., 1913).

American Medical Directory. Chicago, Ill.: American Medical Association, 1912, 1914, 1918, 1925, and 1929.

American Photographer 28 (December 1934), 779. Obituary of Doris Ulmann.

Anderson, Paul Lewis. *The Fine Art of Photography.* Philadelphia: J.B. Lippincott, 1919.

———. *Pictorial Landscape-Photography.* Boston: Wilfred A. French, 1914.

———. *Pictorial Photography: Its Principles and Practices.* Philadelphia: J.B. Lippincott, 1917.

Annan, J. Craig. "David Octavius Hill, R. S. A., 1802–1870." *Camera Work* 10 (April 1905): Plates I–VI, 17–21.

"Annotated Program for the Annual Meeting of the General Executive Board of the Southern Woman's Educational Alliance, St. Regis Hotel, New York City, October 30—November 1, 1932." Richmond, Va.: Southern Woman's Educational Alliance. A pamphlet of this organization.

Annual Report. New York: Pictorial Photographers of America, 1918.

Arnow, Jan. *Handbook of Alternative Photographic Processes.* Cincinnati: Van Nostrand Reinhold Company, 1982.

"Artists to Be Honored Guests at Reception." *Richmond Times-Dispatch.* October 19, 1933.

"Art Photography Exhibit Arranged." *The Richmond News Leader.* October 25, 1933.

Asaf, Allen, and Lynda Wornom. *Members of the Grolier Club: 1884–1984.* New York: The Grolier Club, 1986.

Auer, Michele, and Michel Auer, eds. *Photographers Encyclopaedia International, 1839 to the Present.* 2 vols. Hermance, Switzerland: Editions Camera Obscura, 1985.

Baldwin, Gordon. *Looking at Photographs: A Guide to Technical Terms.* Malibu, Cal.: The J. Paul Getty Museum, 1991.

Bamberger, Bernard. *The Story of Judaism.* New York: The Union of American Hebrew Congregations, 1957.

Banes, Ruth. "Doris Ulmann and Her Mountain Folks." *Journal of American Culture* 8 (spring 1985).

Bannon, Anthony. *The Photo-Pictorialists of Buffalo.* Buffalo, N.Y.: Media Study, 1981.

Barnes, Lucinda, ed. *A Collective Vision: Clarence H. White and His Students.* Long Beach, Cal.: University Art Museum, California State University, 1985.

Barton, Bruce. "Back in Ward Four." *The American Magazine* (March 1931).

Bartram, Michael. *The Pre-Raphaelite Camera.* Boston: Little, Brown, 1985.

Beaton, Cecil, and Gail Buckland. *The Magic Image: The Genius of Photography from 1839 to the Present Day.* Boston: Little, Brown, 1975.

Beck, Otto W. *Art Principles in Portrait Photography.* New York: Baker and Taylor, 1907.

Beck, Tom, and Adrienne Manns. *Building A New World: Black Labor Photographs.* Baltimore: University Library, University of Maryland–Baltimore County, 1982.

Berea College. *Bulletin of Berea College and Allied Schools.* General Catalog, 1933–1934. Berea, Ky.: Berea College Press, 1933.

———. *The Chimes.* Yearbook, 1937. Berea, Ky: Berea College Press, 1937.

Bernard, Bruce. *Photodiscovery: Masterworks of Photography, 1840–1940.* New York: Harry N. Abrams, 1980.

"Bernhard Ulmann's Funeral." *New York Times,* December 3, 1915.

The Bookman. October, November, December 1929, October 1930, May and December 1932, passim.

Boyd, W. Andrew. *Boyd's Greater New York Co-Partnership Directory.* New York City: W. Andrew Boyd and Company, 1899.

"Branch News Items." *Southern Woman's Educational Alliance.* Richmond, Va.: Southern Woman's Educational Alliance, vol. 1, no. 1 (May 1, 1933), no. 2 (October 1, 1933). A newsletter of this organization.

Brilliant, Richard. *Portraiture.* Cambridge, Mass.: Harvard Univ. Press, 1991.

Brown, Lorraine, and Michael G. Sundell. "Stylizing the Folk: Hall Johnson's 'Run Little Chillun' Photographed by Doris Ulmann." *Prospects: An Annual Journal of American Cultural Studies* 7 (1982).

Browne, Turner, and Elaine Partnow. *Macmillan Biographical Encyclopedia of Photographic Articles and Innovators.* New York: Macmillan, 1983.

Bruccoli, M., M. Kennerly, and D.J.R. Bruckner. *Frederic Goudy, Documents of American Design.* New York: Harry N. Abrams, 1990.

Bry, Doris. *Alfred Stieglitz: Photographer.* Boston: Museum of Fine Arts, 1965.

Bunnell, Peter C., Douglas R. Nickel, et al. "The Art of Pictorial Photography." *Record of the Art Museum, Princeton University* 51, no. 2 (1992).

Bunnell, Peter C., ed. *Nonsilver Printing Processes: Four Selections, 1886–1927.* New York: Arno Press, 1973.

———. *A Photographic Vision, Pictorial Photography, 1889–1923.* Salt Lake City: Peregrine Smith, Inc., 1980.

———. *The Reverence for Beauty.* Athens, Ohio: Ohio Univ. Press, 1986.

———. "The Significance of the Photography of Clarence Hudson White (1871–1925) in the Development of Expressive Photography." Master's thesis, Ohio University, Athens, 1961.

Bruckner, D.J.R. *Frederic Goudy.* New York: Harry N. Abrams, 1990.

"The Call." *Pictorial Photographers of America* [Annual Report]. New York: Pictorial Photographers of America, 1917, 8.

The Call 19 (spring 1958). A publication of the University of Oregon Library. Most of this issue is devoted to Doris Ulmann and is illustrated with five of her photographs. It includes articles by Allen Eaton ("The Doris Ulmann Photograph Collection," 10–11); Alfred Heilpren ("Vita," 12); and John Jacob Niles ("Crossing Cut Shine Creek," 23 and "Doris Ulmann: Preface and Recollections," 4–9).

Callahan, Sean, ed. *The Photographs of Margaret Bourke-White.* Greenwich, Conn.: New York Graphic Society, 1972.

Campbell, John C. *The Southern Highlander and His Homeland.* Lexington: Univ. Press of Kentucky, 1969.

Campbell, Olive D. "Doris Ulmann." *Mountain Life and Work* (October 1934), 11.

———. "Our Mountain AE's' New Book on Handicrafts." *Mountain Life and Work* (October 1937), 28–29.

"Carl Ulmann Left $500,000 Estate." *New York Times,* January 9, 1929.

Cary, Melbert B., Jr. *A Bibliography of the Village Press.* New York: The Press of the Woolly Whale, 1938.

Chafe, William H. *The American Woman: Her Changing Social, Economic, and Political Roles, 1920–1970.* New York: Oxford Univ. Press, 1972.

Chamberlain, John. "Books of the Times." *New York Times,* December 15, 1933.

"Charities Benefit by Ulmann Will." *New York Times,* November 19, 1929.

"Charles H. Jaeger, Orthopedist, Dies." *New York Times,* September 14, 1942.

Charleston Communication Center. *Low Country Photographs by Leigh Richmond Miner 1864–1922.* Charleston, S.C.: Communications Center, 1977.

Clark, Emily. *Innocence Abroad.* New York: Knopf, 1931.

Clarke, Graham. *The Photograph.* New York: Oxford Univ. Press, 1997.

Clift, William, and Robert Coles. *The Darkness and the Light: Photographs by Doris Ulmann.* New York: Aperture, 1974.

Coburn, Alvin Langdon. *Alvin Langdon Coburn, Photographer: An Autobiography.* Edited by Helmut Gernsheim and Alison Gernsheim. New York: Dover Publications, 1978.

———. *Men of Mark.* London: Duckworth, 1913.

Coke, Van Deren, with Diana C. du Pont. *Photography: A Facet of Modernism.* New York: Hudson Hills Press; San Francisco: San Francisco Museum of Modern Art, 1986.

Coleman, A.D. "Introducing Doris and the Count." *New York Times,* August 15, 1971.

Columbia University Photographic Studies. New York: Columbia University, 1920.

Coolidge, Mrs. Calvin. "How I Spent My Days at the White House." *The American Magazine* (October 1929).

———. "When I Became the First Lady." *The American Magazine* (September 1929).

Corcoran Gallery of Art. *A Book of Photographs from the Collection of Sam Wagstaff.* New York: Gray Press, 1977.

Corporate Directory for City of New York. Volumes 1909, 1918–1919, and 1921–1922.

Cotton, Jerry. *Light and Air: The Photography of Bayard Wootten.* Chapel Hill: Univ. of North Carolina Press, 1999.

Cox, Sidney. *Robert Frost, Original "Ordinary Man."* New York City: Henry Holt, 1929.

"Crafts of the Southern Highlands." *Craft Horizons.* Asheville, N.C.: Southern Highland Handicraft Guild, 1966.

Crawford, William. *The Keepers of the Light: A History and Working Guide to Early Photographic Processes.* Dobbs Ferry, N.Y.: Morgan and Morgan, 1979.

"Critics Visit City to See Heaven Bound." *Richmond Times-Dispatch,* January 1, 1934.

"Critics to Witness Rehearsal of Play." *The Richmond News Leader,* January 2, 1934.

Crum, Mason. *Gullah.* Durham, N.C.: Duke Univ. Press, 1940.

Curtis, Edward S. *The North American Indian.* Seattle: Edward S. Curtis, 1907–1930. 20 volumes of text and small-format photogravures and 20 volumes of folio photogravures.

Curtis, Verna Posever, and Stanley Mallach. *Photography and Reform: Lewis Hine and the National Child Labor Committee.* Milwaukee, Wis.: Milwaukee Art Museum, 1984.

Dabbs, Edith M. *Face of an Island: Leigh Richmond Miner's Photographs of Saint Helena Island.* Columbia, S.C.: The R.L. Bryan Company, 1970.

Daniel, Pete, and Raymond Smock. *A Talent for Detail: The Photographs of Miss Frances Benjamin Johnston, 1889—1910.* New York: Harmony Books, 1974.

Dater, Judy. *Imogen Cunningham: A Portrait.* Boston: New York Graphic Society, 1979.

Dau's New York Blue Book. New York: Dau Publishing Company, 1907, 1909, 1910, 1911, 1912, 1913, and 1914.

Davidov, Judith Fryer. *Women's Camera Work.* Durham, N.C.: Duke Univ. Press, 1998.

Davis, Keith F. *The Passionate Observer: Photographs by Carl Van Vechten.* Kansas City, Mo.: Hallmark Cards, 1993.

De Caro, Frank. *Folklife in Louisiana Photography.* Baton Rouge: Louisiana State Univ. Press, 1990.

De Cock, Liliane, and Regina A. Perry. *James Van Der Zee.* Dobbs Ferry, N.Y.: Morgan and Morgan, 1973.

Dickson, Edward R. "The Pictorial Photographers of America: The Association's Work and Aim." *Pictorial Photography in America.* New York: Pictorial Photographers of America, 1920, 6–7.

Diner, Hasia R. *A Time for Gathering: The Second Migration, 1820–1880.* Baltimore, Md.: Johns Hopkins Univ. Press, 1992.

"Doris Ulmann Dead: Noted Photographer." *New York Times,* August 29, 1934.

"Doris Ulmann Dies in N.Y." *Berea Citizen,* September 6, 1934.

Doris Ulmann Foundation. Minutes of Meetings for February 28, March 14, May 13, July 12, October 15, and November 20, 1935 and July 20, 1937.

Dow, Arthur Wesley. *Composition: A Series of Exercises in Art Structure for the Use of Students and Teachers.* Garden City, N.Y.: Doubleday Page and Company, 1923.

———. "Mrs. Gertrude Käsebier's Portrait Photographs, From a Painter's Point of View." *Camera Notes* 2, no. 1 (July 1899), 22.

———. "Painting with Light." *Pictorial Photography in America.* New York: Pictorial Photographers of America, 1921, 5.

"Dr. Allen Eaton Will Speak at Forum Meeting." *Richmond Times-Dispatch.* January 31, 1932.

Durant, Will. "How a Great Scholar Brings up His Child." *The American Magazine* (March 1929).

Eaton, Allen H. *A Bibliography of Social Surveys.* New York: Russell Sage Foundation, 1930.

———. *Handicrafts of the Southern Highlands.* New York: Russell Sage Foundation, 1937.

———. *Immigrant Gifts to American Life.* New York: Russell Sage Foundation, 1932.

Eaton, Allen H., and Lucinda Crile. *Rural Handicrafts in the United States.* Washington, D.C.: U.S. Department of Agriculture and Russell Sage Foundation, 1946.

[Editorial.] *New York Times,* June 2, 1928.

"Edna Necarsulmer." *New York Times,* July 6, 1936.

Emerson, Peter Henry. *Naturalistic Photography for Students of the Art.* 1889. Reprint. New York: Arno Press, 1973.

Enyeart, James, ed. *Decade by Decade: Twentieth-Century American Photography from the Collection of the Center for Creative Photography.* Boston: Bullfinch Press; Tucson: Center for Creative Photography, University of Arizona, 1989.

Eskind, Andrew H., and Greg Drake, eds. *Index to American Photographic Collections.* Second Enlarged Edition. Boston: G.K. Hall, 1990.

"Estates Appraised—Bernhard Ulmann." *New York Times,* November 9, 1917.

Evans, Sara M. *Born for Liberty: A History of Women in America.* New York: The Free Press, 1989.

Falk, Ze'ev Wilhelm. "Fuerth." *Encyclopaedia Judaica.* New York: Macmillan, 1971, Volume 7.

Featherstone, David. *Doris Ulmann, American Portraits.* Albuquerque: Univ. of New Mexico Press, 1985.

Ford, Colin, ed. *An Early Victorian Album: The Photographic Masterpieces of David Octavius Hill and Robert Adamson.* New York: Knopf, 1976.

Foresta, Merry A. *American Photographs: The First Century.* Washington, D.C.: National Museum of American Art and Smithsonian Institution Press, 1996.

"406,578 for School: Bulk of Doris Ulmann Estate Willed to Carolina Folk Center." *New York Times,* January 17, 1936.

Freedberg, David. *The Power of Images: Studies in the History and Theory of Response.* Chicago: Univ. of Chicago Press, 1989.

Galbraith, John K. *The Great Crash, 1929.* Boston: Houghton Mifflin, 1961.

Garland, Hamlin. "Doris Ulmann's Photographs." *The Mentor* (July 1927), 41–48.

Gassan, Arnold. *A Chronology of Photography: A Critical Survey of the History of Photography as a Medium of Art.* Athens, Ohio: Handbook Company, 1972.

Gaynes, David. "Southern Highland Handicraft Guild." *The Arts Journal,* July 1979, n.p.

Genthe, Arnold. *Impressions of Old New Orleans.* New York: Doran, 1926.

———. *As I Remember.* New York: Reynal and Hitchcock, 1936.

Gernsheim, Helmut. *Julia Margaret Cameron: Her Life and Photographic Work.* Millerton, N.Y.: Aperture, 1975.

Gernsheim, Helmut, and Alison Gernsheim. *The History of Photography: From the Earliest Use of the Camera Obscura in the Eleventh Century up to 1914.* New York: McGraw-Hill, 1969.

Gillies, John Wallace. *Principles of Pictorial Photography.* New York: Falk Publishing Company, Inc., 1923.

Glazier, Ira, and P. William Filby. *Germans To America: Lists of Passengers Arriving at US Ports.* Volume 19 and volume 20. Wilmington, Del.: Scholarly Resources, Inc., 1991.

Glenn, John H., Lilian Brandt, and F. Emerson Andrews. *Russell Sage Foundation: 1907–1946.* New York: Russell Sage Foundation, 1947.

Goldberg, Vicki. *Margaret Bourke-White: A Biography.* New York: Harper and Row, 1986.

Goldberg, Vicki, ed. *Photography in Print, Writings from 1816 to the Present.* New York: Simon and Schuster, 1981.

Goldman, Helen. "Photographers." *Jewish Women in America.* New York: Routledge, 1997.

Goodlander, Mabel. "The First Sixty Years: The Ethical Culture School." Unpublished essay, 1939.

Goodrich, Frances Louisa. *Mountain Homespun.* Knoxville: Univ. of Tennessee Press, 1989. A facsimile of the original, with a new introduction by Jan Davidson.

Gover, C. Jane. *The Positive Image: Women Photographers in Turn of the Century America.* Albany: State Univ. of New York Press, 1988.

Graybill, Florence Curtis, and Victor Boesen. *Edward Sheriff Curtis: Visions of a Vanishing Race.* New York: Crowell, 1976.

Green, Nancy. *Arthur Wesley Dow and His Influence.* Ithaca, N.Y.: Herbert F. Johnson Museum of Art, Cornell University, 1990.

Greenhill, Gillian Barrie. "The Outsiders: The Salon Club of America and the Popularization of Pictorial Photography." Ph.D. diss., Pennsylvania State University, 1986.

Guimond, James. *American Photography and the American Dream.* Chapel Hill: Univ. of North Carolina Press, 1991.

Gutman, Judith Mara. *Lewis W. Hine, 1874–1940: Two Perspectives.* New York: Grossman Publishers, 1974.

———. *Lewis W. Hine and the American Social Conscience.* New York: Walker, 1967.

Guttchen, Robert S. *Felix Adler.* New York: Twayne Publishers, 1974.

Hagen, Charles. "Rural Social Commentary with a Difference." *New York Times,* November 4, 1994.

Hambourg, Maria Morris, and Christopher Phillips. *The New Vision: Photography Between the World Wars.* New York: Metropolitan Museum of Art, 1989.

Hambourg, Maria Morris, et al., eds. *The Waking Dream: Photography's First Century, Selections from the Gilman Paper Company Collection.* New York: Metropolitan Museum of Art, 1993.

Harker, Margaret F. *The Linked Ring: The Secession Movement in Photography in Britain, 1892–1910.* London: Heinemann, 1979.

Harris, James F. "Bavarians and Jews in Conflict in 1866: Neighbors and Enemies." *Leo Baeck Institute Yearbook* 32 (1987), 103–117.

Hartmann, Sadakichi. [Sidney Allan, pseud.]. *The Valiant Knights of Daguerre: Selected Critical Essays on Photography and Profiles of Photographic Pioneers.* Edited by Harry W. Lawton and George Knox. Berkeley: Univ. of California Press, 1978.

Harvard Society for Contemporary Art, Cambridge, Mass. *Contemporary Photography.* Essay by Lincoln Kirstein. Exhibition catalogue, 1931.

Heller, Adele, and Lois Rudwick, eds. *1915, The Cultural Moment.* New Brunswick, N.J.: Rutgers Univ. Press, 1991.

Helm, Mackinley. *Man of Fire: J. C. Orozco.* Westport, Conn.: Greenwood Press, 1971.

Henry, Louis Lee. *Julia Peterkin: A Biographical and Critical Study.* Ann Arbor, Mich.: University Microfilms, 1966.

"Henry Necarsulmer." *New York Times,* September 2, 1938.

Heyman, Therese Thau, ed. *Seeing Straight.* Oakland, Calif.: The Oakland Museum of Art, 1992.

Higham, John. *Strangers in the Land: Patterns of American Nativism, 1860–1925.* New Brunswick, N.J.: Rutgers Univ. Press, 1988.

Hill, Paul, and Thomas Cooper, eds. *Dialogue with Photography.* New York: Farrar Straus Giroux, 1979.

Hine, Lewis. *Men at Work: Photographic Studies of Modern Men and Machines.* New York: Macmillan, 1932.

Hofstadter, Richard. *The Age of Reform: From Bryan to FDR.* New York: Knopf, 1955.

Homer, William Innes. *Alfred Stieglitz and the Photo-Secession.* Boston: Little, Brown, 1983.

———. *A Pictorial Heräitage: The Photographs of Gertrude Käsebier.* Wilmington: Delaware Art Museum, 1979.

"Homespun Art of the Farm." *New York Times Magazine,* November 28, 1937.

"How We Make Our Photographs." *Pictorial Photography in America.* New York: Pictorial Photographers of America, 1921: 10–14.

Hummer, Patricia M. *The Decade of Elusive Promise: Professional Women in the United States, 1920–1930.* Ann Arbor, Mich.: UMI Research Press, 1979.

Hurley, F. Jack. *Portrait of a Decade: Roy Stryker and the Development of Documentary Photography in the Thirties.* Baton Rouge: Louisiana State Univ. Press, 1972.

Hyman, Paula E., and Deborah Dash Moore, eds. *Jewish Women in America: An Historical Encyclopedia.* Volume 2. New York: Routledge, 1997.

Ibsen, Henrik. *Three Plays: An Enemy of the People, The Wild Duck, Hedda Gabler.* New York: Heritage Press, 1965.

Jacoby, Mary Moore. "The Photographic Work of Leigh Richmond Miner at Hampton University and St. Helena Island, South Carolina." Master's thesis, Virginia Commonwealth University, Richmond, 1990.

Jaeger, Charles H. "Flexion Deformity of the Knee: An Improved Method of Correction." *American Journal of Surgery.* New York, 1916.

———. "The Lorenz Hip Redresser" and "Lorenz Spica." *The New York Medical Journal.* New York: A.R. Elliott Publishing Company, 1903.

———. "Trade Training for Adult Cripples." *American Journal of Care for Cripples.* New York: Federation of Association for Cripples, 1914.

Jaeger, Charles H., and J. Hilton Waterman. "Caries of the Spine: An Analysis of a Thousand Cases." *The New York Medical Journal.* New York: A.R. Elliott Publishing Company, 1901.

Jaeger, Doris U. *The Faculty of College of Physicians and Surgeons, Columbia University in the City of New York: Twenty-Four Portraits.* New York: P.B. Hoeber, 1919.

Jay, Bill. *Robert Demachy.* London and New York: Academy Editions and St. Martin's Press, 1974.

Jeffrey, Ian. *Photography, A Concise History.* London: Thames and Hudson, Ltd., 1981.

Jeffrey, Ian, ed. *The Photography Book.* London: Phaidon Press Limited, 1997.

"John Jacob Niles Legacy." *Beaux Arts.* Summer 1981.

Johnson, James Weldon. *Along This Way: The Autobiography of James Weldon Johnson.* New York: Viking Press, 1933.

Johnston, Frances Benjamin. "What a Woman Can Do with a Camera." *Ladies' Home Journal* 14 (September 1897), 6–7.

Josephthal, Hans. *Stammbaum der Familie Josephthal.* Berlin: Louis Lamm, 1932.

Judge, J. "'Roll, Jordan, Roll' a Social Document." *Savannah Morning News,* January 7, 1934.

"Julia Peterkin as Hedda Gabler." *Theatre Arts Monthly* 16 (July 1932): 603.

"Julia Peterkin on Stage." *New York Times,* February 22, 1932.

"Julia Peterkin Wins Ovation as Actress." *New York Times,* February 26, 1932.

Kaplan, Daile. *Lewis Hine in Europe: The Lost Photographs.* New York: Abbeville Press, 1988.

Kardon, Janet, ed. *Revivals! Diverse Traditions, 1920–1945: The History of Twentieth-Century American Craft.* New York: Harry N. Abrams, 1994.

Keller, Helen. "I Am Blind—Yet I See, I Am Deaf—Yet I Hear." *The American Magazine* (June 1929).

Keller, Judith. *After the Manner of Women: Photographs by Käsebier, Cunningham, and Ulmann.* Malibu, Cal.: J.P. Getty Museum, 1988.

———. "Doris Ulmann." *Doris Ulmann: Photography and Folklore.* Malibu, Cal.: J.P. Getty Museum, 1996.

Keller, Judith, and Katherine Ware. "Women Photographers in Europe 1919–1939: An Exhibition at the Getty Museum." *History of Photography* 18, no. 3 (autumn 1994) (Oxford, England: Taylor and Francis, Ltd., 1994), 219–22.

Keller, Ulrich, and Gunther Sander. *August Sander, Citizens of the Twentieth Century: Portrait Photographs 1892–1952.* Cambridge, Mass.: The MIT Press, 1986.

Kelley, Welbourn. "Plantation Lore: *Roll, Jordan, Roll.*" *Saturday Review of Literature* 10 (December 30, 1933), 377.

Kober, Adolf. "Fuerth." *The Universal Jewish Encyclopedia,* vol. 4, 483–84.

Kowalski, Shelley Kara. "Penumbra: The Photographic Art World and Doris Ulmann." Ph.D. diss., University of Oregon, 1998.

Kramer, Robert. *August Sander: Photographs of an Epoch, 1904–1959.* Millerton, N.Y.: Aperture, 1980.

Lamuniere, Michelle C. "*Roll, Jordan, Roll* and the Gullah Photographs of Doris Ulmann." *History of Photography* 24, no. 4 (winter 1997)(Oxford, England: Taylor and Francis, Ltd., 1994), 294–302.

Landess, Thomas. *Julia Peterkin.* Boston: Twayne, 1976.

Larson, Judy, ed. *Graphic Arts and the South.* Fayetteville: Univ. of Arkansas Press, 1993.

Lears, T.J. Jackson. *No Place of Grace: Antimodernism and the Transformation of American Culture, 1880–1920.* New York: Pantheon, 1981.

Leibowitz, Herbert. "The Appalachian Photographs of Doris Ulmann." *New York Times Book Review,* November 21, 1971.

Lemagny, Jean-Claude, and Andre Rouille, eds. *A History of Photography: Social and Cultural Perspectives.* Translated by Janet Lloyd. Cambridge, England: Cambridge Univ. Press, 1986.

Leuchtenberg, William E. *The Perils of Prosperity, 1914–1932.* Chicago: Univ. of Chicago Press, 1993.

Lippmann, Walter. *A Preface to Morals.* New York: Macmillan, 1929.

"Local Woman Forms Society to Aid Girls." *Richmond Times-Dispatch,* July 24, 1932.

Long, Frank W. *Confessions of a Depression Muralist.* Columbia: Univ. of Missouri Press, 1997.

Longwell, Dennis. *Steichen: The Master Prints, 1895–1914, The Symbolist Period.* New York: Museum of Modern Art, 1978.

Lothrop, Eaton S., Jr. *A Century of Cameras from the Collection of the International Museum of Photography at the George Eastman House.* Dobbs Ferry, N.Y.: Morgan and Morgan, 1973

Lovejoy, Barbara. "The Oil Pigment Photography of Doris Ulmann." Master's thesis, University of Kentucky, 1993.

Lowenstein, Steven M. "The Yiddish Written Word in Nineteenth-Century Germany." *Leo Baeck Institute Yearbook* 24 (1979), 179–192.

Macdougall, Allan Ross, ed. *Letters of Edna St. Vincent Millay.* New York: Harper and Brothers, 1952.

Maddow, Ben. *Faces: A Narrative History of the Portrait in Photography.* Boston: New York Graphic Society, 1977.

Maddox, Jerald C. *Photographs of Clarence H. White.* Lincoln: Sheldon Memorial Art Gallery, University of Nebraska, 1968.

———. *The Pioneering Image: Celebrating 150 Years of American Photography.* New York: Universe Publishing, 1989.

Maddox, Marilyn Price. "The Life and Works of Julia Mood Peterkin." Master's thesis, University of Georgia, 1956.

Mahood, Ruth I., and Robert A. Weinstein, eds. *Photographer of the Southwest: Adam Clark Vroman, 1856–1916.* Los Angeles: Ward Ritchie, 1961.

Malraux, André. *The Voices of Silence.* Translated by Stuart Gilbert. Princeton, N.J.: Princeton Univ. Press, 1978.

Mann, Margery. *Imogen!: Imogen Cunningham Photographs, 1910–1973.* Seattle: Univ. of Washington Press, 1974.

Mann, Margery, and Anne Noggle. *Women of Photography: An Historical Survey.* San Francisco, Cal.: San Francisco Museum of Modern Art, 1975.

Margolis, Marianne Fulton, ed. *Camera Work: A Pictorial Guide.* New York: Dover Publications, 1978.

Marquis, Albert N., ed. *Who's Who in America.* Volumes 16 and 17. Chicago: A.N. Marquis Company, 1930–1934.

"Married by Rabbi Gottheil." *New York Times,* November 28, 1884.

Martin, Ira W. "Women in Photography." *Pictorial Photography in America.* New York: Pictorial Photographers of America, 1929.

"Maturing the Picture." *Pictorial Photographers of America* [Annual Report]. New York: Pictorial Photographers of America, 1917, 13–4.

May, Henry F. *The End of American Innocence: A Study of the First Years of Our Own Time, 1912–1917.* New York: Knopf, 1959.

McCabe, Mary Kennedy. *Clara Sipprell: Pictorial Photographer.* Fort Worth, Tex.: Amon Carter Museum, 1990.

McCandless, Barbara, Bonnie Yochelson, and Richard Koszarski. *New York to Hollywood: The Photography of Karl Struss.* Fort Worth, Tex.: Amon Carter Museum, 1998.

McEuen, Melissa A. "Changing Eyes: American Culture and the Photographic Image, 1918–1941." Ph.D. diss., Louisiana State University, 1991.

―――. "Doris Ulmann and Marion Post Wolcott." *History of Photography* 19, no. 1 (spring 1995) (Oxford, England: Taylor and Francis, Ltd, 1995), 4–12.

―――. "The Love of Her Life." *Kentucky Humanities* 2 (Lexington: Kentucky Humanities Council, 1997), 8–10.

―――. *Seeing America: Women Photographers between the Wars.* Lexington: Univ. Press of Kentucky, 1999.

McNelley, Pat, ed. *The First 40 Years: John C. Campbell Folk School.* Brasstown, N.C.: John C. Campbell Folk School, n.d.

McPherson, Dian. "Doris Ulmann: Cultural Documents." Master's thesis, John F. Kennedy University, 1983.

Meltzer, Milton. *Dorothea Lange: A Photographer's Life.* New York: Farrar Straus Giroux, 1978.

"Membership." *Pictorial Photographers of America* [Annual Report]. New York: Pictorial Photographers of America, 1917, 30.

Mencken, H.L. *My Life as Author and Editor.* New York: Knopf, 1993.

Meriwether, James B. "No Finer Collaboration." Columbia: Institute for Southern Studies, University of South Carolina, 1983. South Carolina Historical Society.

Michaels, Barbara L. *Gertrude Käsebier: The Photographer and Her Photographs.* New York: Harry N. Abrams, 1992.

"Minutes of the Eighteenth Annual Meeting of the Executive Board of the Southern Woman's Educational Alliance, St. Regis Hotel, New York City, October 30 to November 1, 1932." Richmond, Va.: Southern Woman's Educational Alliance, November 1932.

"Mountain Ballads to Be Heard Here." *The Richmond News Leader,* October 18, 1933.

"The Mountain Breed." *New York Times,* June 2, 1928.

"Mrs. Henry Necarsulmer: Women's Conference Chairman of Society for Ethical Culture." *New York Times,* July 5, 1936.

Museum of Modern Art. *Dorothea Lange.* New York: Museum of Modern Art, 1966.

―――. *Steichen the Photographer.* New York: Museum of Modern Art, 1961.

―――. *Walker Evans.* New York: Museum of Modern Art, 1971.

Nadeau, Luis. *History and Practice of Oil and Bromoil Printing.* Fredericton, New Brunswick, Canada: Atelier Luis Nadeau, 1985.

Naef, Weston J. *The Art of Seeing: Photographs from the Alfred Stieglitz Collection.* New York: Metropolitan Museum of Art, 1978.

―――. *Counterparts: Form and Emotion in Photographs.* New York: E.P. Dutton, 1982.

―――. *The J. Paul Getty Museum Handbook of the Photographs Collection.* Malibu, Cal.: J. Paul Getty Museum, 1995.

Naef, Weston J., and Suzanne Boorsch. *The Painterly Photograph, 1890–1914.* New York: Metropolitan Museum of Art, 1973.

Naef, Weston J., gen. ed. *In Focus: Doris Ulmann.* Malibu, Cal.: J. Paul Getty Museum, 1996.

Nash, Roderick. *The Nervous Generation: American Thought, 1917–1930.* Chicago: Rand McNally, 1970.

National Union Catalog Pre-1956 Imprints. Volume 452. Chicago: American Library Association, 1976.

Newhall, Beaumont. *The History of Photography.* New York: Museum of Modern Art, 1982. Revised and enlarged edition.

New York Times. August 29, 1934. Obituary of Doris Ulmann.

Niles, John Jacob. *The Appalachian Photographs of Doris Ulmann.* Penland, N.C.: Jargon Society, 1971.

———. "Autobiography." Unpublished. John Jacob Niles Collection, Special Collections and Archives, University of Kentucky Libries, Lexington.

———. *The Ballad Book of John Jacob Niles.* Boston: Houghton Mifflin, 1961.

———. *Hinky Dinky Barley Brew: A Cry From the Heart.* New York: Old Grist Mill Press, 1932.

———. "The Legend of Doris Ulmann." Typed manuscript. John Jacob Niles Collection, Special Collections and Archives, University of Kentucky Libraries, Lexington.

———. "Notebooks." Unpublished. John Jacob Niles Collection, Special Collections and Archives, University of Kentucky Libraries, Lexington.

———. *Seven Negro Exaltations.* New York: G. Schirmer, 1929.

Niles, Rena. "Inner Spirit: Doris Ulmann's Photography." *High Roads Folio* 8 (1984), 14–17.

"Number of Exposures." *Pictorial Photographers of America* [Annual Report]. New York: Pictorial Photographers of America, 1917,13–14.

"Oil Prints." *The Photo Miniature* 15 (New York: Tennant and Ward, May 1919).

"Organizing." *Pictorial Photographers of America* [Annual Report]. New York: Pictorial Photographers of America, 1917, 7.

"Our Mountain Young People." *Southern Woman's Educational Alliance.* Richmond, Va.: Southern Woman's Educational Alliance, October 1933. A postcard invitation to the first forum of this group, which featured an exhibition of photography by Doris Ulmann, the singing of ballads by John Jacob Niles, and a lecture by Ruth Henderson.

"Our Travel Salons." *Light and Shade.* New York: Pictorial Photographers of America. (December 1931). 9.

Ovenden, Graham, ed. *Clementina, Lady Hawarden.* London and New York: Academy Editions and St. Martin's Press, 1974.

Ovenden, Graham. *Pre-Raphaelite Photography.* London: Academy Editions, 1972.

Parke-Bernet Galleries. *The Notable Collection of Incunabula and Early Printed Books of the Late Carl J. Ulmann.* Sale on April 15 and 16, 1952. New York, N.Y.: Parke-Bernet Galleries, 1952.

Parker, Rozsika, and Griselda Pollock. *Old Mistresses: Women, Art and Ideology.* New York: Pantheon Books, 1981.

Parrish, Michael E. *Anxious Decades: America in Prosperity and Depression, 1920–1941.* New York: Norton, 1992.

Paul Strand: A Retrospective Monograph—The Years 1915–1946. Millerton, N.Y.: Aperture, 1972.

Pelikan, Jaroslav, ed. *The World Treasury of Modern Religious Thought.* Boston: Little, Brown, 1990.

Pen, Ronald Allen. "The Biography and Works of John Jacob Niles." Ph.D. diss., University of Kentucky, 1987.

———. "A Chronology of the Life of John Jacob Niles." Unpublished.

Peterkin, Julia, and Doris Ulmann. *Roll, Jordan, Roll.* New York: Robert 0. Ballou, 1933. In addition to this trade edition, a 350-copy limited edition with photogravure reproductions was released in 1934.

Peterson, Christian A. *After the Photo-Secession.* New York: Norton, 1997.

———. *Alfred Stieglitz's Camera Notes.* New York and London: Norton, 1996.

———. *Index to the Annuals of the Pictorial Photographers of America.* Minneapolis: Christian A. Peterson, 1993.

Phillips, W. *Phillips' Elite Directory of Private Families and Ladies.* New York: Phillips, 1893, 1894, 1898, 1902, 1903, 1906, and 1908.

———. *Phillips' Business Directory of New York City.* New York: Phillips, 1900, 1902, 1903, 1904, 1906, 1910, 1911, 1913, and 1914.

Philipson, David. *The Reform Movement in Judaism.* New York: Macmillan, 1931.

The Pictorial Photographers of America. "The Doris Ulmann Exhibition." *Light and Shade.* December 1929.

———. *Light and Shade.* November 1929.

———. *Light and Shade.* December 1931.

———. *Pictorial Photographers of America Bulletin.* March 1933.

———. *Pictorial Photographers of America Bulletin.* October 1934.

———. *Pictorial Photographers of America Bulletin.* December 1936.

———. *Pictorial Photographers of America Bulletin.* January 1937.

———. *Pictorial Photography in America.* New York: Tennant and Ward, 1920. (59, illus.)

———. *Pictorial Photography in America.* New York: The Pictorial Photographers of America, 1921. (43, illus.)

———. *Pictorial Photography in America.* New York: The Pictorial Photographers of America, 1926. (51, illus.)

———. *Pictorial Photography in America.* New York: The Pictorial Photographers of America, 1929. (12, illus.)

———. *Pictorial Photographers of America Yearbook.* New York: The Pictorial Photographers of America, 1917.

"Portrait Studies of Rural Folk to Feature Forum Here Today." *Richmond Times-Dispatch,* October 22, 1933.

Publishers Weekly, December 6, 1933.

Radest, Howard B. *Toward Common Ground: The Story of the Ethical Societies in the United States.* New York: Frederick Ungar Publishing Company, 1969.

Reed, Alma. *Orozco!* New York: Oxford Univ. Press, 1956.

[Review of *Delphic Gallery Show.*] *New York Times,* November 3, 1929.

[Review of *Handicrafts of the Southern Highlands.*] *New York Times,* December 19, 1937.

Richmond Academy of Arts. "Personals." *Academy News* 2, no. 2 (December 1933).

Riggins, Marie. "Modern Pictorial Photography: The Measure of Its Art." Ph.D. diss., Case Western Reserve University, 1943

Ritchie, Jean. *The Dulcimer Book.* New York: Oak Publications, 1974.

Robeson, Elizabeth. "The Ambiguity of Julia Peterkin." *Journal of Southern History* 61 (November 1995), 761–862.

"Robeson Indians Studied by Woman of National Fame." *The Robesonian* (Lumberton, N.C.), September 30, 1929.

Robinson, Henry P. *Pictorial Effect in Photography.* London: Piper and Carter, 1869.

Robinson, Karl Davis. "Pictorial Photographers of America." *Bulletin of the Art Center* 5, no. 4 (New York: Art Center, December 1926).

Rose, Barbara. *American Art Since 1900: A Critical History.* New York: Frederick A. Praeger, 1967.

Rosenblum, Naomi. *A World History of Photography.* New York: Abbeville Press, 1984.

———. *A History of Women Photographers.* New York: Abbeville Press, 1994.

Rosenblum, Naomi, and Susan Fillin-Yeh. *Documenting a Myth: The South As Seen by Three Women Photographers, Chansonetta Stanley Emmons, Doris Ulmann, Bayard Wootten, 1910–1940.* Seattle: Univ. of Washington Press, 1999.

Rosenblum, Naomi, and Alan Trachtenberg. *America and Lewis Hine: Photographs, 1904–1940.* Millerton, N.Y.: Aperture, 1977.

Russell, Robert Stanley. "The Southern Highland Handicraft Guild: 1928–1975." Ph.D. diss., Columbia University, 1976.

Sander, August. *Men Without Masks: Faces of Germany, 1910–1938.* Greenwich, Conn.: New York Graphic Society, 1973.

Sandweiss, Martha A. *Laura Gilpin: An Enduring Grace.* Fort Worth, Tex.: Amon Carter Museum, 1986.

Scarborough, Dorothy. "Julia Peterkin's Gullahs Sit for Their Portrait." *New York Times,* January 7, 1934.

Showalter, Elaine, ed. *These Modern Women: Autobiographical Essays from the Twenties.* Old Westbury, N.Y.: Feminist Press, 1978.

Sipprell, Clara E. *Moment of Light.* New York: The John Day Company, 1966.

Smith, Frank H. *Appalachian Square Dance.* Berea, Ky.: Berea College, 1955.

Sorin, Gerald. *A Time For Building: The Third Migration, 1880–1920.* Baltimore, Md.: Johns Hopkins Univ. Press, 1992.

"Southern Handicrafts." *New York Times Book Review,* December 19, 1937.

Southern Woman's Educational Alliance: A Service of Educational and Vocational Guidance for Rural Young People. Richmond, Va.: Southern Woman's Educational Alliance, n.d. A pamphlet illustrated with one reproduction of a photograph of a young child by Doris Ulmann, "reproduced from its exhibit at the Century of Progress show in 1933."

The Southern Woman's Educational Alliance: A Guidance Service for Rural Young People, Its Task, Its Trust, Its Program. Richmond, Va.: Southern Woman's Educational Alliance, after September 30, 1936. A pamphlet illustrated with one reproduction of a photograph of a young child by Doris Ulmann, detailing the work of the Alliance from October 1, 1929 to September 30, 1936.

Steichen, Edward. *Steichen, A Life in Photography.* New York: Harmony Books, 1985.

Stevenson, Sarah. *David Octavius Hill and Robert Adamson.* Edinburgh: National Galleries of Scotland, 1981.

Stieglitz, Alfred, ed. and pub. *Camera Work, A Photographic Quarterly.* 50 Issues. 1903–1917. Reprint. New York: Kraus Reprints, 1969.

Stott, William. *Documentary Expression and Thirties America.* New York: Oxford Univ. Press, 1973.

Strong, David Calvin. "Sidney Carter and Alfred Stieglitz." History of Photography 20, no. 2 (Oxford, England: Taylor and Francis, Ltd, summer 1996): 160–62.

"The Stuff of American Drama in Photographs by Doris Ulmann." *Theatre Arts Monthly* 14 (February 1930): 132–46.

Sullivan, Constance and Eugenia Parry Janis. *Women Photographers.* New York: Harry N. Abrams, 1990.

"SWEA Service in Virginia." *Southern Woman's Educational Alliance.* Richmond, Va.: Southern Woman's Educational Alliance, November 25, 1933. A newsletter of this organization.

Szarkowski, John. *Looking at Photographs: 100 Pictures from the Collection of The Museum of Modern Art.* New York: Museum of Modern Art, 1973.

———. *Photography Until Now.* New York: Museum of Modern Art, 1989.

Taylor, John. *Pictorial Photography in Britain, 1900–1920.* London: Arts Council of Great Britain, 1978.

Terrell, Freida Morgan. "An Historical and Contemporary Study of the John C. Campbell Folk School, Brasstown, North Carolina." Master's thesis, University of Tennessee, 1969.

Thomas, James W. *Lyle Saxon.* Birmingham, Ala.: Summa Publications, 1991.

Thomas' Register of American Manufacturers, 1905–1906. New York: Thomas Publishing Company, 1905.

Thompson, H. Dean Jr. "Minerva Finds a Voice: The Early Career of Julia Peterkin." Ph.D. diss., Vanderbilt University, 1987.

Thornton, Gene. "A Romantic Whose Camera Inescapably Captured Reality." *New York Times,* January 6, 1985.

———. "Review of *Appalachian Photographs of Doris Ulmann.*" *Aperture* (February 1971).

———. "Ulmann Forces a New Look at Pictorialism." *New York Times,* January 12, 1975.

Tompkins, Calvin. *Paul Strand: Sixty Years of Photographs.* Millerton, N.Y.: Aperture, 1976.

Toury, Jacob. "Types of Jewish Municipal Rights in German Townships: The Problem of Local Emancipation." *Leo Baeck Institute Yearbook* 22 (1977), 55–59.

Trachtenberg, Alan. *Reading American Photographs: Images As History, Matthew Brady to Walker Evans.* New York: Hill and Wang, 1989.

Trachtenberg, Alan, ed. *Classic Essays on Photography.* New Haven, Conn.: Leete's Island Books, 1980.

Travis, David, and Anne Kennedy. *Photography Rediscovered: American Photographs, 1900–1930.* New York: Whitney Museum of American Art, 1979.

Troth, Henry. "Amateur Photography at Its Best." *Ladies' Home Journal,* January, February, March and April 1897.

Trow, F., and H. Wilson. *Trow's New York City Directory.* New York: The Trow City Directory Company, 1866–1900.

Tucker, Anne, ed. *The Woman's Eye.* New York: Knopf, 1973.

"Ulmann." [Gertrude Maas Ulmann] *New York Times,* February 24, 1913.

Ulmann, Ber Bernhard. *Chronicle of Ber Bernhard Ulmann.* Translated and introduced by Carl J. Ulmann. New York: Carl J. Ulmann, 1928.

Ulmann, Doris. "Among the Southern Mountaineers." *The Mentor* 18 (August 1928), 23–32.

———. *A Book of Portraits of the Faculty of the Medical Department of the Johns Hopkins University, Baltimore.* Baltimore, Md.: Johns Hopkins Univ. Press, 1922.

———. "Character Portraits." *The Mentor* (July 1927), 41–48.

———. "The Mountaineers of Kentucky: A Series of Portrait Studies by Doris Ulmann." *Scribner's Magazine.* (June 1928), n.p.

———. "In Southern Hills." *Theatre Arts Monthly* 18 (August 1934), 615–20.

———. "The People of an American Folk School." *Survey Graphic* 23 (May 1934), 229–32.

———. *A Portrait Gallery of American Editors, Being a Group of XLIII Likenesses by Doris Ulmann.* New York: William Edwin Rudge, 1925. Limited edition of 375 copies.

———. "Portrait Photographs of Fifteen American Authors." *The Bookman* 70 (December 1929), 417–32.

———. "The Stuff of American Drama." *Theatre Arts Monthly* 14 (February 1930), 132–46.

"Ulmann Estate: $1,355,521." *New York Times,* January 1, 1930.

"Uses Brace to Cure Dislocation of Hip: Dr. Jaeger Tells of Successful Treatment of Baby Without an Operation." *New York Times,* May 16, 1925.

Van Dommelen, David B. "Allen H. Eaton: Dean of American Crafts." Unpublished book, 1977. Archives, Southern Highland Handicraft Guild.

Van Doren, Dorothy. [Review of trade edition of *Roll, Jordan, Roll.*] *The Nation,* January 24, 1934.

"Virginia Players Present 'Heaven Bound': A Twentieth-Century Miracle Play." Richmond, Va.: Southern Woman's Educational Alliance, February 2, 1934. A poster advertising the performance of the play at Cabell Hall, at the University of Virginia, in Charlottesville, Virginia.

Wandersee, Winifred. *Women's Work and Family Values, 1920–1940.* Cambridge, Mass.: Harvard Univ. Press, 1981.

Warren, Dale. "Doris Ulmann: Photographer in Waiting." *The Bookman* 72 (October 1930), 129–44.

Warren, Harold. ". . . a right good people." Boone, N.C.: Appalachian Consortium Press, 1974.

Waterman, J. Hilton, and Charles H. Jaeger. "Caries of the Spine: An Analysis of a Thousand Cases." *New York Medical Journal* (New York: A.R. Elliott Publishing Company, November 1901): 1–10.

Weaver, Mike. *Alvin Langdon Coburn, Symbolist Photographer, 1882–1966.* New York: Aperture and George Eastman House, 1986.

Weaver, Mike, ed. *The Art of Photography, 1839–1989.* New Haven, Conn., and London: Royal Academy of Arts; Yale Univ. Press, 1989.

Webb, William, and Robert A. Weinstein. *Dwellers at the Source: Southwestern Indian Photographs of A. C. Vroman, 1895–1904.* New York: Grossman, 1973.

Weber, Max. *Essays On Art.* New York: William E. Rudge, 1916.

———. "The Filling of Space." *Platinum Print.* New York, 1913.

———. Memoir of Max Weber: An Interview Conducted By Carol S. Gruber. New York: Columbia University Oral History Collection, Butler Library, 1958.

Wharton, H.M. *War Songs and Poems of the Southern Confederacy, 1861–1865. A Collection of the Most Popular and Impressive Songs and Poems of War Times, Dear to Every Southern Heart.* Chicago: John C. Winston, 1904.

"What the Southern Woman's Educational Alliance Accomplished in 1931–1932: Annual Statement of Its Activities Covering October 1, 1931 to September 30, 1932." Richmond, Va.: Southern Woman's Educational Alliance, 1932.

Whelan, Richard. *Alfred Stieglitz: A Biography.* Boston: Little, Brown, 1995.

"Where Is Photography Going?" *Light and Shade* (New York: Pictorial Photographers of America, April–May 1932): 4–11.

Whisnant, David E. *All That Is Native and Fine: The Politics of Culture in an American Region.* Chapel Hill: Univ. of North Carolina Press, 1983.

White, Clarence H. "Photography as a Profession for Women." *American Photography* 4 (July 1924), 426–432.

————. "The Progress of Pictorial Photography." *Pictorial Photographers of America* [Annual Report]. New York: Pictorial Photographers of America, 1917, 5–16.

————. "The Year's Progress: An Interview With Henry Hoyt Moore." *Pictorial Photography in America*. New York: Pictorial Photographers of America, 1921, 6–10.

White, Maynard P., Jr. "Clarence H. White: A Personal Portrait." Ph.D. diss., University of Delaware, 1975.

————. *Symbolism of Light: The Photographs of Clarence H. White*. Wilmington: Delaware Art Museum, 1977.

————. *Clarence H. White*. Millerton, N.Y.: Aperture, 1979.

"Who's Who in Pictorial Photography 1927–28." *The American Annual of Photography, 1928*. Boston: American Photographic Publishing Co, 1928.

Wilder, Thornton. *The Angel That Troubled the Waters and Other Plays*. New York: Coward–McCann, 1928.

Williams, Susan Millar. *A Devil and a Good Woman, Too: The Lives of Julia Peterkin*. Athens: Univ. of Georgia Press, 1997.

Willis-Braithwaite, Deborah. *Van Der Zee*. New York: Harry N. Abrams, 1993.

Willis-Thomas, Deborah. *Black Photographers, 1840–1940: An Illustrated Bio-Bibliography*. New York: Garland, 1985.

Wings, the Official Publication of the Literary Guild of America. Ulmann photographs are contained in the following issues: July 1931, September 1931, April 1932, August 1934, and August 1935.

Wisehart, M.K. "The Kind of Poise that Gives You Power." *The American Magazine* (June 1929).

————. "You May Be Young in Years But Old in Hours, If You Do Not Waste Your Time." *The American Magazine* (October 1929).

Witkin, Lee D., and Barbara London. *The Photograph Collector's Guide*. Boston: New York Graphic Society, 1979.

Woloch, Nancy. *Women and the American Experience*. New York: Knopf, 1984.

"Woman's Group Plans Forum on Rural Girl." *Richmond Times-Dispatch*. October 15, 1933.

"Work They Can Do Taught to Cripples: Bronx Hospital of Hope Aims to Make Maimed Independent and Useful." *New York Times*. October 18, 1914.

Yates, Steve, ed. *Proto-Modern Photography*. Santa Fe: Museum of Fine Arts, Museum of New Mexico, 1992.

Yochelson, Bonnie. "Clarence H. White Reconsidered: An Alternative to the Modernist Aesthetic of Straight Photography." *Studies in Visual Communication* 9 (fall 1983): 26-44.

Yochelson, Bonnie, and Kathleen A. Erwin. *Pictorialism into Modernism: The Clarence H. White School of Photography*. New York: Rizzoli International Publications, 1996.

Index

Note: Page numbers in italics refer to photographs.